Masterpieces of Western Sculpture

MASTERPIECES OF WESTERN SCULPTURE

from Medieval to Modern

HOWARD HIBBARD

CHARTWELL BOOKS INC.

Dedicated to Irving and Barbara Kruetz

Published by Chartwell Books Inc.
A Division of Book Sales Inc.
110 Enterprise Avenue
Secaucus, New Jersey 07094

MASTERPIECES OF WESTERN SCULPTURE
FROM MEDIEVAL TO MODERN

Much of the illustrative material is drawn from "I Maestri della Scultura" © 1966 by Fratelli Fabbri Editori, Milan.

Second Edition

ISBN: 0-06-011878-4
Library of Congress Catalog Number: 77-2416

Book design by Massimo Vignelli
Composition by A. Colish, Inc., Mount Vernon, New York
Production supervision by Tree Communications, New York City and Edita S.A., Lausanne.

Contents

Introduction

An essay on sculpture should probably begin with the first written account of the subject, from the Book of Genesis:

Then the Lord God formed a man from the dust of the ground and breathed into his nostrils the breath of life. . . . So God formed out of the ground all the wild animals and all the birds of heaven. . . . The Lord God put the man into a trance, and while he slept, he took one of his ribs and closed the flesh over the place. The Lord God then built up the rib, which he had taken out of the man, into a woman.

God's chief sculptures, man and woman, were created in His image, and most mortal sculpture since then has concentrated on the human form. Since Paleolithic times, in fact, sculptors and patrons of sculptors have agreed, tacitly or openly, on an anthropocentric view of the world. Sculptors, like the the God of the Hebrews, seemingly cannot resist an urge to create forms, not only visible but tactile. Quite probably the first sculptures made by our ancestors were molded and modeled, as in the account in Genesis—but unlike God's works, they have disappeared without a trace. The earliest surviving sculptures are of crudely carved stone and almost certainly served as cult objects, fertility symbols, or amulets. Indeed, man seems to have made his first images of gods.

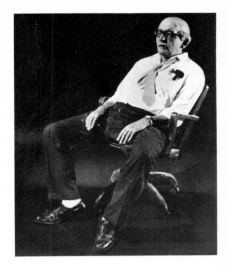

FIG. 1. Duane Hanson, *Businessman.* Polyester resin and fiberglass, polychromed in oil; 1971. Richmond, Virginia Museum of Fine Arts

Sculpture is a spatial art; like architecture, it occupies and displaces space and thus can be distinguished from painting on a flat surface, which sometimes simulates forms in space but cannot create space. Nevertheless, sculpture has usually had more in common with painting since both arts have traditionally attempted to show how things look, or might have looked, or should look. Both arts are often, even usually, figural. In the Italian Renaissance much ink was spilled on pseudophilosophical discussions as to which of the two was better, painting or sculpture. Painting, oddly enough, usually came out the victor just because it was further removed from reality and hence more sophisticated. Even today, "art" probably means painting in most people's minds. For each piece of sculpture we may possess we surely own many paintings; and there is even a widespread feeling that sculpture is in some way an inferior or more limited art.

Part of the problem with sculpture, raised by the passage from Genesis, has to do with how real is "real" and where we draw the line between life and art. A naive inquirer might assume that figural sculpture would naturally aim at achieving perfect realism, like a petrified man, but this has rarely been true. Petrifaction, like embalming, reeks of the grave, and most sculpture seeks to evoke life, not death. A key aspect of this problem is found in the use of color. A figure in Madame Tussaud's is an imitation of lifelike reality; its aim is to fool or beguile. The dummy wears clothes like those of the personage it represents and assumes a characteristic pose that summons up memories of that person or event. Recent "Radical Realist" sculpture simply does the same thing better (see Fig. 1, Plate 144b), but this is an extreme, a *reductio ad absurdum.* Most historical sculpture has avoided coloristic or other aspects of extreme realism since art usually seeks not to delude but to inspire. If the aim of sculpture were to produce a simulacrum of living reality, the greatest works by Phidias or Michelangelo would pale to nothing in confrontation with moving, breathing life, no matter how humble. If our desire for sculpture is as a substitute for reality, like Pygmalion's, then sculpture must indeed occupy a low place, since the world is populated—overpopulated—with real people.

Figural statuary has tread a narrow path, gradually assimilating lifelike qualities as it evolved in ancient Egypt and Greece. Such sculpture was not precisely a substitute or imitation but an invocation, in images of gods, or an evocation, in portraits or memorials. As the classical Greek style developed, an esthetic grew up with it that was in certain respects less realistic than that

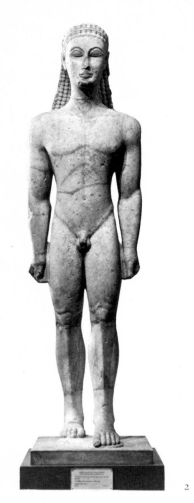

2

of the Archaic style before; and classical sculpture was less obviously colored. Sculpture emerged from antiquity with many possibilities, realism being only one of them.

In addition to realism, there are evocative, even magical qualities to be found in sculpture. A piece of figural sculpture is an object outside ourselves that may represent a sense of our own existence in the world of space. This image is drawn from the visual and tactile impression the sculptor has of others, together with the quite different experience he has of his own body. These ingredients may be mixed in diverse ways, and they are notoriously variable from culture to culture and from person to person. Still, a sculptured image is at least in part an extension of an idea of ourselves. Its partial counterpart in ordinary life is the toy—the doll or play animal that is so valuable to children as an intermediary link between their private fantasy or incoherent experience and the "real" world of grown people, full of changing, frightening, or misunderstood objects and events. The analogy with childhood toys does not precisely parallel the primitive use of sculptural objects, but it may give a glimpse into the early lost world of our ancestors and their need for reassuring images that gave continuity to experience.

While never losing its totemic, magical, or surrogate aspect, sculpture also has a more personal and adult quality, tactile and erotic. Pygmalion's amorous caresses, with the help of Venus, brought his ivory statue to life; although few art lovers take their statues to bed, the need to touch and to fondle is inseparable from our experience of most objects, especially of figural sculpture. All the more frustrating and regrettable, then, that publicly displayed sculpture almost invariably comes with the injunction: DO NOT TOUCH.

Sophisticated sculpture, with which we are chiefly concerned here, is not merely idol or totem, and it goes far beyond primitive levels of imitation and the sense of touch. Nevertheless, these elemental concepts lie behind all sculpture. Our perception of the quality of a sculptural style or the excellence of an individual statue depends on a complex interplay between such universal, even primitive elements, together with the technique and ability of the artist and the sympathy and understanding with which we view his culture.

Types and Techniques

Statuary is of two basic kinds, modeled or carved. The sculpturing God of Genesis modeled man out of the dust of the ground, a technique that has served sculptors from time immemorial. The usual material for modeling is clay, which is kept wet while it is worked, then dried, and, for preservation, sometimes baked. Most modeled sculpture is meant to be cast in metal, often bronze, and so becomes a permanent hard object that still may have much of the autograph individuality of the clay or wax (see Plates 104, 106, 108). The techniques of casting are themselves a specialized craft, and only rarely was the sculptor also the founder, although Cellini cast his own model of *Perseus* (Plate 66). Some modern sculptors work directly in metal with an oxyacetylene torch that cuts, welds, and even colors steel, but this is a very recent technique (see Plates 130, 141).

Much of the great statuary of Greek antiquity was bronze; little has survived, since there have been intervening periods when the material itself was more valuable than the work of art. Indeed, bronze statues that today would be considered the greatest masterpieces of art were melted down for military purposes. Because Greek bronze statuary was prized and rare even in antiquity, it was often copied in marble; our museums are full of these copies and fragments. Often the figure has been given a partial tree trunk to add support to one leg since marble is breakable. This Greco-Roman statuary of white marble was the chief influence on Renaissance art, governing both

sculpture and painting (see Fig. 4). The Greeks and Romans also fashioned original sculptures in stone, such as the great series of monolithic Archaic Kouroi from Athens, which date from the seventh and sixth centuries B.C. (Fig. 2). Sculptural adornment of the ancient temples was carved in marble, free or in relief, and then set in place. The cult statue of such a temple as the Parthenon, however, was a colossus of ivory flesh and beaten gold garments; it has long since disappeared.

The process of carving marble is tedious and painstaking and has therefore been the technique prized by sculptors like Michelangelo, who considered modeling an art of addition, like painting. The stone sculptor typically starts with a block of suitable size, shape, and quality for the figure he wants to carve. He marks the outlines of the figure on the sides of the block and carves in with, first, a pointed chisel (punch) to block out the larger forms. He might then refine the sculpture with a toothed chisel, which he would continue to use until he reached the final stages of rasping and polishing. Some of the markings made by a toothed chisel can still be seen on unfinished sculptures, such as Michelangelo's *Deposition* (Plate 57). On fragile materials like marble, the chisel must be used carefully in order to avoid splitting or cracking; normally it is held at an acute angle to the surface.

Whereas ancient artists, and many modern ones as well, worked in from all sides more or less at the same time, other sculptors have preferred a frontal approach. The Archaic artist of a Kouros worked in from all four sides; but because he did not yet have the fine-toothed chisel, his work inevitably had a blocky effect, chiefly frontal but with four distinct views derived from the original block of stone. The frontal aspect was all-important since these figures are frozen in a forward-looking and forward-moving stance. And because the essential view is from the front, the artist worked from front to back and outlined the outside silhouette from that point of view (see Fig. 2). Silhouettes, or the edges of the mass as seen against the space around it, are one of the characteristic aspects of sculpture, and many sculptors exploit this esthetic possibility in their art (see Plates 24, 58, 75, 136).

Michelangelo's sculptures were also meant to be seen from one point of view; consequently, he would carve back from the main face into the stone, starting in the center and gradually working out and around. The resulting statue was thus capable of being changed somewhat in the course of execution, and this more experimental technique may even have sometimes led Michelangelo to leave his works unfinished as he discovered that he could not do what he had hoped, or that he no longer wanted to do what was still possible. Nevertheless, he planned his sculptures carefully, not only on paper but in clay models that allowed him to produce quickly, in miniature, what would take months to achieve in the final marble. Bernini, too, used clay models extensively, but his sculptures betray no sign of having been carved in from one side or another, and they are always finished to the degree he planned. Bernini's statues and groups are psychologically and physically aimed in one direction, and so, despite enormous technical and spiritual differences, his statuary is, like Michelangelo's, essentially frontal and sometimes relieflike (see Plates 56, 73).

Statuary with more than one view evolved in antiquity and was probably the direct result of the technique of modeling. When classic fifth-century sculptors like Polykleitos perfected the standing figure in an easy contrapposto stance (Fig. 4), they created the sense of a movable body, obeying the laws of gravity, that could potentially turn on its axis. Such statuary was originally of bronze (Fig. 3) and was probably planned with the use of small models that were then successively enlarged (cf. page 68). The final model was formed in the round by the artist, who shaped and worked the soft clay with his hands, moving around the form to give it the aspect he wanted. Modeled sculpture

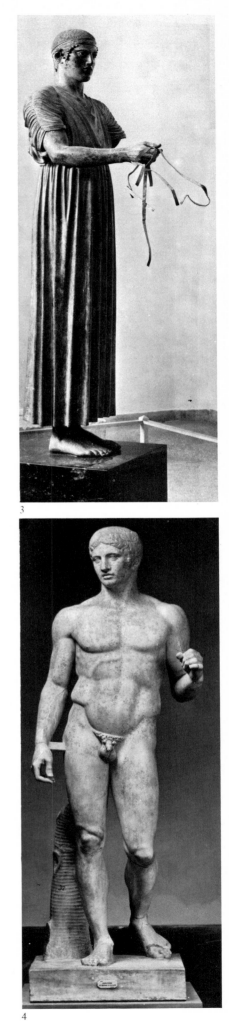

3

4

therefore tends to encourage not merely a three-dimensional but a multifaceted and ultimately even a spiraling esthetic that can lead or even compel the viewer around the statue to see every aspect of the work. This all-round viewpoint developed slowly, however, since even the *Doryphoros,* which was originally bronze, follows the frontal orientation of earlier marble statuary (see Figs. 2, 4). It was not until the time of Alexander the Great that artists like Lysippos conceived the idea of an expressive contour for each viewpoint and even actually forced the viewer out of the frontal plane—in one famous instance, by an assault that smashed the esthetic envelope of space that had formerly surrounded Greek statuary (Fig. 5).

Such communication between a work of art and the spectator, such penetration of our space and our psyche by the gesture or aspect of a work of art, is also characteristic of the seventeenth century, the age of the Baroque, whose great expositor was Bernini. Still, Bernini never broke down the barriers between art and life completely; although his works make a claim on our hearts and minds (he was the greatest religious propagandist in the history of sculpture), they do not assume the color of life (see Plates 73, 76, 78). The statuary of Bernini affects us so positively and immediately because it is essentially frontal and dramatic. Conversely, the kind of multifaceted sculpture that can trace its lineage back to Lysippos is typically sophisticated, often art-for-art's-sake, and keeps its esthetic distance. Thus the statuary of Giambologna invites us to move around it in order to discover successive unfoldings of an endless variation of contours with an ever changing set of new relationships within the silhouette (see Plate 71, Fig. 28). These variations are directed inward self-consciously and affect us passively, unlike the active charge of Bernini's focused drama. But whether frontal or spiraling, sculpture tends to work on our sensibilities as a relationship of mass and volume to the surrounding space, often with expressive contours that, like the volumes they enclose, change as we move around the work for a succession of different views (see Plates 21, 31, 38, 66, 68).

So far we have discussed statuary as a work of art in space, unattached and free, but there are many kinds of sculptures that are not free-standing, which are called relief (see Plates 2–13, 33–37). In Egypt, these reliefs were often incised into the face of the stone, or only outlined; even if uncolored, they were clearly closer to drawing and painting than to sculpture as we know it. In Greece we find both high and low reliefs, but both tend to rely on cutting back the face of the block of stone to create a plane against which the figure or scene stands out. Low reliefs are raised only a few inches, or even less (see Plates 3, 36). The various kinds and senses of relief sculpture differ, therefore, depending on the period and the place. This difference is partly the result of the position and function of the relief: smaller objects like sarcophagi, pulpits, or altar frontals could be carved in varying depths since they were typically viewed from nearby (see Plates 2a, 13, 18, 20). But relief sculpture is also the normal decoration for architecture and is inseparable from the buildings of several of the greatest epochs of art.

The classical Greek temple in marble probably evolved from a wooden prototype with beams and rafters. Spaces between the upper supports came to be filled in and decorated—ultimately with marble relief sculpture when the building was of marble. Thus the convention arose in classical times (unlike precedents in Assyria and Egypt) to reserve sculpture for nonfunctional places on the building: reliefs on the frieze and statues in the pediments. The metopes of the entablature of the Parthenon were far above the viewer and were therefore carved boldly, in high relief; the pediments of a Greek temple were often filled with sculpture carved separately in the round that gave the effect of relief when set in place. The structural members of the temple, the columns and architraves, were left unadorned. In the Hellenistic and Roman

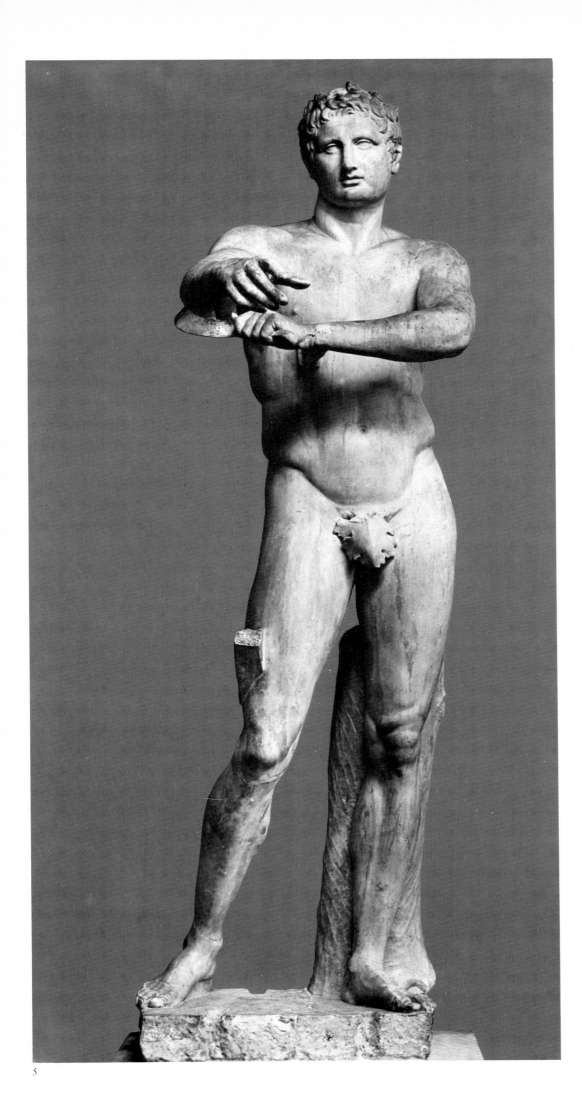

5

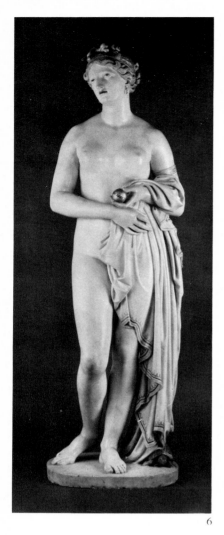

FIG. 6. John Gibson, *Tinted Venus*. Poly-chromed marble; first exhibited 1862. Liverpool, Walker Art Gallery

FIG. 7. Gaudenzio Ferrari, *Crucifixion*, scene from the Passion. Painted wood and terracotta, frescoed walls; ca. 1522–24. Varallo, Sacro Monte

periods these distinctions carried on with modifications; there were even occasional capitals with sculptured figures, unlike the practice in classical Greece.

The high medieval period, from about 1100 on, was the great postclassical era of architectural sculpture. Sculpture was used on just those parts of the building that had been left without decoration in classical antiquity. In the eleventh and twelfth centuries, Romanesque artists began to decorate their churches with elaborately carved capitals showing both sacred and profane scenes (Plates 4, 5a). The portals and façades of the churches gradually began to sprout and grow relief scenes depicting the Last Judgment and other biblical stories (Plates 6–11). All of this culminated in the expansive Gothic portals of the twelfth to fourteenth centuries with their myriad figures, which grew increasingly realistic and ever more independent of the architecture from which they sprang (see Plates 17, 19). A rebirth of statuary was gradually achieved in the later Middle Ages, and in a sense this was only modified and developed in the Renaissance, which was a period of more conscious historicism. Architectural sculpture, by comparison, was less notable or appropriate in later years, when architecture and sculpture tended to evolve along different paths. Still, the Neoclassic era around 1800 was a period of much retrospective carving in white marble relief, a tendency that continued into the Romantic period and later (see Plates 102, 103).

The Use of Color

The purpose of this book is to present in color a number of typical and attractive examples of sculpture produced in the last thousand years. This opportunity demands some consideration of the place and use of color in sculpture, a topic that has been little discussed. For the modern viewer, the simplest and most satisfying value of a color illustration is that it gives a better idea of the true look and feel of the material—marble, bronze, gold, iron, ceramic. Even Carrara marble is not a pure white crystalline substance; and as the sculptor chisels and polishes, it takes on new aspects that time changes even more, for better or, usually, for worse (see Plates 24, 33, 57). Thus even the white statuary of the Renaissance and post-Renaissance periods must be seen in color to be seen truly, and often it is in a setting that is colored even if the sculpture itself is not (see Plates 73, 75). Sometimes the statuary itself was painted. Laurana's geometrically abstract bust (Plate 48) is quite realistically colored, and Conrad Meit's alabaster *Judith*, a Renaissance *femme fatale*, has delicately tinted lips, eyes, and hair (Plate 62).

The myth of a white classicism, though dear to the man of the Renaissance, is not historically founded. Ancient Greek sculpture was vividly colored in conventional tints. Archaic stone statues and reliefs originally shone out with reds and blues that probably derived from more primitive periods when sculpture was made of perishable materials and painted for decorative or magical effect. As the mature classical style developed in the fifth century B.C., color was probably used more discreetly, but our knowledge is limited by the weathering that all architectural sculpture has undergone. Other ancient sculpture, when it survives, has almost always been severely aged underground or underwater. But we are told that even in classical times marble flesh was tinted by a process that the Greeks called *gamosis;* such a tinted statue was produced, provocatively, by a nineteenth-century English classicist, John Gibson (Fig. 6).

Materials other than marble have more obvious reasons to be seen in color—much medieval church sculpture is in metal, even gold, and is often studded with jewels and other ornaments (see Plates 2a, 13). The dazzling splendor of these treasures was produced to adorn the house of the Lord; no treasure was too rich, no jewel too costly to honor God and to reflect, however

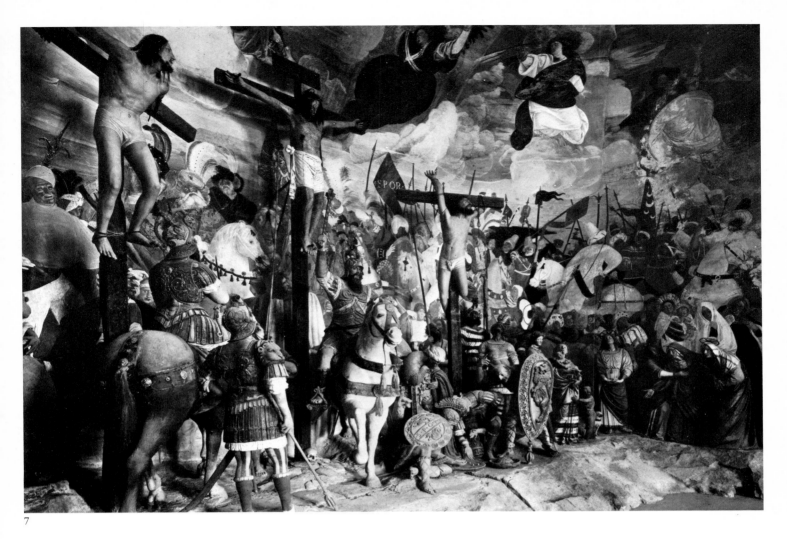

7

dimly, the refulgence of heaven. The color given by precious materials is
symbolic of the value invested in the work, not only as an object of artistic
merit but also as one of intrinsic worth. The same esthetic prevailed in cheaper
materials, which were almost always painted to resemble something more
valuable (see Plates 1, 5a, 14). Marble and bronze have always been expensive
substances; sculpture in even more precious materials occasionally served
during turbulent periods of history as the best way to keep one's assets close
and secure—and our coins today are still ornamented with symbolic reliefs
and portraits.

Ancient bronze statuary was not usually colored (although even that is not
always certain). Bronze statues were often gilded, either to accent ornaments
or costumes or simply to make them shine like gold, a practice that continued
in the Middle Ages and Renaissance (see Plates 32, 36, 70). In addition, many
of them were given eyes of paste or glass, which added an immense sparkle
of life to the unnatural patina of the metal flesh (see Fig. 3). The realistically
painted eye was a hallmark of ancient sculpture whether in bronze or marble;
the modern concept of white classical statuary with blank staring eyes is
wholly unwarranted and false.

We have already noted that color, like other aspects of lifelike realism, was
something that most sculptors have treated with cautious respect so as not to
confuse the realms of art and life. Realistic color is most familiar in folk art and
survives in provincial reflections of more sophisticated (usually uncolored)
foreign styles. Although this realistic, colored sculpture exists in great quantities,
it takes a relatively minor place in the usual versions of the history of art. Most
of it is considered to be on the borderline between art and something else—
kitsch—and is usually associated with the sideshow, waxworks, cheap religious
artifacts, or the ventriloquist's dummy. Highly colored sculpture with realistic

effect is more widespread than we realize; it can be traced back confidently to the early medieval period and survives on many levels of sophistication, from toys to Baroque altar decorations and memorials (see Plates 14, 22–23, 25, 26, 84–85, 86, 87). These painted sculptures are usually of wood or plaster, and their illusionism can be remarkable; the *trompe l'oeil* effect is occasionally bolstered by perspective paintings (see Fig. 7, Plate 86). In addition, sculptures were sometimes given real clothing—even the old image of the Athena Parthenos (displaced by the chryselephantine idol by Phidias) was attired in a new peplos on every Panathenaic holiday. Some Spanish Renaissance figures have removable clothing and armor of staggering craftsmanship (see Plate 64); and several of Degas's *Dancers* wear real cloth tutus and other items of clothing (see Plate 108). In recent times, a few sculptors have used new materials to produce almost completely lifelike figures, but this is a tendency that has nowhere to go (see Plate 144b, Fig. 1).

Even in marble sculpture, coloristic effects are possible. By cutting and undercutting, a sculptor can give a statue chiaroscuro that modulates from brilliant highlight to deep shadow and varies with the changing light. By polishing more or less, a sculptor can vary the surface of marble to imitate the effects of nature, and this too can be done in realistic or expressive ways. Michelangelo, for complex reasons, left most of his statuary unfinished (see Plates 57–59). The chisel marks that remain set up a textural colorism, probably not intended by the master, that inspired such diverse artists as Bernini and Rodin to proceed in different directions with illusionistic or expressive textured surfaces. Bernini, more than his predecessors, worked coloristically with the marble, creating shadows, lines, and textures that we read as equivalents of more natural coloration. When he was in Paris in 1665, working on the portrait of Louis XIV, Bernini discoursed on the difficulties of marble portraiture, saying that if a man were to fall into a barrel of flour he would hardly be recognized, even by his close friends. When we are ill and pale we are told that "we do not look like ourselves." Bernini said that in order to imitate the natural colors of life in a marble portrait, the sculptor must make something unnatural. For example, in order to represent the livid area around an eye in a realistic way, he must incise the spot to give an effect of shadow in the white material. Bernini was also a clear thinker about giving the pupils of the eyes a dark shadow and sparkle. He did this, as did many of his contemporaries, by incising them in different ways for coloristic effect (see Plates 76, 78, 79, Fig. 31).

In modern sculpture we find new ways of looking at color; it is often used ironically or in an abnormal manner in order to point out the problem of reality versus artifact, truth versus illusion (see Plates 116, 143). Cubist sculpture is often more colorful than Cubist painting, color here having a dematerializing function. This seems also to be the case with more abstract sculptures, such as many by David Smith, Donald Judd, or Tony Caro, in which color may unify a design, make a crude substance more elegant, or give weighty materials a sense of lightness (Plate 140). Polished bronze, brass, and steel reflect light and color, and some modern sculptures are essentially mirrors. Other polished metal sculpture is deliberately left with buffing marks in order to give it a coloristic texture (see Plate 136). In George Segal's work the white figure is set off by the realistic color of the environment. And in the use of sculptured light by Schöffer and Chryssa, color becomes the very material of the work (see Plates 146, 147).

The chapters that follow attempt a brief sketch of the history of sculpture from the Middle Ages to modern times, with emphasis given to the masters and works that are illustrated. The notes on the plates provide more specific information. The bibliography is a beginning guide to the vast literature.

I The Middle Ages

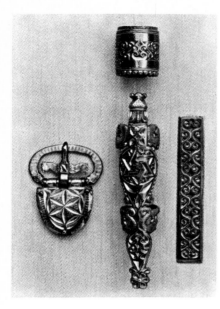

FIG. 8. Merovingian Ornaments. 5th–6th century. New York, Metropolitan Museum of Art. Gift of J. Pierpont Morgan, 1917

Despite its military and governmental successes, ancient Rome was subject to cultural counter-conquest. The first great influences were from Greece, as Horace stated in a famous line: *Graecia capta ferum victorem cepit* (Captive Greece defeated its wild conqueror). One familiar kind of Roman art was essentially Greek, and much of our knowledge of Greek statuary derives from Roman copies. But the beautiful canon of proportions found in Greek classic art (see Fig. 4) and in Roman art of the early Empire was already an antique, almost foreign style when the emperor Constantine officially changed the religion of the Empire to Christianity in the fourth century. For example, the figures on the Arch of Constantine in Rome are squat and dwarflike and present a rigidly frontal, hierarchical aspect. Another, evidently native, Roman style is represented by Republican portraiture, plain-speaking and bluntly realistic; this, too, gave way to portraits of late antiquity whose generic, otherworldly quality was emphasized by huge staring eyes. These late antique styles, which had local variants and originally may even have been provincial invasions, became the source of Early Christian art. The relatively unchanging art of Byzantium, the survivor of the old Roman Empire in the East, continued another variation of late antique art in the service of Christianity until the fall of Constantinople to the Moslem Turks in 1453 (see Plate 2a).

In the West, the provincial organization of the Roman Church had been based on the geographical divisions and government of the old Empire; in place of political unity the Church offered communion of worship. But Roman culture, never assimilated in the northern and central outposts, collapsed with the Empire under successive waves of Huns, Lombards, Goths, and Vandals. Monumental architecture and sculpture ceased to be created in the West and was replaced by an art of the possible: portable objects of precious metal or ivory, often finely worked in an abstract, interlaced "animal style" (Fig. 8). The illiterate authors of such works must have seen the humanistic art of antiquity as totally foreign, and the confrontation of their intricate folk art with the grand figural traditions of Greece and Rome resulted in a temporary obliteration of Mediterranean artistic tradition. But the Church withstood what the Empire could not, and the survival of Christianity carried along with it great chunks of ancient civilization in the form of the Latin language, manuscripts both pagan and devout, customs, and oral traditions.

The disruption and barbarism that almost wiped out all past culture from the libraries and temples and churches had a few notable interruptions, the most famous of which was the effort by an outstanding leader of the eighth century to reunite the Western world. This unusual achievement culminated in the coronation of the German king, Charles the Great, as emperor by Pope Leo III on Christmas Day, 800, which instituted the tradition of a "Holy Roman Empire" that finally died with Napoleon. Charlemagne knew Latin (he particularly loved the works of St. Augustine) and even understood some Greek, but he could not write. Because "he did not begin his efforts in due season, but later in life, they met with ill success." This vigorous blond man of the North surrounded himself with learned clerics who revived Roman script, attempted to purify the debased Latin language, and began a renewal of the visual arts—a "Carolingian Renascence" that is inherent in the very concept of his Empire. Charlemagne's Cathedral at Aix-la-Chapelle (Aachen) was loosely modeled on the Roman-Byzantine church of San Vitale in Ravenna; Carolingian monasteries produced illuminated manuscripts with recognizable human forms and recollections of antique modeling and perspective. Byzantine as well as ancient books and works of art found their way to the West, and from them coins, images, and the very language seemed to make ancient Rome live again.

Charlemagne's domain comprised what is now France, Germany, and Austria, and extended east to Poland, Rumania, and Bulgaria, even into Italy

and Yugoslavia. Saxons and other pagan tribes were forced to convert to Christianity. But although the religion prevailed, Charlemagne's Empire did not. The land was divided in 843 between his three grandsons, roughly, into Germany, France, and a strip in between, west of the Rhine, that has been a battleground ever since. Political unity for Europe has remained an ideal, briefly achieved only by Napoleon, although the Empire was revived locally and sporadically by the Ottos, Germanic kings of the tenth to thirteenth centuries.

A number of refined objects from the Ottonian period, such as the altar frontal shown in Plate 2a, attest to the fruitful contact of central European artists with the sophisticated late antique art of Byzantium, and what little is realistic in the relief in Plate 2b derives from the same confluence. By and large, however, Western artists had to begin anew. These beginnings are tied to the one institution to survive the fall of Rome, the Church, with its secular organization of archbishops, bishops, and priests and with its monasteries and their increasingly busy economic and cultural life. Only the Church could provide education to a poor but talented boy of the Middle Ages, and for centuries it was the only bond that united Europe, however loosely, from Ireland to Italy and from Spain to Poland. Only churchmen had access to a body of written literature: Bibles, or parts of Bibles, and such copies of pagan works as were made before the old scrolls were lost or destroyed. Western monasteries with their scriptoria of literate monks insured the survival of whatever antique writing was thought worthy of preservation—and the loss or destruction of everything else.

The monasteries that spread over all of western Europe in the Middle Ages owed their impetus to St. Benedict of Nursia (died 543), who, angered by the corrupt and unruly practices he found, set up an ideal Christian community north of Naples at Monte Cassino, building it, symbolically, from the stones of a pagan temple. This monastery became the inspiration for a movement that culminated in the eleventh and twelfth centuries with the Abbey of Cluny in Burgundy. Cluny, founded in 910, was independent of the state as well as free from ties to the secular Church. At first the Cluniac reformers proposed nothing more revolutionary than a return to Benedict's humane Christian ideals, but their highly centralized organization, which was governed by the Abbot of Cluny, eventually spread to encompass several hundred monasteries. In the arts Cluny was progressive, and the Abbey Church emerged as the greatest building of a successful new architectural style, the Romanesque.

Old, small, wood-roofed churches often burned down or were destroyed by invaders; they needed sturdy, fireproof structures to replace them (see Fig. 9). In the eleventh and twelfth centuries a multitude of new churches built of stone sprang up all over western Europe, and shortly after 1000 the Cluniac chronicler Raoul Glaber wrote that "it was as if the whole world . . . were clothing itself in the white robe of the Church." The interiors of these buildings were covered by round stone vaults that were supported by heavy walls whose windows allowed only a little light to enter. The massive Romanesque choir with radiating chapels or staggered apses became the center of architectural development because of the richer liturgy of the time and the importance of the cult of relics. Each relic, often set into a richly decorated reliquary (see Plate 13), had to have its own altar and, by extension, its own chapel. In order to display the treasures and relics in a manner that could accommodate the growing numbers of pilgrims (and attract more), the east ends of the churches underwent rapid expansion, as did the crypts below. The monks of Cluny successively enlarged and rebuilt their church until Cluny III, begun in 1088 but not finished until the next century, was higher and larger than any other in Christendom, with an enormous choir, an ambulatory, and five radiating

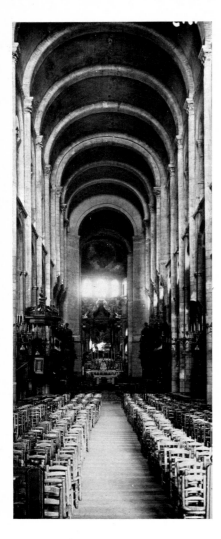

FIG. 9. Toulouse, St.-Sernin, nave. Early 12th century

chapels at the east end, as well as two transepts, double aisles, and a narthex with twin towers.

Architecture, the necessary art, preceded sculpture; indeed, large-scale sculpture was the last of the medieval arts to develop, since the Carolingians were reluctant to institute what may have seemed like a return to idolatry. When artists in the West finally desired to create a monumental figural style, they had to relearn sculptural technique; and only slowly did they begin to form human images that had a resemblance to reality (see Plates 1, 2b). Also, there was a continuing need for small-scale luxury objects: metal shrines and reliquaries, crucifixes, baptismal fonts, bishop's thrones (see Plates 2a, 12, 28–29). The use of cult images produced such figures as the crucifix in Plate 1, and the growing worship of the Virgin Mary is shown by the early Madonna in Plate 14. Medieval decorations in ivory, metal, glass, wood, and stone were often of high artistic quality. Even the famous Abbot Suger (died 1151), whose church of St.-Denis announced the beginnings of the Gothic style of architecture, was more impressed with the minor arts he had commissioned than with the church itself or the novel sculpture around its portals. Suger appreciated not only the intrinsic value of the precious objects but also their artistic qualities, writing proudly that "the craftsmanship surpassed the material."

It was not until the Romanesque period that stone sculpture first appeared in quantity on the capitals of the churches, especially in the choirs (see Plates 4, 5a). Only then did capitals become a major field for figural sculpture, a characteristic medieval perversion of an antique tradition. At first this sculpture was tentative, often flat and crude, following the form of antique capitals with the figures distorted to fit the space and shape. Frequently the capitals mixed secular or even pagan forms, Eastern monsters, and fabulous demons. At Cluny an unknown master of genius achieved a brilliant decorative scheme on his capitals that kept a general classical shape despite modeling and deep under-cutting that far surpassed that found on the typical examples of the genre (see Plate 4). He also gave his compositions a rhythmic life and decorative vitality that is far more sophisticated than the naive charm of most capitals (see Plate 5a). Many of these sculptures were painted, although often the color that survives is a later restoration.

Later in the Middle Ages Durandus wrote that "paintings and ornament in churches are a source of learning and scripture for the lay congregation." He was thinking not only of capitals but also of sculptured portals, whose tympana showed scenes of judgment and salvation. The parishioners could not read about these things since there were no printed books, and few could write so much as their names. Often the sins of our fathers were portrayed in touching, even humorous ways, as in the famous fragmentary lintel from Autun (Plate 5b) in which Eve, like the serpent who seduced her, crawls on her belly in an ornamental Paradise as she grasps the forbidden fruit. Many of these early images owe more to paintings or drawings than they do to any tradition of three-dimensional carving; the treatment of form is primitive, drapery is patterned and flat, space does not exist (see Plate 7). Such sculptured evocations of sin and redemption greeted noble, peasant, and pilgrim alike as they approached the church door (see Figs. 10–12).

Before the mid-eleventh century we find little stylistic contact between the crude mason-sculptor of portals and capitals and the finer artists who were responsible for the precious reliquaries and other *ars sacra* of church furnishing. The latter were no doubt of a higher class, often monks who were literate, if not learned. They particularly flourished in Germany (see Plates 2a, 12). One of these was a monk called Theophilus who wrote a manual on artistic techniques (*De diversis artibus*), especially metalwork. By the time Theophilus wrote (ca. 1100), there was a growing fusion of the fine artist with the crude sculptor of more monumental forms. The result was a new breed, a professional

sculptor who was able to integrate figures and even whole compositions into the architecture of the church portal and thus produce some of the greatest and most characteristic Romanesque achievements (see Fig. 10, Plates 6, 7, 9, 11, 16). The emergence of these artists, practicing a style that is only dimly related to the art of antiquity, has been compared to the gradual growth and recognition of the vernacular languages of the West: French, Spanish, Italian, Portuguese. In a much less direct evolution, the artistic styles of the Middle Ages ultimately derive from a classical figural style; the Romanesque artist carved or painted in vernacular Romanesque, just as he spoke or wrote in a "Romance" language that was no longer Latin.

The greatest Romanesque achievements are found in the churches of France, such as the awesome sculptured portals of the twelfth century, which, like so much else, derived from the lost example of Cluny. In portals like Moissac, Autun, or Vézelay we find an integrated composition built of layers of ornamental columns and arches that frame a majestic tympanum with its scene of the Last Judgment or of Christ in Majesty (see Fig. 10). These portals were often so wide that they needed a central support, or *trumeau*, which was also carved with figural sculpture. Rich and fantastic carvings cover structural elements that had been left undecorated in Greece and Rome: capitals, lintels, and even arches and columns now grow a lush covering of sculpture (see Plates 6, 7, 9). The Romanesque begins to develop into what is now discernible as incipient Gothic at St.-Denis and Chartres (Fig. 11), where fully carved figures stand before the columns. Such portals, which grew ever deeper, lead directly to the cavernous, populous façades of the High Gothic period (see Fig. 12).

A number of pervasive influences within the Romanesque contributed to the shaping of local styles. Byzantine forms invaded Ottonian work in Germany (see Plate 2a), betraying Eastern contact that was less common in France. In Italy, artists were never far from antique models; the characteristically novel and expressive medieval styles of northern Europe became blander as we go south until, in Rome, they can hardly be distinguished from the general classical survival. Even North Italian art of the Middle Ages has a distinctive quality that derives as much from its ancient heritage as from the North. On the other hand, in much of France (and in Ireland and England) the artists had little or no contact with classicizing models.

Medieval people moved about much more than is popularly thought (witness the crusades and pilgrimages), and along the great pilgrimage roads huge churches sprang up with relics to visit; these churches were typically decorated with rich carvings inside and out. Four well-traveled roads led from France south across the Pyrenees, where they joined and continued on to the church of Santiago (St. James, patron of pilgrims) at Compostela in northwest Spain. Naturally the artistic ideas of these connected areas intermingled; we must suppose that artists themselves moved freely along these roads and learned from the art they saw. Thus Conques, in central France, displays carvings similar in style to those found at Santiago. Nevertheless, there were distinctive regional schools of sculpture that did not always correspond to the architectural styles of the churches—sculptors had become independent craftsmen.

By 1100 we can distinguish in France a Burgundian school (see Fig. 10, Plates 4, 5b), related to the imperial Ottonian art of Germany, and a south-western school in Languedoc, with its center at Toulouse. This style also appears in northwest Spain at stopping points along the pilgrimage road, where local realistic elements are mixed with the more elegant importations from the North. Spain may even have been the inspiration for some French art, and we are still sometimes confused about which way the influence ran—it was a two-way road (see Plate 10). Still, the traditional belief in the primacy of

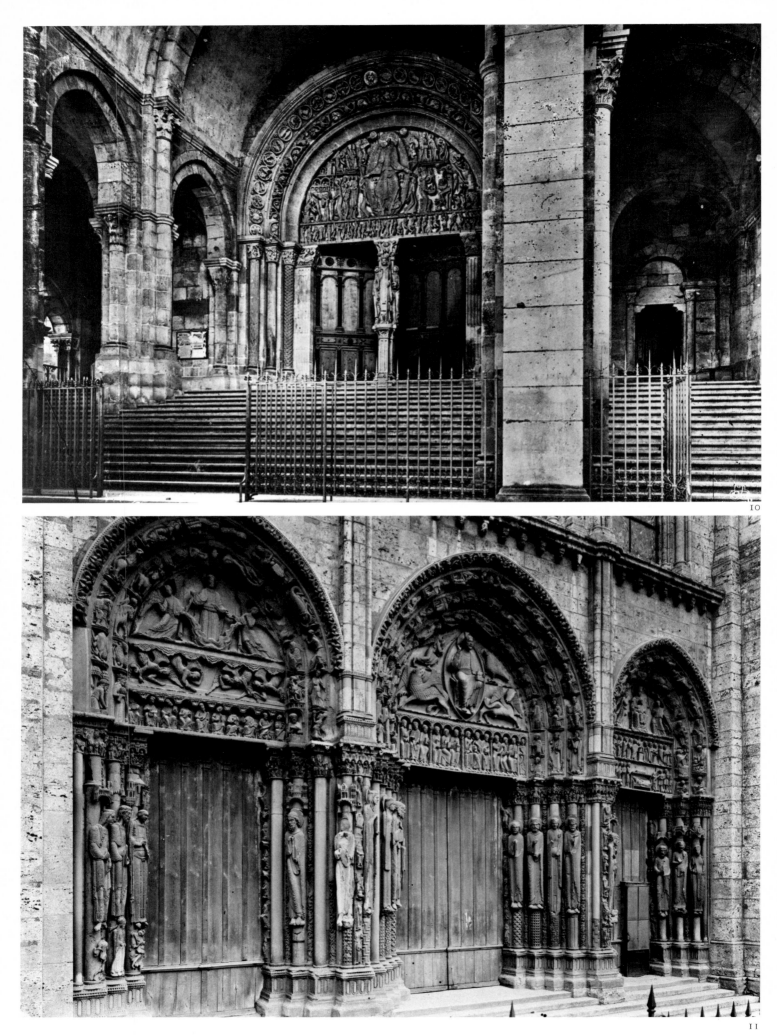

French Romanesque is essentially correct. The later schools of Aquitaine, also centered in Toulouse, continued to influence Spanish artists, as can be seen in a charming relief at Silos, where the elegant bodies with their crossed legs show through flat, clinging drapery that folds in ornamental patterns (Plate 8). The great originals of this style are in France, as the *Isaiah* at Souillac demonstrates in his dancelike pose of postured elegance and the arbitrarily decorative drapery that swirls and blows around his slender form (Plate 11).

Still another school of sculpture flourished farther north, embellishing many façades with lavish ornamental decoration (see Plate 7). Here sculptured tympana are lacking but all else on the façade is carved—a style that spread to Spain, to Normandy, and to England. Perhaps the most distinctive French Romanesque school is that of Provence, a late-blooming contemporary of the Early Gothic that first appears farther north (see Plate 9). Roman monuments abound in this region and their influence is pervasive: on friezes derived from ancient sarcophagi and on niche figures, which have a classical look, a *gravitas* that is stylistic leagues away from the charmingly quirky deformities of the Romanesque to north and west.

At a transitional moment just before 1200, a new style of fine craftsmanship emerged that we associate particularly with a single artist whose name we know, Nicholas of Verdun. His first works were in flat enamelwork, but even these early figures have the firm sense of modeling, of drapery covering believable anatomy, that we find in the magnificent shrine of the Three Magi (Plate 13). A miniature building such as this, glittering with gold and precious stones, illustrates the medieval conviction that nothing could be too precious, too carefully or elaborately worked, to decorate the house of God. The figures are based on observation as well as on classical tradition, which makes Nicholas a kind of proto-Renaissance artist of the Early Gothic period.

The architecture we call Gothic was generated in an area where the Romanesque style had been weakest, in the royal lands around Paris known as the Ile-de-France. Since the great monasteries had already built their mammoth churches in the Romanesque style, new architecture had to develop where churches were needed, in growing medieval cities like Paris, Amiens, Chartres, and Reims. Gothic architecture is easier to recognize than to define, but it included a new kind of vault, based on the pointed arch, whose weight was carried to the ground by means of ribs, piers, and buttresses. This skeletal system allowed greater height and less wall and, consequently, generated a great demand for stained glass. Gothic churches were created as vast interiors rising upward in a kind of paradigm of heaven, mystically glowing with the light of their blue, red, and yellow glass, which became more important and spectacular than the murals or illuminations of the same period. The exteriors of these high churches were hardly more than the outside of the interior— fascinating though we may find the multiplicity of rising apses and boldly cocked buttresses as they cut through the air to hold up the giant structures. The one consciously developed and elaborated part of the exterior was the façade, usually with two massive towers sheltering three deeply cut and carved entrances (see Fig. 12).

Gothic sculpture developed in the later twelfth and thirteenth centuries in these increasingly complex church portals. Early Gothic sculpture, like Romanesque, is architectural and is only occasionally independent from an architectural environment. But, unlike the Romanesque, the Gothic portal has greater depth, with almost free-standing figures that line the jambs in serried ranks: queens and kings, saints and martyrs, who welcome and, as it were, accompany the visitor as he makes his way from the secular world to the realm of God within (see Figs. 11, 12). The complex intellectual conception that underlies these sculptural programs is often compared to scholastic

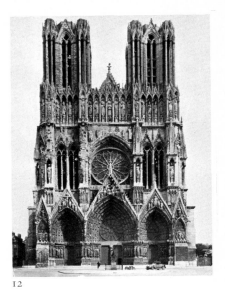

12

FIG. 10. Gislebertus of Autun, *Last Judgment*. 1130. Autun, St.-Lazare, west portal tympanum

FIG. 11. Chartres, Cathedral, west portals. ca. 1154–70

FIG. 12. Reims, Cathedral, west façade portals. ca. 1225–35

theological writings such as the *Summa Theologiae* of St. Thomas Aquinas (died 1274). But the popular theology of the people is of equal importance in assessing these images, and one of the great changes from Romanesque to Gothic is found, not only in the programs themselves, but in the dedications of the churches—the majority of Gothic cathedrals were dedicated to the Virgin Mary, a symptom of the "Mariolatry" that elevated the Mother of God (her official title since 431) to absolute prominence in the popular Christian pantheon.

In lieu of grim monsters or geometric ornament on the portals, the stepped voussoirs of their pointed arches now teem with angelic figures, saints, or other comforting images standing upright within the architectural frame. The larger figures on the jambs often carry little architectural canopies over their heads that seem to set each one in its own space, despite its attachment to the column (see Plate 17). As time goes on, these figures become more and more independent and less columnlike in form; eventually they turn and converse, setting up little dramatic ripples that give the monotonous arrangement a rhythmic as well as iconographic interest. Such column statues are altogether different from the Spanish column figures of Plate 16, where body and column share the same block of stone and support an elaborately carved capital.

At Reims we see a phenomenon characteristic of Gothic workshops: figures by different masters with widely different styles, in this case deriving from almost opposite concepts of drapery carving, both of the highest quality (Plate 17). The *Visitation* group at the right is strikingly different from the *Annunciation* in that the sculptor is directly and forcefully imitating a lost Greco-Roman model. The figures give a sense of physical being through the artist's mastery of *contrapposto*, the art of suggesting potential movement by showing the body in counterbalanced, natural positions. But most important is the classical effect of the drapery, made up of parallel folds that reveal the hips and leg of Mary and the knee of Elizabeth—a style that goes all the way back to the Parthenon pediments. Still, no one could possibly confuse these gracious figures with antique statuary, since their elongated proportions and their individualized faces pronounce them to be Northerners of a different stylistic race. We now see more clearly the difference between these High Gothic figures and transitional statuary like that in Plate 16, where despite the charm of pseudo-conversation between figures there is a generic approach to form and feature that is more stylized than the portraitlike individuality of either pair in the opposite plate. The Spanish sculptures still show naturalistic polychromy that gives the faces an eerie lifelikeness that remained a Spanish ideal up to modern times (see Plates 82, 83).

The charm and insouciance of the later Gothic in France is seen in the Judgment portal at Bourges (Plate 19), where the simple elegance of the clothing leaves the world of antique drapery far behind and the variations in hair styles show an interest in fashion. The graceful proportions of the figures are close to normal and the faces show a sunny charm, a disposition that becomes common throughout the later Gothic world. When we move to the border between modern France and Germany, as at Strasbourg, we find a courtly, gracious Gothic style that links eastern and western central Europe (see Plate 27). These large sculptures begin to proliferate inside the church as well as outside, a change that becomes characteristic of German Gothic and of the Late Gothic in general as sculpture finally becomes an independent art. Farther east in Germany, where the Late Gothic flourishes, the Prophets on the choir screen of Bamberg Cathedral exhibit quite different qualities that bear the marks of previous styles (Plate 18): elaborately patterned, restless, deeply cut drapery with Romanesque undertones, arbitrary postures (the *Hosea* at the right is both coming and going), and intense, argumentative

attitudes. Such sculptures may derive from Ottonian ivories or miniatures but they are monumentally conceived.

Sculptured projects for interiors take precedence in the later Gothic period, partly because there was less need for new churches and, consequently, what sculpture there was had to be independent of architecture. Elaborately carved marble pulpits were a characteristic Italian genre, brought to a peak of populous splendor by Nicola Pisano and his son Giovanni (Plate 20). Even in this Gothic pulpit the Italian artist betrays his classicizing background; there is also a powerful French influence on both the figures and the compositions. Although Italian art remained predominantly Gothic into the fifteenth century, it was an increasingly international Gothic of sophistication and elegance that flourished in Paris and Prague, Vienna and Verona.

In Late Gothic sculpture the cult of the Madonna flowers in independent images. At first they derive from Gothic statues on *trumeaux*, such as the *Vierge dorée* at Amiens (Fig. 13). Free-standing figures become common in France and Germany. The contrast seen in Plates 14 and 15 between Spanish Romanesque and Italian classicizing Gothic is pursued in Plate 24, where Giovanni Pisano's fourteenth-century statue still shows powerful classical ties, most obviously in the profile head. A whole series of "Beautiful Madonnas" in a soft, sweet style were produced in the North in the years around 1400 (Fig. 14). Tilman Riemenschneider's early *Madonna* (Plate 25), in the poly-chromed wood favored in Germany, displays this gentleness of manner, together with a brilliant, unanatomical display of drapery folds that is characteristic of this very late Gothic style, which is on the northern border of the Renaissance.

The outstanding personality in the North around 1400 was Claus Sluter, who came from the Netherlands but worked in Dijon for Philip the Bold, Duke of Burgundy. Sluter's realistic style made an enormous impression—it announced, in fact, the beginning of the end of Gothic sculpture (see Plate 21). Increasing realism is a characteristic of most late medieval styles (Jan van Eyck is the obvious, even notorious example in painting). But this naturalism is still subject to an elaborate symbolic program of references that is essentially medieval. Artists like Sluter were men of the court who attended great dukes and kings. As a consequence, sculpture is pressed into the service of dynastic pride, most obviously in tombs with portrait sculpture (see Plate 22–23). The recumbent Duke Philip, although dead and actively mourned by angels as well as by monkish figures in the elaborate Gothic arcade below, displays the costume and regalia of his exalted worldly state. So resplendent is this brilliantly staged sculptural monument that it would seem to be the duchy of Burgundy that is honored. By contrast, the dead Infante Alfonso is shown as if alive at prayer in a niche that displays the love of overall ornament typical of Spanish art (Plate 30); here, too, we seem to be approaching the border between Gothic realism and the new humanistic world of the Renaissance. The lively equestrian memorial to Can Grande della Scala (Plate 31) is still resoundingly medieval in its warlike trappings and makes no concession to the classical ideal of the equestrian portrait, which re-emerges a century later in Donatello's *Gattamelata* (Fig. 19).

Another developing feature of the Late Gothic was the elaborately sculptured wooden shrine, often with folding wings and sometimes including paintings, like Grünewald's altar at Colmar. Some late examples are enormously tall—the record is held by an altar in Kraków by Veit Stoss, which is some thirteen meters high and almost as wide. Michael Pacher's altar at St. Wolfgang is only slightly smaller (Fig. 15) and includes brilliantly realized, portraitlike figures with natural coloration (Plate 26). Although Tilman Riemenschneider sometimes produced polychromed statues (see Plate 25), he preferred to leave his carvings in the natural wood to display the brilliant intricacy of his

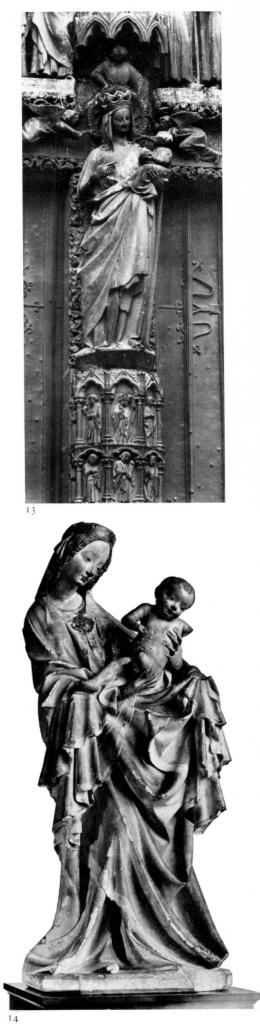

13

14

FIG. 15. Michael Pacher, *Coronation of the Virgin*, St. Wolfgang Altarpiece (detail). Wooden shrine, painted and gilded; 1471–81. St. Wolfgang (Salzburg), pilgrimage church

technique and the rich color and grain of the material (see Plate 28–29).

Stylistic terms are misleading if pressed too hard, but, by and large, northern Europe kept to the Gothic in the sixteenth century and in some areas into the seventeenth. The greatest Italian Baroque architect, Francesco Borromini, was apprentice mason at the Gothic Cathedral of Milan as late as 1618. Provincial centers stayed Gothic much longer—there is even a kind of carpenters'-Gothic church in Virginia, and in remote parts of Britain it is hard to say whether certain Gothic traits of the eighteenth century represent a survival or a revival.

The sophisticated, elegant, courtly style associated with such painters as Simone Martini is called the International Gothic; it survived into the fifteenth century in paintings by Gentile da Fabriano and even in the sculpture of Lorenzo Ghiberti (see Plate 35). But a new age was dawning in Florence, a new style had been born, and this truly Renaissance style is the subject of the next chapter.

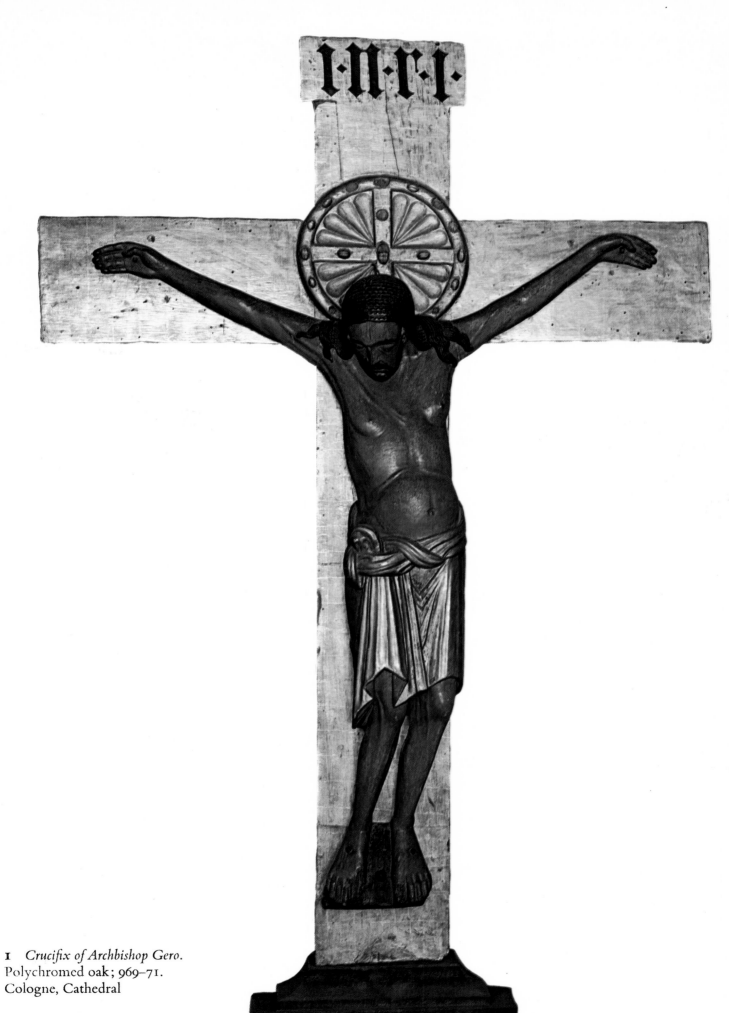

1 *Crucifix of Archbishop Gero.*
Polychromed oak; 969–71.
Cologne, Cathedral

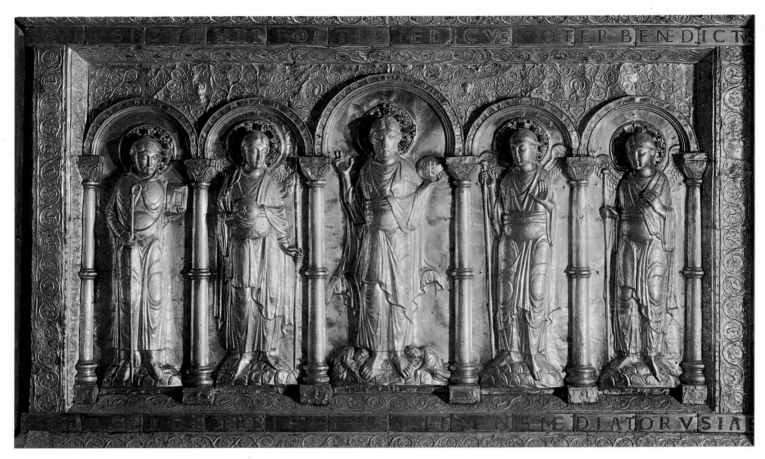

2a *Christ with St. Benedict* [far left] *and the Archangels Gabriel, Raphael, and Michael.* Altar frontal from Basel Cathedral (detail). Beaten gold; ca. 1022–24? Paris, Musée de Cluny

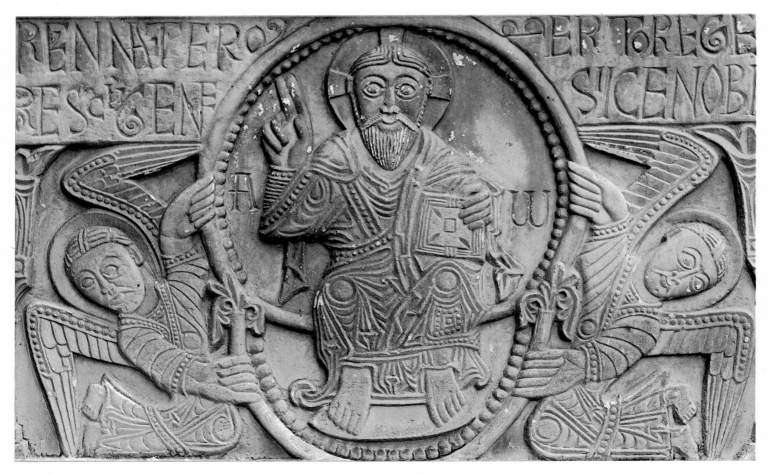

2b *Christ in Glory,* central section of lintel. Marble; 1019–20 (inscription). St.-Genis-des-Fontaines (Pyrénées), west portal.

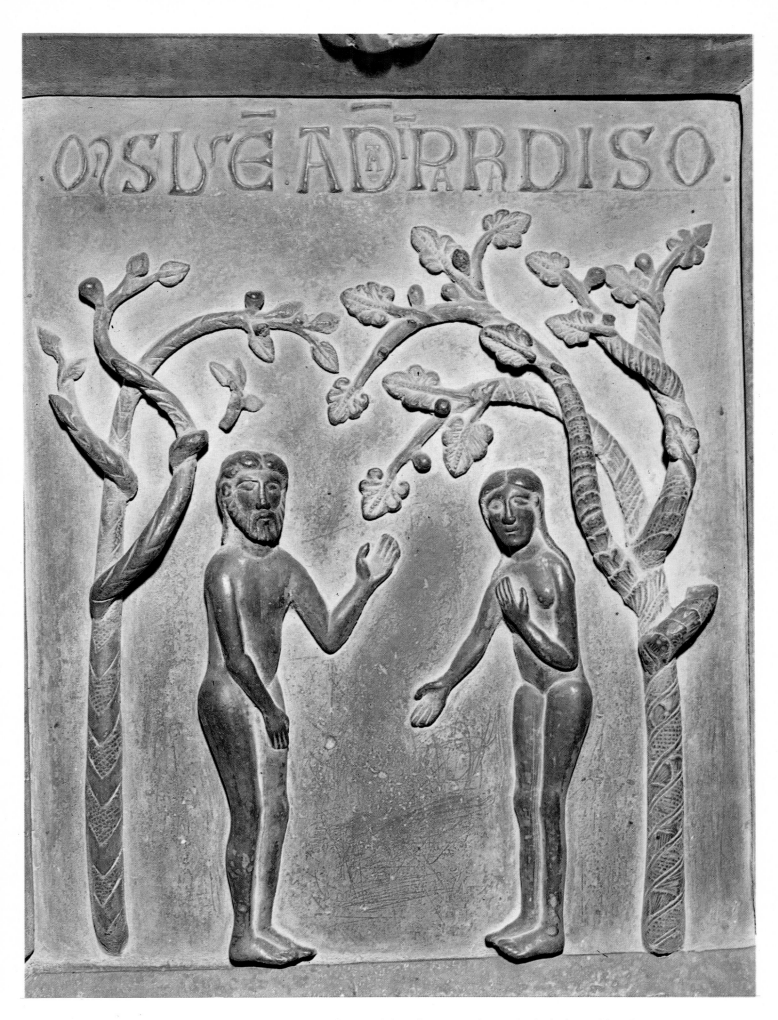

3 Bonnano Pisano, *Adam and Eve*. Bronze; 1185 (signed and dated). Monreale, Cathedral, doors (detail)

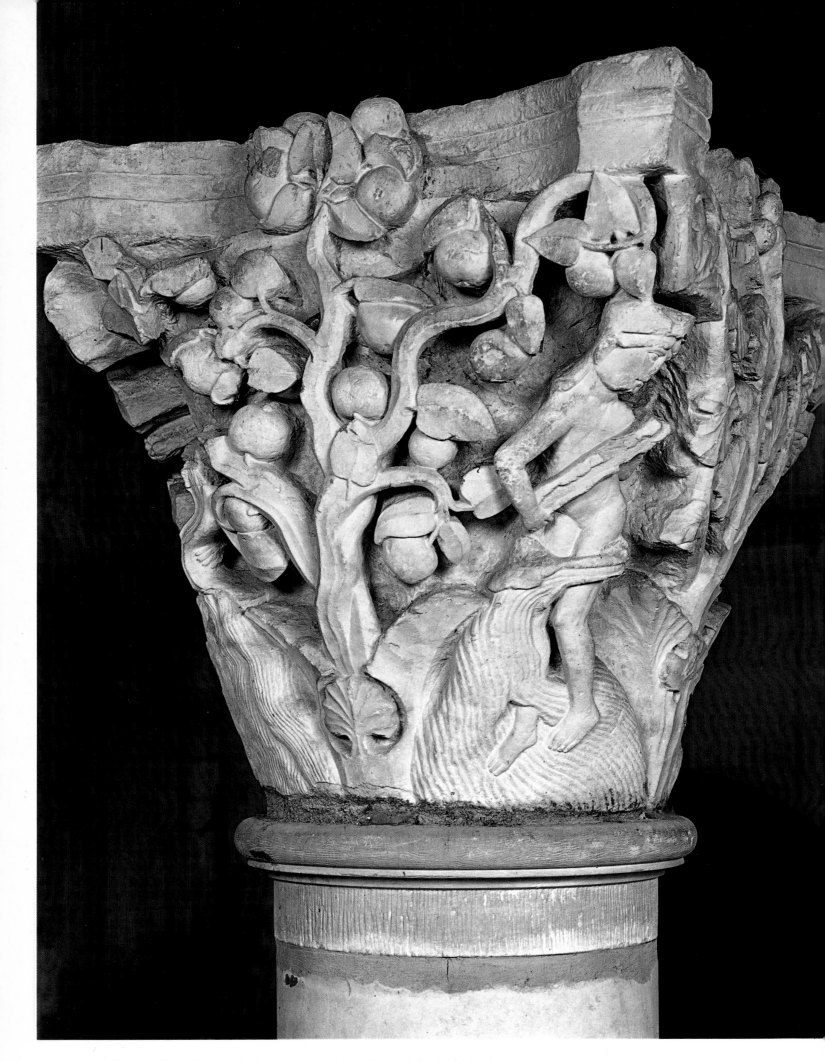

4 *Rivers and Trees of Paradise*, capital. Stone; ca. 1095. Cluny, Musée du Farinier

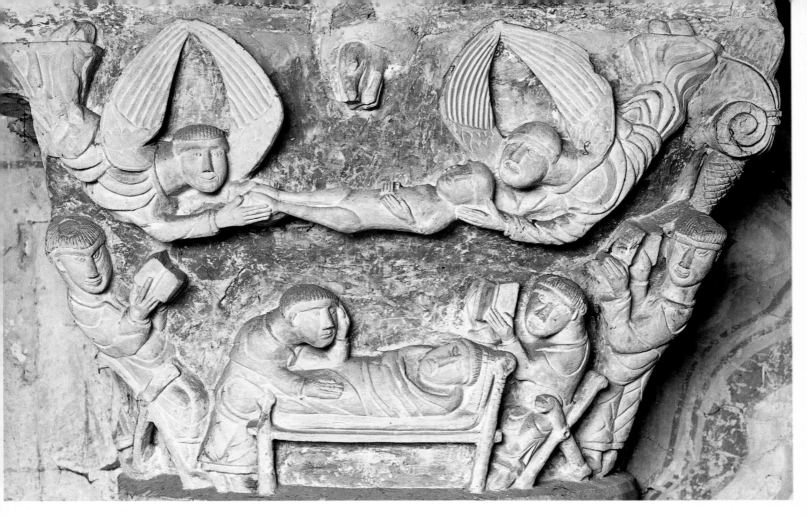

5a *Death of St. Hilary*, capital. Painted stone; ca. 1130? Poitiers, St.-Hilaire

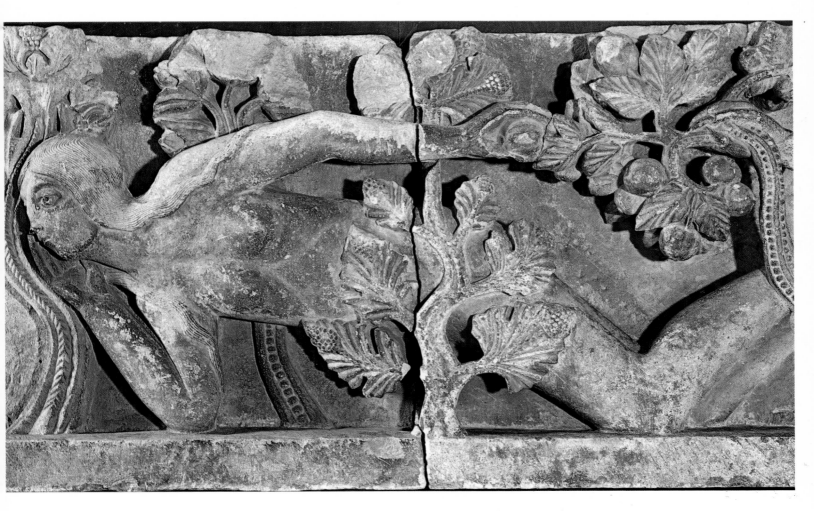

5b Gislebertus of Autun (?), *Eve*, fragment of a sculptured lintel from St.Lazare. Stone; ca. 1125–30. Autun, Musée Rolin

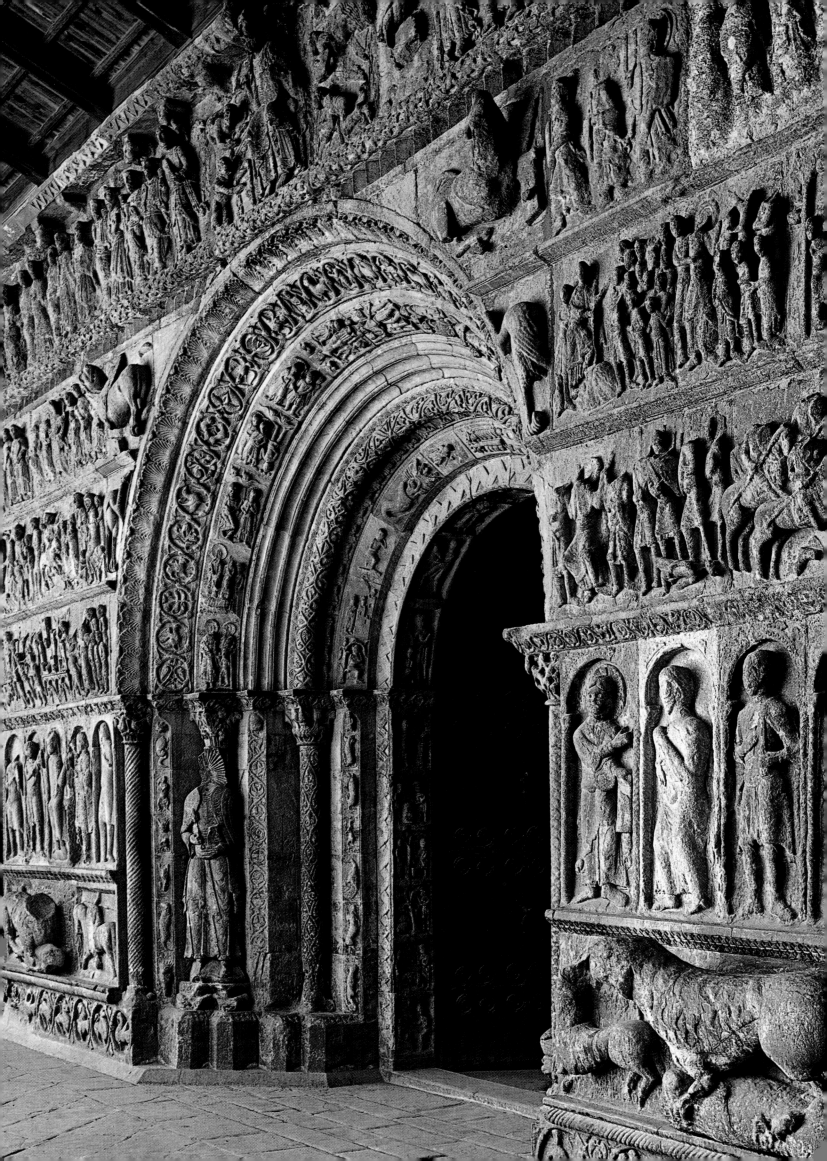

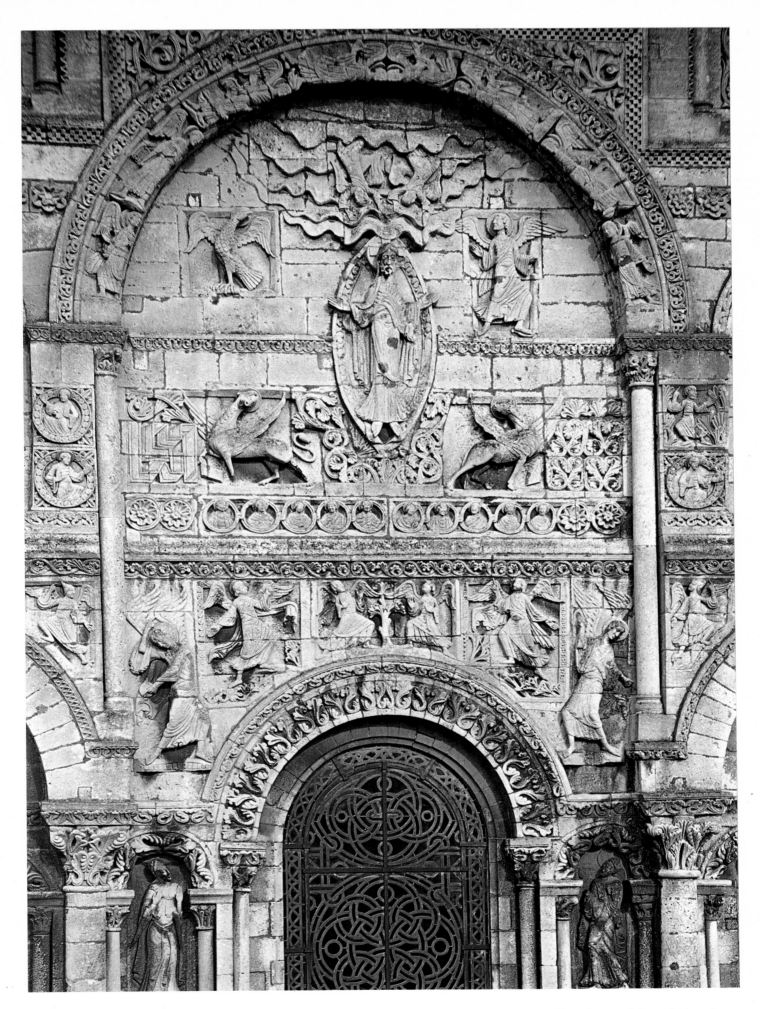

7 *Christ surrounded by the Evangelical Beasts* [Matthew, man; Mark, lion; Luke, winged bull; John, eagle], *with Apostles.* Stone; ca. 1125–ca. 1150; reconstructed. Angoulême, Cathedral, west façade (detail)

6 (opposite) Ripoll (Gerona, Catalonia), Santa Maria, portal. Marble; ca. 1150 (or earlier)

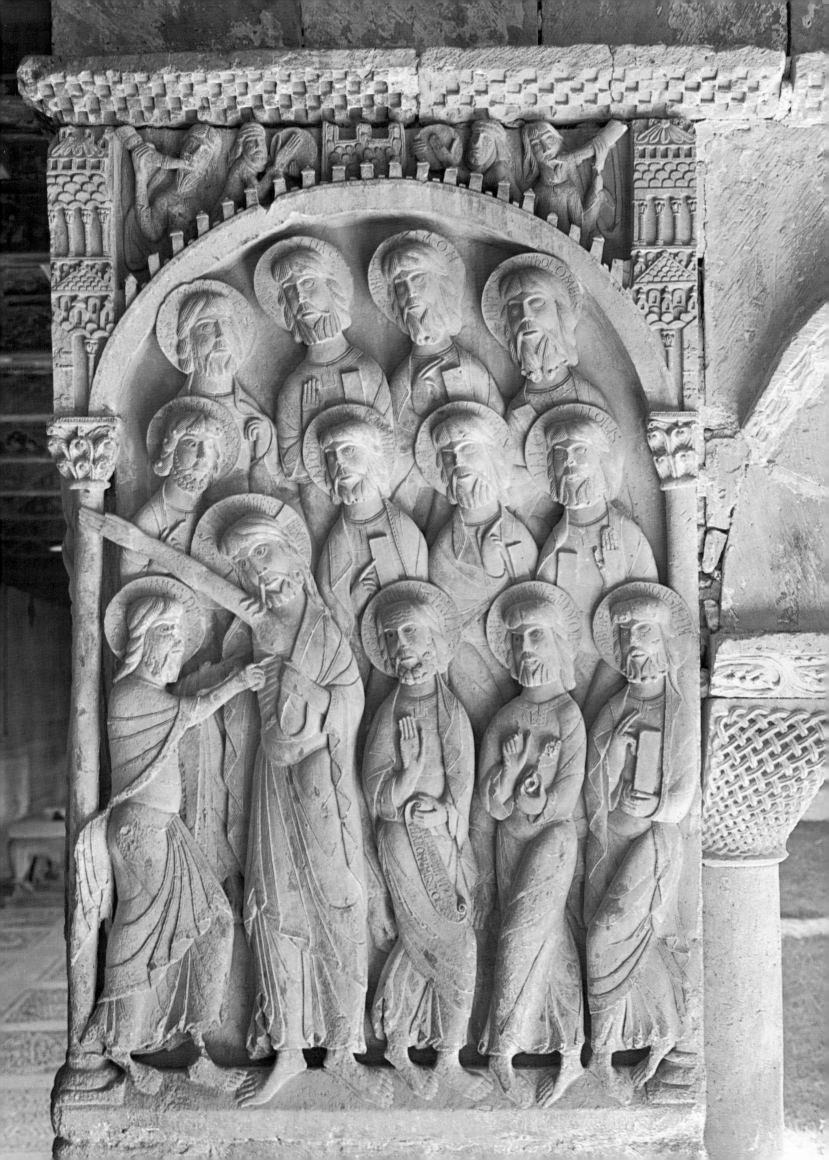

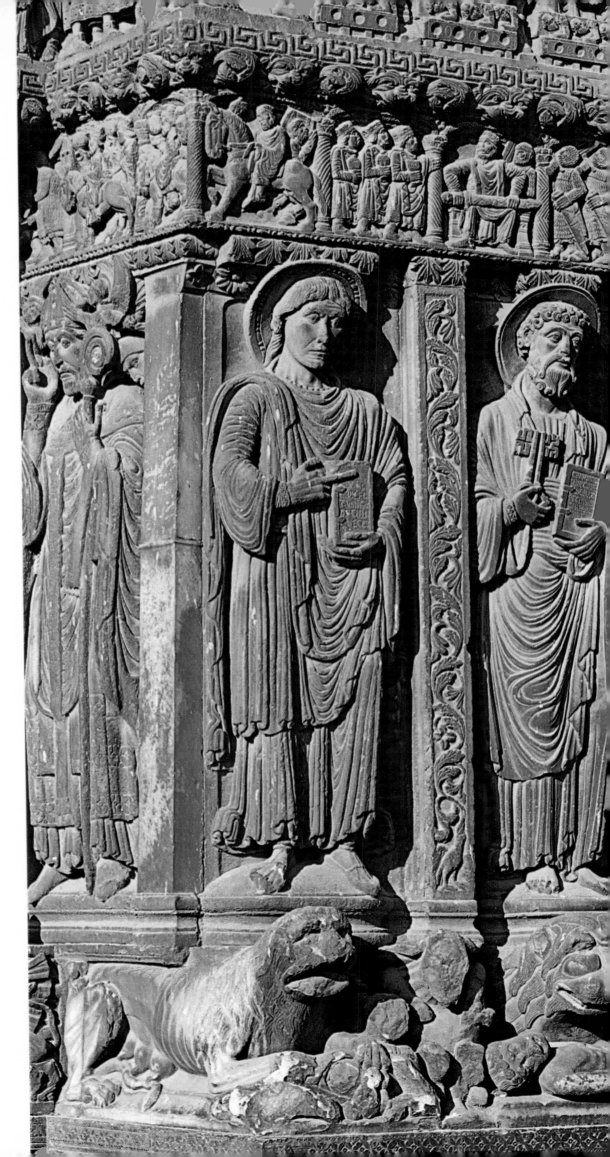

8 (opposite) *The Incredulity of St. Thomas*. Stone relief panel; ca. 1135–40 (?). Santo Domingo de Silos, cloister pier

9 *St. Trophime, St. John the Evangelist, St. Peter*. Stone; 1190–1200. Arles, St.-Trophime, west portal (detail)

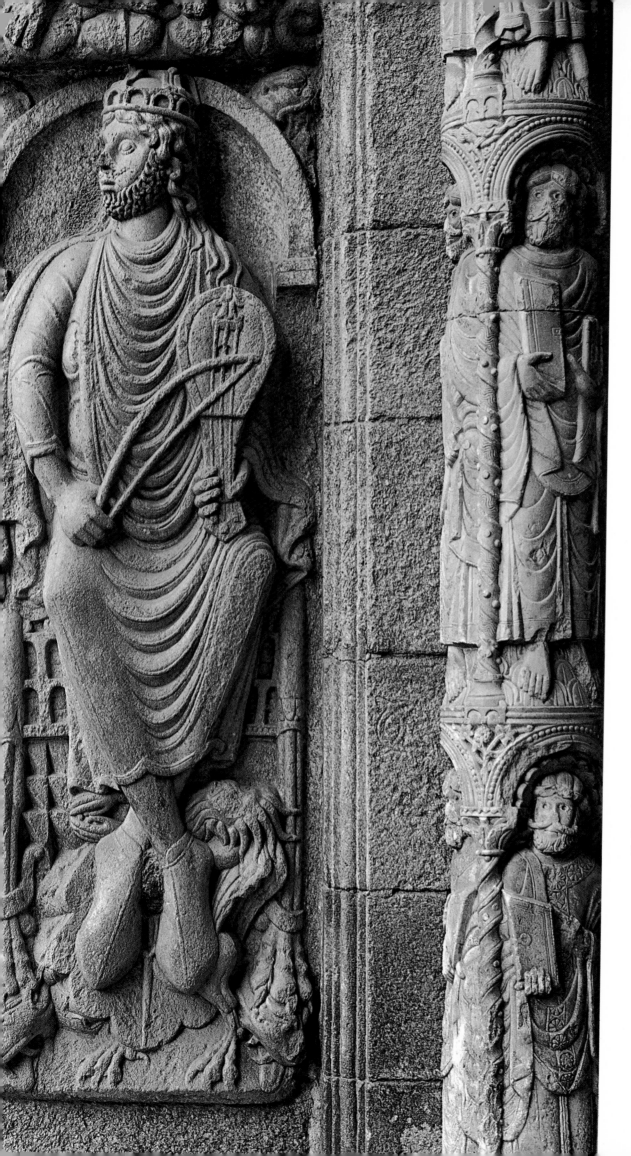

10 *David*. Granite relief; ca.
1120. Santiago de Compostela,
Cathedral, Puerta de las
Platerías (west jamb)

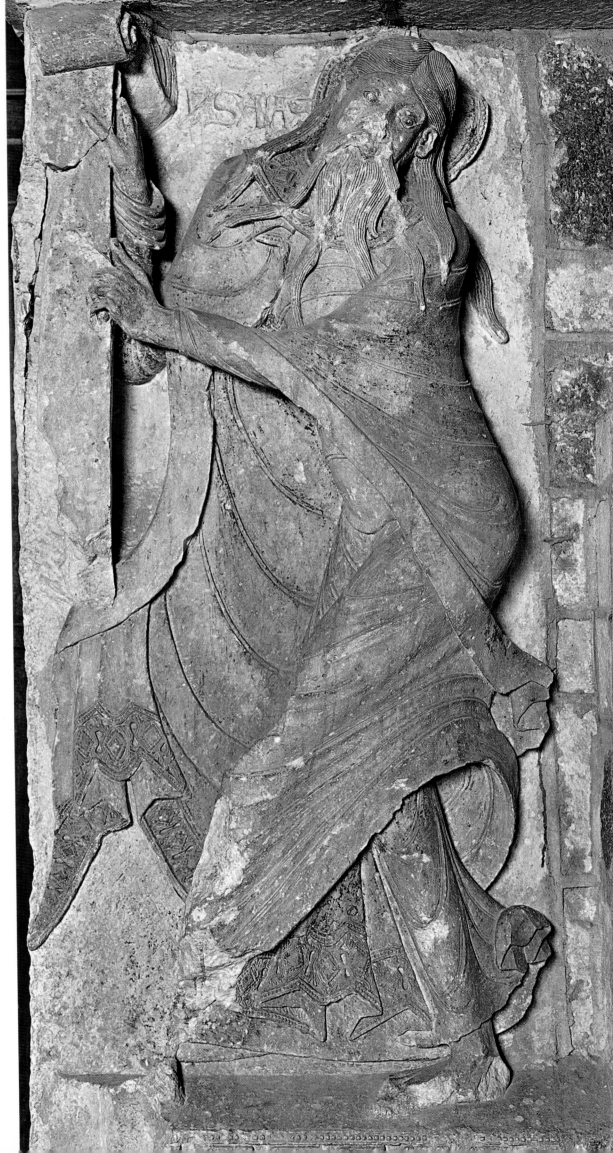

11 *Isaiah*. Stone; ca. 1130–40.
Souillac, Abbey Church, portal
(fragment)

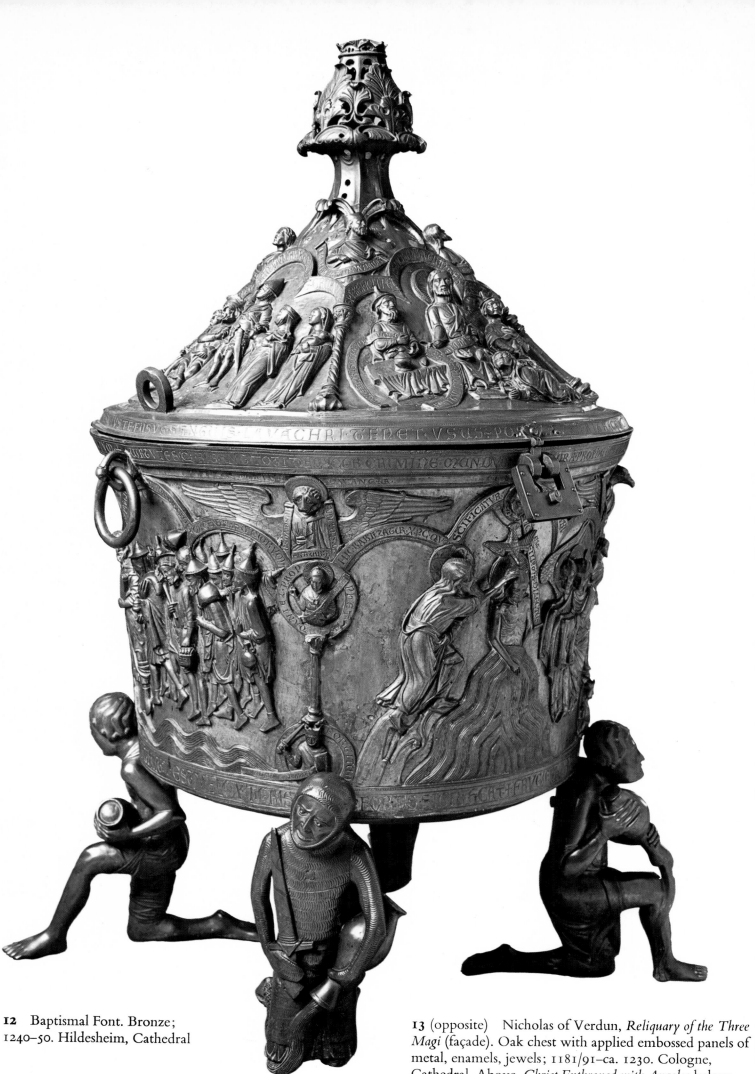

12 Baptismal Font. Bronze;
1240–50. Hildesheim, Cathedral

13 (opposite) Nicholas of Verdun, *Reliquary of the Three
Magi* (façade). Oak chest with applied embossed panels of
metal, enamels, jewels; 1181/91–ca. 1230. Cologne,
Cathedral. Above, *Christ Enthroned with Angels;* below,
The Adoration of the Magi with Emperor Otto IV and
The Baptism of Christ

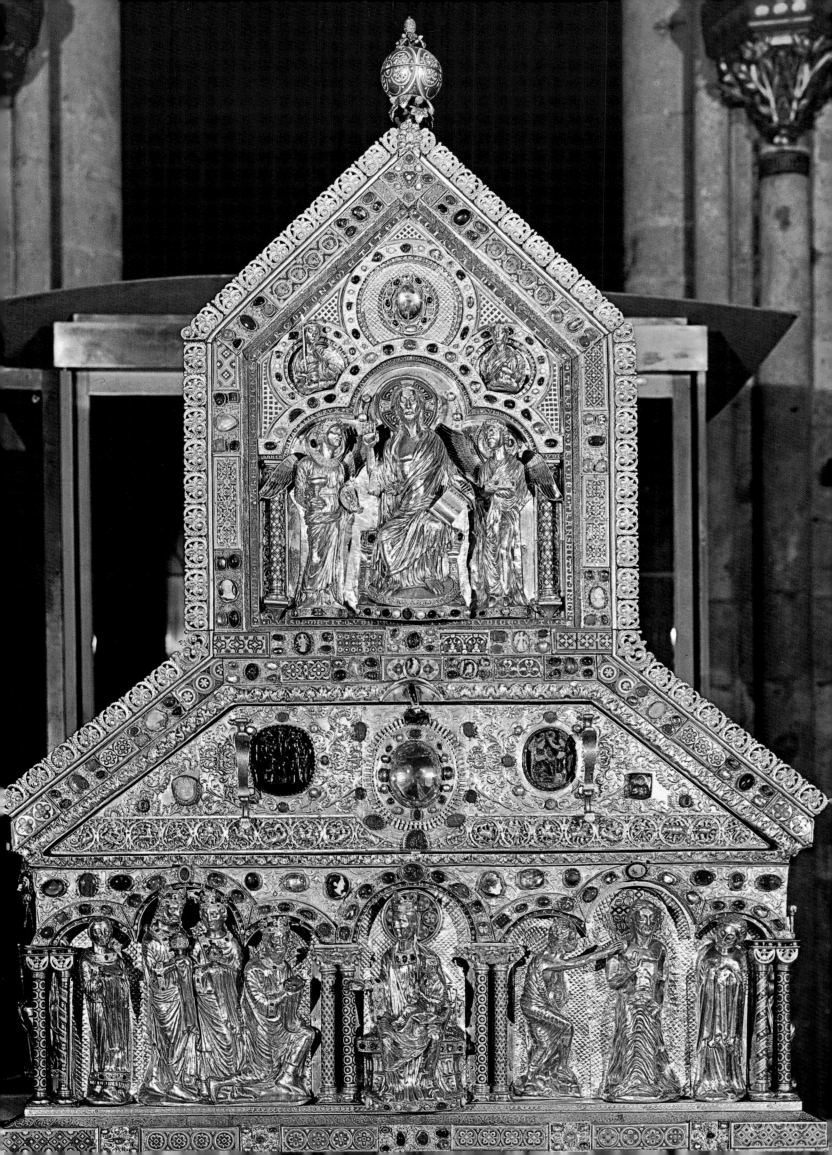

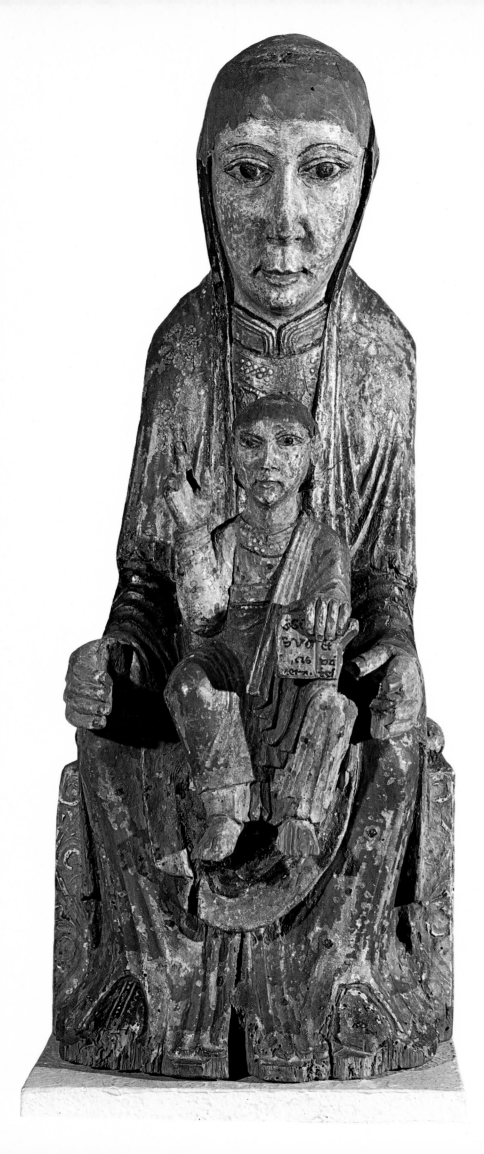

14 *Madonna from Ger.* Polychromed wood; ca. 1150–1200. Barcelona, Museo de Arte Cataluña

15 (opposite) Arnolfo di Cambio. *Enthroned Madonna.* Marble; ca. 1282. Orvieto, San Domenico, Tomb of Cardinal de Braye

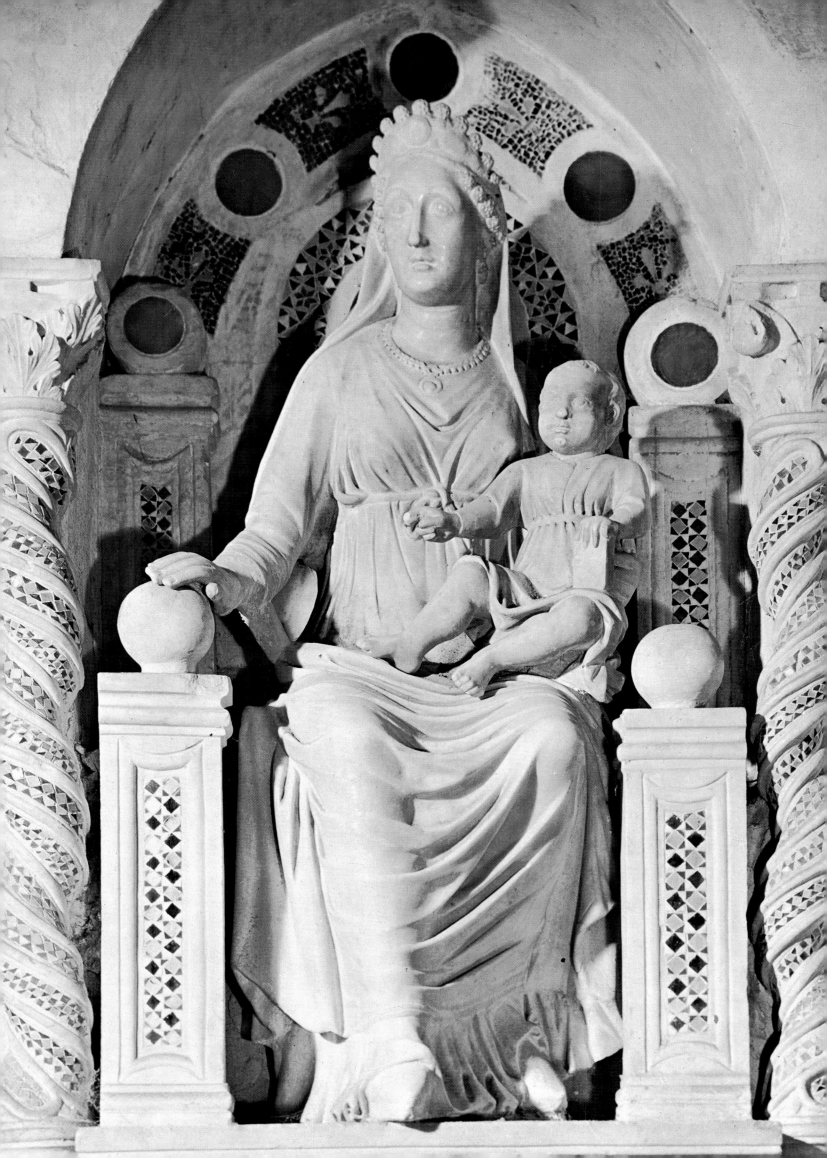

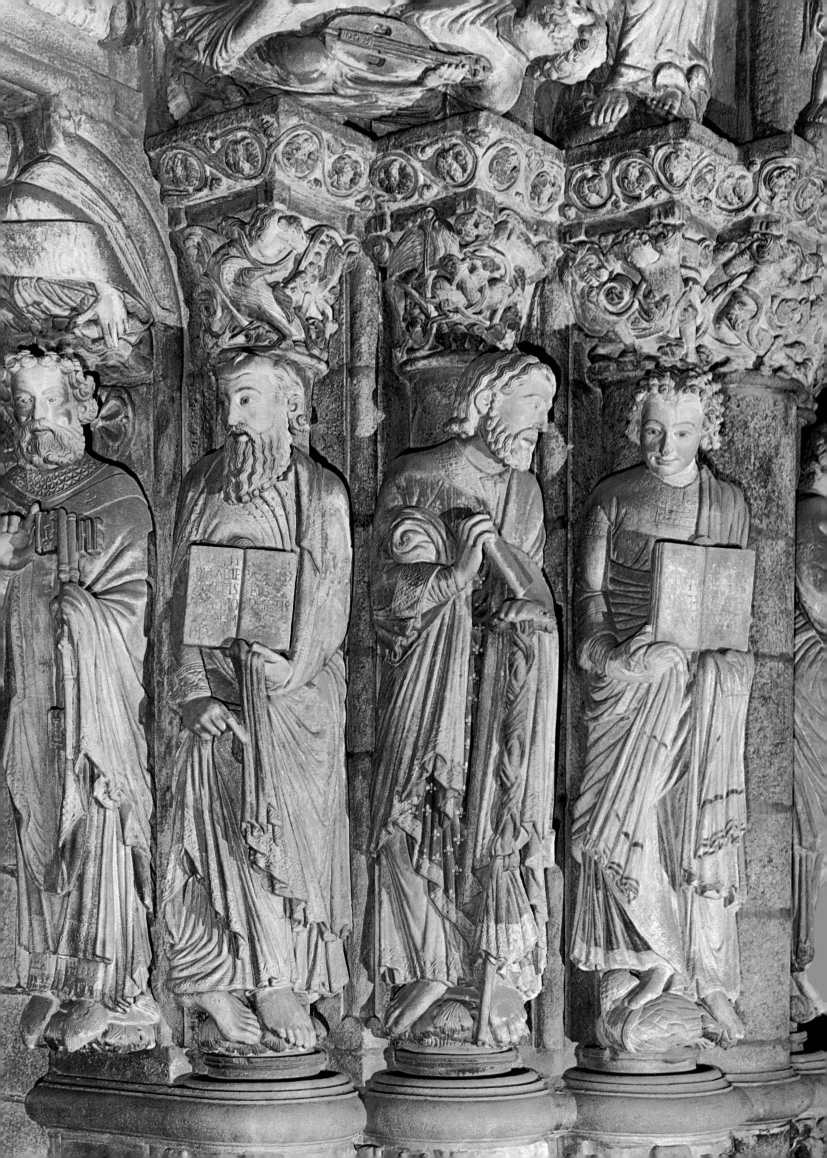

16 (opposite) Master Mateo, *Apostles*. Granite,
formerly polychromed; 1188 (signed and dated).
Santiago de Compostela, Cathedral,
Puerta de la Gloria

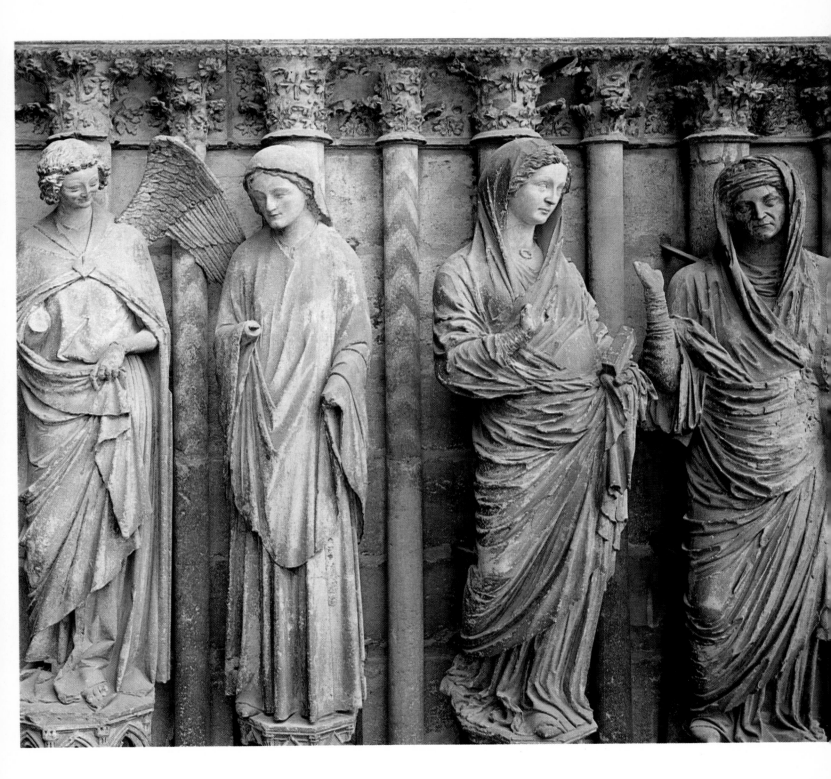

17 *Annunciation* and *Visitation*. Stone; ca. 1230–33; Angel, ca. 1245–55? Reims, Cathedral, west façade,
central portal (right jamb)

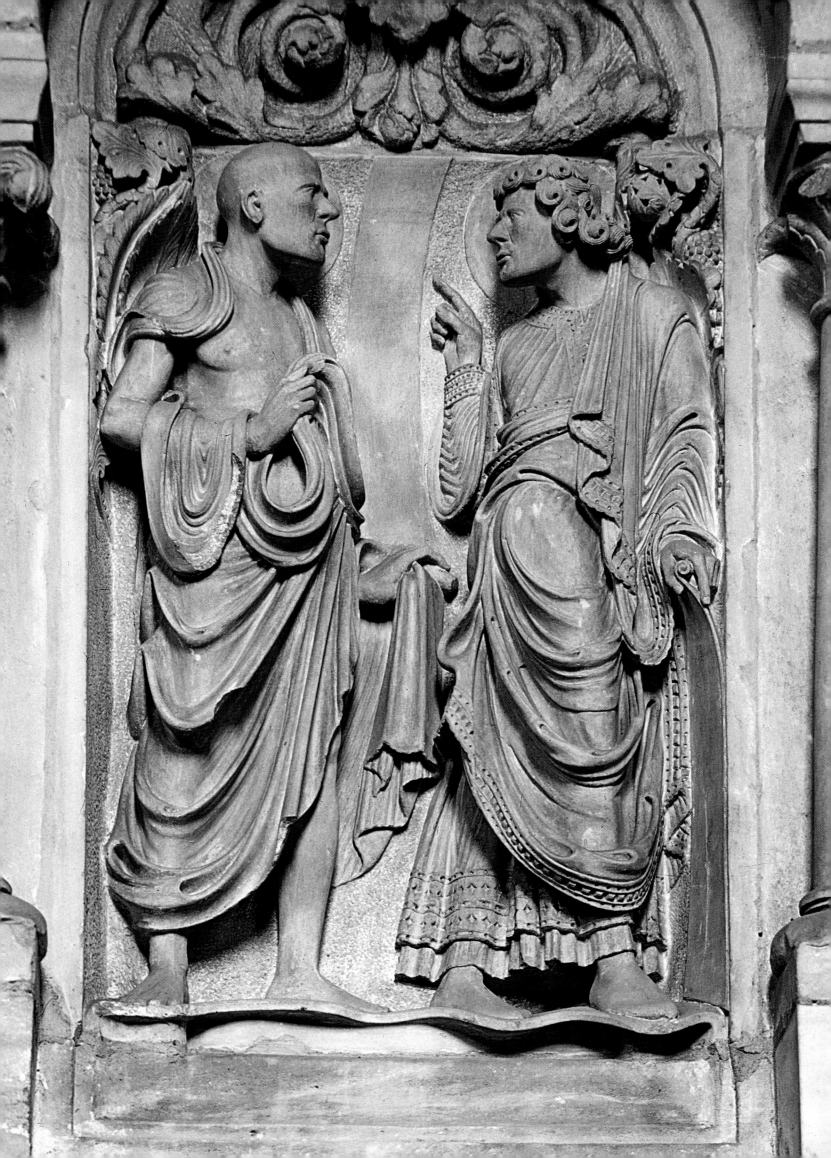

18 (opposite) *Jonah* and *Hosea*. Stone; ca. 1225–30. Bamberg, Cathedral, St. George's Choir Screen

19 *The Elect*. Stone; 1255–60? Bourges, Cathedral, west façade, tympanum of central (Judgment) portal

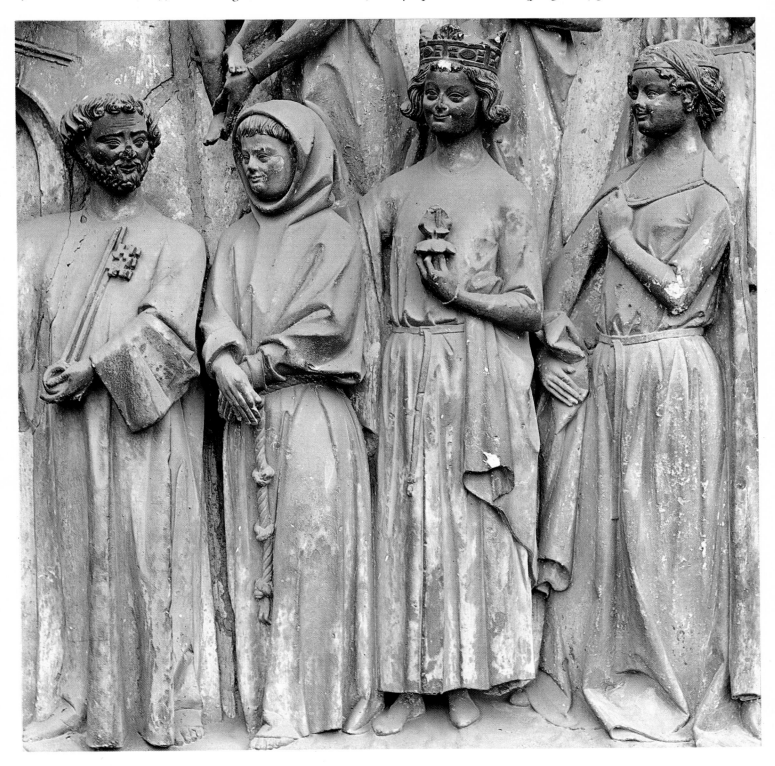

Overleaf and following:

20 Giovanni Pisano, Pulpit. Marble; finished 1301 (inscription). Pistoia, Sant'Andrea

21 Claus Sluter, "Well of Moses." Polychromed and gilded stone; 1395–1403. Dijon, Chartreuse de Champmol

22–23 Claus Sluter, *Tomb of Philip the Bold, Duke of Burgundy*. Black marble slab, white alabaster figures, partly painted; finished 1410, reconstructed early 19th century. Dijon, Musée de Beaux-Arts

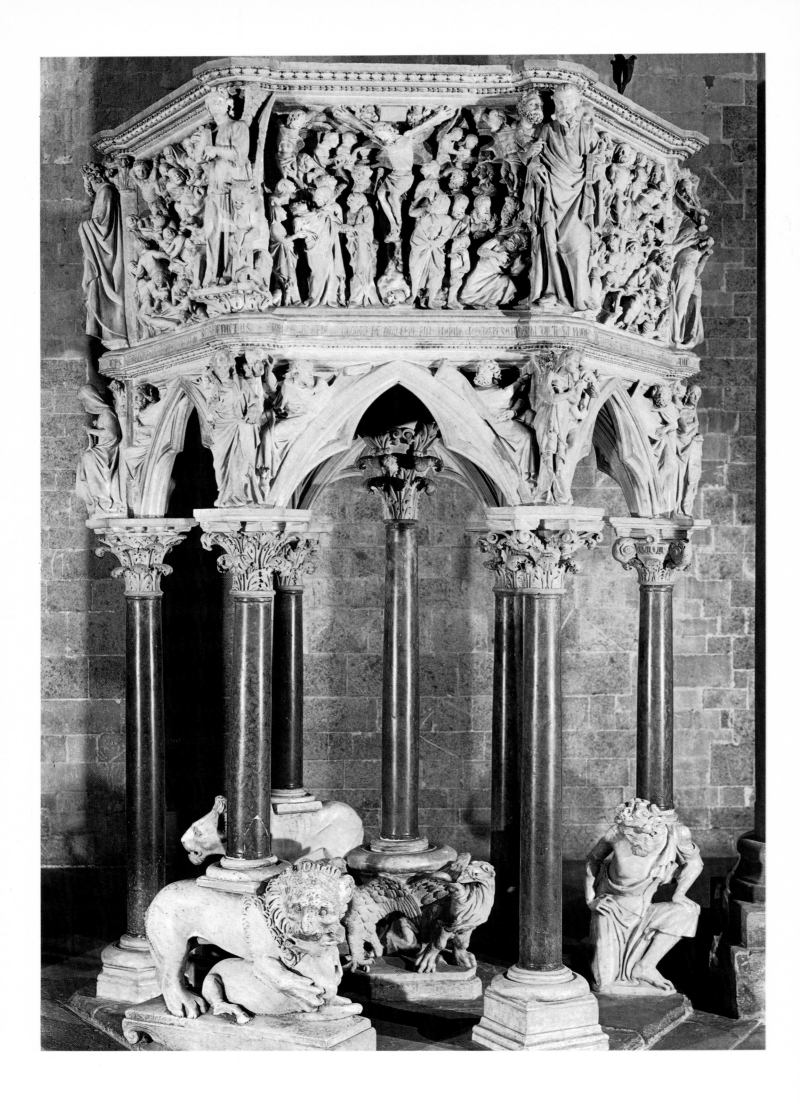

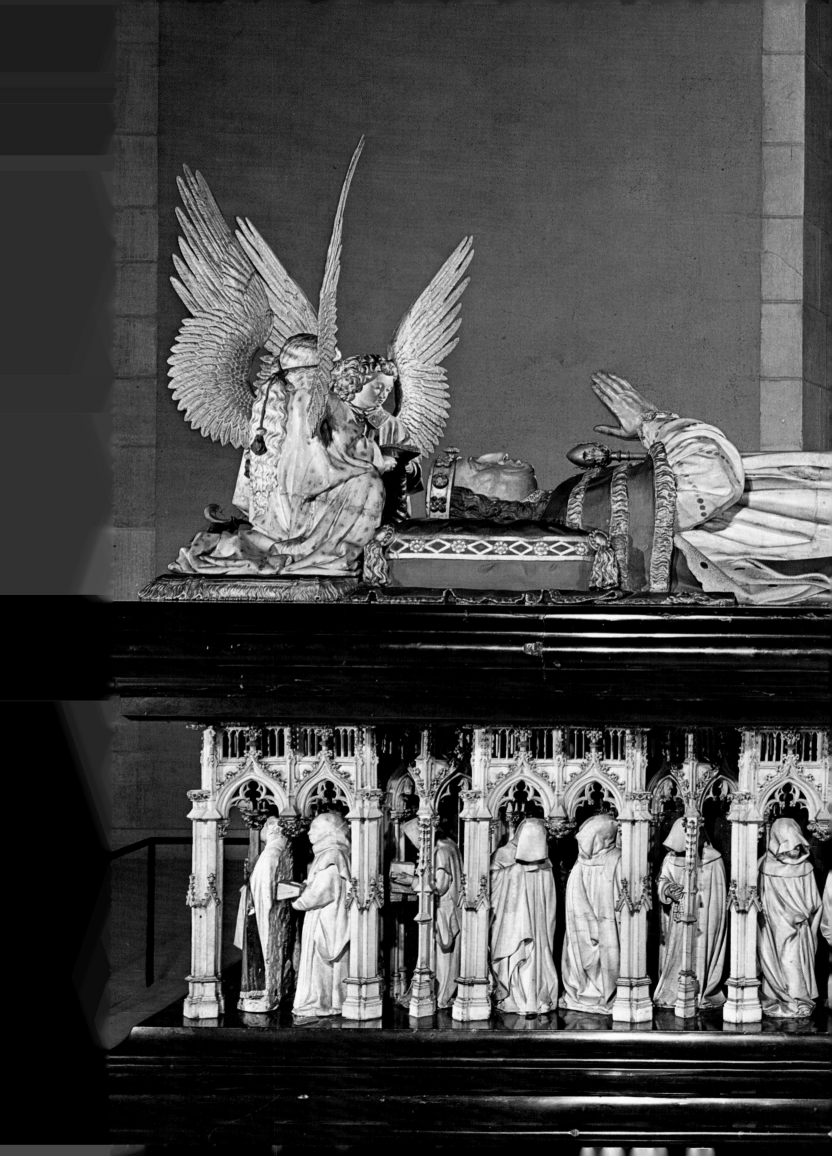

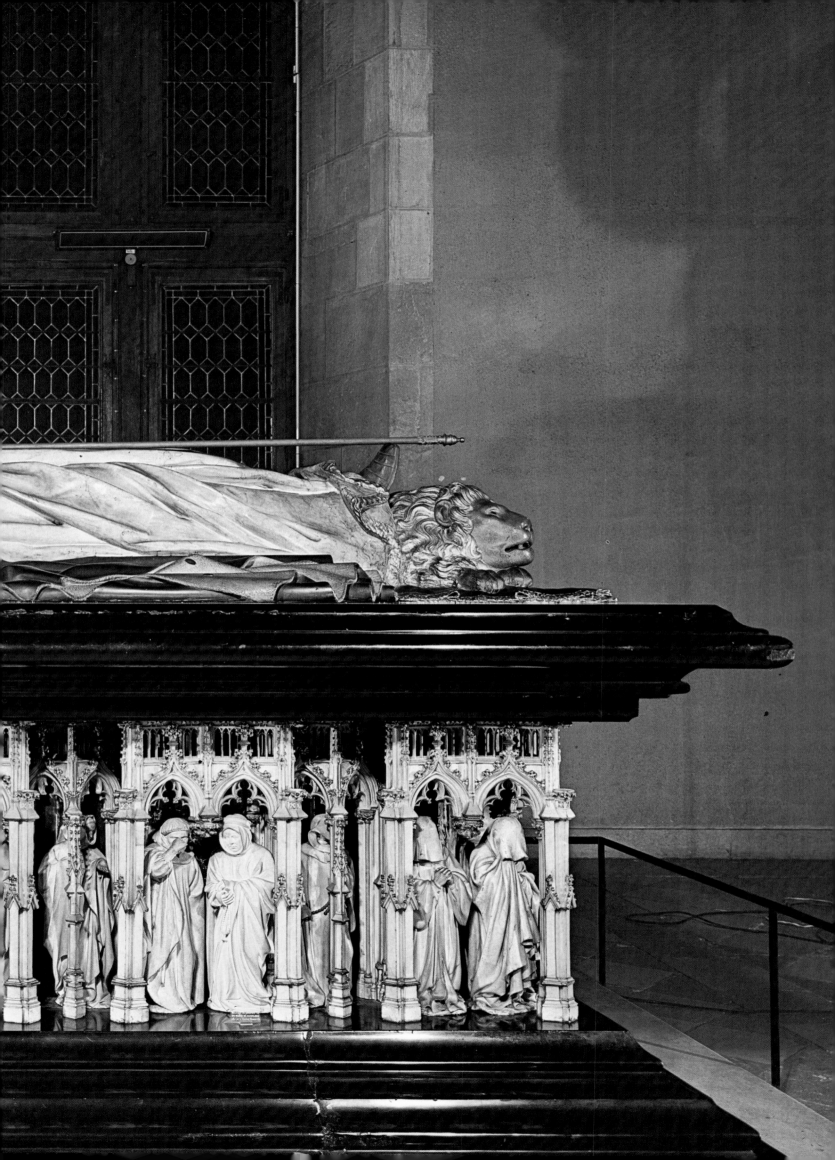

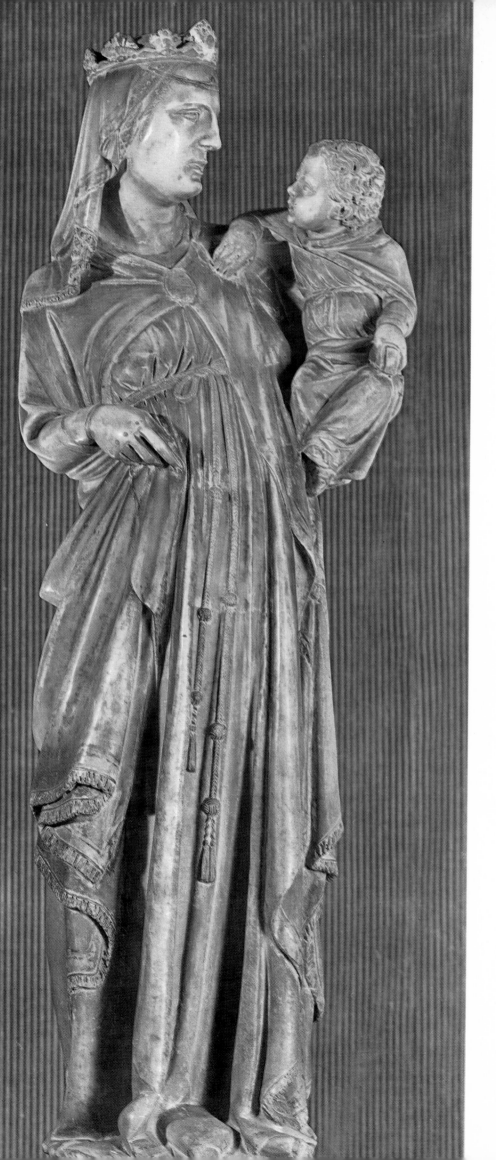

24 Giovanni Pisano, *Madonna*. Marble; 1305–6 (inscribed: DEO GRATIAS + OPUS JOHANNIS MAGISTRI NICOLI DE PISIS). Padua, Arena (Scrovegni) Chapel

25 Tilman Riemenschneider, *Madonna*
fromWürzburg Cathedral. Gilded and
painted lindenwood; ca. 1485. Vienna,
Kunsthistorisches Museum

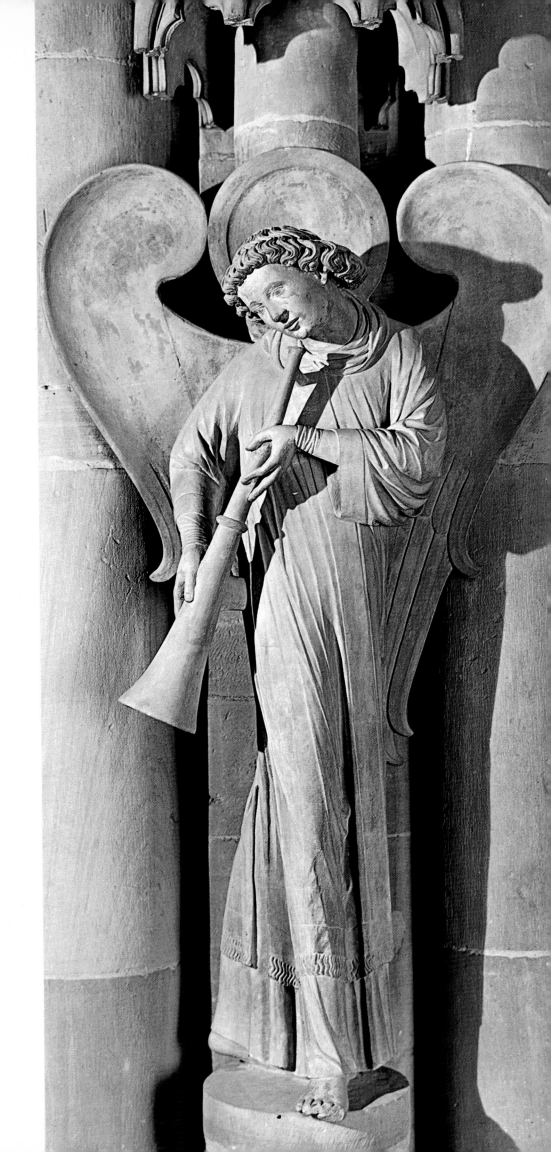

26 (opposite) Michael Pacher,
St. Florian, St. Wolfgang Altarpiece
(detail). Gilded and painted wood;
1471–81. St. Wolfgang, pilgrimage
church (Salzburg)

27 *Angel Pilaster* (detail). Polychromed
sandstone; ca. 1230. Strasbourg,
Cathedral

Overleaf:

28–29 Tilman Riemenschneider, *Altar
of the Holy Blood*. Lindenwood figures,
pine frame: 1501–04/5. Rothenburg
ob der Tauber, Jakobskirche

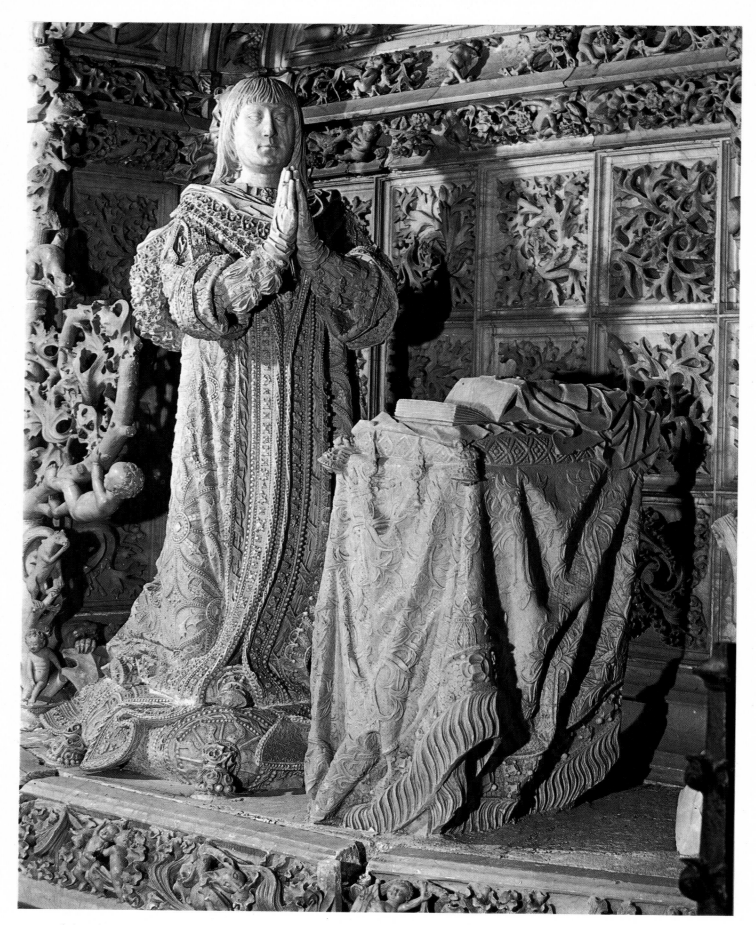

30 Gil de Siloe, *Tomb Monument of the Infante Alfonso*. Alabaster; designed 1486, executed 1489–93.
Burgos, Cartuja de Miraflores

31 (opposite) *Can Grande della Scala*. Marble; ca. 1330. Verona, Castelvecchio

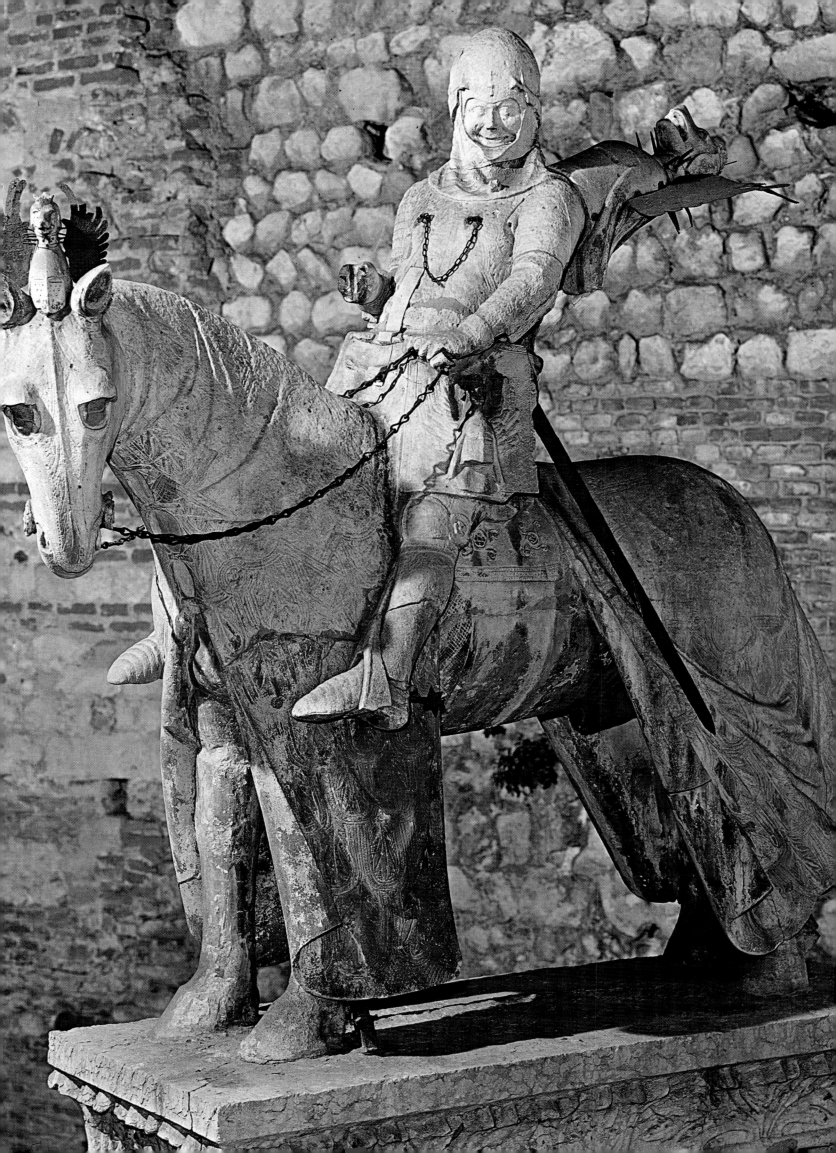

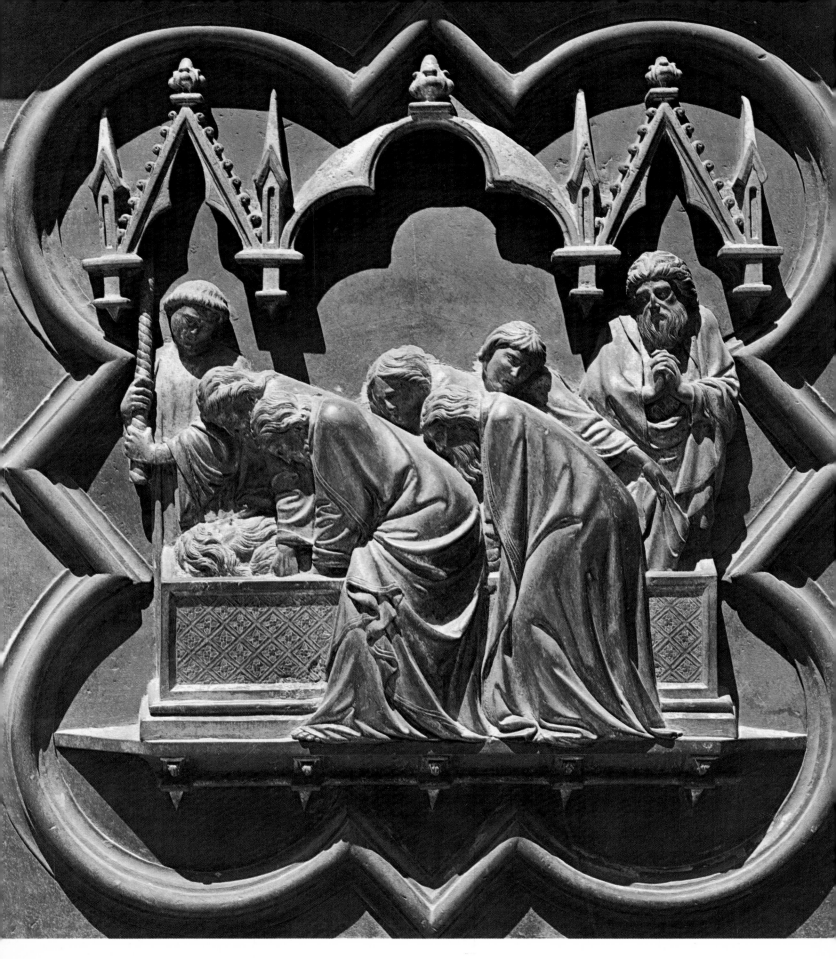

32 Andrea Pisano (Andrea da Pontedera), *Burial of St. John the Baptist*. Gilded bronze; 1330, set up 1336. Florence, Baptistery, doors (detail)

2 Renaissance and Mannerism

There really was a Renaissance. At least there was a Renaissance of Italian art. We have seen that medieval art in Italy was often classicizing; and a more programmatic and thoroughgoing revival of antique forms and ideas, a reunification of antique style with its classical content, was probably inevitable. Perhaps the Renaissance was already foreshadowed when Dante took Vergil as his guide and model for the trip through the Inferno. But Dante's view of the world, and of the world to come, was still thoroughly medieval. Succeeding generations of writers—Boccaccio and Petrarch are the famous examples—made a more systematic exploration of antique literature, hunted down lost manuscripts by pagan authors, and modeled their writing on the ancients. Some of these men learned or tried to learn Greek. When Constantinople finally fell to the Turks in 1453, Greek studies got a great boost with an influx of learned exiles, especially to Padua and Florence, the early centers of Renaissance scholarship. The Humanists, men who revived the "humane letters" of antiquity, not only studied ancient languages but produced a pseudo-antique literature as well. By extension, Humanism implies a new focus on man himself, a worldly point of view that conflicts with the original meaning of Christianity, which was an Eastern mystery religion with emphasis on the hereafter. But the Church had come to terms with the world over the first thousand years of its existence, and most men of the Italian fifteenth century (the "quattrocento") found no difficulty in reconciling their traditional belief in Christ as it was interpreted in Rome and their growing interest in man as he had been perceived in the Greco-Roman past.

Nineteenth-century historians, trying to characterize the spirit of the Renaissance, pointed to a Discovery of the World and of Man. These "discoveries" are notable tendencies of the time, but they had sturdy foundations in the Middle Ages. Later Gothic art is as meticulous and factual in its representation of the world as the sophisticated knowledge and techniques of the artists could make it. This hyper-realism was, however, in the service of the Church—for example, in a painting by Van Eyck, a cloth might be at one and the same time a humble towel and the symbolic winding-sheet of Christ. Nevertheless, this symbolism did not mitigate the keenness of observation or the uncannily tactile representation of the visible world that we find in later Gothic painting and sculpture (see Plates 26, 28–29, 30).

The Renaissance has at its core what the name implies: the sense of a rebirth, and a conscious one, of classical antiquity. This attitude was essentially Italian; only there did the actual buildings and statues of the antique world continue to exist and to exert a force on medieval art. Medieval Italy, and the late-blooming Italian language, were themselves versions of ancient civilization. Ruined and not-so-ruined buildings and statues held out endless opportunity for study and emulation. Indeed, many medieval Italian churches, whether "Romanesque" or "Gothic," have more in common with Early Christian basilicas in Rome than with Cluny or Chartres. Medieval Italian reliefs rarely depart altogether from the magnificent models to be found on Roman sarcophagi; medieval Italian Madonnas show a sturdy kinship with the empresses and goddesses of the pagan world (see Plates 15, 24). But the Renaissance was more than an intensification of this kind of survival. It was part of a conscious revival of antiquity that at times was so successful that it created real problems of identity that can still puzzle us: Is a given work of literature or art really ancient, or is it an imitation?

These tendencies to more antique form and content can be found from Naples to Venice, but their first real home was in Florence. Why Florence, when Rome was the obviously predestined center for a Renaissance of antique art? In the Middle Ages, Rome's *raison d'être* was the papacy, which in the fourteenth century was disrupted by a Great Schism that put the real popes in Avignon, leaving only feeble antipopes, or none at all, in Rome. When the papacy finally settled down again in 1420 with Rome as the capital, the old

caput mundi was hardly more than a village. It took almost half a century for the popes and cardinals to become patrons on an important scale. Florence, by contrast, with no antique heritage of its own, had become a center of manufacturing and banking with an unusual interest in the arts. Dante and his followers were Florentines, and perhaps this literary heritage encouraged Florentine awareness of the other arts. Dante himself mentions the fame of the painter Giotto (died 1337), whose powerfully grave figures add dramatic intensity to late-medieval Italian art. By 1378 Florentine artists were allowed to form into a new group within their guild because, according to the government, their work was "important for the life of the state." Thus the state recognized the practical value of art: Early Renaissance art in Florence had sound economic and cultural footing. What could not have been predicted was the extraordinarily gifted and varied group of artists in every medium, working together and as rivals, that make the early fifteenth century one of the great moments in the history of art. Florentine artists had a sense of form and beauty that still seems wholly exceptional.

Perhaps the first inkling of what was coming is furnished by the competition in 1401 for a new set of bronze doors for the Baptistery. Many talented artists entered the contest; in the end the decision was made between the only two reliefs that still survive, by Filippo Brunelleschi (1377–1446) and Lorenzo Ghiberti (1378–1455) (Figs. 16, 17). Brunelleschi's relief, still within the prescribed quatrefoil found in the earlier doors by Andrea Pisano (Plate 32), can perhaps be considered the first truly Renaissance composition. Brunelleschi effectively ignored his Gothic frame, conceiving an expressive relief full of quotations from antiquity coupled with an urgent realism that Ghiberti never commanded in his prime. Nevertheless, the technical perfection of Ghiberti's spatially sophisticated narrative won him the commission and gave him his life's work. His first doors (Plate 35) were so successful that he got the commission for a second set, the so-called Gates of Paradise (Fig. 18; Plate 36). These reliefs, freed from the constraints of medieval framing, present a series of fluent sculptured pictures ranging from high to very low relief.

Brilliant and successful as these doors are, the great sculptor of the Early Renaissance was not Ghiberti. Nor was he Brunelleschi, who soon turned from the trade of goldsmith, to which he had been apprenticed, to become the first Renaissance architect, the inventor of one-point perspective, and in a sense the magus of early quattrocento art. It fell, rather, to Brunelleschi's younger friend and associate Donatello (1386–1466) to establish sculpture as the leading visual art of the entire period. Unlike any of the contemporary painters, Donatello had the vitality, the vision, the personal resources, and—not least—the long life necessary to establish new standards for almost all the categories of Renaissance art. Included among these accomplishments was the first relief sculpture with an accurate vanishing point, carved before 1420. This was followed by such brilliant tours de force as the relief in Plate 37, where we see an elaborate perspective scene in correct foreshortening, with groupings of emotional and physical veracity unprecedented even in antiquity. In works like this, Donatello exemplifies the productive fusion of antique ideals with the Christian heritage that is so characteristic of the Renaissance. He could also carve reliefs in marble, scenes of charm and energy, as we see in his *Cantoria* of the 1430s (Plate 41). Donatello helped make the transition from the medieval to the Renaissance tomb, for which he had important, perhaps dominant, help from his associate Michelozzo, who was also an architect. Yet another contribution was his free-standing marble and bronze niche statuary in believable proportions and of unusual force and personality. Above all, Donatello reinstituted a tradition of nude sculpture in his bronze *David* (Plate 38), a work unprecedented in the Middle Ages, not wholly classical in appearance but of undoubted

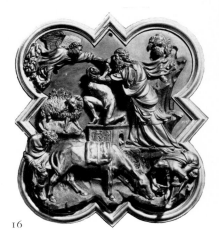

16

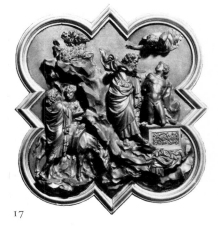

17

FIG. 16. Filippo Brunelleschi, *The Sacrifice of Isaac*, competition panel for the doors of the Baptistery of Florence. Gilded bronze; 1401–2. Florence, Museo Nazionale del Bargello

FIG. 17. Lorenzo Ghiberti, *The Sacrifice of Isaac*, competition panel for the doors of the Baptistery of Florence. Gilded bronze; 1401–2. Florence, Museo Nazionale del Bargello

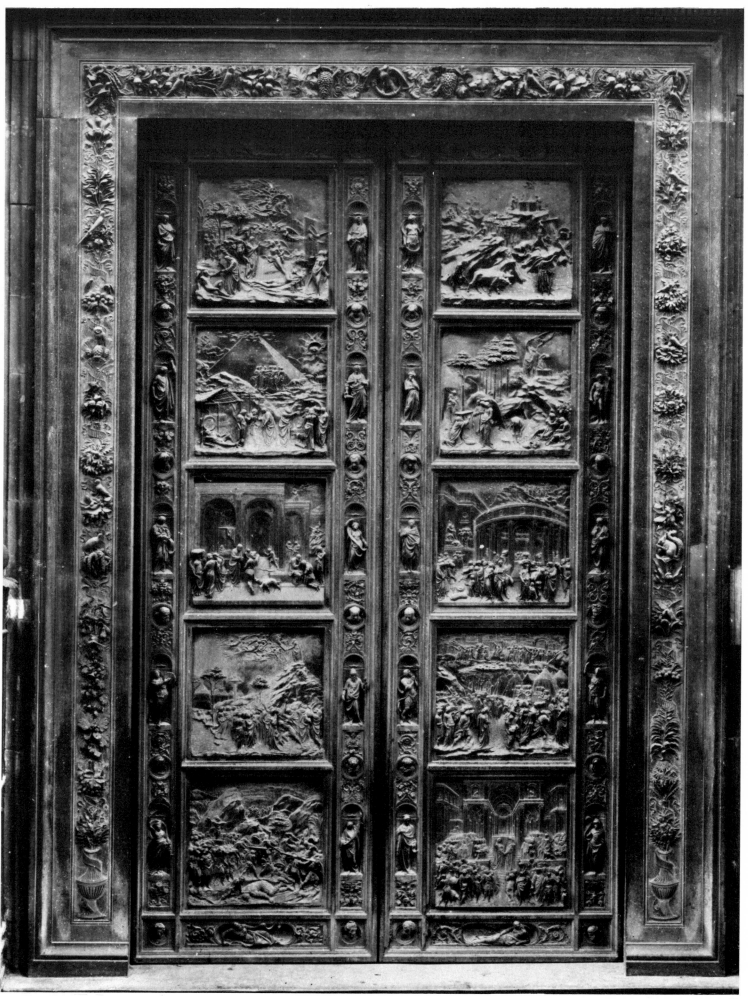

antique inspiration. It represents a distinct break with the medieval past.

Finally, Donatello single-handedly revived an antique tradition that honored triumphant emperors with a colossal bronze equestrian monument. His *Gattamelata* (Plate 47; Fig. 19) is of course no emperor but a victorious *condottiere*, or mercenary captain, whom Venice wished to honor. Such a civic memorial was wholly secular and antique in its inspiration, and indeed derived from close study of the bronze *Marcus Aurelius* in Rome. It is a symptom of the heightened interest in man's works, the desire to preserve the fame of great men and to honor the state that nourishes them. These ideals were not unknown in the Middle Ages (see Plates 22–23, 30, 31), but never had they been expressed in so succinct or monumental a way; nor is there a medieval monument that is so closely based in form and content on the antique. The corollary art is that of more normal portraiture, as found in the sculptured Renaissance bust, and although Donatello's part in this equally significant revival is less clear, there is reason to suppose that there, too, he was a pioneer.

In his knowledge of antique style and expression, in his penetration of human motives and emotions, in his range of sympathy and imagination, Donatello is unique in the Early Renaissance and unsurpassed in the entire history of art. When we turn from him to his contemporaries and successors, we inevitably step down to a lower but still distinguished level of accomplishment.

Other sculptors of the Early Renaissance explored more limited but often fruitful aspects of the newly emerging range of expression and emotion that they discovered in antique art and in their observation of life itself. Nanni di Banco (ca. 1384–1421) began in a Gothic tradition but soon made figures that so successfully imitate Roman portrait sculpture that they stood out even in the Renaissance for their classicism. Had he lived longer he might have been a serious rival to Donatello (see Plate 33). The Sienese sculptor Jacopo della Quercia (1374–1438) never wholly freed himself from Gothic figural formulas, but his expressive power was so marked that it appealed to Michelangelo, and reliefs such as the one in Plate 34 may lie behind some of the more famous scenes on the Sistine Ceiling.

One of the Florentine sculptural developments that made the greatest impression on contemporaries was the invention by Luca della Robbia (1400–1482), of glazed terracotta reliefs and statues. Indeed, Leon Battista Alberti in his *Della pittura* of the 1430s praised Luca (along with Brunelleschi, Donatello, Ghiberti, and Masaccio) as one of the Florentine renovators of art. This polychrome sculpture fit well into domestic interiors and found its way into artistic conglomerates that were in a sense Renaissance versions of medieval traditions. An example of this is the Tomb Chapel of the Cardinal of Portugal in San Miniato, above Florence (Plate 42). There a glazed, colored terracotta roundel of the Virgin is carried down by angels (a Christian version of an antique motif) to preside over the recumbent marble figure of the Cardinal, who is ministered to by Christian angels and pagan putti alike. All of this is contained in a niche—seemingly revealed to us by drawn marble drapery —which is only part of a larger chapel painted in fresco. Thus the contrasts of marble architecture and sculpture are deliberately set into a gilded and painted environment that seems to indicate different levels of reality or lifelikeness, as well as providing a richly ornamental setting for a Christian tomb. By contrast, Verrocchio's tomb of two Medici, only a few years later, is serenely architectural, restrained in its beautiful relief decoration and coloristic contrast of marble and expressively worked bronze, and without overt Christian reference (Plate 43). The greatest tombs were of course reserved for the greatest men, and so the Florentine Antonio del Pollaiuolo (ca. 1432–1498) went to Rome and made tombs for popes, including the finely worked, free-standing bronze monument to Sixtus IV, builder of the Sistine Chapel (Plate 44–45). Its elaborate antique references, such as the personifications of the Liberal Arts,

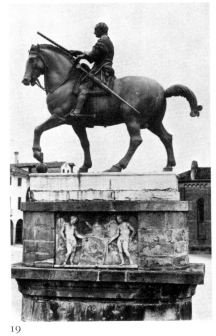

19

FIG. 18. Lorenzo Ghiberti, "Gates of Paradise" (East Doors). Gilded bronze; 1425–52. Florence, Baptistery

FIG. 19. Donatello, *Equestrian Monument of Gattamelata.* Bronze; 1445–50. Padua, Piazza del Santo

which Sixtus nourished, would have been unthinkable pagan intrusions on a papal memorial only a generation earlier.

Tombs were a natural vehicle for exhibiting the art of Renaissance portraiture, which blossomed sooner in sculpture than in painting. (Indeed, we could well assert that Renaissance sculpture was the leading figural art—and not surprisingly, in view of the survival of so much antique sculpture and so little antique painting.) Early Renaissance families often had shelves and cupboards and chapels full of clay or wax effigies of deceased members of the family; although few of these homely mementos survive, their form is imitated in marble busts that became popular by the mid-quattrocento (see Plates 46, 48, 49). Some of these, like the bust in Plate 49, reflect late-medieval folk traditions in their realistic polychromy; others are of an unprecedented sophistication and even abstraction (see Plate 48). These busts are demonstrably antique, however, in their use of the arbitrarily truncated upper body; many are stiff and stony as well, with something of the deathlike rigidity that indicates a posthumous image. Renaissance portraits often were posthumous or were executed in anticipation of death—the very purpose of a portrait was, in Alberti's famous words, to "make the absent seem present and the dead alive."

In the later quattrocento we discover increasingly successful attemps to make these portraits seem more real by continuing the bust down to the waist and by showing the arms and hands. The ultimate in these lifelike portraits is Leonardo's *Mona Lisa*, a work of the mature High Renaissance. Its great precursor was a marble sculpture by Leonardo's teacher, Andrea del Verrocchio (1435–1488), in which a young girl, almost more appealing because of her lack of perfect beauty, holds a little nosegay to her breast with one hand and displays the other before her waist (Plate 46). This is not so much a bust as the upper half of a free-standing statue, a novelty in portraiture, which lagged far behind the portraitlike figures in imaginative religious sculpture and painting of the Early Renaissance.

Apart from Jacopo della Quercia from neighboring Siena, we have discussed only Florentine sculpture. But the sculptor of Plate 48 was a Venetian who worked in France and Sicily; Quercia traveled all over central Italy; and Donatello spent a productive and influential portion of his career in Padua. Hence the gospel of Tuscan Renaissance sculptural art gradually spread and became an Italian—and eventually an international—style. There were, of course, medieval holdovers, and even in rather progressive cities like Bologna innovative Renaissance sculpture could coexist with a pietistic style that was in reality only a version of northern Gothic realism. One such exponent is Guido Mazzoni of Modena (died 1518), whose *Pietà* (Plate 52–53) is one of a number of hyper-realistic groups, in wood or terracotta, of great expressive and emotional power. Mazzoni translated religious scenes into *tableaux vivants* that are not so much sculpture as petrified drama. Indeed, this kind of popular polychromed sculpture had a long life that survived into the Baroque period (see Plates 82–87), when it disappeared into the general theatricality of some later manifestations of that era. Mazzoni worked in the south of Italy, in France, and in England, carrying his realistic, emotional style to areas where it may not have seemed very different from the indigenous Gothic. This style had been practiced by a South Italian artist, Niccolò dell'Arca (died 1494), who also worked marble with delicate realism (see Plate 50). After Niccolò's death, his incomplete Arca di San Domenico in Bologna afforded the young Michelangelo an opportunity to finish the monument with more powerful and expressive figures.

It is to Michelangelo (1475–1564) that we must turn for the next great developments in Renaissance sculpture; for although he is unique and even isolated as an artistic personality, it is his distinction to have carried Renaissance sculpture into, and through, its classic "High Renaissance" phase. This is first manifest

in the youthful *Pietà* in St. Peter's (Plate 56), done when the artist was not yet twenty-five but already the greatest sculptor in the world. Just how he achieved his technical and intellectual stature is still a mystery, for he had been apprenticed only briefly to a painter and seems to have learned sculpture on his own. While young he received protection and encouragement from Lorenzo de'Medici, "Il Magnifico," and this recognition started him on a path of independent personal achievement that distinguishes his life and art from the common run of artists.

The *Pietà* is a work of religious devotion, carved for a cardinal's tomb in the central church of Western Christendom, but it has a cool Florentine beauty and estheticism that was soon considered blasphemous by the more severe standards of the Catholic Reformation. Certainly it seems to belong to a different world from Mazzoni's version of the same subject. Chronologically, Michelangelo's *Pietà* is still a work of the quattrocento and has some of the decorative abundance, the pleasure in virtuosity, that we associate with that youthful style. But with the *David* of 1501–4 (Fig. 20), his next masterpiece, there was no attempt, nor was there need, to disguise the origins of the work—the pose and anatomy are both classically inspired. Its total nudity had a precedent in Donatello's bronze (see Plate 38), but the gigantic scale of the marble figure, which is almost fifteen feet high, makes it a colossus. The novelty of the statue derives from a combination of its pagan sources with a new psychological awareness that is communicated by *David*'s worried glance—the battle with the giant Goliath has not yet been fought, and Michelangelo's choice of this moment ushers in a new era in sculpture.

What Michelangelo might have accomplished had he remained a Florentine we will never know. He was fated to work for the Church, and most of the rest of his life was spent on papal commissions, including two projects for tombs, both incomplete. The first—but also the last to be finished—was the ill-fated commission for the Tomb of Julius II, first planned in 1505 but finally installed, in totally different form, only in 1547. The parts of this monument are greater than the whole, and indeed, most of the sculpture Michelangelo carved for it is not on the tomb at all. The so-called "Dying Slave" (Plate 58), a sensuous evocation of pagan statuary (and possibly a very personal expression of Michelangelo's repressed hedonistic fantasies), was considered too secular for a tomb of the 1540s and eventually was given to a friend. The *Moses*, from the same period, was originally meant to be one of a number of personages on a multistoried, free-standing tomb with dozens of figures; its present place in the center of the reduced tomb is a travesty of the original design (see Fig. 21, Plate 59). Yet, the commanding figure is so expressive that it has survived its change of place and level, and it is still probably the one piece of Renaissance sculpture that tourists remember after a trip to Rome.

The other set of tombs was commissioned by Medici popes, Leo X and Clement VIII, who wanted to honor their illustrious dead in Florence (see Fig. 22). Michelangelo originally planned to have three tombs, but only two were close to completion when he left Florence for good in 1534. The remnants are nevertheless his greatest sculptural accomplishment. Within the novel architecture we find timeless "portraiture" of an ambiguous and fascinating kind that still puzzles scholars—we are not even sure which Medici is which. Below these commemorative statues are the Times of Day, two figures of even greater fascination (in Fig. 22, *Night* at left and *Day* at right). These recumbent statues also raise questions that hover around much of Michelangelo's later work. They are obviously unfinished, and we can never be sure whether they were simply abandoned or whether, as he worked on them, the artist began to experience the modern feeling that less finish is more expressive and potentially more meaningful—that, in short, he determined to leave them as finished despite their lack of polish.

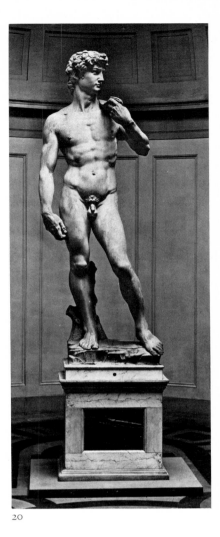

20

21

FIG. 20. Michelangelo, *David*. Marble; 1501–4. Florence, Accademia

FIG. 21. Michelangelo and assistants, *Tomb of Julius II*. Finished 1547. Rome, San Pietro in Vincoli

63

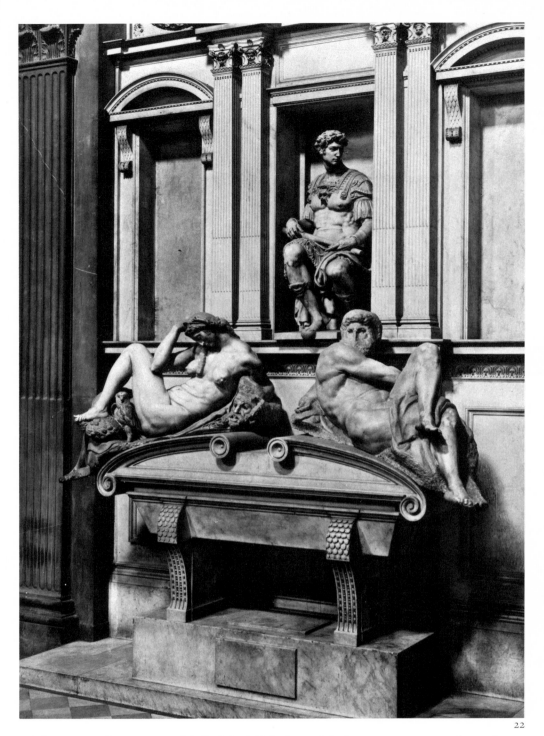

These questions are multiplied in Michelangelo's last, more personal works done for his own delectation. They are particularly pressing when we discuss the *Pietà*, or, more properly, *The Deposition*, now in Florence, that he began for his own tomb and then partially destroyed before its completion (Plate 57). In a sense the group is a revival of the old motif that he had carved early in life (see Plate 56) and, together with other *Pietàs* by the master, leads us to believe that the subject had a particular and personal meaning for him, an emotional hold that may have become overwhelming and ultimately caused its destruction. The group as it stands is a monument of personal religious devotion and a poignant expression of religious longing that is unique in art. Michelangelo, who lived so long, spent the last decades of his life thinking about death and worrying about his own salvation. "With death so near and God so far away," he wrote, in one of his moving sonnets—not, as we might suppose, at the end of his life, but over thirty years earlier. And yet the sentiment seems to pertain to *The Deposition* of Plate 57, where his own self-portrait as the standing Nicodemus seems to preside over the dead Christ and his mourning Mother.

The evolution of Michelangelo's thought is complex, but when we turn back to the *Pietà* in St. Peter's of more than fifty years earlier, we see very clearly the change in his sculptured ideal from the stoic restraint of the early work with its decorative surface to the unbearable emotion of the unfinished late group, with its fusion of Mother and Son in a last farewell that probably so affected the artist that he found it impossible to finish.

Michelangelo is unique and his vision of sculpture was unusual and even out of step with the times. His obvious aim in the Tomb of Julius II was to create a sculptural monument that would rival, and indeed surpass, every other work of art whether antique or modern. Other sculptors accepted the more subordinate and decorative place of sculpture that we saw in such works as the Chapel of the Cardinal of Portugal (Plate 42). For most of Michelangelo's contemporaries, sculpture was an adjunct to architecture, a companion to painting, or a decoration to admire and even handle, like the small bronzes that were increasingly produced in imitation of the antique (see Plate 70).

Michelangelo's most able contemporary was the versatile Jacopo Sansovino (1486–1570), a Florentine who spent the second half of his life in Venice. Sansovino, although trained as a sculptor, was also a distinguished architect, and much of his sculpture was produced for architectural settings. The elegant bronze *Apollo*, set in a niche in Sansovino's own decorative Loggetta at the foot of the Campanile in Piazza San Marco (Fig. 23; Plate 60), seems to reflect Raphael's art rather than Michelangelo's. Sansovino had a great pupil, Alessandro Vittoria (1525–1608), who carried on the emotional, yet decorative, style of his master with some added influences from Michelangelo (see Plate 61). Like Giovanni Bologna in Florence, Vittoria takes us up to the dawn of the Baroque era.

Italy had been invaded by the French army of Charles VIII in the 1490s, and some of the men in his entourage took back memories of Italian art that haunted them until they died. One even wrote back to Florence, asking for a copy of Donatello's *David* (Plate 38), a work that was ultimately produced by no less a personage than Michelangelo although his statue is now lost. Successive Italian campaigns by Louis XII (reigned 1498–1515) and Francis I (reigned 1515–47) had a more lasting effect on French taste; indeed, the court of Francis I was under pervasive Italian influence. His chateaux, still basically Gothic, blossom with Italianate detail. In sculpture the influence was direct, since Charles VIII had brought Guido Mazzoni back from Naples in 1495 to do his tomb (now destroyed) in St.-Denis; Mazzoni was soon followed by the brothers Giusti, who executed the tomb of Louis XII and went on to form a dynasty of Italianate workmen in France. Francis I employed first the Florentine painter and decorator G. B. Rosso (1494–1540) and then Francesco Primaticcio

FIG. 22. Michelangelo, *Tomb of Giuliano de' Medici*, with figures of *Night* and *Day*. 1519–34. Florence, San Lorenzo, New Sacristy

FIG. 23. Jacopo Sansovino, Loggetta, Campanile. 1537–45; rebuilt early 20th century. Venice, Piazza San Marco

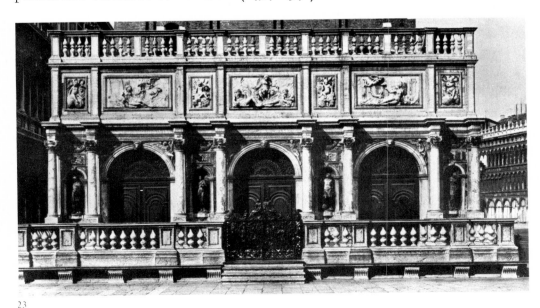

23

24

25

FIG. 24. Giorgio Vasari and his school,
Studiolo of Francesco I. 1570–75.
Florence, Palazzo Vecchio

FIG. 25. Benvenuto Cellini, *Saltcellar of
Francis I.* Gold; 1539–43. Vienna,
Kunsthistorisches Museum

FIG. 26. Bartolommeo Ammannati and
others, *Neptune Fountain*. Marble and
bronze; 1560–75. Florence, Piazza della
Signoria

FIG. 27. Rosso and Primaticcio, Gallery
of Francis I. Begun 1534. Fontainebleau

FIG. 28. Giovanni Bologna, *Rape of a
Sabine Woman*. Marble; completed 1583.
Florence, Loggia dei Lanzi

(1504/5–1570), originally from Bologna, to decorate his gallery at the Chateau of Fontainebleau, the first great monument of Franco-Italian decoration (Fig. 27). It combines stucco figures of elegant Mannerist proportions with paintings and ornamental forms in stucco and marble to establish a new standard of erudite, sophisticated decoration for a secular interior. Such a design was essentially Italian in its elements, but as applied to the long room, which was wholly Northern, it gave birth to a succession of elaborate galleries, great and small, that culminated a century and a half later in the Galerie des Glaces at Versailles.

By mid-century there were also a few French sculptors who had made a personal fusion of their own Late Gothic heritage with the new humanistic style of Italy. This achievement must be at least partially credited to Benvenuto Cellini, who lived in France between 1540 and 1545. The dominant French sculptor of the next years, Jean Goujon (died 1563?), seems to show Cellini's influence, along with others that probably point to a stay in Italy (see Plate 63). One of Goujon's most famous works, the *Diana of Anet* (Plate 67), is by no means certainly by him even though it bears all the earmarks of the later school of Fontainebleau: refinement, elaboration, elegance. These characteristics are also found in the works of Goujon's successor, Germain Pilon (ca. 1530–1590), and it is just possible that the *Diana* is his. But there is no doubt that Pilon executed the sculpture on Primaticcio's imposing Tomb of Henry II and Catherine de'Medici (Plate 65).

In Spain, too, the Renaissance was largely carried in by Italians, and for some time there existed an uneasy truce between classicizing tendencies and a love of overall decoration and lifelike polychromy. Many earlier sixteenth-century Spanish altars are really late-medieval holdovers with Renaissance trimmings. The court tended to prefer the pure Italian product, especially as produced by the Leoni, father and son. The Leoni were originally Tuscans who had worked in Padua, Milan, Rome, Brussels, and Augsburg—which alone gives an idea of the rapid spread of the Renaissance style in the mid-sixteenth century. The Leoni's most elaborate commissions, portraits and tombs, were from Spain. The companion monuments to Charles V and Philip II (Plate 64) are the work of Pompeo, the son (ca. 1533–1608). Their staggering detail, including removable costumes, is the work of Spanish goldsmiths and can be considered a relic of Late Gothic naturalism rather than a typical Italian Renaissance product (see Plate 30).

Germany, rather surprisingly, produced genuine Renaissance artists as early as 1500, most obviously Albrecht Dürer, who traveled to Italy early in his career. His counterpart in sculpture is Conrad Meit, whose nude statuette of Judith is a Dürer-like compromise between Northern realism and the classical ideal (Plate 62). Such a work was produced in the midst of the emotional Late Gothic world of Riemenschneider (see Plate 28–29) and Grünewald; its almost repulsive eroticism has its counterpart in the courtly nudes of Lucas Cranach.

The elegant art of Rosso and Primaticcio at Fontainebleau (see Fig. 27) parallels a taste that developed simultaneously in Florence during the mid-sixteenth century at the court of Duke Cosimo I de'Medici. The ties between Florence and France were close; indeed, Catherine de'Medici, wife of King Henry II of France, bore three French kings. We have mentioned Cellini's visit to France—that fascinating mountebank was trained as a goldsmith, and his most famous work is the brilliant *Saltcellar*, a triumph of craftsmanship fashioned for Francis I (Fig. 25). But Cellini (1500–1571) also aspired to monumental sculpture and produced in his bronze *Perseus* (Plate 66) a worthy exhibit for that outdoor gallery of Florentine sculpture that slowly grew outside the Palazzo della Signoria and under the old Loggia dei Lanzi. Michelangelo's *David* was already there (see Fig. 20), and the *Perseus* makes a fascinating comparison with it in a fundamental respect. Michelangelo's works are in marble and were carved back from the surface plane, producing a basic

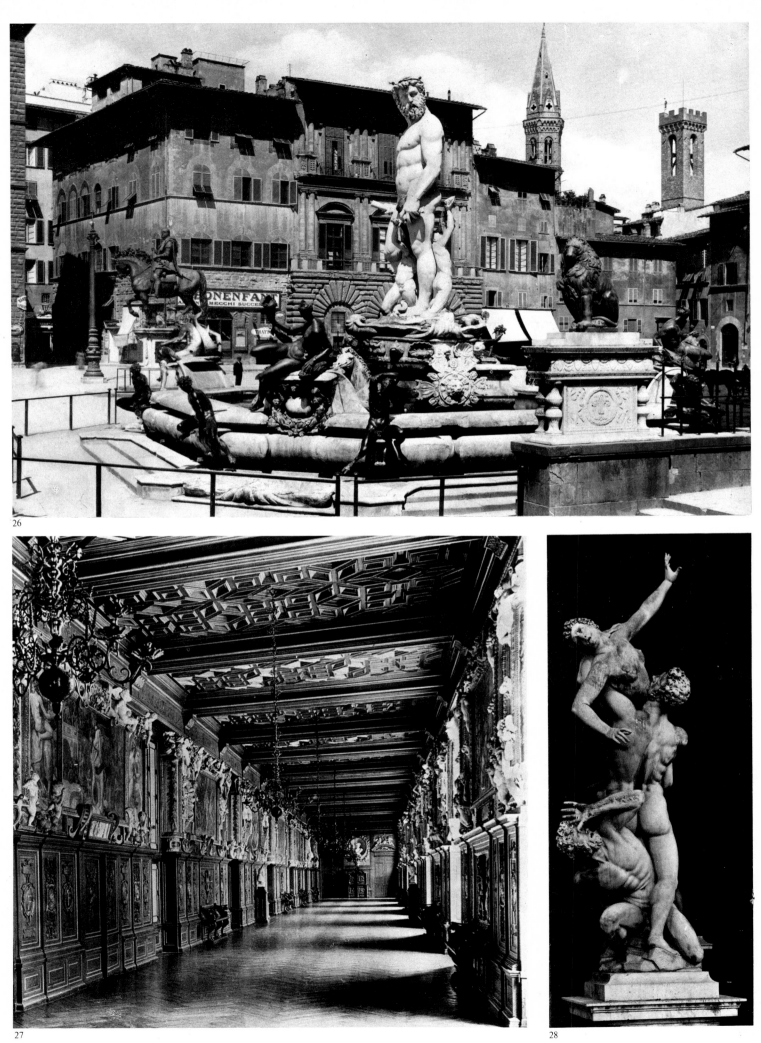

26

27

28

FIG. 29. Benvenuto Cellini, Base of *Perseus*. Marble, with bronze statuettes; 1545–54. Florence, Loggia dei Lanzi

frontal viewpoint (see Plates 56–59). Cellini's statue, like most bronze statuary, was conceived as a small model in wax that could be turned and modified and adjusted until it was effective from several, or even many, points of view. This model was then reproduced on a larger scale—still in a malleable material—and the process of refinement and adjustment continued. Finally, a cast was made of the model, a mold was built, and the statue was cast in bronze. (Cellini himself gives a dramatic and fascinating account of this process in his *Autobiography*, one of the great documents of the age.) Thus a bronze statue, and Cellini's *Perseus* in particular, is typically conceived by a process that encourages a three-dimensional approach, which implies many points of view—as indeed are required of the free-standing statue in its corner position in the open Loggia.

Perhaps the finest elements of Cellini's statue are the four small bronzes—now, sadly, removed to safety—that decorated the base (Fig. 29). These carry on the tradition of small bronze statuary that was developed by such North Italian masters as Riccio and Antico (see Plates 51, 70) and that later flowered in the decorations of the Studiolo of Francesco I (Fig. 24). The great master of the Late Renaissance small bronze is Giovanni Bologna ("Giambologna," 1529–1608), a Fleming who traveled to Rome and then settled in Florence. It is he who produced bronze statuettes of the greatest refinement and elegance (Plate 71) and whose sculpture seems to represent the high point of the *maniera*—the stylish, elegant, courtly art of the later cinquecento. Giambologna's typical products were small or medium-sized bronzes that were often repeated for decades by masters trained in his shop. Often these works evolved into larger versions in marble, but they still betray their bronze origins in the multifaceted complexity of the poses and in the obvious need they produce for the viewer to circle around the statue in order to understand the entire composition. Giambologna's *Rape of a Sabine Woman* (Fig. 28) is an example of a marble enlargement of a small model, and in the treatment of the marble we find a new development—a tendency to perceive it like bronze, without thought to the form or integrity of the original block. In this respect, as in other ways, Giovanni Bologna left the world of Michelangelo far behind in his search for elegance, variety, and rhythm. Giambologna was, however, a full-blooded Fleming with an earthy humor, and in early works like the *Florence* on top of a fountain designed for a Medici villa, we see a robust and sensual aspect of his art (Plate 68). In the gigantic *Apennine* (Plate 72), again for a Medici villa, we find a gargantuan humor that belies the fact that in a sense this is an imitation of an antique statue. A few of Giambologna's contemporaries, like the older Bartolommeo Ammannati (1511–1592), sometimes rivaled him in elegance and refinement, but when the fountain for the Florentine piazza was completed by Ammannati in 1575 (Fig. 26; Plate 69), Giambologna had already shown that it was he who carried the future of Florentine sculpture before him.

The next quarter century was indeed the age of Giambologna, who fully deserves to stand beside the other giants of Italian sculpture. Among other accomplishments, he reduced naturalistic references down to an abstract geometry of quasi-human forms, as in the *Astronomy* (Plate 71). This required a surface devoid of overt sensual references to actual skin and flesh, as can also be seen in his marble groups (see Fig. 28). The nudity, and the subject itself, demanded that the artist avoid realistic surface references in order to give the complex, and indeed exhibitionistic, aspects of the work their full play. The artist was not himself concerned with the details of the subject—*whose* rape it is was not at first even determined. What interested him was, rather, the opportunity for a tour de force of dramatic yet elegantly intertwined figures mounting upward. The great sculptural revolution of the next century was Bernini's reversal of these exacting criteria in the service of new, Counter-Reformatory goals.

33 Nanni di Banco, *Assumption of the Virgin Mary*. Marble; commissioned 1414, left "incomplete" at Nanni's death in 1421, installed 1423. Florence, Cathedral of Santa Maria del Fiore, Porta della Mandorla .(detail)

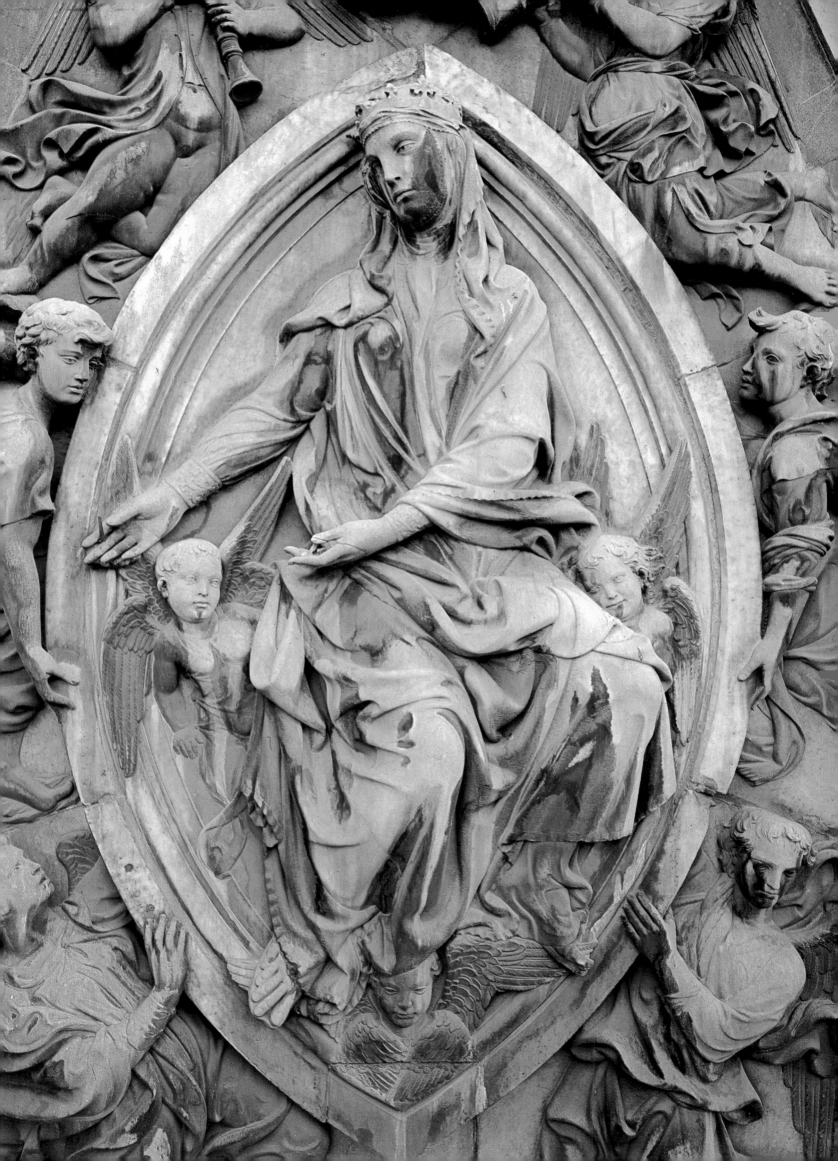

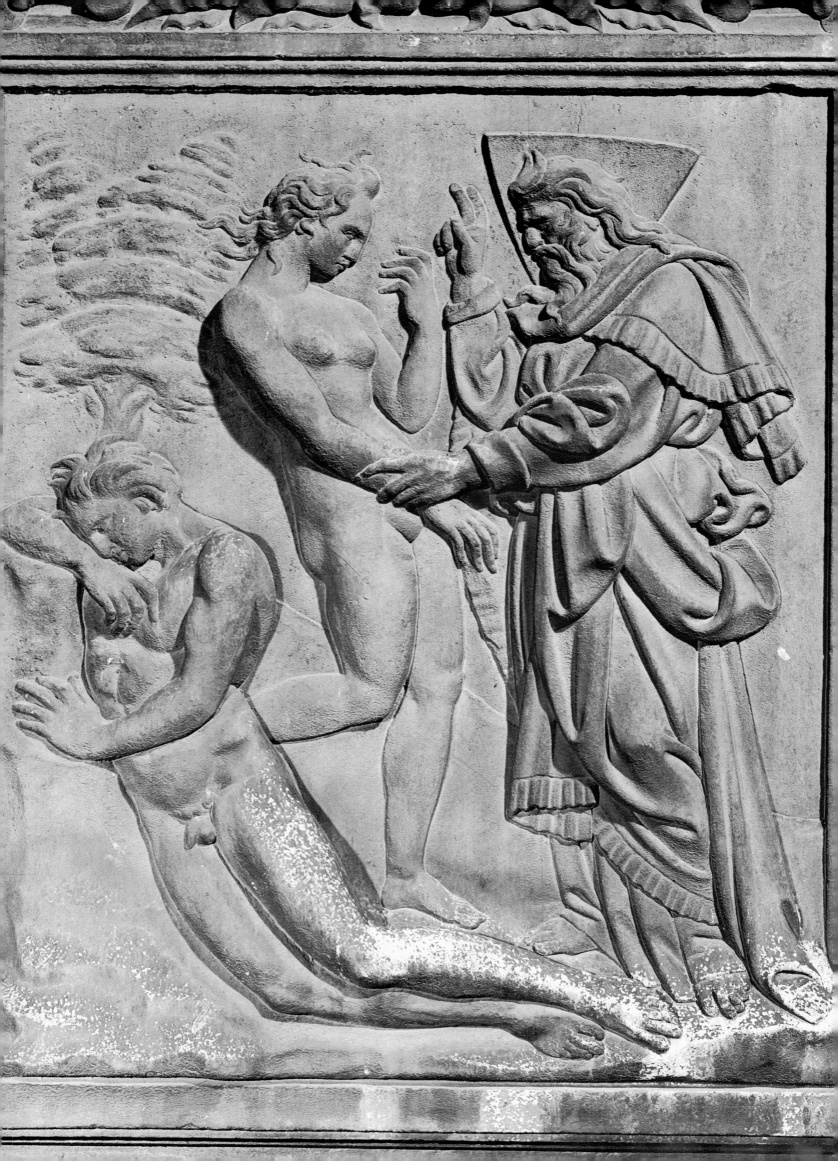

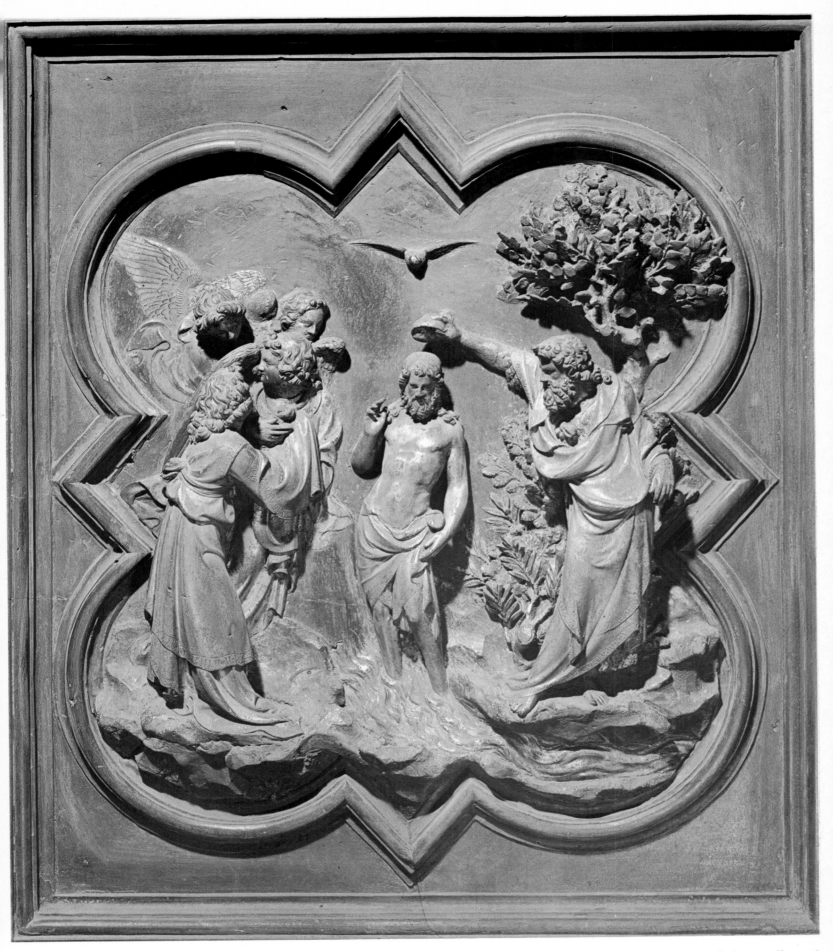

35 Lorenzo Ghiberti, *The Baptism of Christ*. Gilded bronze; 1407–24. Florence, Baptistery, north (originally east) doors (detail)

34 (opposite) Jacopo della Quercia, *The Creation of Eve*. Istrian stone; 1430–34. Bologna, San Petronio, portal (detail)

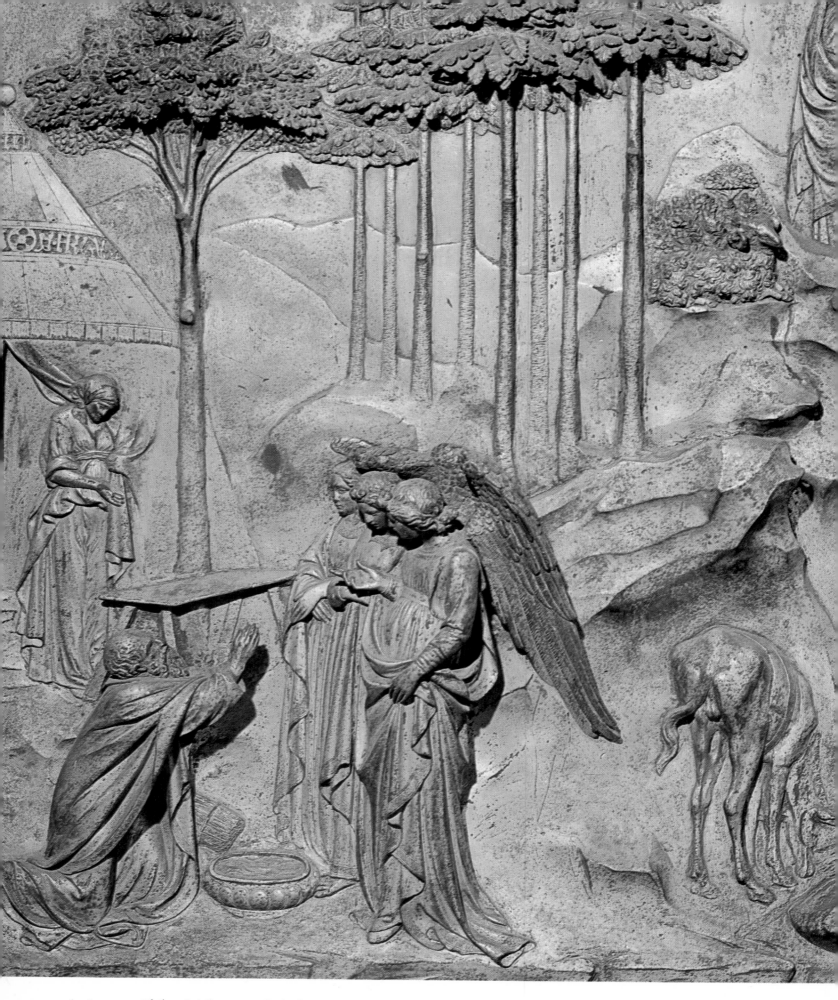

36 Lorenzo Ghiberti, *The Story of Abraham* (detail). Gilded bronze; commissioned 1425, cast by 1436, finished 1452. Florence, Baptistery, east doors

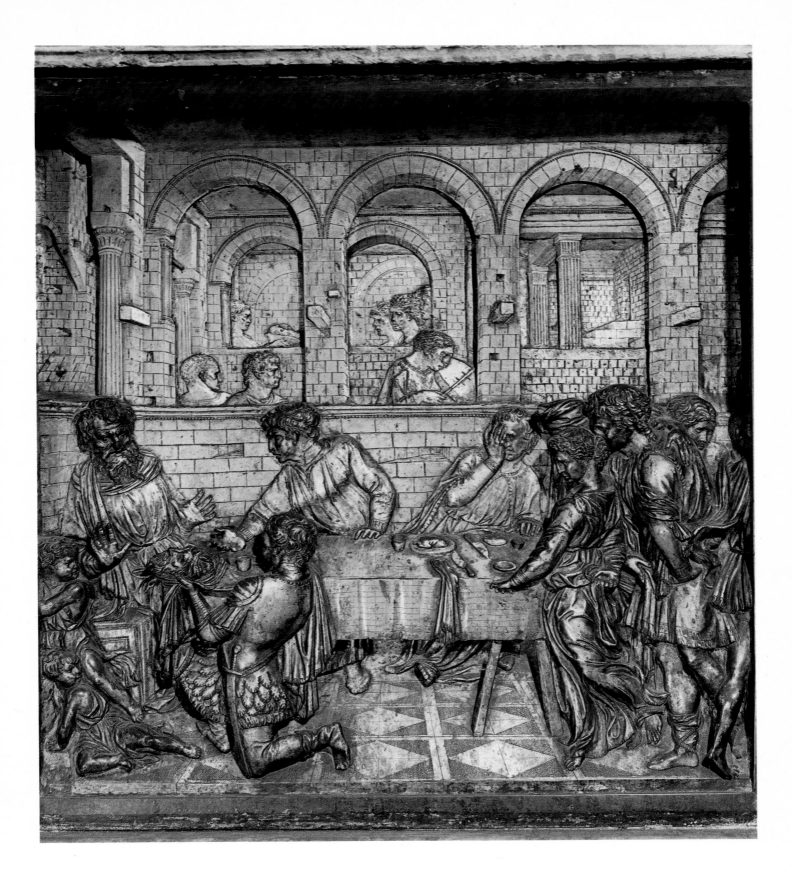

37 Donatello, *Herod Presented with the Head of St. John the Baptist*. Gilded bronze; 1423–27. Siena, Baptistery, baptismal font (detail)

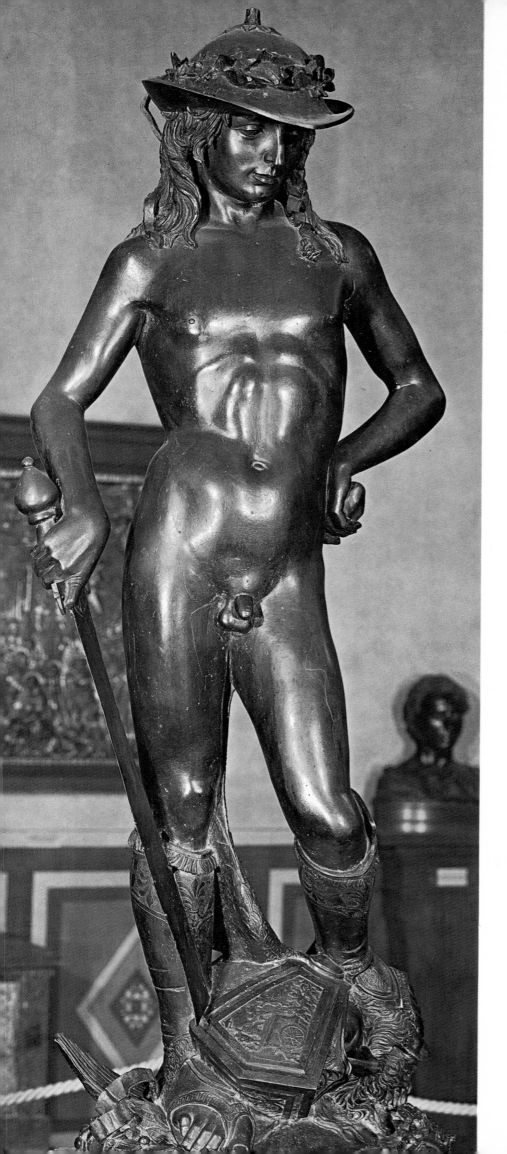

38 Donatello, *David*. Bronze; ca. 1430/40(?).
Florence, Museo Nazionale del Bargello

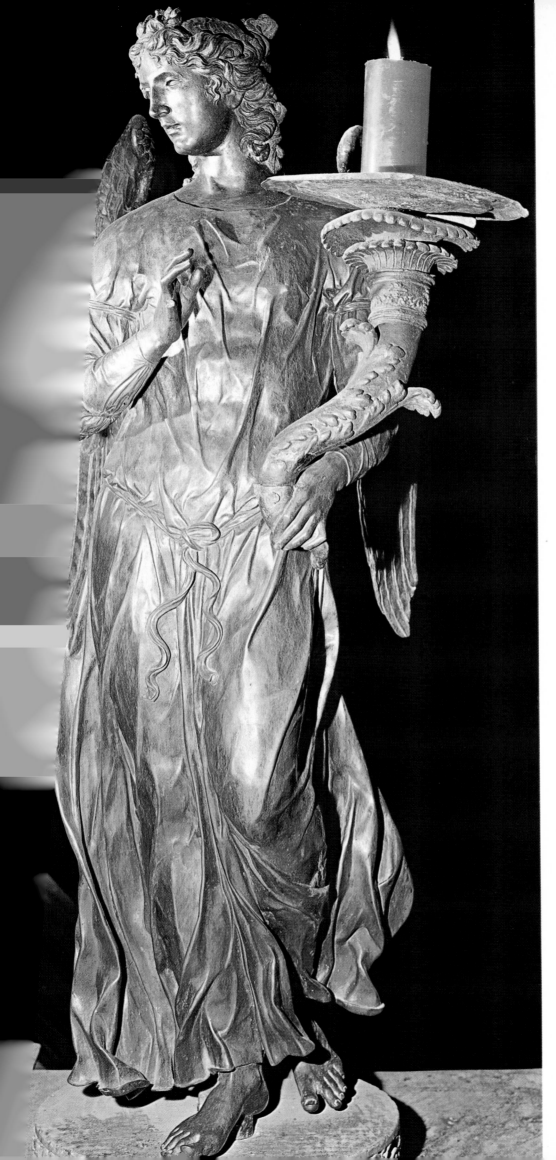

39 Francesco di Giorgio, *Angel Bearing a Candlestick*. Bronze; finished 1497. Siena, Cathedral, high altar

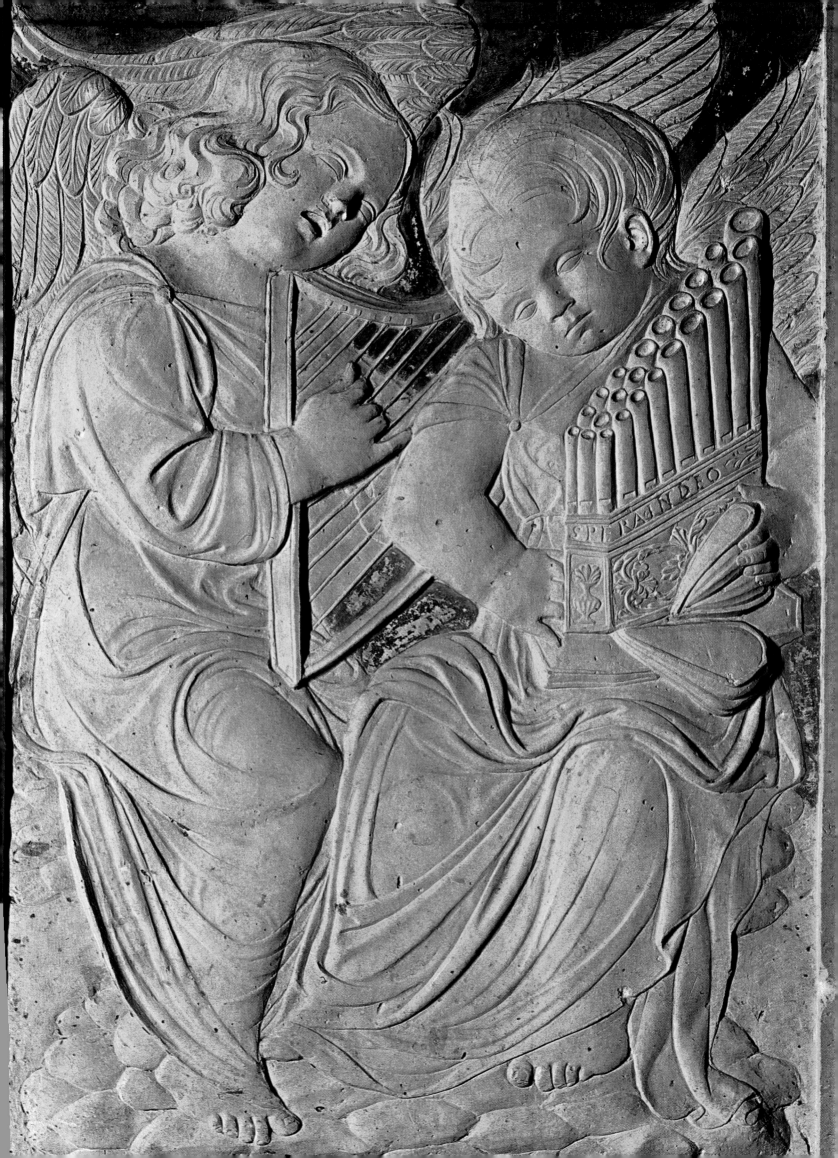

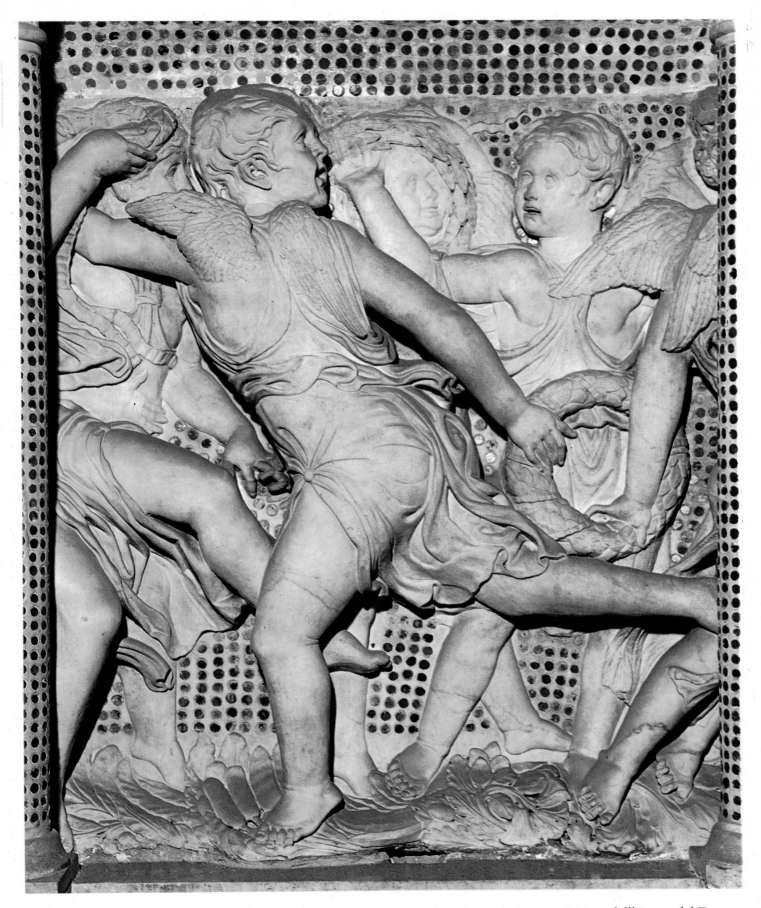

41 Donatello, *Cantoria* (detail). Marble; 1433–39. Florence, Museo dell'Opera del Duomo

40 (opposite) Agostino di Duccio or Matteo de' Pasti, *Music-Making Angels*. Marble; 1450–57.
Rimini, San Francesco, Chapel of St. Michael (di Isotta)

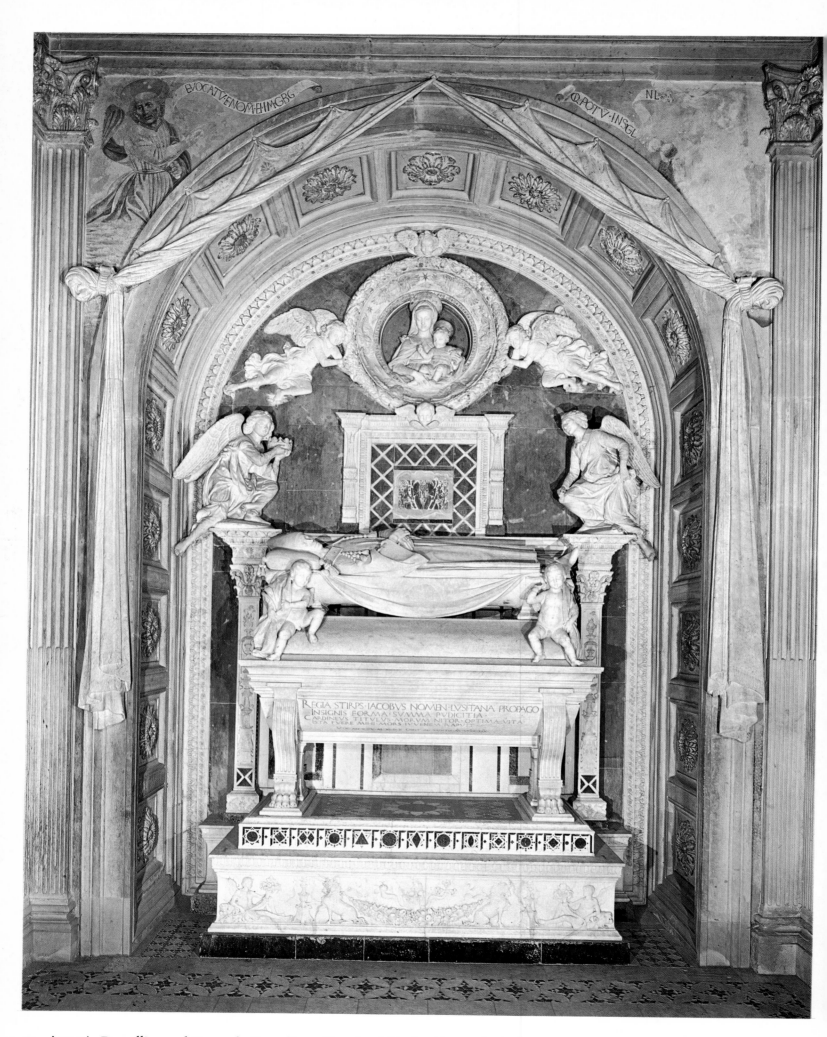

42 Antonio Rossellino and Bernardo Rossellino, *Chapel and Tomb of the Cardinal of Portugal.*
Marble and other materials, partly painted; 1461–66. Florence, San Miniato al Monte

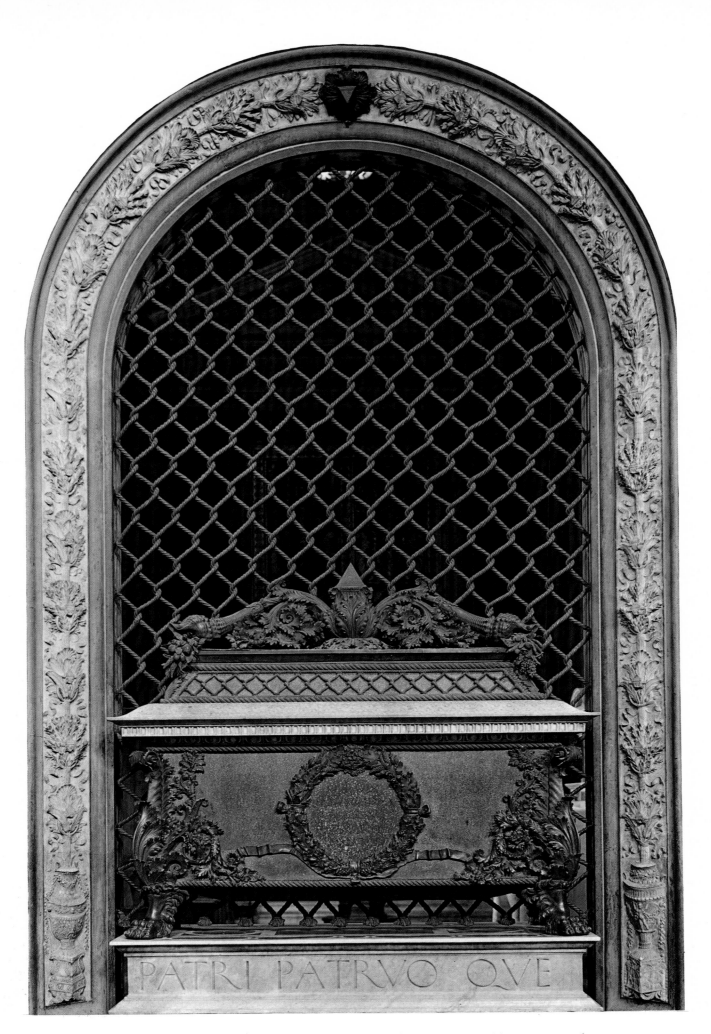

43 Andrea de Verrocchio, *Tomb of Piero and Giovanni de' Medici*. Porphyry and bronze sarcophagus on a marble base set on bronze tortoises; pietra serena architecture with marble frieze; bronze grill; 1469–72. Florence, San Lorenzo, between the left transept and the Old Sacristy

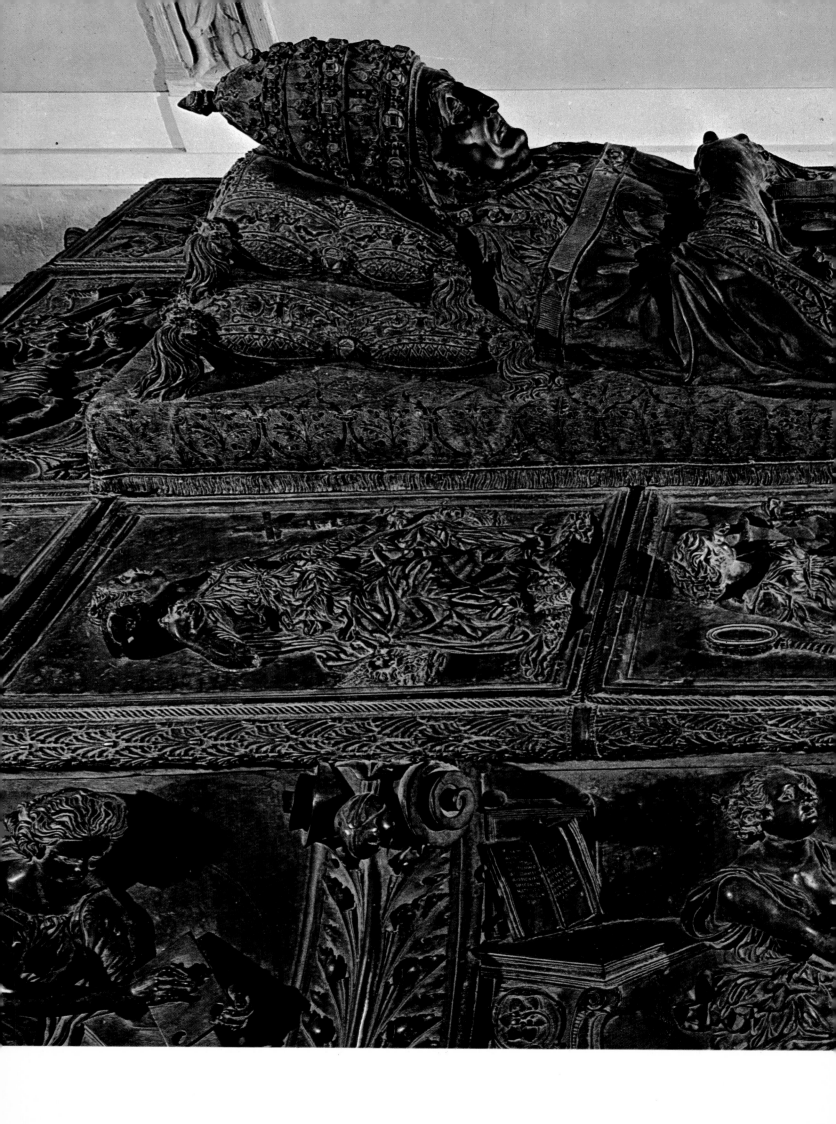

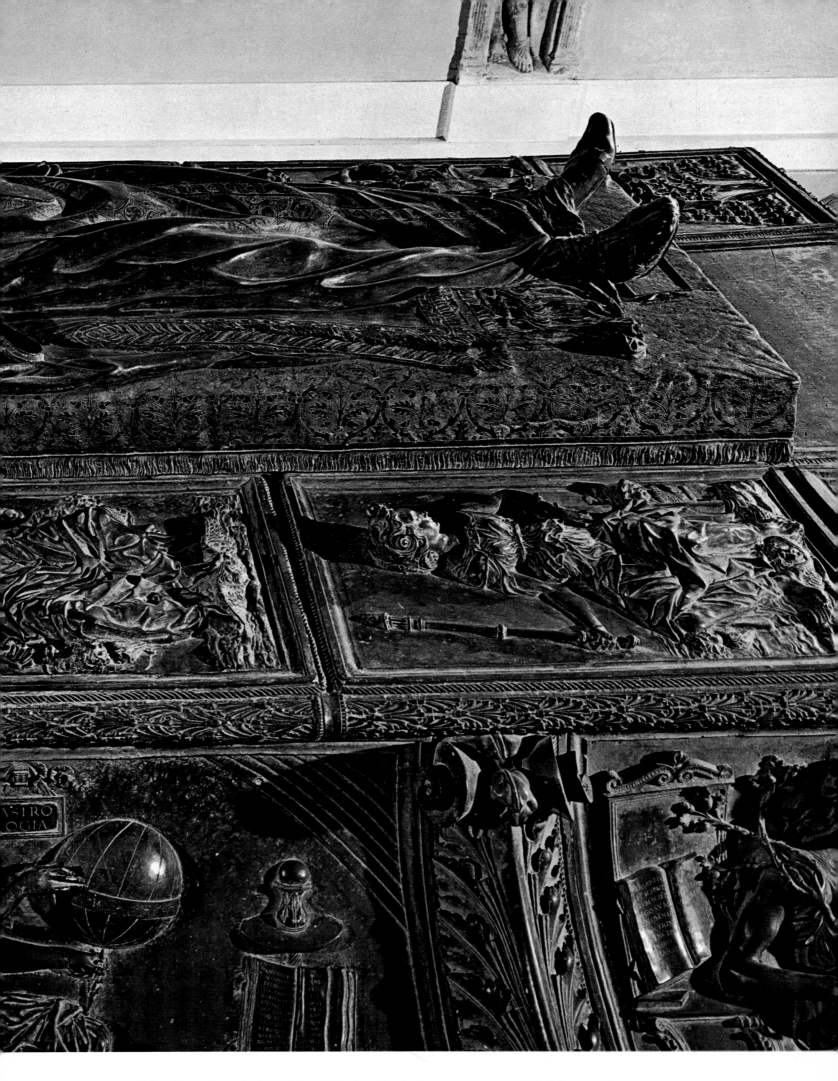

44–45 Antonio del Pollaiuolo and Piero del Pollaiuolo, *Tomb of Pope Sixtus IV*. Gilded bronze; begun 1484, finished 1493 (inscription). Rome, St. Peter's, Grotte Vaticane

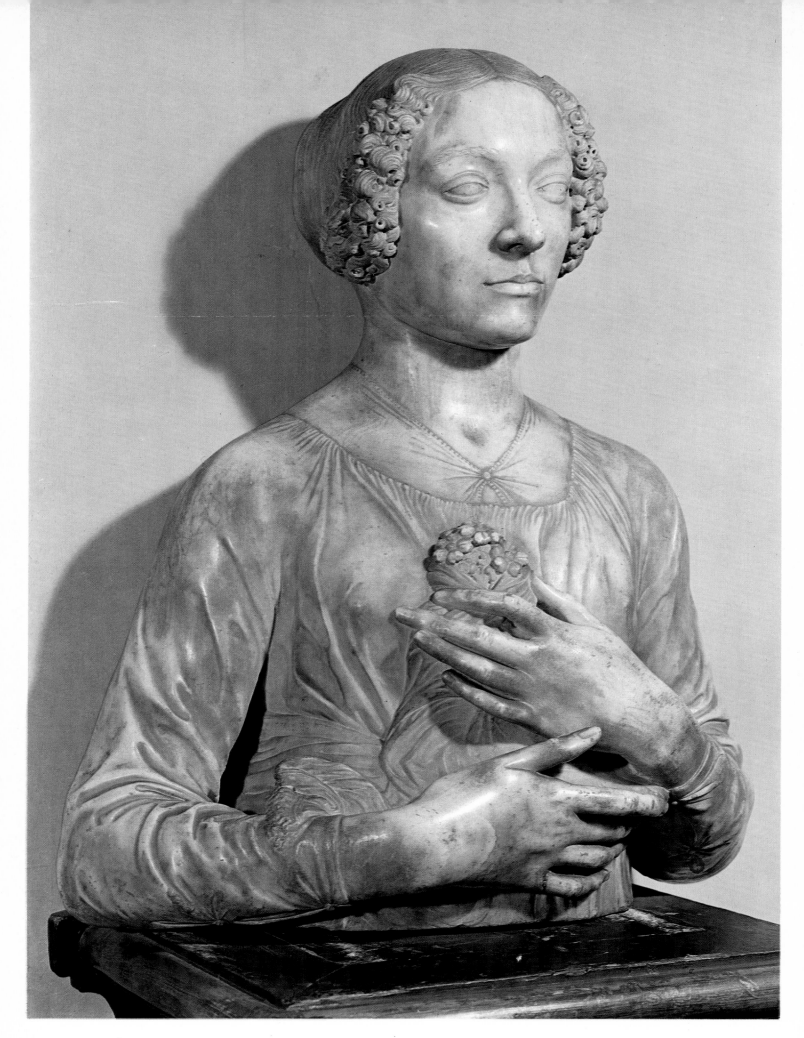

46 Andrea del Verrocchio, *Bust of Woman with Flowers* (Ginevra de'Benci?). Marble; ca. 1475–80.
Florence, Museo Nazionale del Bargello

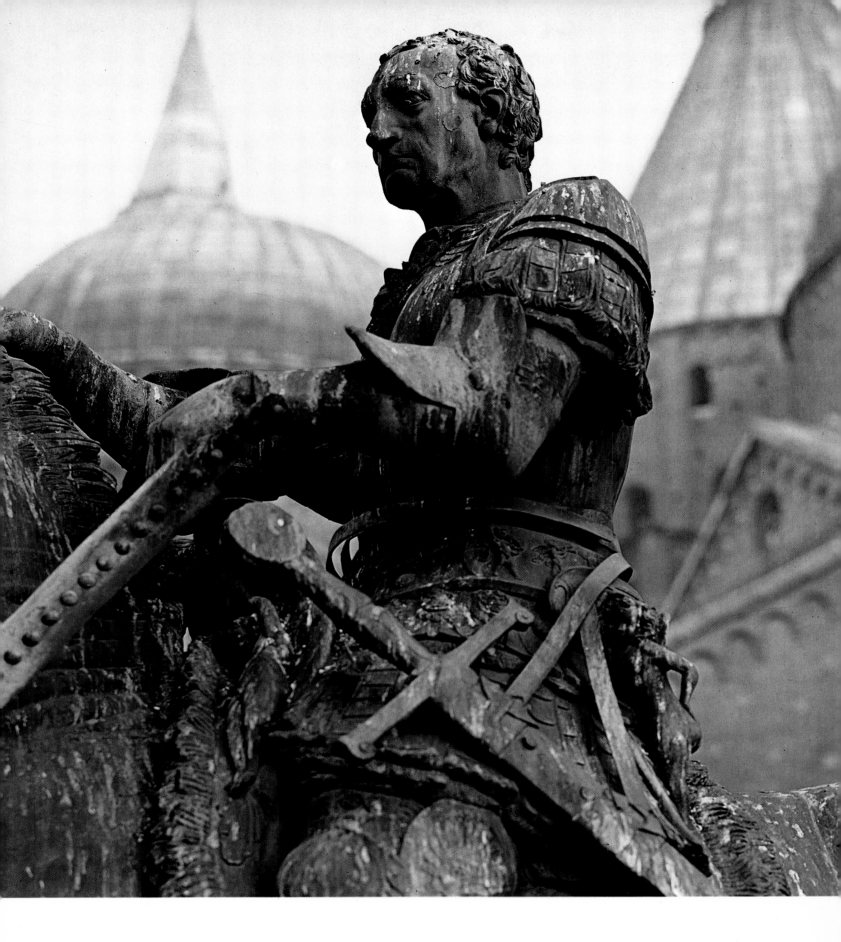

47 Donatello, *Gattamelata* (Erasmo da Narni), detail. Bronze equestrian statue,
marble base, limestone pedestal; 1445–53. Padua, Piazza del Santo

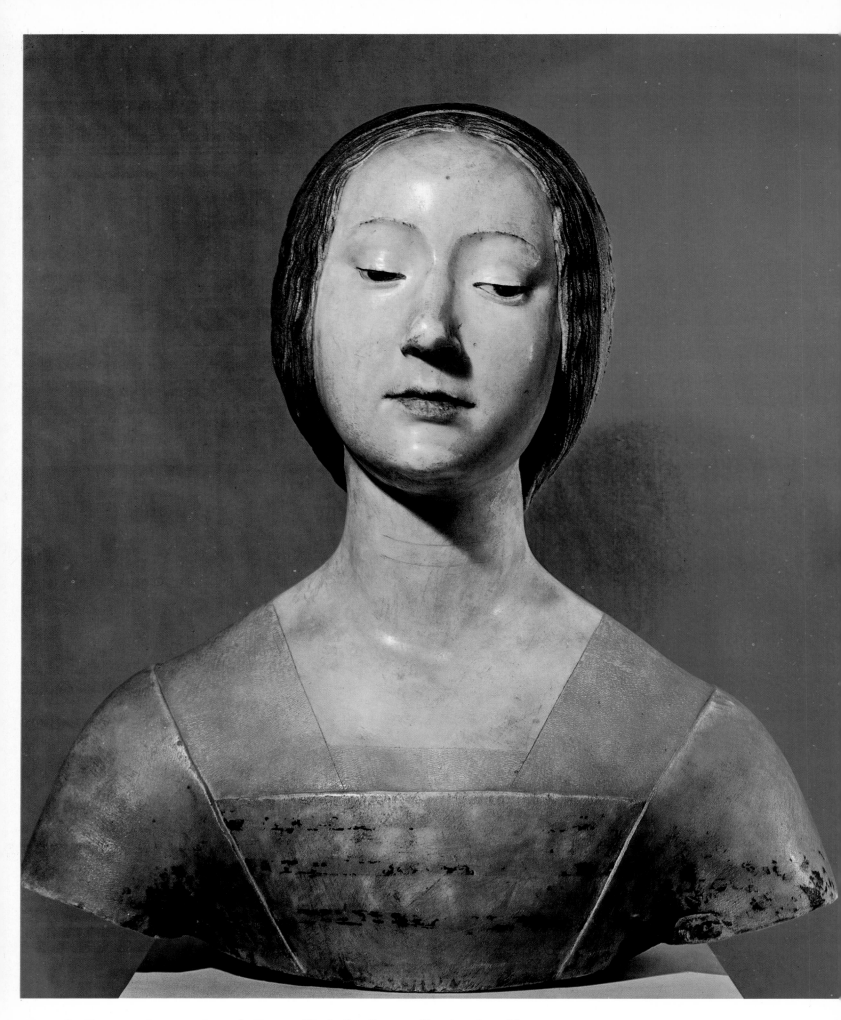

48 Francesco Laurana, *Bust of a Woman* ("Isabella of Aragon"). Tinted marble; ca. 1487–88?
Vienna, Kunsthistorisches Museum

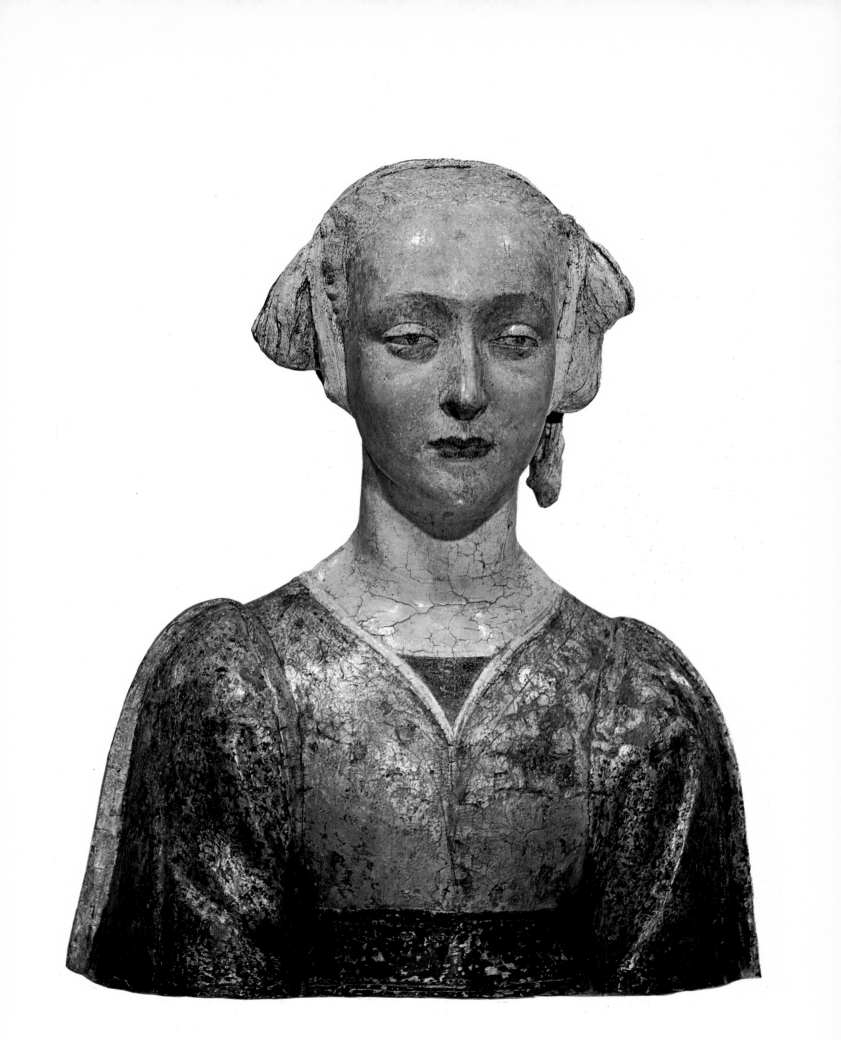

49 Andrea del Verrocchio (workshop?), *Bust of a Woman* ("Isotta degli Atti"). Wood, gilded and polychromed; ca. 1461–64. Paris, Louvre

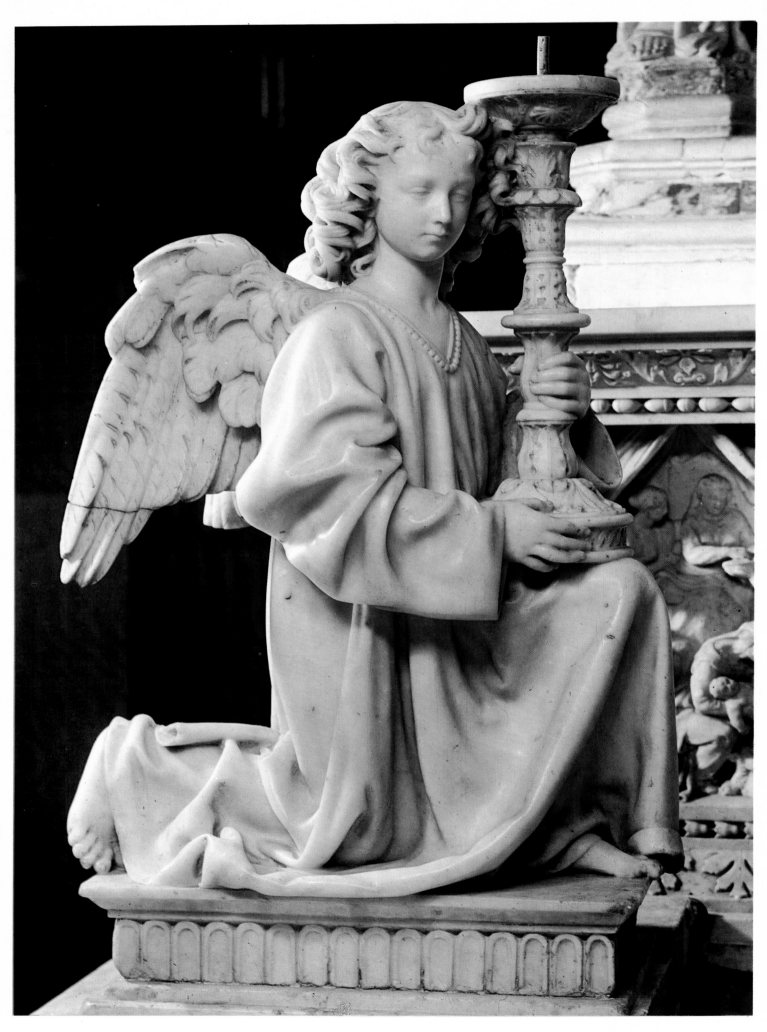

50 Niccolò dell'Arca, *Angel with a Candlestick*. Marble; ca. 1469–78. Bologna, San Domenico, Shrine of St. Dominic

51 (opposite) Il Riccio, Andrea Briosco *Putto with Tragic Mask*, Easter Candlestick (detail). Bronze, marble base; 1507–15. Padua, Sant'Antonio

52–53 Guido Mazzoni, *Lamentation over the Body of the Dead Christ (Pietà)*. Painted terracotta; 1477–80.
Modena, San Giovanni della Buona Morte

Overleaf and following:

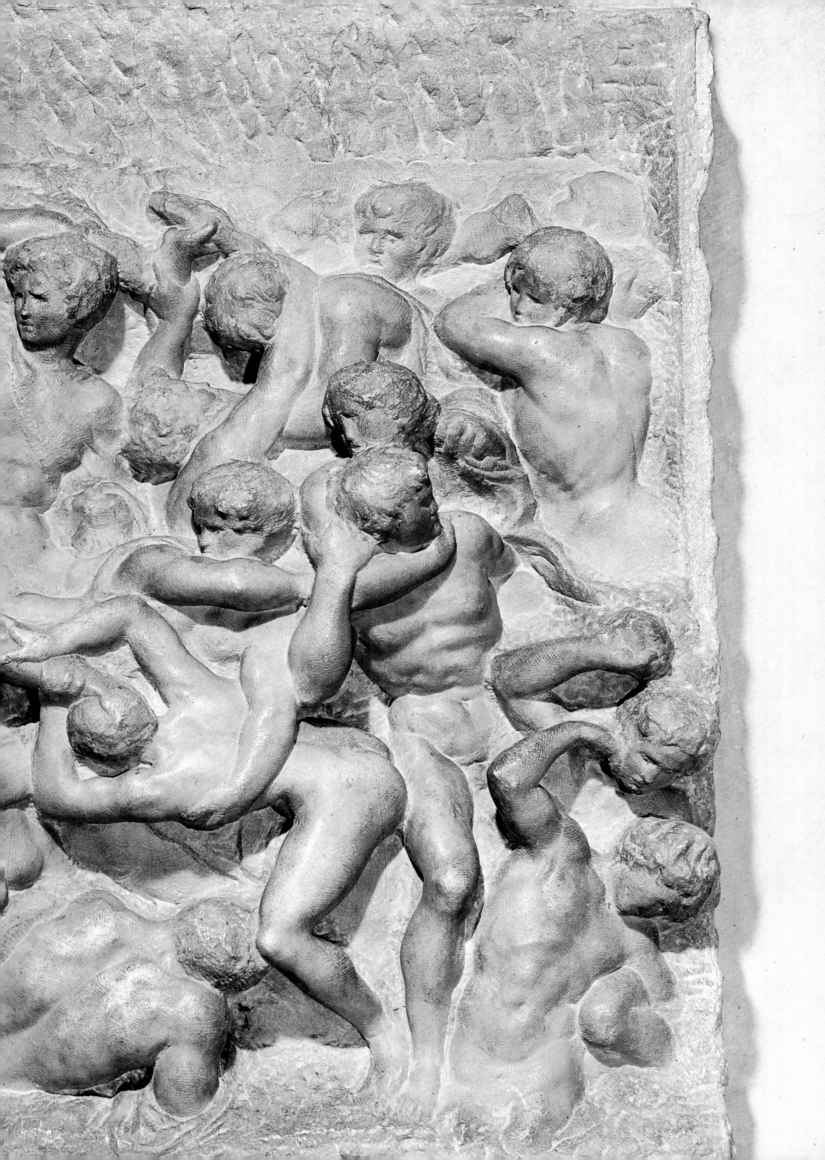

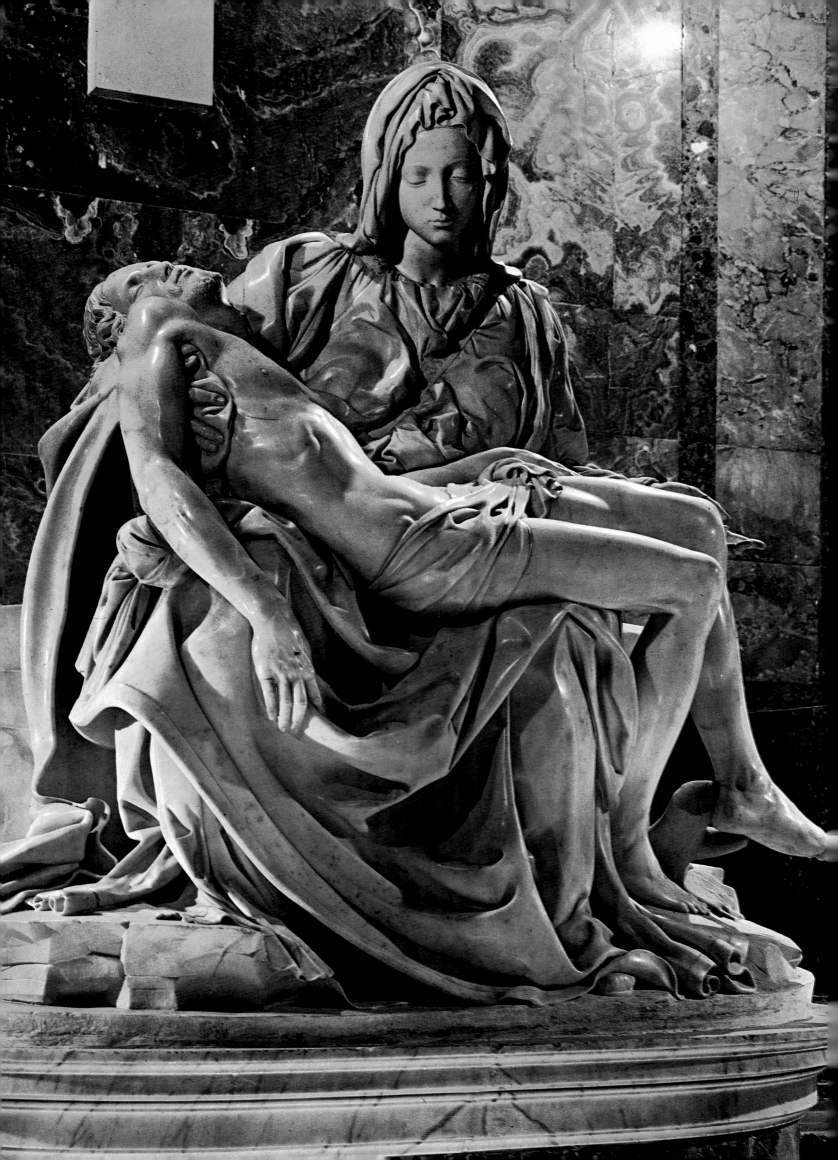

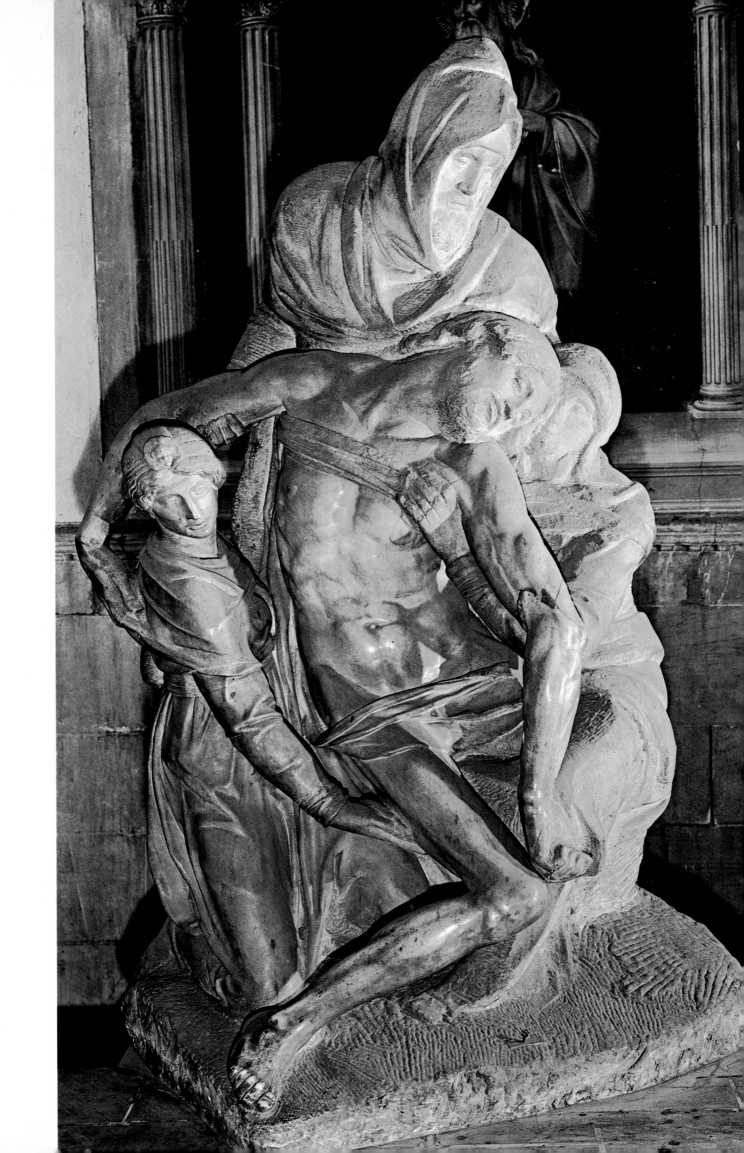

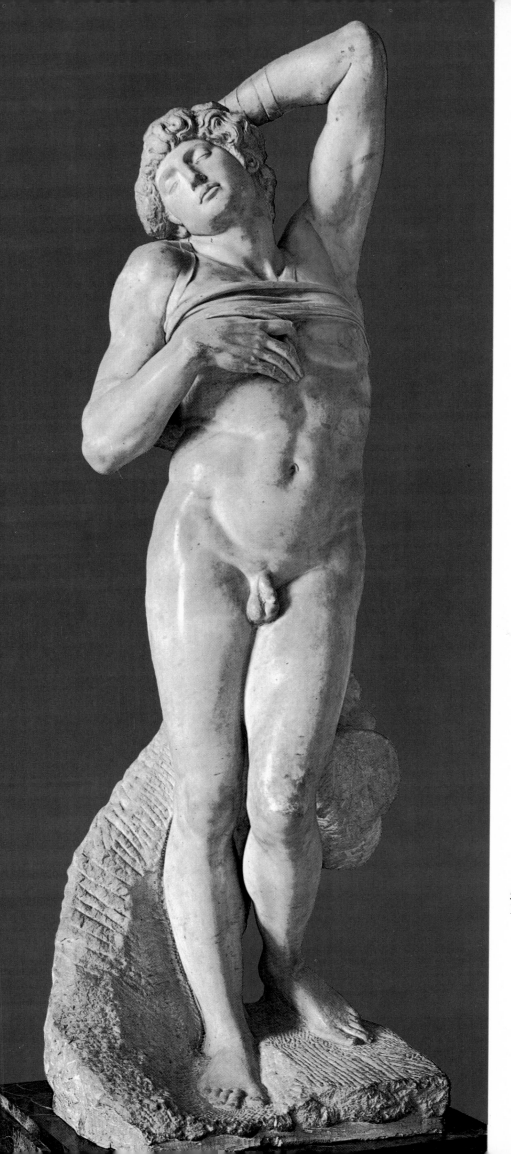

58 Michelangelo Buonarroti, "Dying Slave."
Marble; 1513–16. Paris, Louvre

59 (opposite) Michelangelo Buonarroti,
Moses. Marble; 1513–16, 1542–45. Rome,
San Pietro in Vincoli

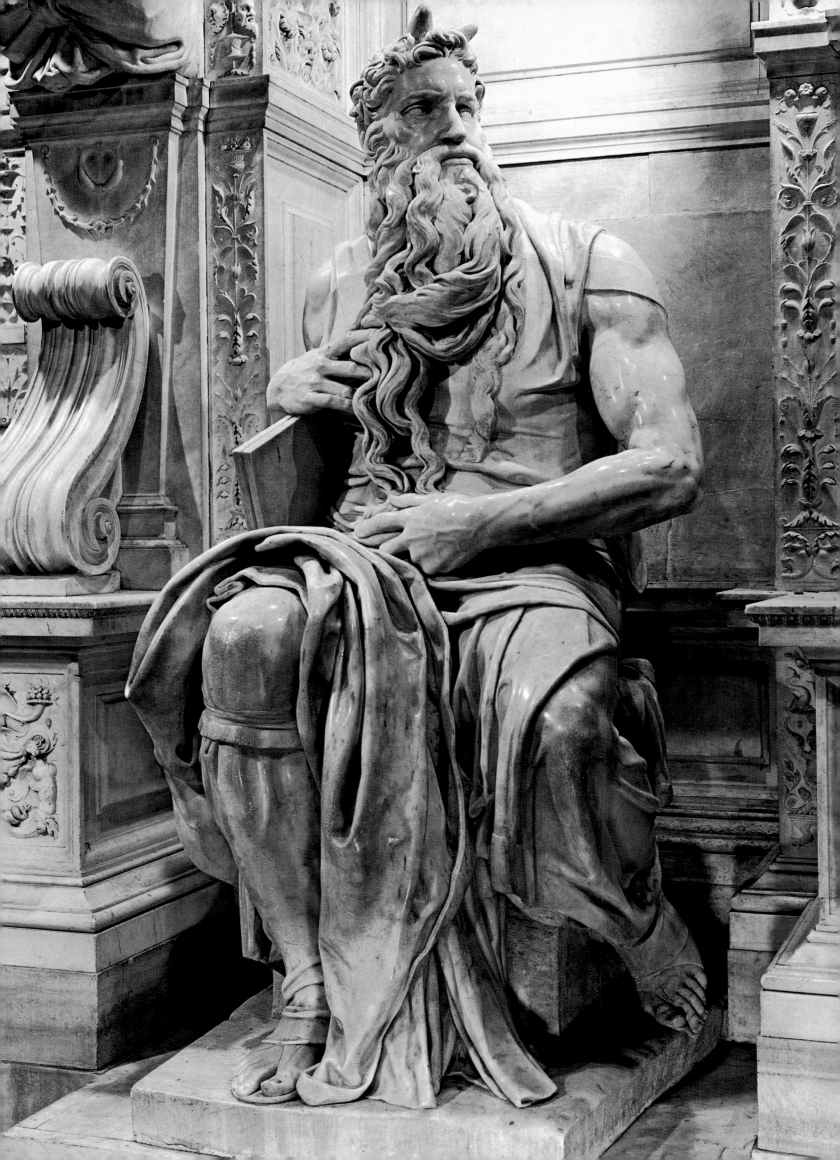

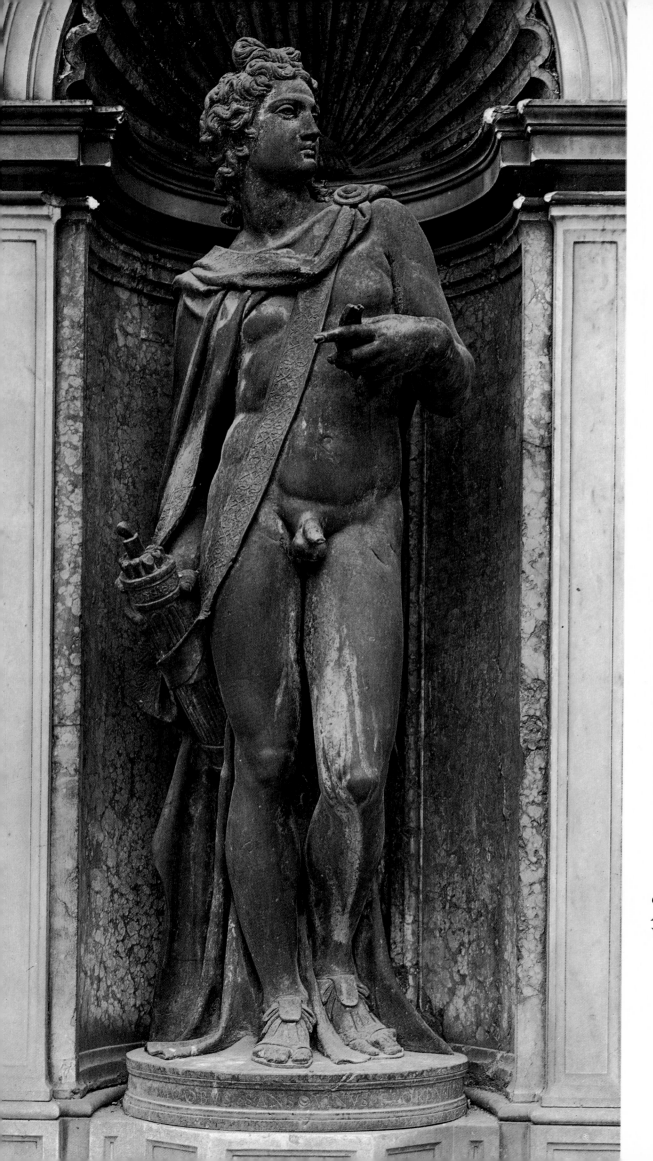

60 Jacopo Sansovino,
Apollo. Bronze; 1540–45.
Venice, Loggetta

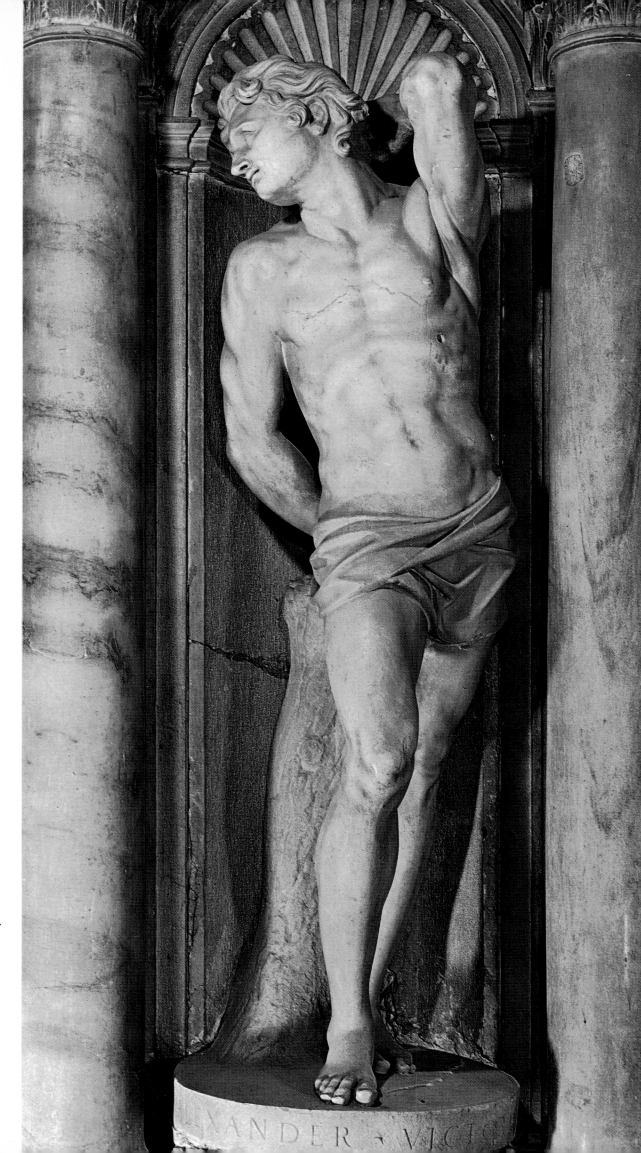

61 Alessandro Vittoria,
St. Sebastian. Marble; 1563.
Venice, San Francesco
della Vigna

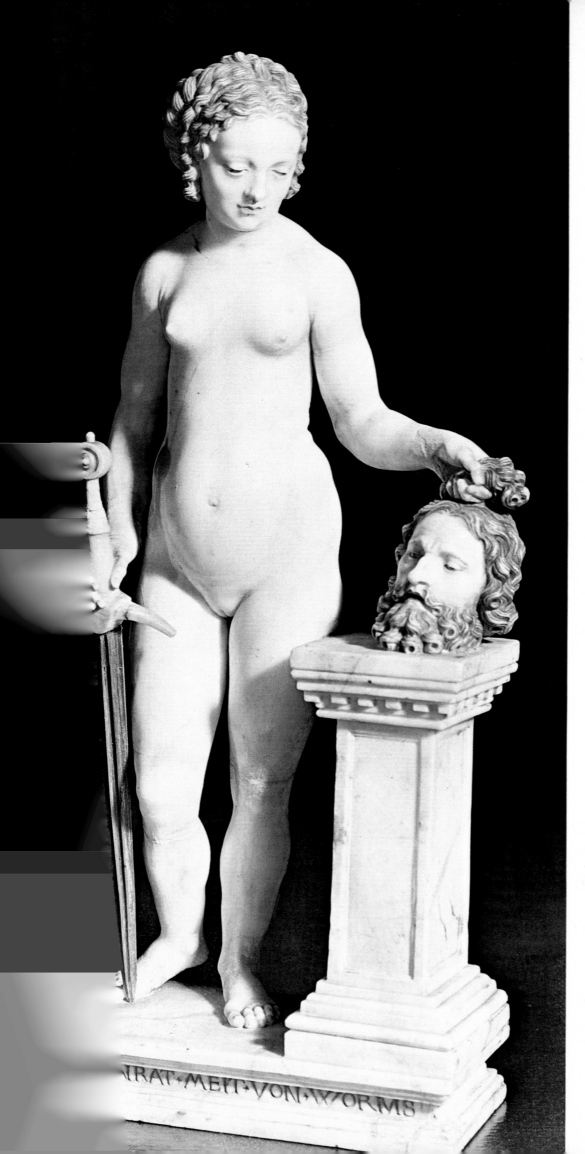

AIRAT · MEIT · VON · WORMS

62 Conrad Meit, *Judith*. Tinted alabaster; ca. 1525–28(?). Munich, Bayerisches Nationalmuseum

63 (opposite) Jean Goujon, *Caryatids*. Stone; 1550–51. Paris, Louvre, Salle Lescaut (detail)

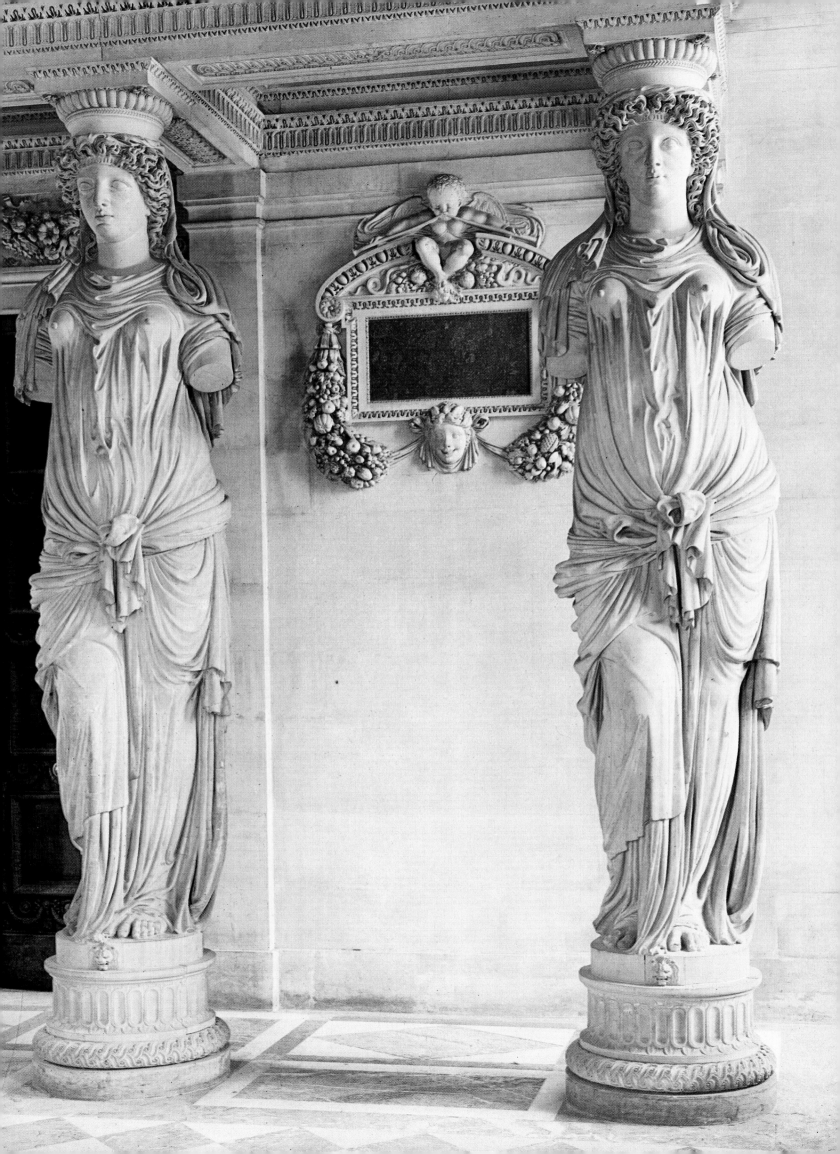

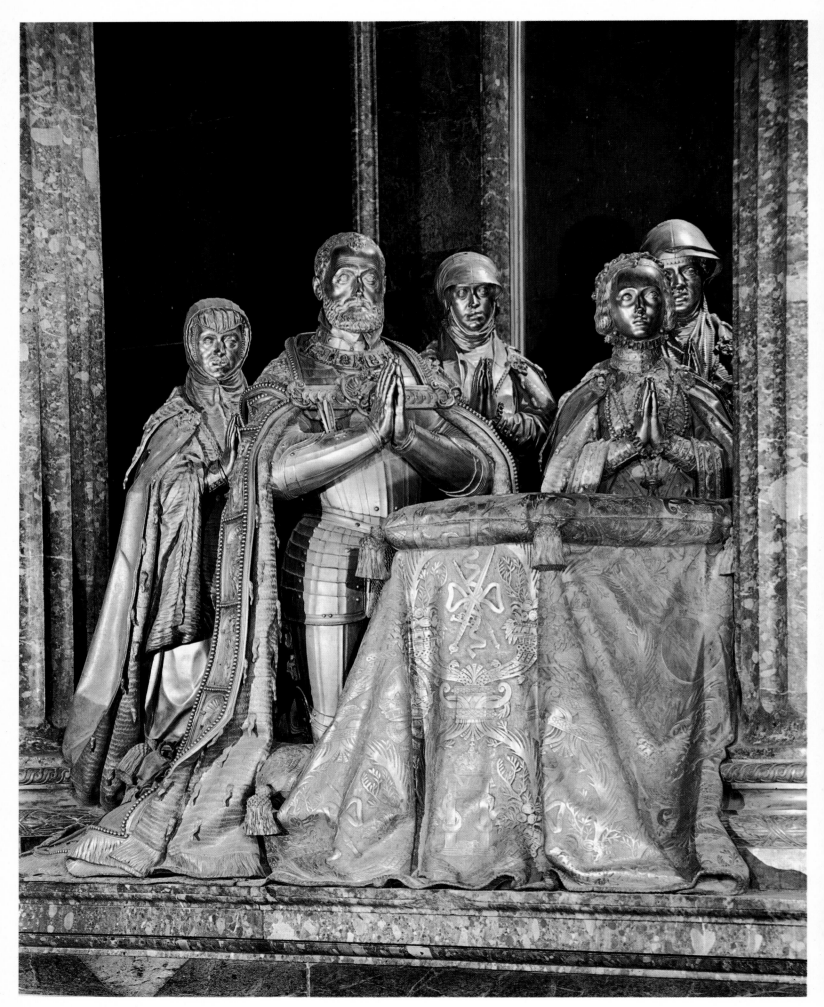

64 Pompeo Leoni, *Mausoleum of Charles V*. Gilded bronze; 1591–98.
El Escorial, San Lorenzo, High Altar Chapel

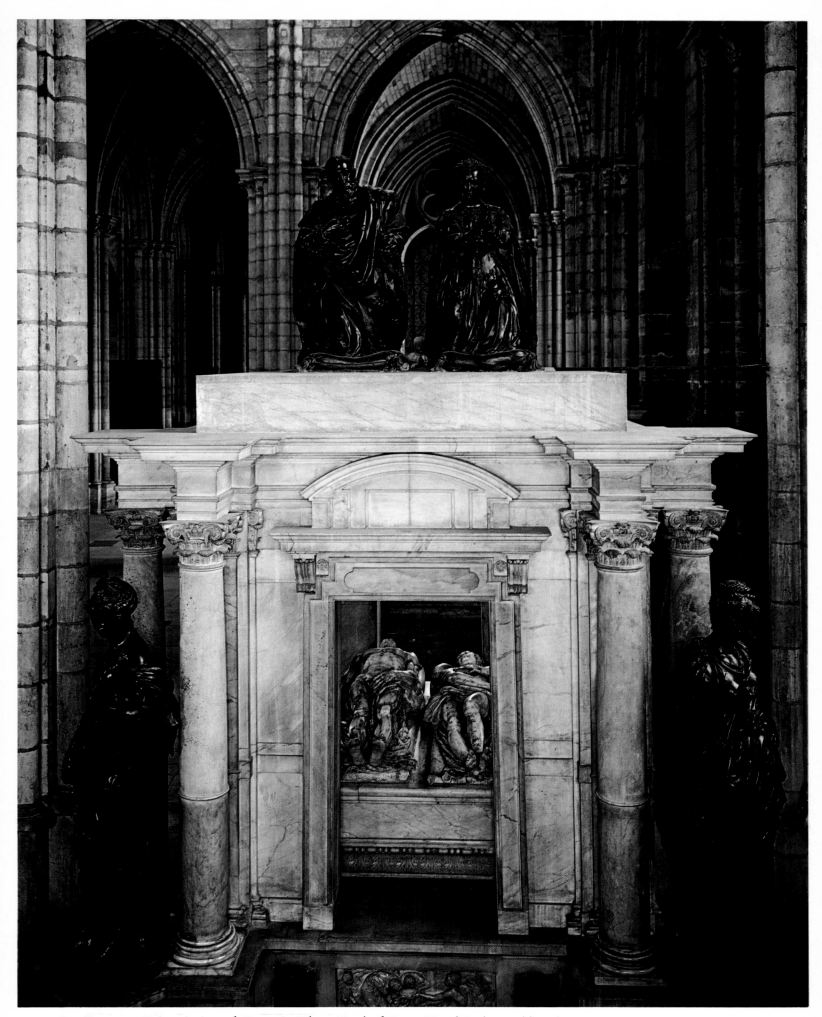

65 Francesco Primaticcio and Germain Pilon, *Tomb of Henry II and Catherine de' Medici.*
Marble and bronze; 1563–70. Paris, St.-Denis

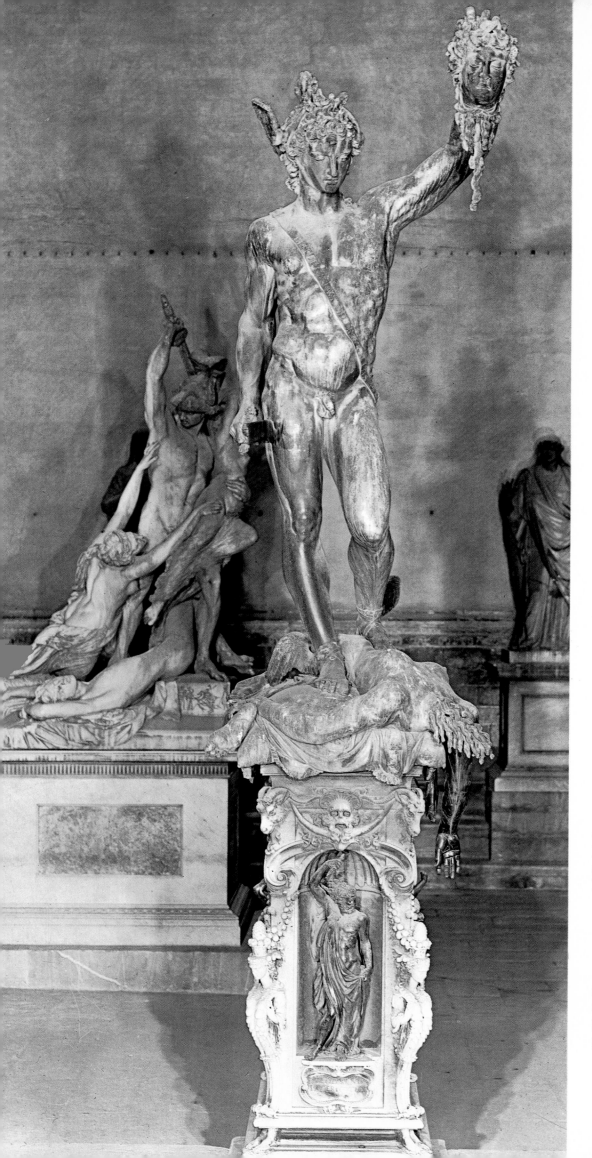

66 Benvenuto Cellini, *Perseus.*
Bronze, marble base with bronze
statuettes; 1545–54. Florence,
Loggia dei Lanzi

67 (opposite) Jean Goujon or
Germain Pilon, *Diana of Anet.*
Marble; before 1554. Paris, Louvre
(originally Chateau d'Anet)

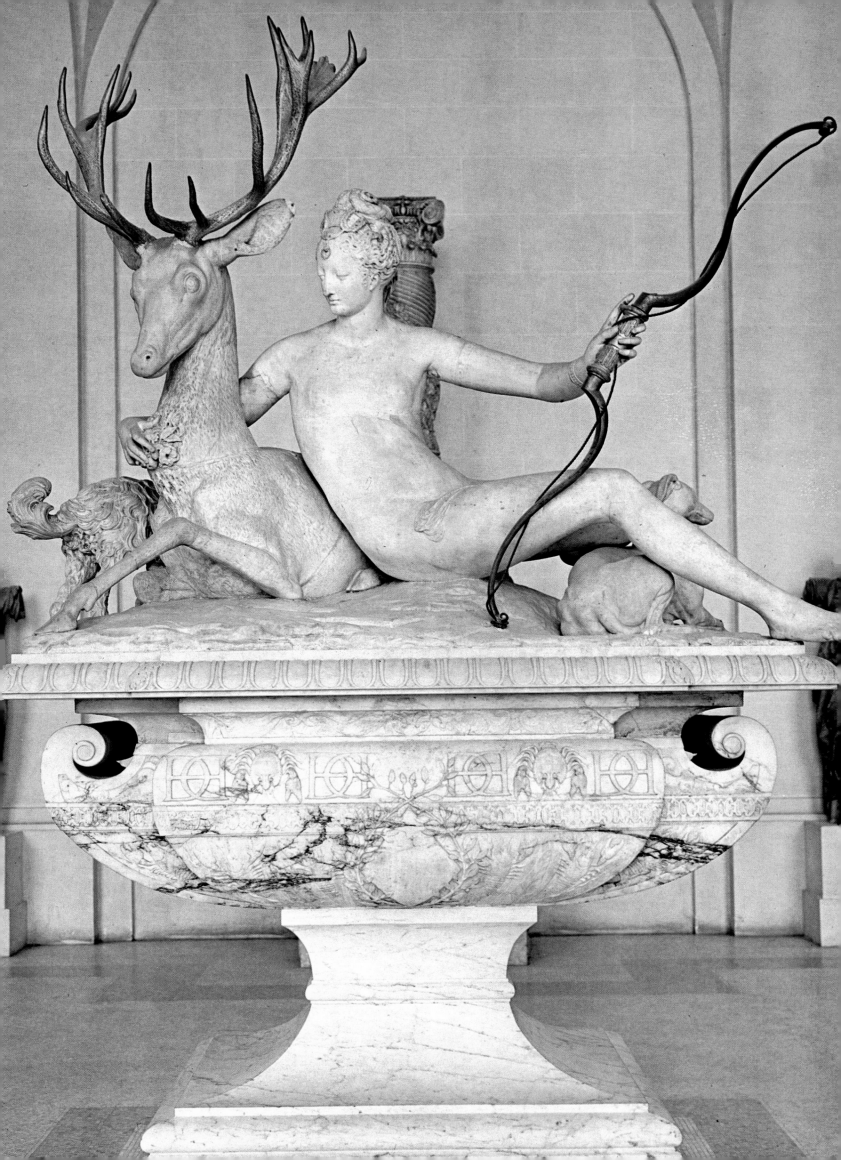

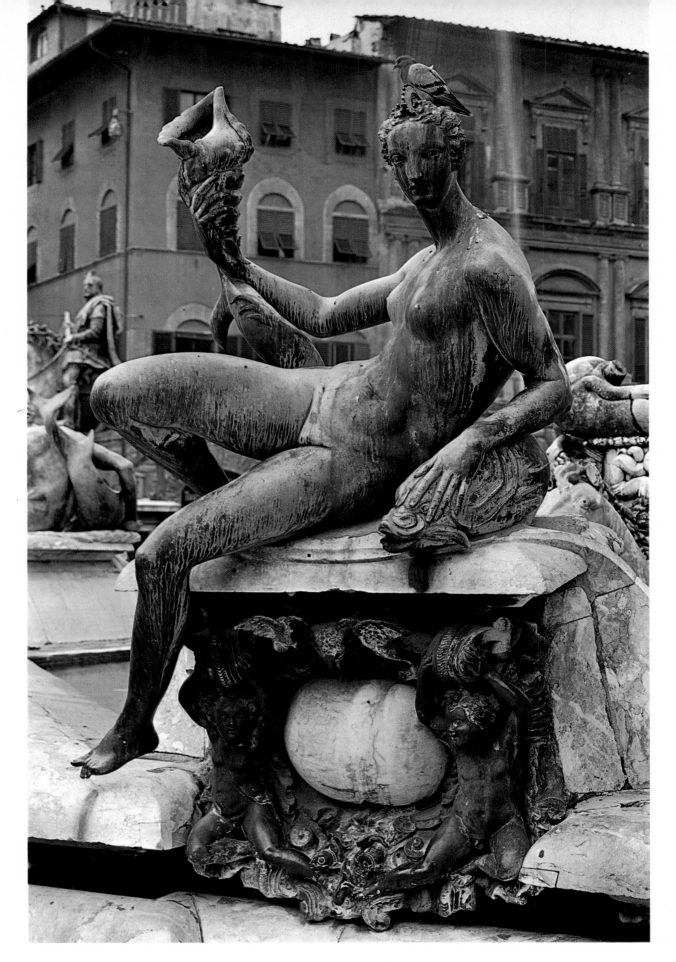

69 Bartolommeo Ammannati, *Nymph* (Doris). Marble and bronze; 1563–75.
Florence, Piazza della Signora, Neptune Fountain

68 (opposite) Niccolò Tribolo and Giovanni Bologna (Jean de Boulogne; "Giambologna"),
Fountain of the Labyrinth. Marble fountain by Tribolo with bronze figure of *Florence* by
Giambologna; 1555–60. Florence, Villa della Petraia (formerly Villa di Castello)

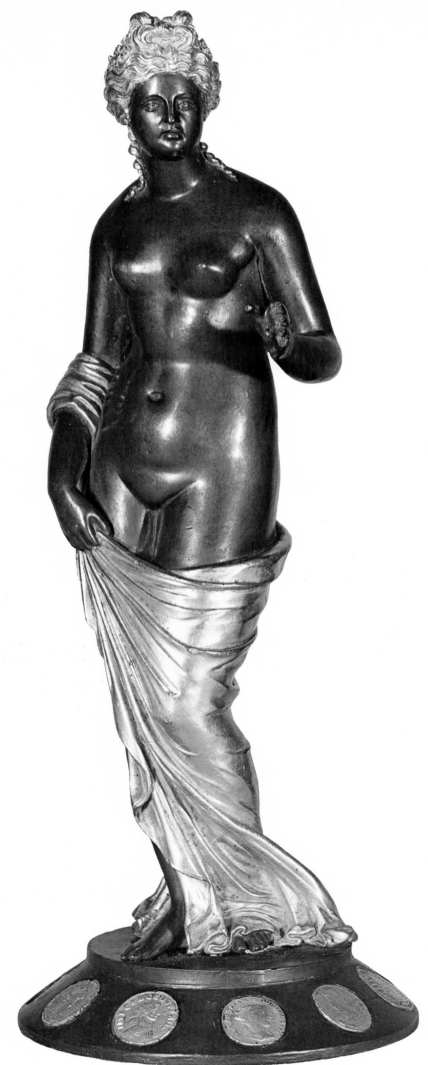

70 L'Antico (Pier Jacopo Ilario Bonacolsi), *Venus Felix*. Bronze, gilded hair and drapery, silver inlaid eyes, base inset with nine silver coins of late antiquity; date unknown. Vienna, Kunsthistorisches Museum.

71 (opposite) Giovanni Bologna (Jean de Boulogne; "Giambologna"), *Astronomy*. Gilded bronze; ca. 1565–70. Vienna, Kunsthistorisches Museum

Overleaf:

72 Giovanni Bologna, *Apennine*. Stone, bricks, mortar; 1580–82. Florence, Villa di Pratolino

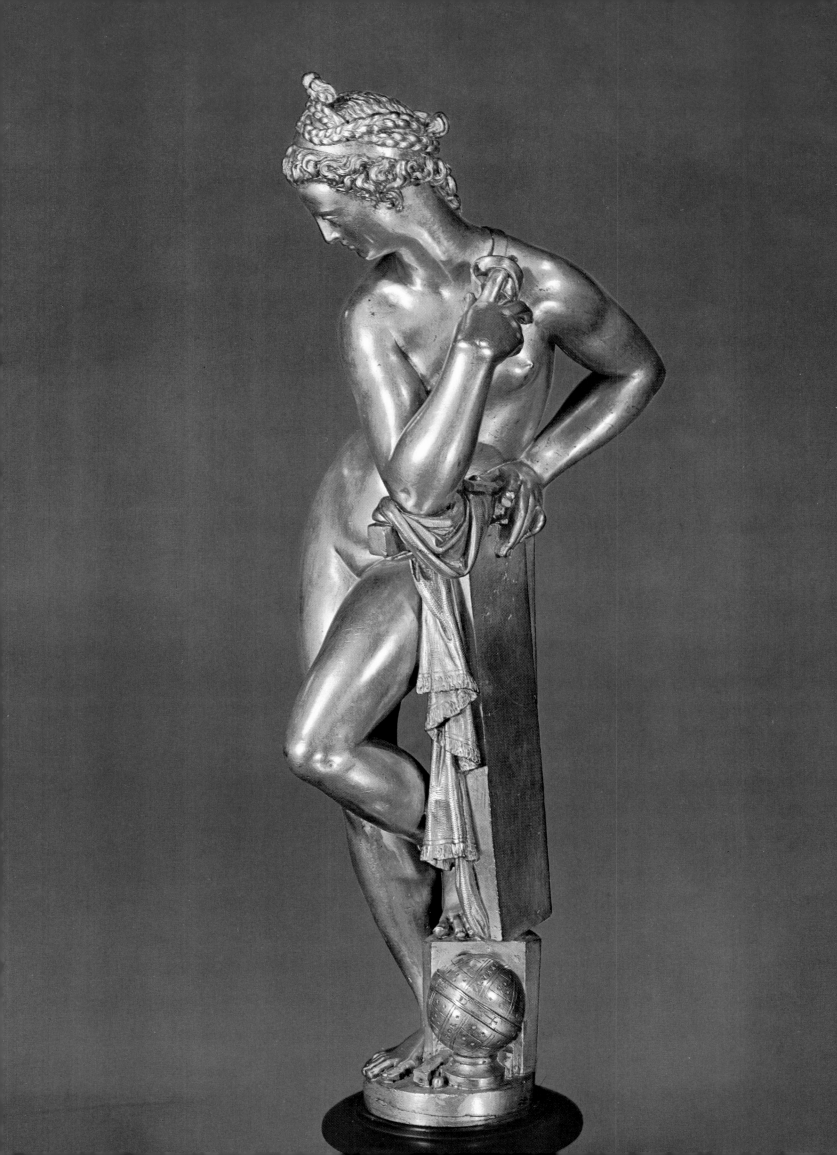

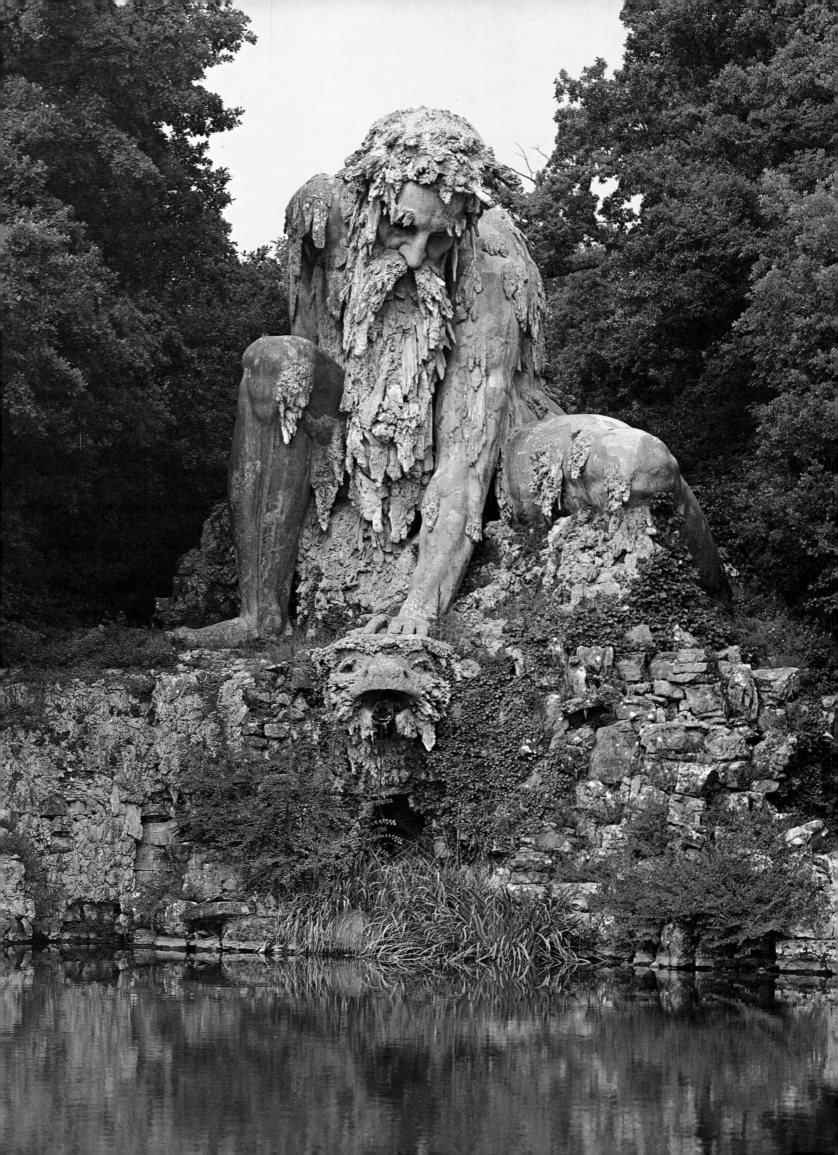

3 Baroque to Romantic

FIG. 30. Stefano Maderno, *St. Cecilia*.
Marble; 1600. Rome, Santa Cecilia in
Trastevere

FIG. 31. Gian Lorenzo Bernini, *Bust of
Louis XIV*. French Marble; 1665.
Versailles

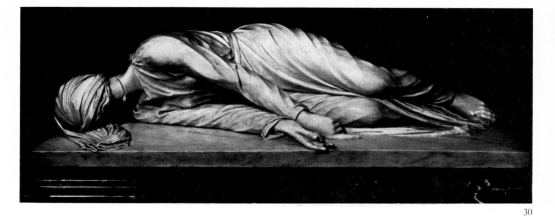

30

Historians used to worry excessively about dating and defining stylistic periods
of art—Renaissance, Mannerism, Baroque, Rococo, and so on. Now we see
these stylistic tendencies more naturally, as having centers and peaks but no
clear boundaries or national limits. The style practiced by Giambologna in
Florence was only the most brilliant of a late Mannerist tendency that con-
quered Europe—his Northern pupil and counterpart, Adrian de Vries (died
1626), continued a version of this style well into the seventeenth century,
working in Prague and Augsburg. Another pupil, Pietro Tacca (1557–1640),
succeeded Giambologna as sculptor to the grand dukes of Tuscany and com-
pleted the master's commissions for royal equestrian monuments in Madrid and
Paris. But although this elegant court style did live on, we sense new currents
in the seventeenth century that have their roots in the religious crises of the
preceding period. What most of us call Baroque art—the paintings of Rubens,
the sculpture of Bernini—has its source in the Catholic Counter-Reformation.

The Protestant Reformation was the product of long and varied dissatis-
faction with the conduct and theology of the Roman Church, but it is sym-
bolized by the life and work of one man, Martin Luther (1483–1546). At first
Luther, like others, was only a reforming Catholic priest; but his eventual break
with the Church led to religious wars and persecutions that were temporarily
stopped in central Europe by the Peace of Augsburg in 1555, a settlement
that decreed that the people should follow the religion of their sovereigns.
But in France, England, and the Netherlands it took longer to settle down to a
new status quo; indeed, never again has the world had even the illusion of a
united Christianity.

Faced with internal dissent and foreign revolt, the Roman Church hastened
to mend itself. Among the several trends that can be distinguished, the most
important was the establishment of new religious orders dedicated to reform
and to missionary work. The militaristic Jesuits were the best known. Founded
by the Spaniard Ignatius Loyola and confirmed by Pope Paul III in 1540, the
Jesuits excelled at conversions: by the seventeenth century there were more
Catholics in the world than ever before, despite the rise of Protestantism. The
Jesuits went forth among Protestants and pagans, even in the face of sure
martyrdom, on all four known continents. Other new orders—Barnabites,
Theatines, Oratorians—worked less ostentatiously to the same ends, the reform
and spread of the Catholic religion. Older orders, which had often grown cor-
rupt or complacent, found new reformers, such as the Carmelite Teresa of Avila.
The somewhat discredited Franciscans achieved new life through the Capuchin
Friars. Many of the leaders of these new religious movements were canonized
or beatified soon after 1600 and so helped further a new religious iconography,
now mystic, now militant (see Plates 73, 84–85).

Another aspect of the Counter-Reformation is symbolized by the Council of
Trent (1545–1563), which failed to be ecumenical (no Protestants even
attended) but which ultimately promulgated an official Catholic line on a
number of sore points, among them the place of religious images in a Christian

world. The Protestants, who tended to devalue the Catholic veneration of saints, also questioned the use of religious images. Some of the early reformers had been violently iconoclastic. Luther himself was for a time in doubt, and Albrecht Dürer, a convert to Lutheranism, may even have stopped working on his art temporarily because of this dilemma. The Catholic position on the place of religious images in art was stated formally by the closing session of the Council of Trent in 1563. It tried to distinguish between imagery and idolatry by asserting that the honor that is shown to religious images "is referred to the prototype which they represent, so that by means of the images which we kiss and before which we uncover the head and prostrate ourselves, we adore Christ and venerate the saints whose likeness they bear." The Council proscribed nudity in religious images unless it was theologically necessary (e.g., Adam and Eve before the Fall); it also made a number of other recommendations of less significance. But even the Jesuits seem not to have exercised strict control over the artists who worked for them, and most artists of the later sixteenth century were by and large independent of reforming considerations—Giambologna was even reported to be a secret Protestant. Others, although surely Catholic, were content to follow in the footsteps of their masters, which is to say in a style formed before the Counter-Reformation was generally under way.

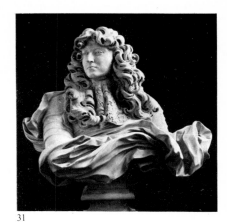

In the late sixteenth century there began to appear signs of something new that we may call the art of the Counter-Reformation. The center of this movement (it is hardly a style) was Rome. The Gesù, the principal church of the Jesuits, was for the most part built during the 1570s and 80s, the first of a series of big aisleless churches intended to hold the crowds who came to hear brilliant preachers trained by the new orders. The popes themselves began a vast program of urban renewal centered on St. Peter's and the other Basilicas. The breviary and missal were reformed according to what seemed to be older and more hallowed models; a "documented" history of the early Church was written by Cardinal Baronius to prove the validity of the papal succession; early churches were excavated, graves of the early martyrs explored, and Christian catacombs given their first serious attention. These last are part of the early history of Christian archaeology and brought about new constructions modeled on supposed Early Christian prototypes, statues of early martyrs (see Fig. 30; Plate 75), and paintings influenced by the catacombs. The new reformative spirit finally molded a generation of artists, largely born in the 1590s, who produced a new and serious religious style. This style was not simply pietistic and devout, as some artists of the late cinquecento undoubtedly were; rather, it combined a sense of Catholic truth and Catholic triumph with the older Renaissance sense of art as a joyous celebration of life. The artists of this new generation were by no means equal or similar. At the forefront of the group is Gian Lorenzo Bernini (1598–1680), the greatest sculptor of the Baroque; he was also a painter, an innovative architect, a man of the theatre, and a brilliant courtier and entrepreneur who directed the artistic affairs of St. Peter's for over half a century.

Bernini became famous as a portraitist in marble when he was still a boy; he may have carved busts as a child and there is no doubt that as a teenager he was already a virtuoso who outshone his father Pietro, a facile Mannerist sculptor of some distinction who came to Rome to work for Pope Paul V (1605–1621). Bernini's later busts, whether formal (see Fig. 31) or intimate (see Plate 78), reveal him to be the greatest portraitist of the age. Plate 78 shows his mistress, Costanza Bonarelli, in a frankly sensual and revealing intimacy totally out of character for the period; rather, it appears to anticipate the unvarnished realism of Houdon (see Fig. 41). In his portraits of the great, Bernini reconciled the ancient form of the truncated bust with the pomp of the Baroque court. Rather than reflecting reality, these busts seem symbolic of a grandeur that the Sun

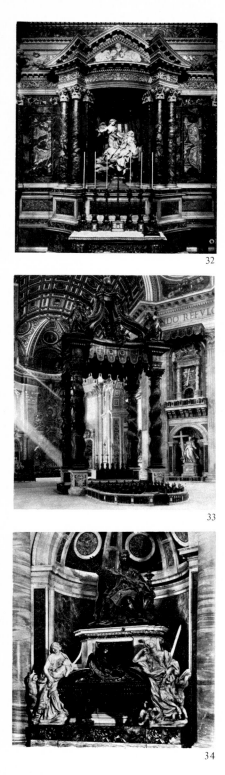

FIG. 32. Gian Lorenzo Bernini, Cornaro Chapel. ca. 1644–52. Rome, Santa Maria della Vittoria

FIG. 33. Gian Lorenzo Bernini, *Baldacchino*, with the *Throne of St. Peter* in the background. 1624–33 and 1657–66. Rome, St. Peter's

FIG. 34. Gian Lorenzo Bernini, *Tomb of Urban VIII*. Marble and gilded bronze; 1628–47. Rome, St. Peter's

FIG. 35. François Girardon, *Apollo and the Nymphs*. Marble; 1666–72. Versailles

King himself strove to achieve. Bernini's bust of Louis XIV (Fig. 31) is consciously modeled on portraits of Alexander the Great, a reference that was easily understood in this period of erudite flattery.

Bernini evolved new dramatic principles of sculptural presentation that demand a new stylistic label—Baroque. The *Apollo and Daphne* (Plate 76) is first of all an unprecedented piece of virtuoso carving. The subject seems utterly unsuited for marble sculpture and is hardly known before Bernini. In order to reveal all at once the full psychological and physical drama of Apollo's frustrated pursuit and Daphne's transformation into a laurel tree, Bernini revealed the group completely from one point of view, as if it were a relief freed from its ground. In other words, he returned to the frontality that had been favored by Michelangelo (see Plates 56–59) and rejected the teasing, lingering, multiple viewpoints of Mannerist statuary. But unlike Michelangelo, who had an almost mystical sense of an ideal figure within the block of marble, Bernini was no respecter of the integrity of the stone—he gladly perforated it, as had the Mannerists, and when necessary or convenient he would use more than one piece of marble. The effect on the viewer was always uppermost in his mind.

The *Apollo and Daphne* is a mythological work of considerable sensual attraction; although commissioned by a cardinal, it is steeped in the Renaissance love of antiquity, and the figure of Apollo is a blatant adaption of the *Apollo Belvedere*, the most beloved of antique marbles. But Bernini was seemingly destined to put his thaumaturgic gifts at the service of the reformed Church, and the opportunity came with the election of Maffeo Barberini as Pope Urban VIII (reigned 1623–1644), who had already become Bernini's great friend. Ultimately, Bernini achieved a religious apotheosis of his dramatic style in such works as *The Ecstasy of St. Teresa* (Plate 73), in which we see the decisive mystical moment in the life of the reforming saint frozen into marble and transported above an altar. Here Bernini operates almost more as a magician than as a traditional sculptor since the group is illuminated by means of a hidden shaft that brings the actual light of day down onto the marble—a heavenly illumination that is dramatized by the gilt rays behind it. Such a work is not precisely sculpture in the traditional sense; it is not clearly either free-standing or relief but is revealed to us behind a stagelike proscenium that makes it more like a picture than a traditional statue. Bernini's *Teresa* has some bonds with the popular tableaux of the late Middle Ages (see Plate 28–29); but there is more to the group than this, for it forms the centerpiece of a funerary chapel in which portrait busts of the Cornaro family seem to look on from left and right (Fig. 32). Above, the ceiling of the chapel has been stuccoed and painted to give the impression of clouds floating in, and among the clouds, illuminated by golden light, are a host of angels. We are to believe that one of these has descended to give the saint that painful joy of which she wrote so clearly in her *Autobiography*. And so in the Cornaro Chapel Bernini broke down the ancient barriers between painting, sculpture, and architecture, combining and uniting them in the service of a religious and dramatic goal that was essentially novel. Bernini's desire to create an environment for dramatic confrontation with a religious event led him to design entire churches, organized around a central theme related to the principles of the Cornaro Chapel but with a total control of the spectator and the space he enters: the most successful of these is Sant'Andrea al Quirinale in Rome.

Bernini's earliest commission for St. Peter's was for a canopy over the tomb of the martyred Peter, the "first pope." He designed a monumental decoration in gilt bronze; its four columns echoing the smaller twisted marble columns that had been used as a choir screen in the early church (Fig. 33). Above these he created a bronze version of the cloth canopy of a baldachin, and above that a novel decoration made up of four volutes rising to an orb and cross. Neither sculpture nor architecture, this brilliant structure was Bernini's first fusion of

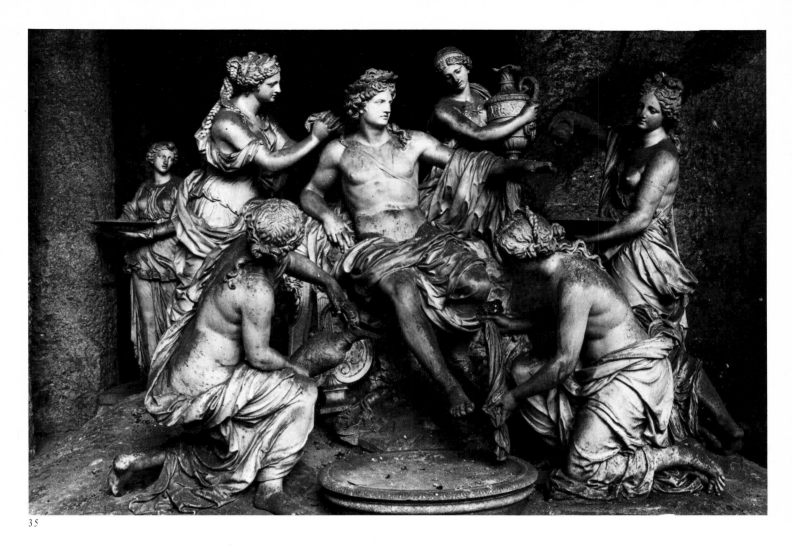

35

different and previously unrelated genres. Although scholars find precedents of
one sort or another for this and other of Bernini's creations, it was only he who
finally achieved these marvels of dramatic synthesis. One function of Bernini's
Baldacchino was to frame the altar over the tomb and still allow a view into the
apse, where three decades later he would create another decoration, a frame for
the symbolic throne of St. Peter. Here, in a different way, he utilized sculpture
in an architectural setting; and faced with an unwanted window in the middle
of the apse, he transformed it into a stained-glass image of the Holy Spirit,
whose light radiates down onto God's angels, bathes the throne with its saintly
adjuncts, and illuminates the entire church.

A novel aspect of Bernini's sculptural revolution was his use of color. We
have seen in the Cornaro Chapel that he combined white marble, gilt rays, and
real light. All of this was set into a rich architecture of variegated marble, and
as a result the smaller group in white shines out of the polychrome setting like
a vision. In his tomb of Pope Urban VIII (Fig. 34), Bernini cast the figure of
the pope and his sacrcophagus in bronze, but the accompanying Virtues are of
creamy marble. Although the bronze elements are united by marble archi-
tecture, the tomb comes to life by means of a typically Berninesque idea: a
skeletal figure of Death perches on the sarcophagus, writing the inscription that
will be placed on the tomb. Beneath is inscribed the name of a preceding pope
—this is very much Urban's personal tomb, and we see him, the embodiment of
the *Ecclesia Triumphans*, seated above. It is, however, the tomb of a pope, and
although Death comes to popes as it must to all men, the papacy is eternal and
lives on—that is the dual message of the papal statue and the skeleton with the
inscriptions.

Bernini was himself devoutly religious; he was the companion of Jesuits and
had a nephew who was an Oratorian. His unique achievements embody much of

FIG. 37. Matthäus Daniel Pöppelmann
(architect) and Balthasar Permoser
(sculptor), Wall Pavilion. 1709–32.
Dresden, Zwinger

FIG. 38. Asam Brothers. Abbey Church,
Weltenburg. 1716–18. Altar, ca. 1771;
sculptural group gilded, silvered, and
polychromed by the Asams' sister, Maria
Salome Bornschlögel, 1723–24

FIG. 39. Clodion, *Nymph and Satyr*.
Terracotta; ca. 1775. New York, Metro-
politan Museum of Art. Bequest of
Benjamin Altman, 1913

FIG. 40. Étienne-Maurice Falconet,
Equestrian Monument of Peter the Great.
Bronze; 1766–82. Leningrad

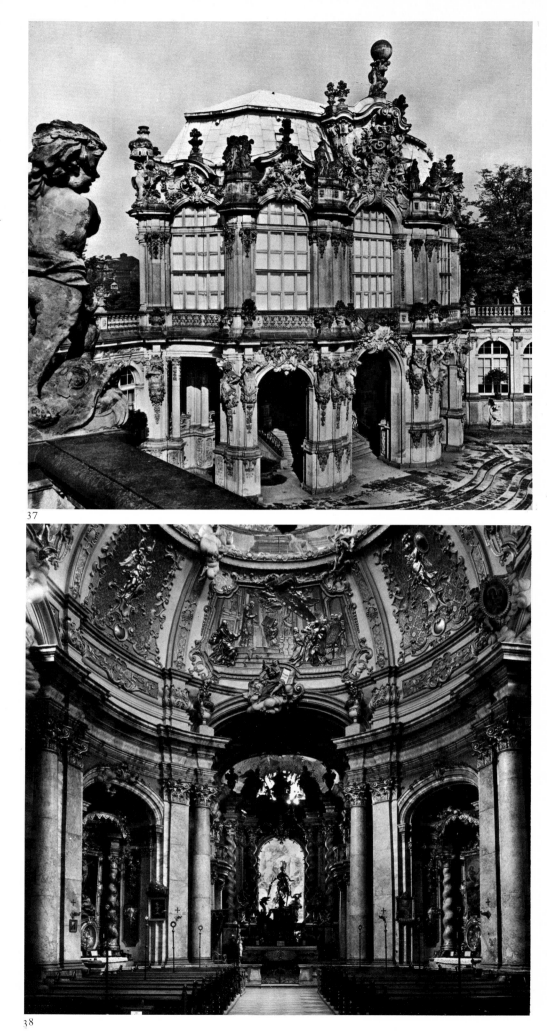

37

38

was made possible by a developed style, cheap material, and a host of trained workmen ready to decorate chapels and churches, palaces and halls.

Even in France, the new home of classicism, we find what could be called a Baroque tomb in the middle of the eighteenth century (Plate 98). Nevertheless, what we see here is the relatively controlled French style, in contrast to the exuberant charm of Bavaria (see Plate 87). The allegory is somewhat creaky, with supporting figures and animals that only partially convey their intention. But the Maréchal de Saxe himself strides purposefully down the stairs of death—as one writer put it, like Don Giovanni braving the invitation to visit Hell.

We have mentioned the Rococo, that gracious style that swept over much of Europe in the eighteenth century. It was in France, after the heavy pomposities of the *style Louis XIV*, that this decorative manner gradually evolved. There was perhaps never such a thing as Rococo architecture, but in interiors the style reigned supreme. It touched the heavy Baroque with a feather and made it smile and curtsey, transforming the serious art of Bernini into the erotic charm of a Clodion or Falconet (see Fig. 39; Plate 97).

39

40

The eighteenth century seems in retrospect even less unified than the preceding ones—the Italianate Baroque survived in southern Catholic countries and spread fruitfully through much of central Europe. The eighteenth century was also the first serious age of archaeology: expeditions set out to explore and measure and publish such diverse monuments as the Parthenon at Athens, the Palace of Diocletian at Split, and the ruins of Palmyra. Johann Joachim Winckelmann (1717–1768) preached the supreme authority of Greece and of Greek sculpture, and a historicism entered into art and the history of art that, in a sense, has never left. Although Winckelmann hardly knew a Greek original, his description of the "noble simplicity and calm grandeur" of Greek art was the foundation stone of a Neoclassicism that was basic to the later eighteenth century. His *History of Ancient Art* (1764) was soon translated into English and French; his theories influenced the popular painter Anton Raffael Mengs (1728–1779), who carried a classicizing version of the Baroque from Rome to Spain. But the full impact of their influence was first seen in the next generation, which is typified by the painter Jacques-Louis David (1748–1825). David arrived at the French School in Rome in 1775, soon changed his style from Rococo to Neoclassic, and painted *The Oath of the Horatii*, perhaps the most important early monument of Neoclassicism, in Paris in 1785.

Sculpture can provide no parallels to the art of David, which moved smoothly from invocation of Republican courage and virtue, through a battling for Revolution, to the celebration of Napoleon as emperor-god. In part, the creation of sculpture was simply too slow a process to keep up with events—yesterday's hero was often today's villain, and even David had to hide his *Death of Marat* shortly after painting it.

Like French painting, the sculpture that was produced in France in the later eighteenth century wavers between conflicting loyalties—Rococo elegance and classical serenity, Baroque drama and realistic candor. The world of Marie-Antoinette and the play farm at Versailles seem to be conjured up by Julien's *Girl with a Goat* (Plate 96); and even Falconet, friend of the Encyclopedist Denis Diderot, never really escaped the Rococo (see Plate 97) except to create the last great Baroque monument to an absolute monarch, the rearing equestrian statue of Peter the Great in St. Petersburg (Fig. 40). Much eighteenth-century portraiture indulges in the conceit of presenting the person as someone else—a fancy most easily digested by us today if the personage was in fact an actor (see Plate 95). This taste for dressing up, this penchant for the unusual, is also found in portraits of genuine exotics, like the bust of a black named Paul (Plate 94), done in the sympathetic medium of red terracotta, in which many sculptural sketches were modeled. The relative ease of working gave terracotta

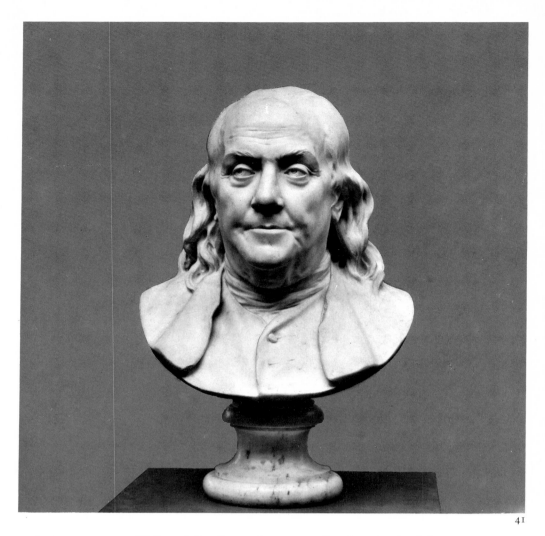

41

sculpture a sense of life and liveliness that was often lost in the laborious transference to marble.

The exception to this generalization is furnished by the disarmingly realistic portraits of Jean-Antoine Houdon (1741–1828), the only sculptor worthy of comparison to David; unlike David, however, Houdon was essentially a portraitist and much less a quick convert to the Napoleonic revolution, during which he narrowly escaped imprisonment. Plates 92 and 93 very neatly show the change in one generation from French Late Baroque to Neoclassicism, of which Houdon is not so programmatic an exponent as David. Both styles originated in Rome—despite Winckelmann, Greek sculpture was still relatively unknown and the new severe style was based on Roman art or Roman copies. Houdon's realism far exceeds that of his ancient models, however, for he gave a magical sense of the sparkle and warmth of personality that we never find in antiquities (see Fig. 41) and that transcends the label Neoclassicism. Portraiture, for many eighteenth-century artists, was the only road to follow for success; in an Age of Reason, a "likeness" was the only acceptable kind of art. Hence the large number of French and English portraits in pastel, oil, terracotta, marble, and bronze.

In an official commission like the *George Washington* (Plate 100), Houdon is properly Neoclassic, giving Washington the *fasces* of Republican Rome while dressing him in contemporary clothing. Houdon was even capable of naked portraiture (his seated statue of Voltaire), but it remained for the arch-Neoclassicist Antonio Canova to show Napoleon in the full splendor of antique nudity (Plate 101).

Canova (1757–1822) was a Venetian and arguably the last Italian artist of truly international stature. His fame surpassed even that of Bertel Thorwaldsen (died 1844), a Romanized Dane, or the Englishman John Flaxman (1755–1826),

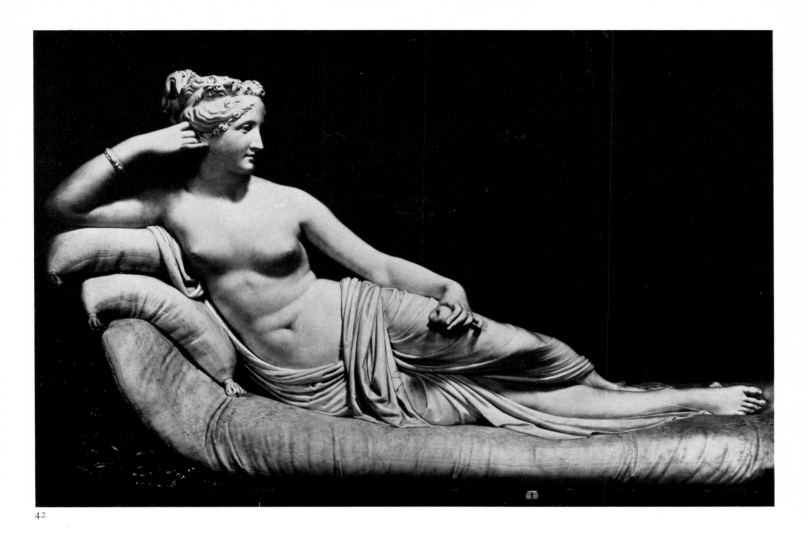

42

who worked for Josiah Wedgwood and produced line engravings to illustrate the *Iliad* (a new cult of Homer was another manifestation of the Neoclassic age). Canova became particulary famous for his tombs, including two of popes, but his greatest was created in Vienna, where he fled from Napoleon's invasion of Italy (see Plate 99). No overt Christian symbolism mars this sepulcher, whose pyramidal form echoes the oldest monuments to the dead. Although the flying figure bearing the portrait of Maria Christina may invoke memories of the Baroque, the timeless classical allusions to the stages of life and our progression to the eternity of death have never been expressed more simply or profoundly.

Eventually Canova became reconciled with Napoleon and produced not only the colossal nude figure of Plate 101 but also other statues of the emperor, including an equestrian portrait; he also did portraits of members of Napoleon's family, of which the most famous is the cooly erotic portrait of his sister, Pauline Borghese, as Venus (Fig. 42).

The Greek and Roman revivals, perhaps most familiar to us from nineteenth-century architecture and statuary and such official cities as Washington, D.C., are only a part of later eighteenth-century revivalism. Another, still with us in churches and universities, is the renewal of interest in the Gothic, and as such sheds new light on Neoclassicism. All of these revivals are evidence of both a yearning for the past, for a lost perfection, and a desire for the adventure of exploration and discovery, for the exotic. This description of course fits the Romantic movement, which was once thought to be the exact opposite of Neoclassicism, and its successor in the nineteenth century. We now see these movements as two aspects of the same tendencies and desires, as two sides of the same coin. Both the Neoclassic and the Romantic are products of the eighteenth century, that confusing period of a Catholic Baroque that jostles the Age of Reason, of a Rococo that breeds revolution.

Nineteenth-century art immediately conjures up the names of a succession of stylistic movements—Romanticism, Realism, Impressionism, Post-Impressionism. And when we think of their great exponents—Delacroix and Turner, Courbet, Monet, Cézanne—we are plunged into the world of painting. There are periods when one medium seems to lead, and the other follow, and sculpture certainly was not in the ascendancy in the nineteenth century. The retrospective art that Winckelmann seemed to prescribe was a particular danger to sculptors, for if Greek sculpture was, as he claimed, man's finest possible achievement, what could still be done? An imitation was at best only an imitation, but a failure to imitate was even worse. The dilemma seemed insoluble, and sculpture slowly succumbed. Indeed, the sculptor was faced with a problem inherent in the three-dimensional medium: what could he provide other than an imitation of life, a petrified man? Our parks and squares are full of the prosaic answers to this question. Displays of outright theatrical chauvinism, such as in François Rude's *Marseillaise* (Plate 102), echo disturbingly through more recent absolutist visions of heroism in Fascist Italy, Nazi Germany, and Soviet Russia. This sort of official art was pleasantly modified by Rude's pupil, J.-B. Carpeaux (1827–1875), who was a kind of sculptural parallel to Delacroix although his most famous work seems to hark back to the lost gaiety of the Rococo (see Plate 103). Just how lost it was became evident when the artist was attacked on the grounds that his sculpture was immoral—the Victorian public correctly perceived in Carpeaux's art a pagan spirit that would have been more at home a century earlier.

The most successful aspect of nineteenth-century sculpture is perhaps found in the small bronze. Its finest exponent was Antoine-Louis Barye, the greatest *animalier* of his time (see Fig. 43), who, in his exotic and often violent subject matter, is most closely akin to Gericault and Delacroix. The small bronze is a difficult field for the connoisseur and one that is only now being seriously explored. The welter of nineteenth-century casts and models may soon be revalued to produce a picture of greater sculptural significance than the one we now have. In any event, it seems clear that sculpture was in the doldrums in the nineteenth century, and relief from official or academic works came largely from amateurs or part-time, unofficial practitioners, as in the portrait-caricatures of Daumier or in the deglamorized dancing figures by Degas (see Plates 104, 108). Only toward the end of the century does an authentic sculptural genius arise, Auguste Rodin, and only with him do we enter a period that seems recognizably modern.

73 Gian Lorenzo Bernini, *The Ecstasy of St. Teresa*. Marble, gilded wood rays; ca. 1648–52. Rome, Santa Maria della Vittoria, Cornaro Chapel

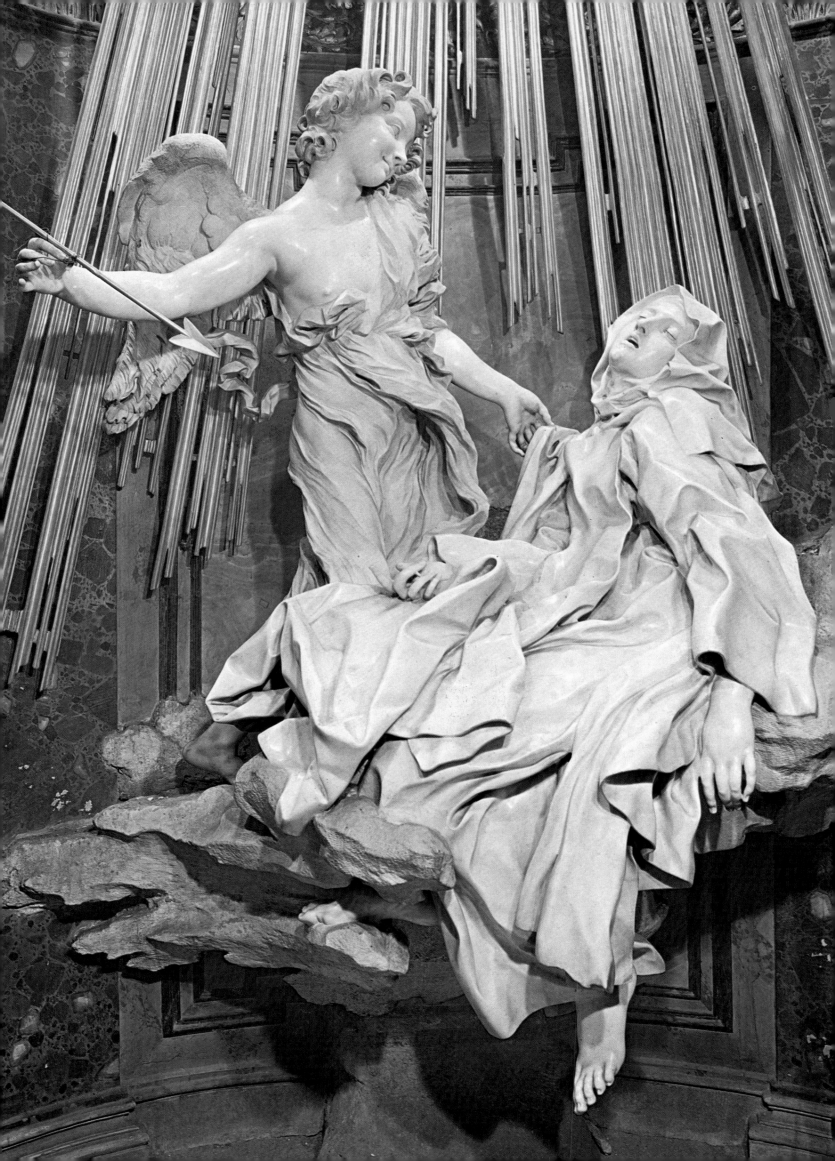

74 Francesco Mochi, *Virgin of the Annunciation*. Marble; 1605–8. Orvieto, Museo dell'Opera del Duomo (reserve)

75 (opposite) Alessandro Algardi, *Beheading of St. Paul*. Marble; 1641–47. Bologna, San Paolo, high altar

76 Gian Lorenzo Bernini, *Apollo and Daphne*. Marble; 1622–25. Rome, Galleria Borghese

77 (opposite) Giuseppe Sammartino, *Christ Under a Shroud*. Marble; 1753. Naples, Cappella Sansevero de'Sangri

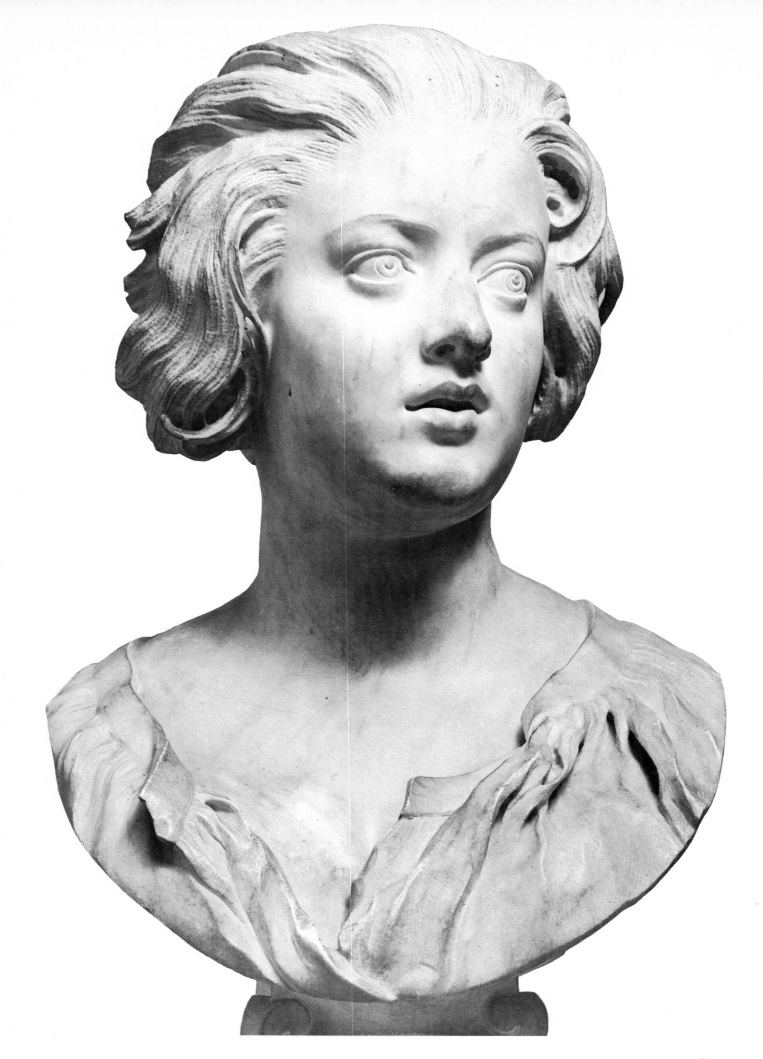

78 Gian Lorenzo Bernini, *Bust of Costanza Bonarelli*. Marble; ca. 1635. Florence, Museo Nazionale del Bargello

79 (opposite) Francesco Duquesnoy, *Bust of John Barclay*. Marble; 1627–28. Rome, Sant'Onofrio, Museo Tassiano

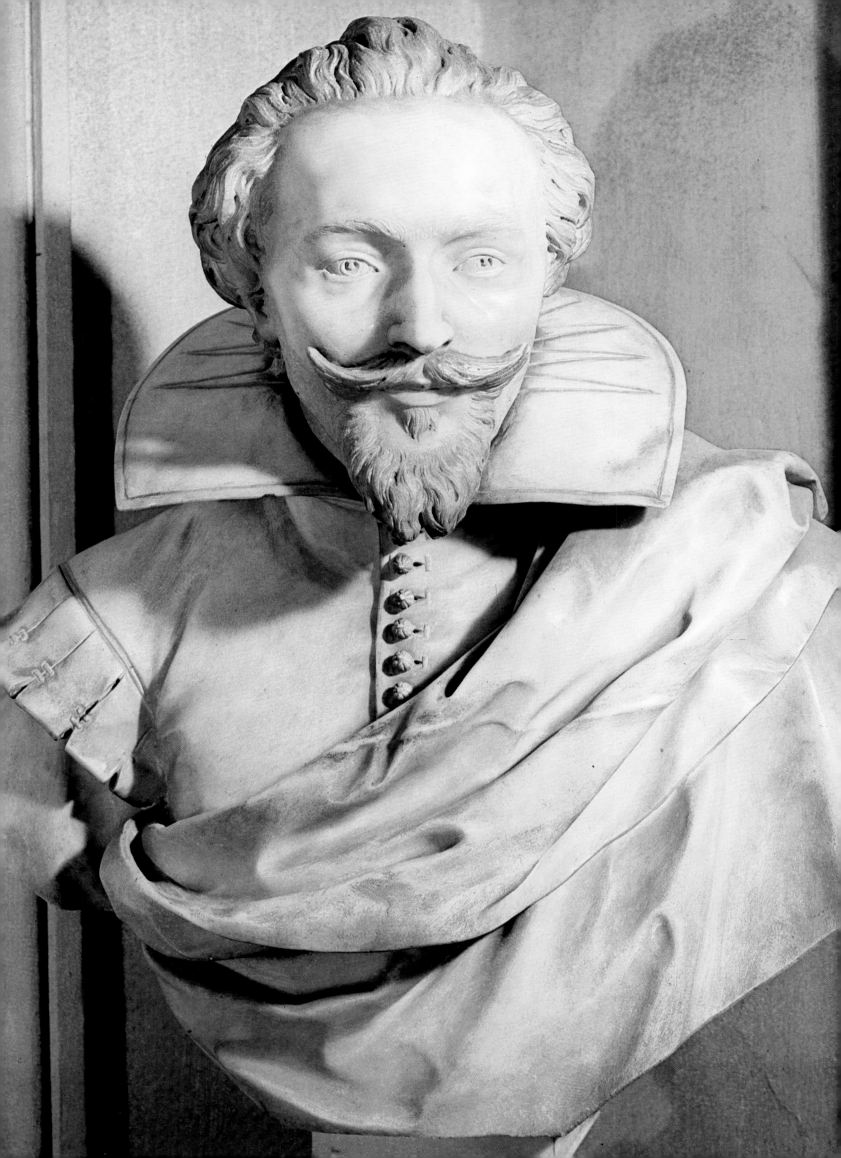

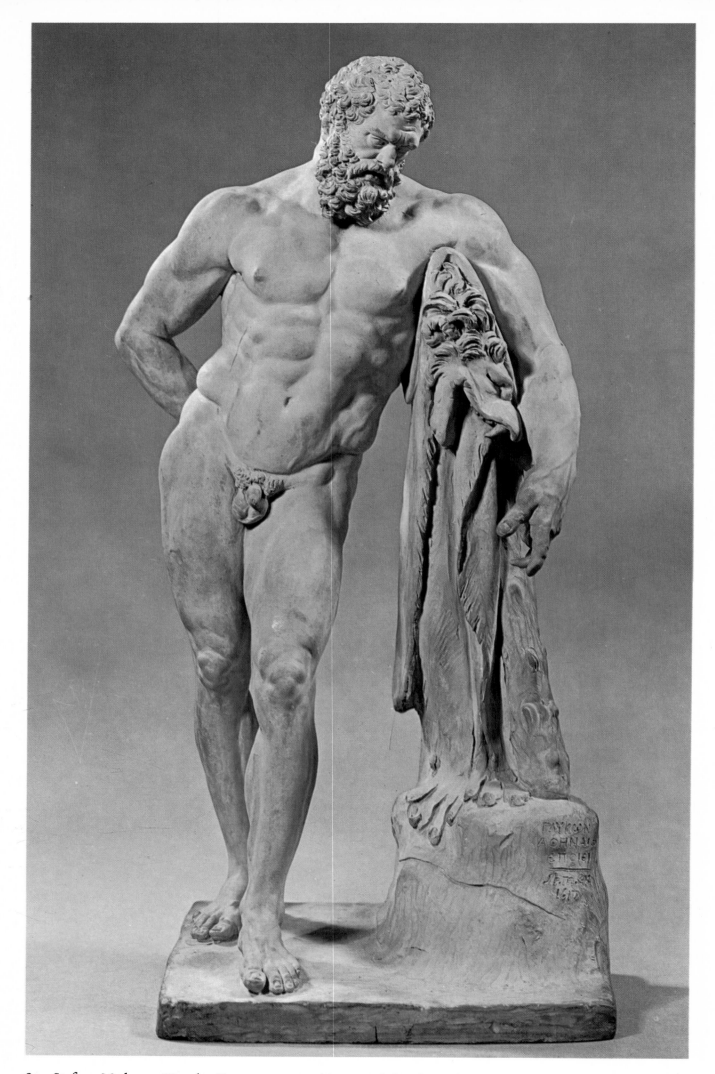

80 Stefano Maderno, *Hercules*. Terracotta; 1617 (signed and dated). Oxford, Ashmolean Museum

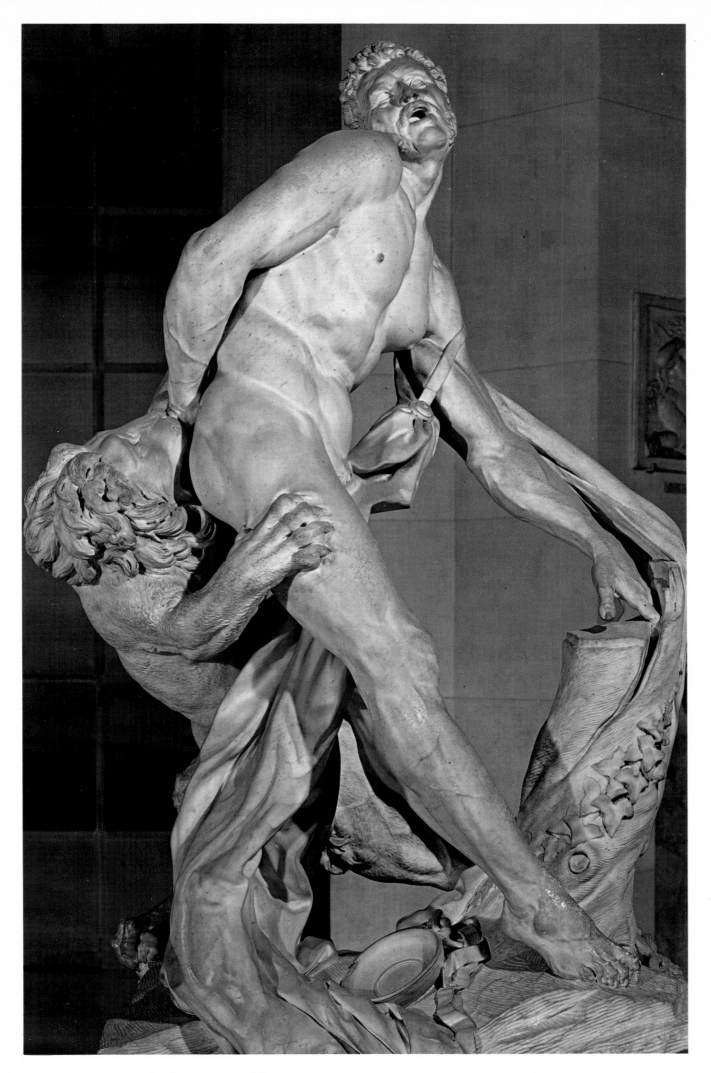

81 Pierre Puget, *Milo of Crotona*. Marble; 1671–83. Paris, Louvre

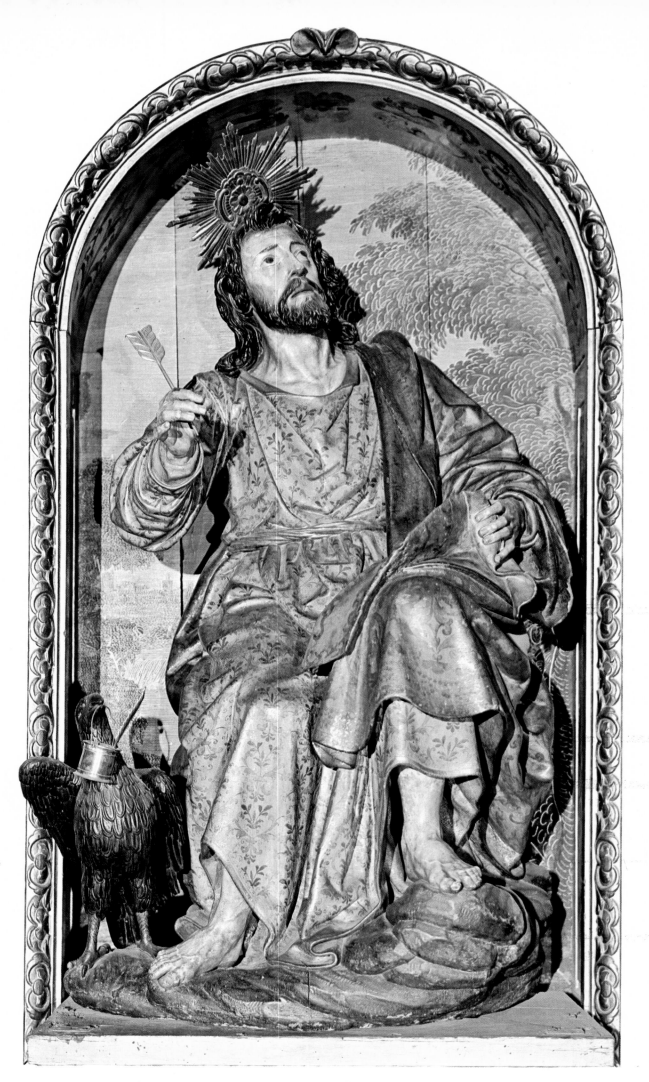

82 Juan Martínez Montañés, *St. John the Evangelist*. Polychromed wood; begun 1637. Seville, Convent of Santa Paula

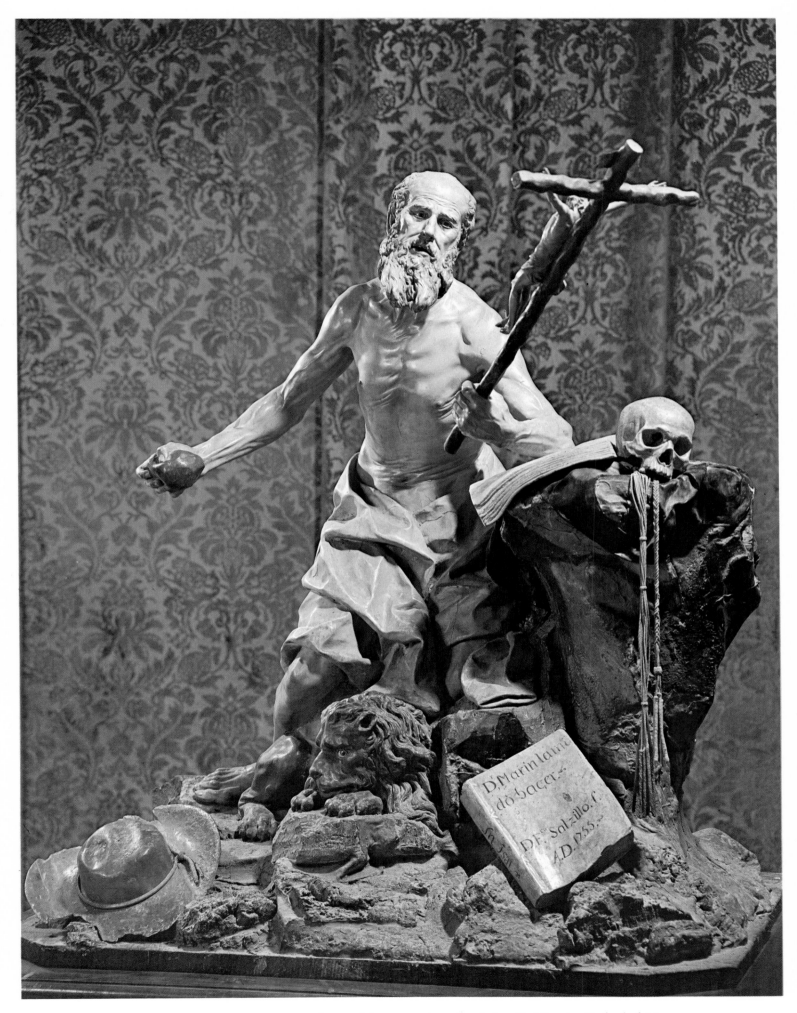

83 Francisco Salzillo, *St. Jerome in Penance*. Varied materials; 1755 (signed and dated). Murcia, Cathedral Museum

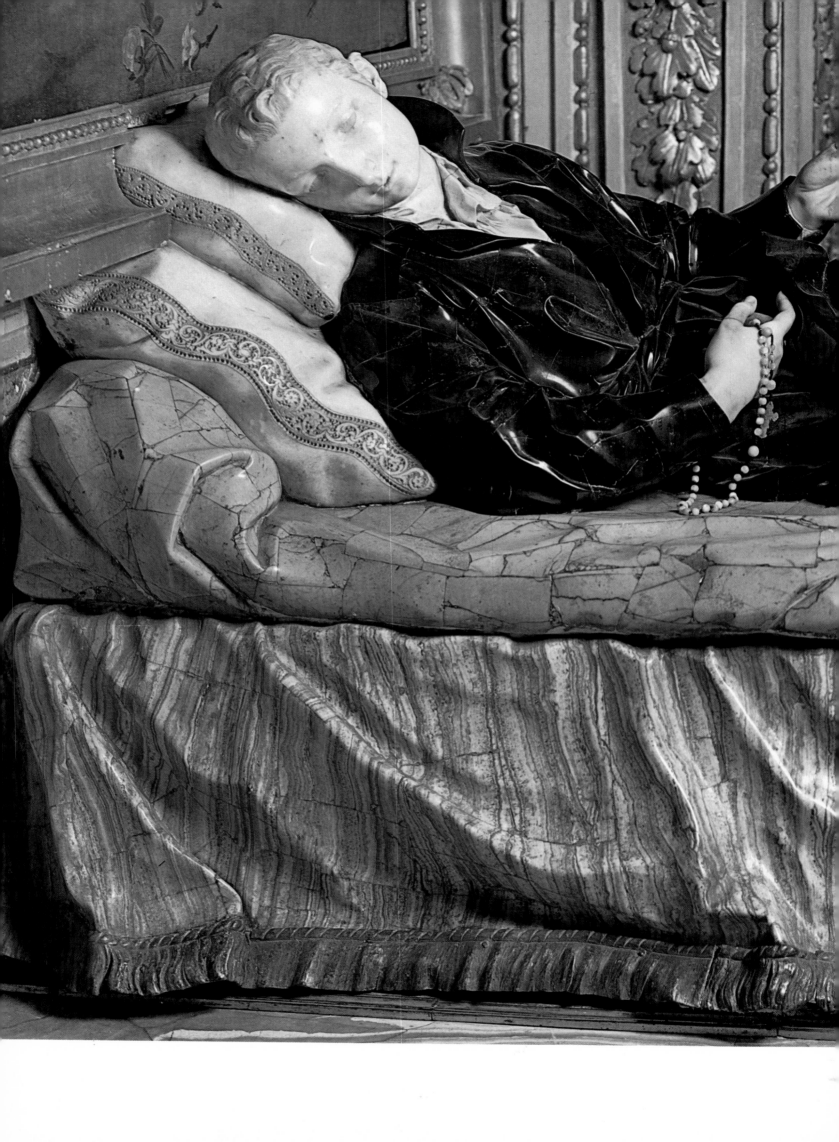

84–85 Pierre Le Gros, *Blessed* [now *Saint*] *Stanislas Kotska*. Marble; begun 1703. Rome, Sant'Andrea al Quirinale, dormitory

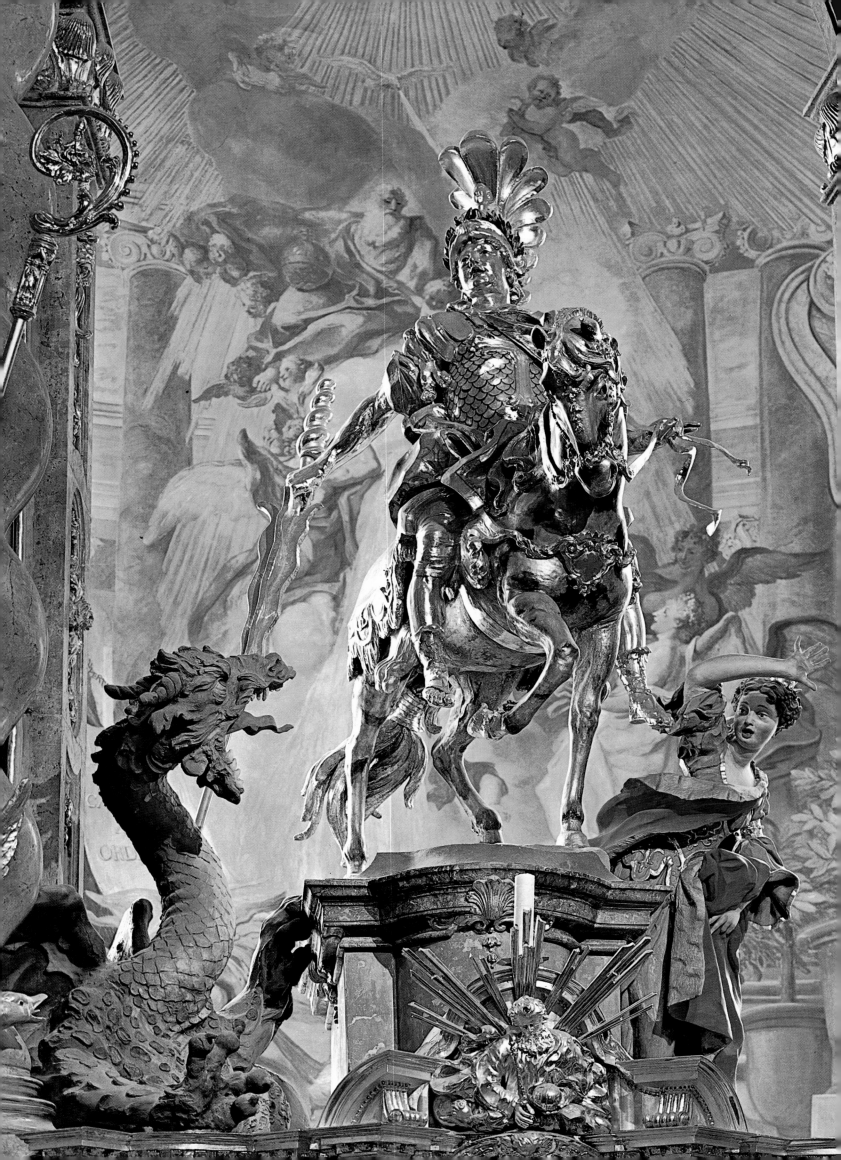

86 (opposite)
Egid Quirin Asam,
St. George. Polychromed
and gilded stucco; 1721.
Weltenburg,
Benedictine Church

87 Ignaz Günther.
Annunciation. Polychromed
wood; 1764. Weyarn
(Miesbach, Bavaria),
Stiftskirche

88 Joseph Anton
Feuchtmayer,
St. Anne. Stucco; 1746–50.
Birnau, Pilgrimage
Church, high altar

89 (opposite)
Johann Joseph Christian,
Isaiah. Stucco;
1752–56. Zwiefalten,
Abbey Church, high altar

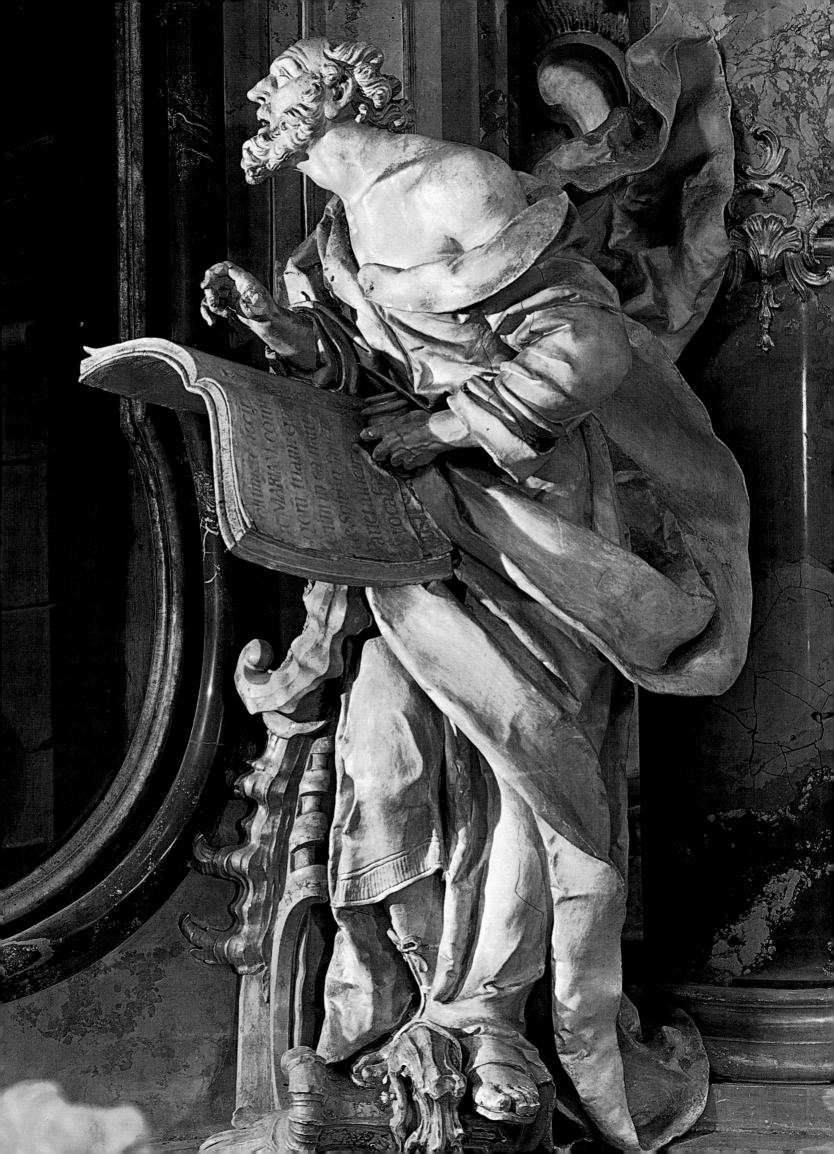

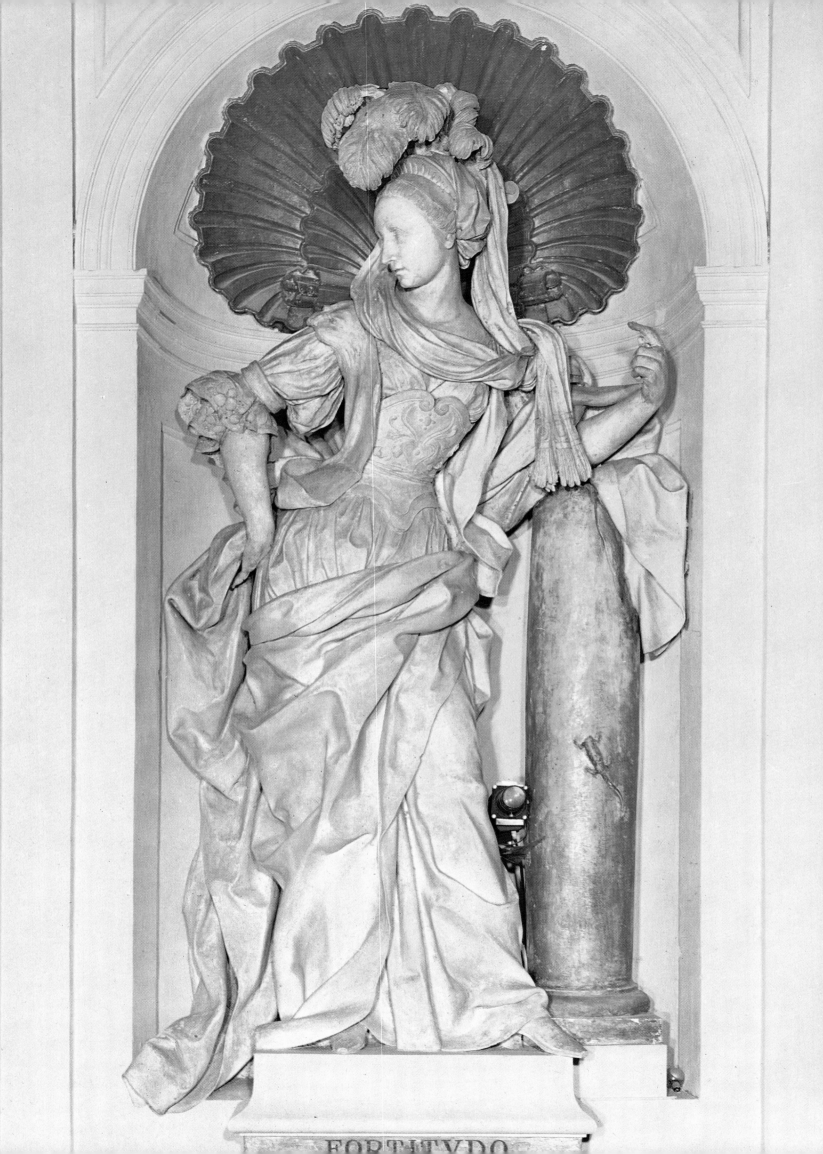

FORTITVDO

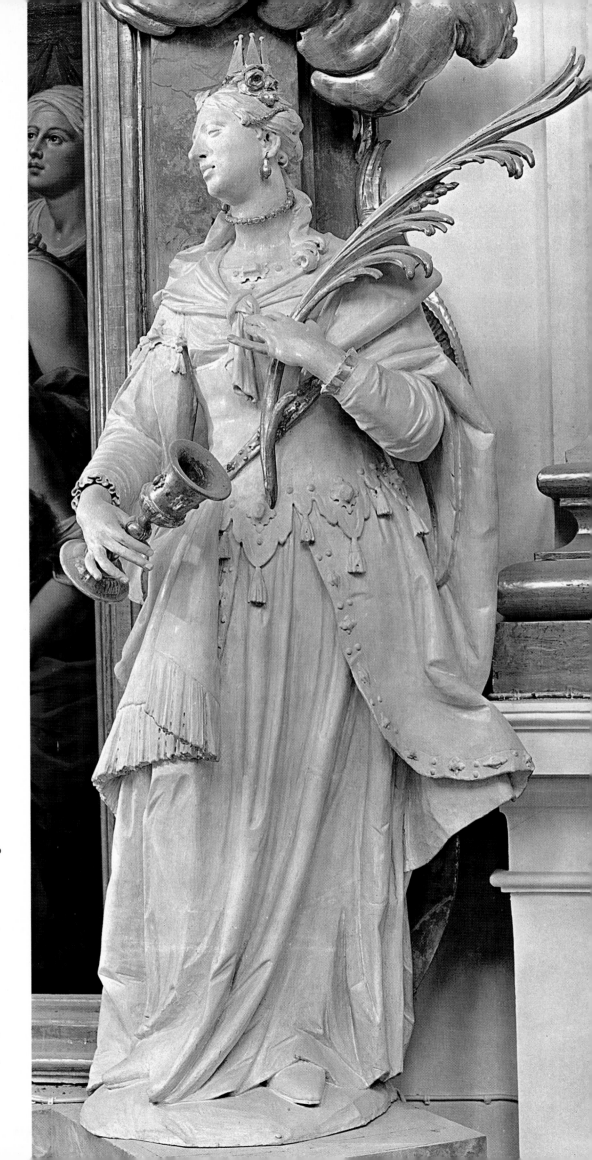

90 (opposite) Giacomo Serpotta,
Fortitude. Stucco, gilded column
and shell; 1714–17. Palermo,
San Domenico, Oratorio del Rosario

91 Johann Baptist Straub,
St. Barbara. Stucco painted white
and gold; 1752–56. Ettal,
Klosterkirche, Altar of St. Catherine

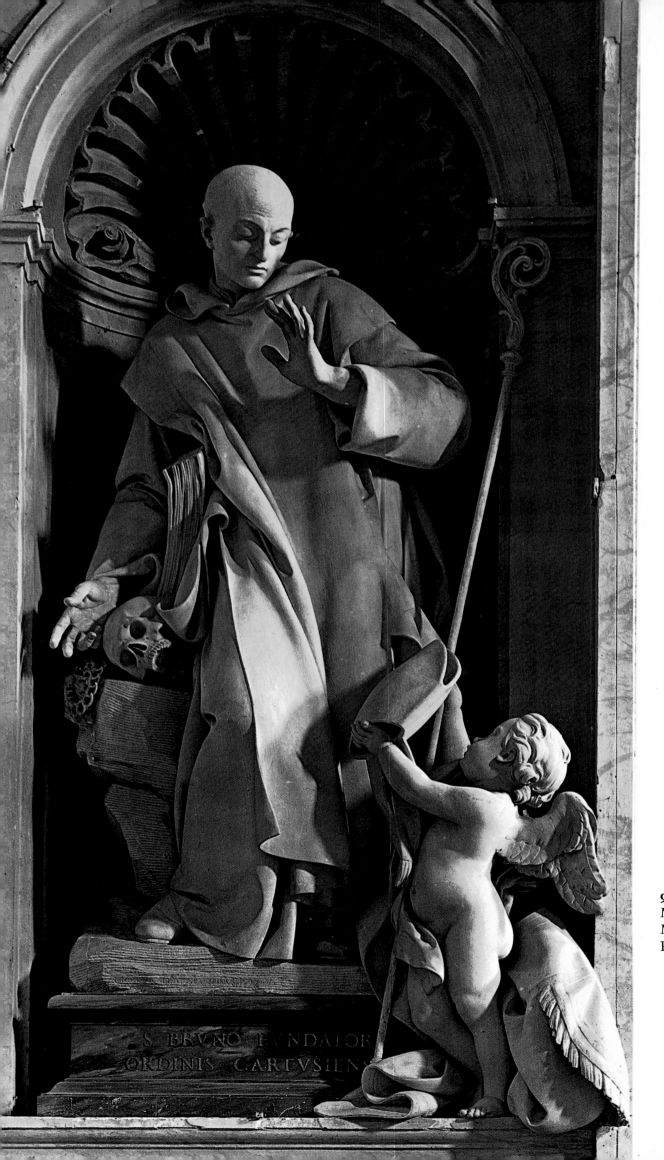

92 Michel-Ange (René-Michel) Slodtz, *St. Bruno.* Marble; finished 1744. Rome, St. Peter's, nave

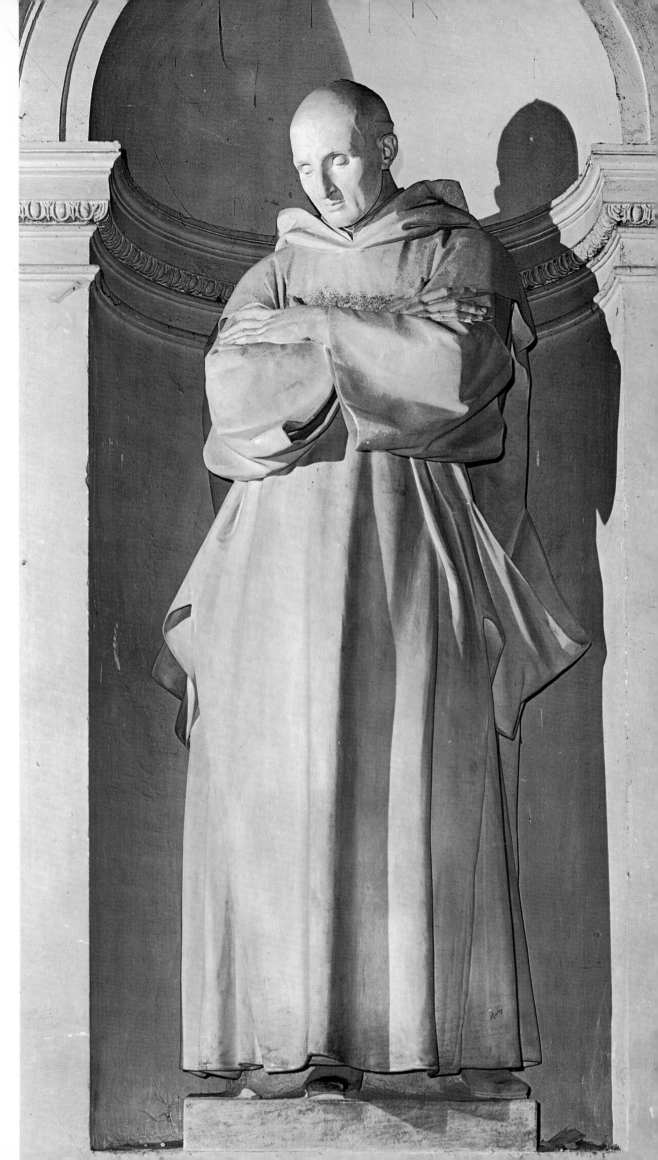

93 Jean-Antoine Houdon,
St. Bruno. Stucco; 1766.
Rome, Santa Maria degli
Angeli

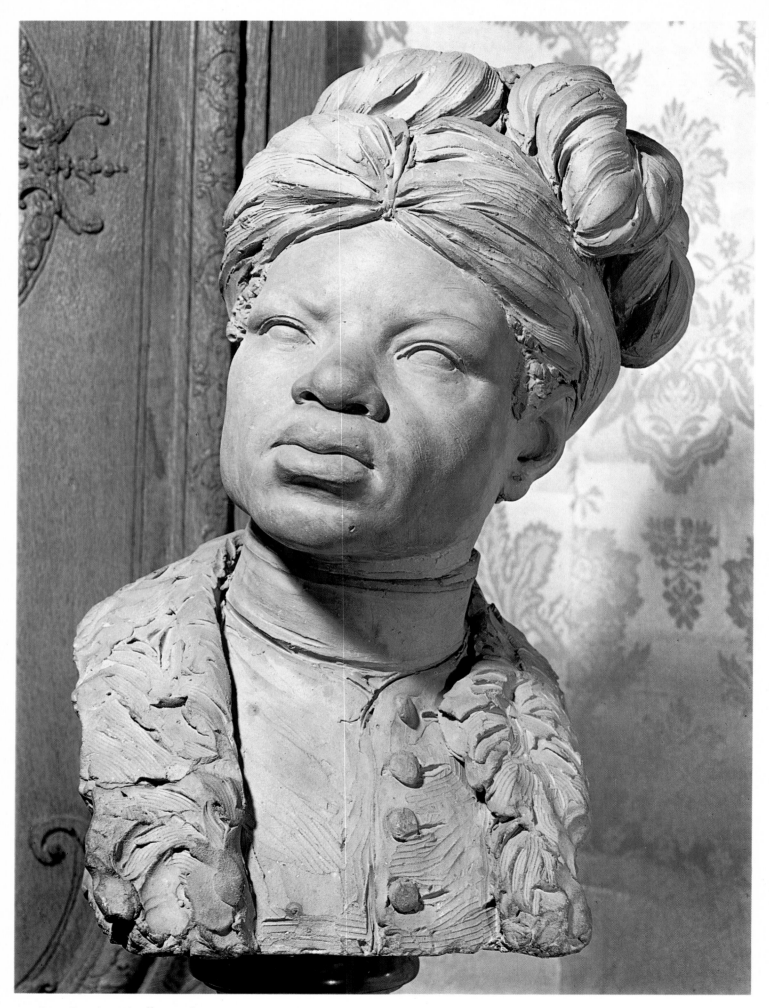

94 Jean-Baptiste Pigalle, *Paul*. Terracotta; ca. 1760–61. Orleans, Musée des Beaux-Arts

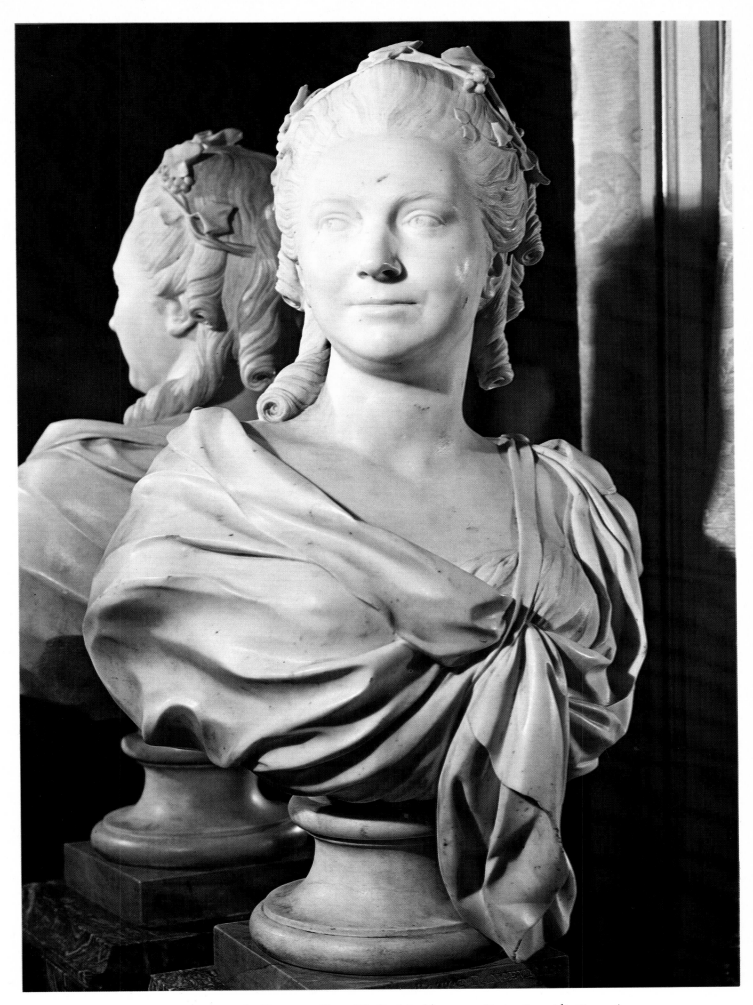

95 Jean-Baptiste II Lemoyne, *Bust of Mlle Dargeville as Thalia*. Marble; 1771. Paris, Comédie Française

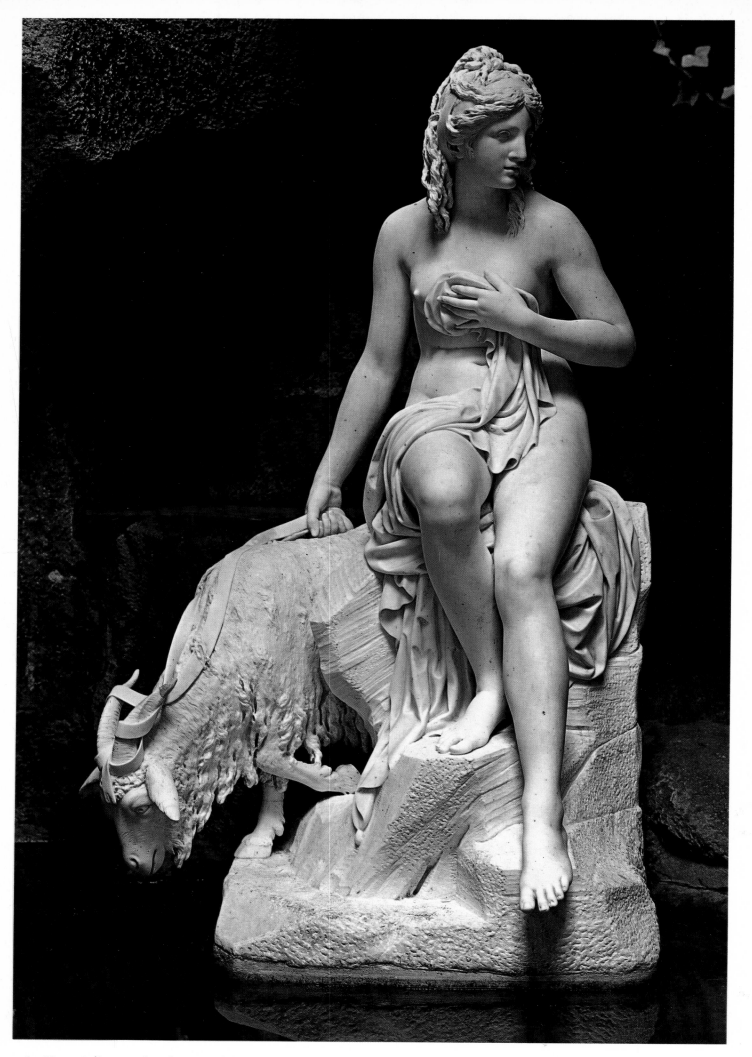

96 Pierre Julien, *Girl with a Goat* (Amalthea). Marble; 1786–87. Paris, Louvre (formerly Rambouillet, Castle Dairy)

97 (opposite) Étienne-Maurice Falconet, *Bather*. Marble; ca. 1757. Paris, Louvre

98 Jean-Baptiste Pigalle, *Tomb of Marshal Maurice de Saxe.* White and colored marble; 1753–76. Strasbourg, St.-Thomas

99 (opposite) Antonio Canova, *Mausoleum of the Archduchess Maria Christina of Austria.* Marble; 1798–1805. Vienna, Augustinerkirche

GEORGE WASHINGTON

100 (opposite) Jean-Antoine Houdon,
George Washington. Marble; 1785–91
(signed and dated 1788). Richmond,
Virginia, Capitol

101 (right) Antonio Canova, *Napoleon*.
Colossal bronze; 1809–11. Milan,
Palazzo di Brera, courtyard

Overleaf and following:

102 François Rude, *La Marseillaise*.
Stone; 1833–36. Paris, Arc de Triomphe

103 Jean-Baptiste Carpeaux, *The Dance*.
Marble; 1868–69. Paris, Louvre
(formerly Opéra)

104 Honoré Daumier, *Caricature of the
Financeer Lefébure*. Bronze; ca. 1832.
Milan, Borletti Collection

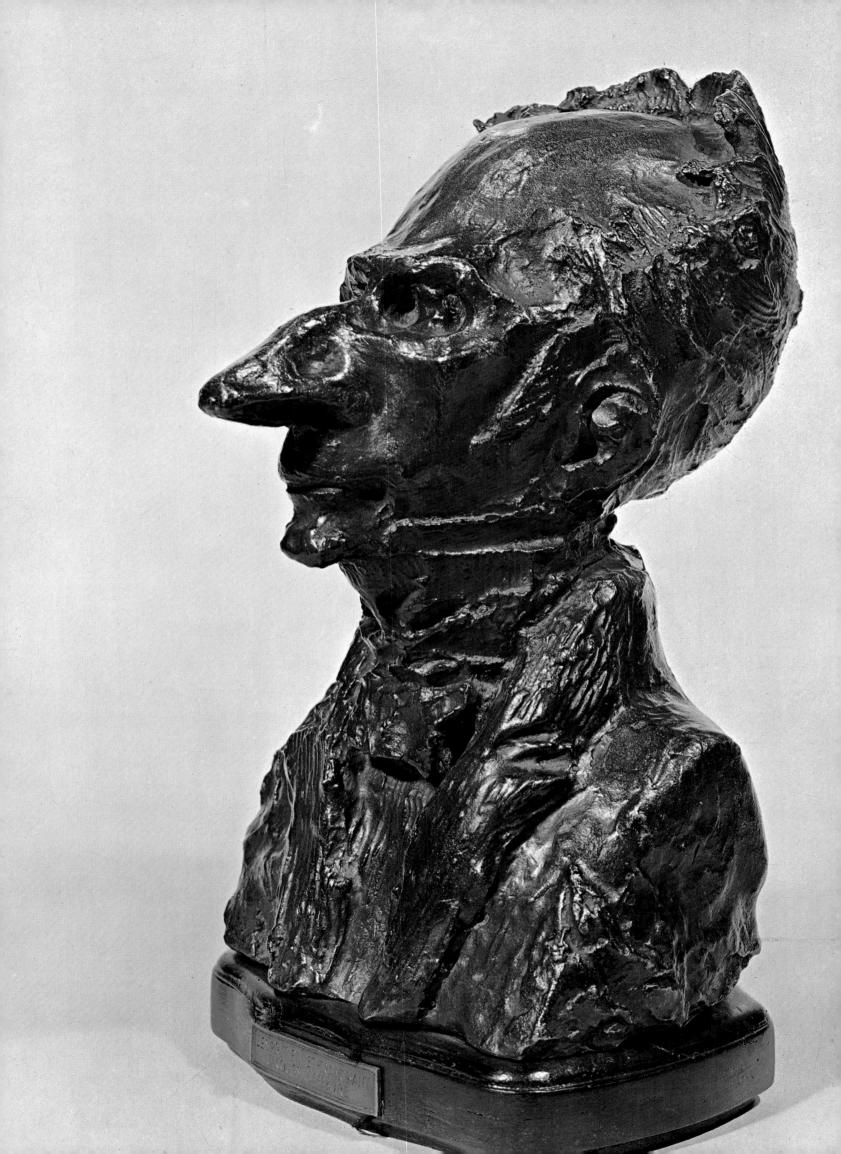

4 From Rodin to the Present

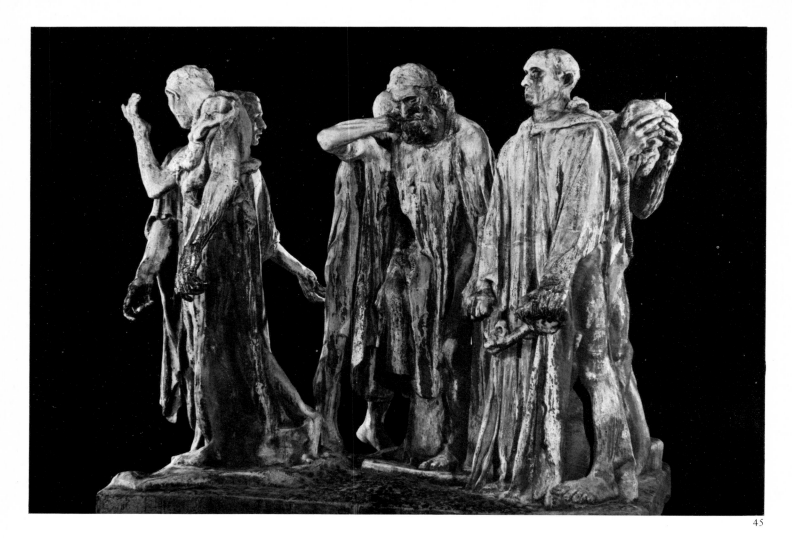

45

FIG. 44. Auguste Rodin, *The Gates of Hell*. Bronze; 1879–1917. Paris, Musée Rodin

FIG. 45. Auguste Rodin, *The Burghers of Calais*. Bronze; 1884–88. Washington, D.C., Hirshhorn Museum and Sculpture Garden

FIG. 46. Auguste Rodin, Project for *Balzac* (standing nude). Bronze; 1892. Pikesville, Maryland, Collection Mr. and Mrs. Alan Wurtzburger

FIG. 47. Edward Steichen, *Silhouette, 4 A.M.* (detail). Pigmented print; 1908. New York, Metropolitan Museum of Art. Gift of Alfred Stieglitz

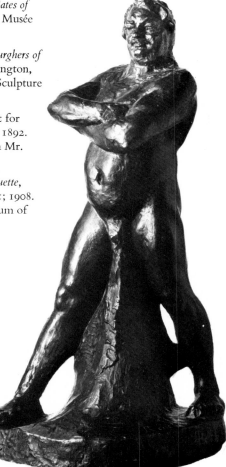

46

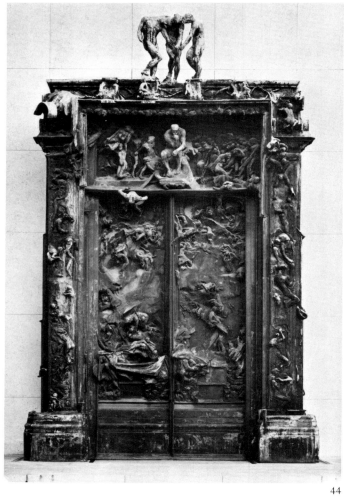

44

August Rodin (1840–1917) is usually considered the first sculptor of the modern movement. Nevertheless, he had a strong sense of tradition, exhibited his works in the official Salons, and was finally elected to the French Academy. His greatest statues were produced on official commission and it is within the context of French academism that his art must be seen.

Despite his precocity, Rodin failed to be admitted to the Ecole des Beaux-Arts, but he never repudiated the Ecole or tried to overthrow it. Indeed, the Ecole offered a traditional professional training in sculpture that seems to have been technically better than what was available to painters. Both it and its counterparts all over Europe produced sculptors of unparalleled competence, trained in the art of the past. Upon graduation, the schools helped guide young practitioners into commissions that could establish their reputations. But patronage itself was rapidly changing; most obviously, the Church was increasingly worried over idolatry and thus ceased to be an important source for commissions. By contrast, funerary art flourished, with the result that cemeteries are often the best museums of nineteenth-century sculpture. Local and state governments, when they were stable, were a more secure source of work, but they demanded a depressingly familiar repertory—patriotic monuments to dead heroes (see Plate 102) or pious records of the outward appearance of outstanding citizens. These monuments, realistic or allegorical or both, furnished the basic subject matter for Rodin as well as for his forgotten contemporaries of the Salons.

There was, however, a new kind of patron, the less wealthy individual of the middle class who wanted to partake of culture even if only in a small way. For him sculptors created small versions in bronze of their compositions, and many sculptors were able to survive without a major commission, turning out copies of works created only for this market. Canova seems to have been the inventor of a new category of sculpture, the "original plaster," which was itself not truly original but a cast of a perishable clay model. Like Canova, sculptors who came after him had a desire to create classic works despite the lack of monumental commissions—hence the growth of independent sculptors' studios producing uncommissioned works (see Fig. 43) that could be reproduced by modern mechanical methods in any size or material. As a result, autograph originals tend to disappear and are replaced by endless copies or casts of varying sizes, confusing to the connoisseur. This situation obtained even with Rodin, whose *Thinker* must exist in thousands of copies in dozens of sizes. Yet it was not at first meant to be an independent work. Like much of Rodin's sculpture, it was part of an unaccepted monument that was never completed.

Rodin's career developed slowly during a self-imposed apprenticeship that lasted almost twenty years. His first exhibited work, *The Age of Bronze*, seemed so realistic that it was criticized as being no more than a cast of an actual model. In fact, Rodin had an uncanny sense of the surface of things, which he brought out in his deft modeling. His variegated surfaces, "unfinished" and broken up into facets that catch the light to create a sense of potential movement, have been called Impressionistic. But the similarities between Rodin's modeling, which tried to give a sense of matter animated from within, and the visual abstractions on canvas of Impressionist painters like Monet (1840–1926), are superficial. Rodin was a born modeler whose preferred medium was clay or wax. His strong sense of the momentary is perhaps best attested to by the 7000 drawings preserved in the Musée Rodin in Paris; we are told that he often kept several nude models walking around his studio in order to get, by accident, a pose he liked.

Rodin's sense of the momentary is nevertheless related to the Impressionists' insistence on the light of a particular time as the true subject of their paintings; thus Monet could paint many Haystacks during the day, all essentially the same composition but each very different because they reveal the effects of light at various times of day. Rodin too had an experimental approach, and some if not

47

most of his sculpture seems to be the by-product of an endless series of changes that have no foreseeable end. Thus one of his greatest commissions, *The Gates of Hell* (Fig. 44), begun in 1879, remained unfinished and unfinishable as it spawned figures and groups that he carried on as independent sculptures.

Since Rodin was essentially a modeler, his most characteristic and appealing works are cast in bronze. He also produced a large number of marble sculptures and after 1900 preferred that medium, although his carvings are almost invariably the work of assistants, some of whom, like Antoine Bourdelle (1861–1929), went on to have distinguished careers (see Plate 107).

Rodin's fame today rests on a few great commissions, such as the monumental *Burghers of Calais* (Fig. 45), begun in 1884. It evolved over the years as the stubborn artist slowly beat down the opposition to his conception and at the same time made his own modifications on a group that never became totally successful from every angle. The committee that commissioned the work had wanted a single figure flanked by allegories. Rodin's figures, which represent the heroic self-sacrifice of six leading citizens during the Hundred Years' War, contrast with the usual grandiloquent monuments of the century (see Plate 102). And yet his subject is a typical one—heroic, literary, patriotic. His works are freshly thought, personal versions of familiar, even Romantic subjects.

Although the *Burghers* was set up in Calais in 1895, it was installed in the town square (where it was originally meant to be) only in 1926. Rodin's greatest single statue, the monument to Balzac (Plate 106), had an even stranger gestation and history. It was commissioned in 1891 by a literary group but was never cast during the sculptor's lifetime. Rodin himself was more than usually puzzled in his preliminary studies and tried many totally different conceptions, sitting and standing; over forty separate projects survive (see Fig. 46). The large plaster of the final work had to be withdrawn from the Salon of 1898 because of the furor it created; it was in Rodin's garden at Meudon that Edward Steichen, one of the pioneers of modern photography, captured it so memorably by moonlight (Fig. 47). These photographs, and indeed the statue itself, belatedly cast and set up in Paris in 1939, reveal the tired, defiant virility that seems at the core of this strange conception of haunted genius. Constantin Brancusi, perhaps the greatest sculptor of the new century, called it the "starting point of modern sculpture."

Rodin's own followers and favorites have faded from view; his was a unique vision, an unlettered combination of traditional values and forms with a sensibility, an instinct, and a touch that were singular a hundred years ago and that still seem modern. Rodin characteristically revered, imitated, and misunderstood Michelangelo, who was essentially a marble carver. When Michelangelo left a work unfinished it was because he did not, or could not, complete the carving. With Rodin the "unfinished" became an esthetic means of expression, another effect or tool in his bag of tricks. But this perhaps deliberate misinterpretation had enormous influence.

Perhaps the only contemporary of Rodin's worthy to be mentioned in the same breath is Medardo Rosso (1858–1928), whose "Impressionist" works are chiefly in wax (see Fig. 48). Rosso supposedly influenced Rodin, but his main interest for us is his painter's sensibility transferred to modeling: his sculptures have basically one viewpoint and are strongly pictorial and coloristic.

Two great nineteenth-century painters also made important individual contributions to the birth of modern sculpture: Edgar Degas (1834–1917) and Paul Gauguin (1848–1903). Degas's sculpture was chiefly a private hobby that flowered later in his career, but the exhibition in 1881 of the wax model of the statue in Plate 108 caused a sensation because of its uncanny naturalism, its use of realistic color and clothes, and its obviously true portrayal of a young girl in a difficult ballet pose. This new, iconoclastic style was a false dawn of the modern movement and has no immediate successors. But Degas's attempt to

capture the transitory effects of real life parallels Rodin's attempts to destroy
the cult of the masterpiece by producing independent fragments—tendencies
that led away from the monumental, official, and academic.

Gauguin started working with Degas, and may have influenced him; by the
time he had produced carvings such as *Be Loving You Will Be Happy* (Plate
105), which was first exhibited in Brussels in 1891, he had moved into a
pseudo-primitive relief style that is paralleled in his later paintings. His primitiv-
ism, his use of color, and his arcane symbolism are all important, but their
influence was not felt until much later.

Despite Rodin's innovations, Degas's startling realism, and Gauguin's primitiv-
ism, an academic or traditional version of ideal art lived on and was revised by
different sculptors of the new century. Most of these were negligible followers
of a lost dream, but the yearning for a beautiful, serene, and monumental past,
expressed by Wickelmann and periodically visible in the art of such otherwise
diverse sculptors as Canova, Hiram Powers, and Renoir, achieved a kind of
modern calm in the sculpture of Aristide Maillol (1861–1944). Over a long
career Maillol produced essentially one statue in many versions (Plate 109), a
static, monumental female nude that seems to be a modern interpretation of an
ancient Greek ideal (he visited Greece in 1908). Although eminently compact
and sculptural, Maillol's works were usually cast from models that he worked
up in soft materials. He had begun as a student painter in Paris in the 1880s and
was briefly influenced by Paul Gaugin; but Maillol's serene and unclouded art
went a different way, one that Rodin once applauded as "absolutely beautiful,
absolutely pure. . . ." Nevertheless, Maillol's approach to sculpture was essen-
tially contrary to Rodin's since Maillol refused to follow either Rodin's
psychological drama or his flickering surfaces. Maillol owed a great deal to the
late nudes by the aging Renoir (1841–1919), who modeled or directed model-
ing when he could no longer work with his own hands. Maillol's rather
conservative return to a simplistic classicism may have inspired others to create
more simplified and abstract forms—thus he played a part in leading younger
men to the more abstract art of the next generation. A Franco-American
variation on Maillol is found in the erotic sculpture of Gaston Lachaise (1882–
1935). He too was influenced at first by Rodin; after immigrating to the
United States in 1906 he carried on his essentially European style with con-
siderable success, alternating an almost ecstatic bouyancy in some of his heavy
figures with a ponderous classicism (see Plate 122).

The history of modern art, like that of the nineteenth century, is usually
given its form by the masters and movements of painting rather than of
sculpture. Familiar labels like Post-Impressionism, Fauvism, and Cubism are
vague enough when applied to individual works and have only a modest use in
describing the sculpture of the early twentieth century. Nevertheless, many of
the masters whose painted works seem to define the birth of modern art were
also sculptors, notably Picasso and Matisse (see Plates 112–114). Pablo Picasso
(1881–1973) worked in sculpture from an early period, although it was always
a sideline, and late in his life he produced a series of decorated ceramics. Henri
Matisse (1869–1954) was already involved in sculpture before the turn of the
century. Both these men show in their early works the exploratory nature of
sculpture after Rodin, and, like him, they were modelers rather than carvers.
Picasso was still wedded to the surface in *Head of a Jester* (Plate 112), which is a
sculptural version of his circus figures of the Rose Period; alienated and
estranged, the Jester is the Everyman of the new century. Rodin's surfaces are
also found in Matisse's early *Jeannette* (Plate 113), but in later versions a gro-
tesque distortion transforms the work into a lumpy abstraction typical of the
period 1910–13 and seen, for example, in Picasso's *Woman's Head* (Fig. 49).

Picasso, together with Georges Braque (1882–1963), was the founder of

49

FIG. 49. Pablo Picasso, *Woman's Head.* Bronze; 1909. New York, Museum of Modern Art

FIG. 50. Alexander Archipenko, *Walking Woman.* Bronze; 1912. Denver Art Museum

FIG. 51. Constantin Brancusi, *The Kiss.* Limestone; ca. 1912. Philadelphia Museum of Art. The Louise and Walter Arensberg Collection

50

Cubism, perhaps the most important new style of the century. Cubists moved away from the surface preoccupations of later nineteenth-century art to make a conceptually based abstraction from visual forms. The movement was productive and successful in ridding painting of much old baggage, particularly historical associations and sentimental or Romantic content. Picasso practiced this style in sculpture as well as in painting (see Plate 114), and sometimes he first achieved in rapid three-dimensional forms the effects that he exploited more persistently in paint.

Henri Laurens (1885–1954), a pupil of Rodin's, moved toward Cubism in the first decade of the century and after meeting Braque in 1911 became a true Cubist. Plate 115a shows his amusing Cubist style of 1915–25, which is a more delicate version of Picasso's own. Like most of his works, it is a painted relief— one might even call it a Cubist painting asserting its natural three-dimensionality. But here, as with some other Cubist sculptures, we encounter a problem: Cubist painting was often a witty analysis of form and void, of motion and stasis, of inside and outside simultaneously perceived through painted contours and planes. This intricate simultaneity finds its most expressive mode in two-dimensional drawings and paintings since the essence of the style is an abstraction away from three-dimensional form. Translating back into three dimensions tends to stultify the sprightly wit of the painted models. Cubism nevertheless became an international language, learned in Paris by artists of many countries.

Alexander Archipenko (1887–1964) came from Russia to Paris in 1908 and by 1910 was trying to do Cubist sculpture. Like Picasso, he was led to a new, more primitive version of human form by the study of African sculpture and the other arts of tribal peoples. His aggressive and sometimes imaginative art in this early period is exemplified by Figure 50 and Plate 116. His later career, in the United States after 1923, was less distinguished.

Another aspect of Cubism is found in the related art of the Italian Futurists. According to Umberto Boccioni's preface to the catalogue of the first Futurist exhibition, held in Paris in 1912, the intent of these artists was to give a "synthesis of *what one remembers* and of *what one sees.*" In his *Manifesto of Futurist Sculpture* (1912) Boccioni (1882–1916) advocated the "absolute and complete abolition of the finite line and closed sculpture. Let us break open the figure and enclose the environment in it." Boccioni's belief in representing ideals of dynamic motion in space was embodied in four striding figures, of which only one survives in several casts (Plate 118). Just where this style would have led Boccioni and others who died in the First World War, we will never know (see Plate 115b), but the Cubists carried on and the Futurist rhetoric still has a familiar ring.

Perhaps the best known of the early Cubists was Jacques Lipchitz (1891–1973), a Lithuanian Russian who went to Paris in 1909 to study sculpture in the traditional schools. Only in 1914 did he emerge as a true Cubist—Plate 117 shows a transitional moment. Even more than the others, Lipchitz's sculptures seem to move in space with a changeability that depends on light effects. Like Rodin, he depended on carefully modeled surfaces to enhance the life of the form. His sculpture evolved in the twenties and thirties, partially under Picasso's influence, into an occasionally Surreal style related to African art. But Lipchitz declined radically when he was removed from the center of innovation in Paris. After 1941 he worked in New York in an increasingly dramatic, personal, and embarrassingly unconvincing style.

Sculptural abstraction, which evolved in one direction in the works of the true Cubists, took on a somewhat different character in the works of two Russian brothers, Antoine Pevsner (1886–1962) and Naum Gabo (born 1890). They participated in the first, often anarchic, artistic experiments in Moscow after the Revolution, where at first they subscribed to the socially conscious Con-

structivist ideology of Vladimir Tatlin (1885–1953). Artists like Tatlin wanted the modern artist to embrace the technological revolution of modern times, and although the Soviet Union soon found abstract art subversive, Pevsner and Gabo, living abroad, remained true to the ideal of geometric abstraction (see Plates 120–121). Gabo tried to capture space with webs of abstract matter, linear or perforated walls of translucent or transparent material that define or enclose volume. Lines are no longer descriptive of natural objects but are edges of forces or rhythms that give direction and shape to space, with astronomic or other scientific analogies. Pevsner made similar, even more mathematical statements, usually in opaque materials. Both men influenced younger sculptors like Calder and even Schöffer (see Plates 134–35, 146).

51

In Germany the art movement roughly contemporary with Cubism is called Expressionism, and it, too, had various sculptors loosely associated with it. The name is really self-explanatory—instead of the cool formality and detached humor of Cubism, Expressionism emphasized human emotion, especially pain, estrangement, and despair. Ernst Barlach (1870–1938) stands out as a man in touch with primitive folk traditions. He remained a mystic whose sympathy was always with the simple, remote life of the peasant (see Plate 111). Another German, Wilhelm Lehmbruck (1881–1919), came under Rodin's influence before he moved to Paris in 1910, when his mature style emerged. Exhibiting a mixture of German Gothic traditions and decorative Art Nouveau, the mature Lehmbruck makes a nice Germanic contrast to Maillol, who appears by comparison to exemplify the earthiness of Mediterranean man (Plate 109). Lehmbruck's *Kneeling Woman* (Plate 110) is all angles, tall yet graceful, with an attenuated classicism. His sculpture seems a fitting prelude to the Age of Anxiety—he himself committed suicide—and his figures affect every viewer with their frustrated sentiment, an *Angst* that is barely controlled by their beautiful form. Ossip Zadkine (1890–1967), a Russian, was an expressive Cubist (see Plate 119) whose later connections are at least as much with German Expressionism as with France. At first a carver, he turned to modeling and bronze casting in the twenties, producing dramatic and finally melo-dramatic works.

The most significant sculptor of the first half of this century was perhaps Constantin Brancusi (1876–1957), a Rumanian who began his career as a pro-vincial woodcarver. It was not until 1904, after training in the local craft schools, that he arrived in Paris (he actually walked from Munich) and enrolled in the Ecole des Beaux-Arts. Later he declined a chance to work with Rodin and is reported to have said that "sculptured nude bodies are less sightly than toads." Although his early figural works are quite radically removed from traditional forms, Brancusi never became a totally abstract artist; even in his later sculptures there is always a remote relationship to nature (see Fig. 52). Unlike Rodin, Brancusi was essentially a carver of stone and wood; early in his career he actually produced a monument, repeated in several versions, called *The Kiss* (Fig. 51). It is surely a stone sculptor's comment on the fancy, erotic, almost Rococo pseudo-carving by Rodin (Plate 107); moreover, it insists on a primitivism common to many earlier cultures that was one of the great liberators of art in the first decade of the century. Unlike either Rodin or Maillol, Brancusi exemplified the defiantly iconoclastic and revolutionary nature of twentieth-century art. He was influenced by Negro art as well as by his own Rumanian folk memories, and these primitive sources are strikingly reflected in *The Kiss*.

Although Brancusi was interested in diverse materials as such, he made easy transitions from marble to bronze—the *Mlle Pogany* (Plate 124) exists in three marble and at least nine bronze versions cast from them, produced over a nineteen-year period. But neither this head nor other chic sculptures of the kind

52

fully reveal Brancusi's significance. His lifelong search was for the essential core of visible matter (something that had also interested Rodin), and in this endeavor he simplified and abstracted from nature. Heads gradually became eggs and could then be given such novel titles as *Sculpture for the Blind*. Brancusi worked on a series of limited themes during most of his life and his works exist in many versions and materials, but most of them had their origins in a carved marble (or wood) prototype that might then be cast, enlarged in plaster, and cast again. He considered carving the "true road to sculpture"; nevertheless, his carved surfaces are without trace or mark of chisel and rasp, a "machine esthetic" that actually depends on careful finishing and polishing by hand. Brancusi paid special attention to the bases of his sculptures; above them he reduced all life and matter to a few delicately poised, polished, and simplified symbols. His ultimate place in the history of art will probably derive from his mature works in series, such as *Fish*, or *Bird in Space* (Fig. 52), gleaming abstractions in marble or bronze that grasp the essence of speed and freedom.

Jean (or Hans) Arp (1887–1966), an Alsatian by birth, shared Brancusi's esthetic and goals (see Plate 125). But the organic quality of Arp's poetic work depends more on intuition and accident—his quirky titles, unlike Brancusi's, were conceived only after the object was finished, which makes Arp a more essentially abstract artist. He once claimed that his purpose was "to inject into the vain and bestial world and its retinue, the machines, something peaceful and vegetative." Arp, like Rodin, usually worked in plaster and then had his conceptions carved by craftsmen or cast in bronze, a distinction from Brancusi that is not particularly relevant to the viewer, owing to the smooth abstraction of his works.

Arp developed his individual style after experiencing the Expressionism of the Blaue Reiter in Munich in 1911–1912, a stay in Paris (1914), where he knew Apollinaire and his group, and then residence in Zurich, where he was a founder of the Dada movement. Dada based its artistic philosophy on anarchy or chance, but it was not altogether whimsical (as we might sometimes believe from the works and their titles—see Plate 126). Dada was possible only after Freud's discovery of the unconscious mind (*The Interpretation of Dreams*, 1901). There was plenty of nonsense produced by the original group, which was in many ways anti-art, rejecting all former modes of expression. Nevertheless, Dada was a liberating force for many kinds of artists and led rather directly to another movement, Surrealism. After the First World War Arp went to Cologne, where his Dada sympathies were transmitted to Max Ernst. He then settled in Paris, profoundly influencing Surrealist artists and producing successive concretions of his more or less unconscious imagination.

Max Ernst (1891–1976), essentially a painter, was a founder of the Surrealist movement in the early twenties and its chief theoretician. Such a work as the famous *Two Children Are Threatened by a Nightingale* of 1924 illustrates his Surreal esthetic, which he described as "the chance meeting of distant realities on an unfamiliar plane" (Fig. 53). The terror of a child's dream is here unfolded before a landscape (based on Giorgio de Chirico's haunting perspectives) by means of a "real" gate, a house with painted figures, and an unsettling knob that seems to indicate that the whole thing can be opened like a cupboard. In a long and distinguished career Ernst produced a succession of styles that continued after his removal to the United States in 1941 and his return to Paris in 1953. His sculptures became more important from the thirties on; although they were often only three-dimensional equivalents of verbal or pictorial ideas, they sometimes have a haunting power that transcends mere Surrealism (see Plate 128).

Marcel Duchamp (1887–1968) is also inseparable from the Dada and Surrealist movements, although his contributions were so perverse and experimental that they still fall outside our normal conceptions of art (see Plate 126). Duchamp's

idea of new art was to transport a urinal to an exhibition, label it *Fountain*, and then call it and other "readymades" nonsculpture. This kind of gesture, once the shock has worn off, leaves little that is useful other than a new freedom, which artists were winning anyway in more fruitful ways. Nevertheless, Duchamp is the grandfather of Pop Art, which served a similar purpose after the portentous critical acclaim for Abstract Expressionism.

The one truly major Surrealist sculptor was Alberto Giacometti (1901–1966), a Swiss who, after a traditional apprenticeship in the Paris schools and the studio of Bourdelle, began in the twenties, "in desperation, to work at home from memory" in order to produce a new vision of reality (see Fig. 54). After a brief excursion into open wire constructions in the early thirties, which later had echoes in the postwar period, he left the Surrealists in 1934 and only gradually evolved his personal, gnarled, reductionist style of exceptionally thin and elongated figures (see Plate 131), some of which are exceedingly tiny. These later works, the product of an extraordinary, obsessed, and possibly half-mad genius, are unique examples of the dilemma of the modern artist in the face of two overwhelming facts: visual reality, and the monumental figural tradition stretching back to Greek and Egyptian antiquity. Giacometti's confusion and gradual reorganization in the thirties was partly the result of his disenchantment with Surrealism; but it was also symptomatic of a more general malaise. Slick academic moderne and new social realism continued to be practiced, but sculpture was again in the doldrums. Brancusi himself was unproductive for a time in the years around 1930. Cubism, vital force though it continued to be, was dead as a movement, and Picasso was at least temporarily at a loss for new ideas.

In retrospect, however, there were several new artists and new tendencies that led to satisfying results. Like Giacometti, a number of sculptors born around the turn of the century questioned the traditional relationships of form and space, of mass and gravity, of living forms and intellectual abstractions. Metal sculpture, assembled and welded out of wires, sheets, or plates, became a new force in the hands of Julio González and David Smith (see Plates 130, 136). And Henry Moore emerged in England as Brancusi's successor in the production of organic, usually humanoid, forms of classical power and conviction without any taint of the Academy.

Henry Moore (born 1898), basically a carver like Brancusi, long tried to express elemental human life and experience in forms best suited to the carved materials he used, wood or stone. His early work reflects his discovery of Pre-Columbian sculpture, which led him to the blocky forms he has since continued to favor. He once said: "I was really rather glad not to have an English 'tradition of sculpture' behind me. . . . I'd known since 1921, from what I'd seen in the British Museum, that the whole repertory of form-ideas was there. . . . Picasso and the British Museum were the only sources I really needed." Like Arp, Moore seems to be able to reach down into unconscious memories of experience to create sculptural works that have the quality of archetypes. This elemental force is usually expressed in simple rounded shapes, as if eroded by time and weather, often with expressive or symbolic holes, such as his sculptures of abstract female forms, seated or reclining figures, family groups, or kings and queens (see Plate 129). In Moore's work the perimeter of the mass often seems only the placid exterior of some long-exposed object, but because of the hollow interiors there is a controlled interaction between mass and space that is new and evocative. After 1950 Moore began to prefer bronze to his former carved materials, valuing the freedom allowed by modeling, but he continued his old motifs, particularly his interest in the relationship of man and nature, which remained a constant in his work.

Moore's exact contemporary was Alexander Calder (1898–1976), the creator of the mobile. Whereas Gabo, Pevsner, and others tried to embody a sense of motion in their time-space constructions, Calder actually set his light, thin,

53

54

FIG. 52. Constantin Brancusi, *Bird in Space*. Bronze; 1928(?). New York, Museum of Modern Art

FIG. 53. Max Ernst, *Two Children Are Threatened by a Nightingale*. Oil on wood with wood construction; 1924. New York, Museum of Modern Art

FIG. 54. Alberto Giacometti, *Woman with Her Throat Cut*. Bronze; 1932 (cast 1949). New York, Museum of Modern Art

FIG. 55. Julio González, *La Montserrat.* Wrought and welded iron; 1936–37. Amsterdam, Stedelijk Museum

FIG. 56. David Smith, *Hudson River Landscape.* Steel; 1951. New York, Whitney Museum of American Art

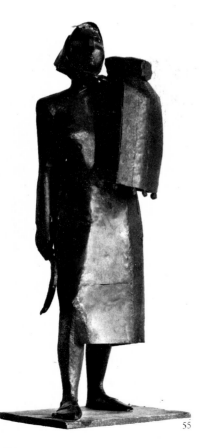

55

abstract forms swinging and floating, sometimes activating them with motors. This interest in moving forms in space is even found in his "Stabiles," more traditional fixed sculptures in sheet metal that seem to embody the potential of motion; other works combine fixed and moving parts (see Plate 134–135). Calder's achievement was considerable, as much technical as esthetic. He often incorporated color in his works, and his abstract forms usually summon up familiar ideas—schools of fish, trees, or birds—reinforced by the often humorous titles of his sculptures.

If abstraction seemed to be the winning mode in the thirties, there was also a continuing tradition of figural sculpture, ranging from the schlock moderne of Manship and Milles, through Elie Nadelman (see Plate 123), to the sophisticated abstractions from nature of Brancusi, Giacometti, Calder, and Moore. In Italy, the perennial home of classicism, modern figural sculpture continued with Marino Marini (born 1901) and Giacomo Manzù (born 1908)—(see Plates 132, 133). Marini drew chiefly on the timeless theme of horse and rider, expanding his references to the art of the T'ang Dynasty in China and to Pre-Columbian figures while remaining in an identifiable Italian tradition. Manzù, somewhat younger and more daring, combines real, Surreal, and expressive forms into an equally Mediterranean fusion of realism and idealism.

After the Second World War, sculpture at first seemed to continue on much the same path with many of the same Old Masters. The outstanding success in painting was Abstract Expressionism, which had no precise parallels in sculpture; but whereas Abstract Expressionism now seems to be a historical art of the past, a number of sculptural styles loosely connected with it continue to have vitality and capacity for growth. The geometrical tendencies we have outlined helped produce new abstractions of various kinds (see Plates 134–41). But these styles were often pretentious, occasionally even fraudulent, and they reaped their reward—Pop Art. Although the future of Pop seems to be nil, this reductionist movement was salutary in a number of ways. Like Dada in the twenties, it questioned the pretense and the long traditions of serious image making. A plastic hamburger or a melted typewriter, at first funny to see in an art exhibition, is also by extension a comment on the ambiguous nature of reality and experience. Pop was thus, ironically, in the hallowed tradition of modern art since 1900, which Picasso said must be subversive and revolutionary. Claes Oldenburg (born 1929) exploits the shock of opposites—hard ice cream, soft toilets—with both humorous and serious results (see Plate 145). His *Lipstick* mounted on a gun carrier at Yale (the first of his designs for mock public monuments actually to be executed in monumental form) seems to deny all the familiar chauvinistic memorials to War and Heroism, even art itself, while making a charming bow to the old saw, *amor vincit omnia* (shortly afterward, Yale College admitted women for the first time). George Segal (born 1924), not precisely Pop, cast real people in surgical plaster bandages, using the outside of the cast as the ultimate figure and setting it into a fragmentary context of mundane reality (see Plate 143). Such a work gets a shock of recognition on two levels: the mini-environment is lifelike; the numb, frozen plaster is an ultimate *reductio ad absurdum* of the white classicism of Canova or Thorwaldsen (see Plate 99, Fig. 42). Yet it also carries with it a presence or sentience that is striking. Pop may be the ultimate in twentieth-century insistence on the irrelevance of the past, the death of classical and Renaissance culture. But the Radical Realism of John de Andrea and Duane Hanson, who create figures that are almost indistinguishable from living beings (see Plate 144b, Fig. 1), is probably not more than a novelty, fascinating (or horrifying) as their works sometimes are. Jean Dubuffet (born 1901) attacked past culture by yet another route; his fascination with esthetic unorthodoxy led him to reject accepted ideas of beauty and control (see Plate 142).

56

Unlike these essentially adversary artists, we can distinguish other sculptors who made their own productive accommodations to the growing modern tradition. Both Louise Nevelson (born 1900) and Joseph Cornell (1903–1972) created abstract pictorial groupings within frames or boxes, which can be large or small, public or private (see Plates 127, 138–39). Such works depend on Dada and Surrealism as a starting point, while Nevelson stakes out a new area, an art of assemblage. Nevelson's "pictures," or walls, are often formed of the products of a woodworker's shop or other found objects, and the mechanistic elements have some of the craftsman's rustic charm, put together to make an abstract series of groupings that are personal and unmechanical. Cornell's little boxes are Surrealy private and even changeable, often with parts that move or slide, and usually with associations that can only be guessed at. Edward Kienholz (born 1927) creates a kind of pop Surrealism in his bitingly satirical tableaux, which are often made up of ordinary found materials (see Plate 144a).

It is however David Smith (1906–1965) who maintains the greatest reputation of all postwar sculptors in his increasingly muscular and expressive works in welded metal, which date back to 1933. Smith's greatest source was the briefly flowering career of Julio González (1876–1942), who, like the younger Picasso, was from Catalonia and also a painter. Although he was from a family of metalworkers, González began to concentrate on sculpture only in 1926; his essential inspiration was at first Cubist (see Plate 130), and over a long friendship with Picasso the influences ran in both directions. In 1930–32 González taught Picasso the technique of working in metal, and during those years his own art began to develop into a uniquely affecting little *oeuvre* that ranged from brilliant abstraction to a stoic realism (see Fig. 55). Smith gradually moved away from an enigmatic, linear symbolism dependent on González (see Fig. 56) to powerful totemic forms in space, which often reflect light from their buffed surfaces and always imply great energy under control. Smith's later sculptures are related to Abstract Expressionism—*Cubi* III (Plate 136) is one of a triumphant series of welded stainless-steel boxes begun in 1961. Smith was the pioneer in constructed sculpture, three-dimensional works that are neither carved nor modeled—a process that ultimately derived from the first constructions of Picasso. William Rubin has called these works "the first alternatives to certain fundamental assumptions about sculptural aesthetics and methods since ancient times."

The contemporary torchbearer of this new "tradition" is Anthony Caro (born 1924), an Englishman who studied with Moore and first came to the United States in 1959. He was then impressed by a work of David Smith's, changed his material from bronze to steel, and began working with beams, usually laid out horizontally without a base. Caro's strength rests in part on the careful relationships set up between diverse forms, usually the result of improvisation, and in part on the monochrome color, which helps divorce the steel from its normal associations, unifies the different forms, and even makes them appear weightless (see Plate 141). His sculptures go beyond Smith's in their lack of implied frames or boundaries, an open-ended esthetic that connects him with environmental artists like Tony Smith (see Plate 137) even though Caro's works make no environmental claims.

A different sense of engineering or motion, in frustrating or enigmatic lack of context, is exemplified in the work of Mark di Suvero (see Plate 140b), who translates into three-dimensional forms (beams, chains, etc.) some of the bold strokes and angles of Abstract Expressionist painting. For better or worse, di Suvero (born 1933) is also related to those sculptors who value found objects, assemble junk (see Fig. 57), or otherwise try to make us see ordinary, unesthetic materials in new combinations and contexts. Perhaps the ultimate in "junk" sculpture was achieved by Jean Tinguely (born 1925), who made works that destroyed themselves.

Like David Smith and Tony Caro, several others have turned to geometric abstractions for new visions of form in space. Some of these works are reductionist, attempting to minimize forms to essential elements, separating volume, mass, and weight (see Plate 140a). But Minimal Art, attractive though it sometimes is, seems to be a road with no exit, whereas the abstract spatial works by Gabo and Pevsner in plastic or beaded bronze seem to lead on to sculpture in light, or to moving wire constructions revealed by light, as in the work of Richard Lippold (born 1903). Nicolas Schöffer (born 1912) created sculptures of luminous spatial complexity to which he lent portentous names and elaborate theories (see Plate 146). The effort to create a music of colors, which emerged generations ago in such modes as the color organ and the painted abstractions of Wassily Kandinsky (1866–1944), has influenced sculptors from Calder to Schöffer and Varda Chryssa (born 1933), a Greek-American who has produced Pop American sign sculpture (see Plate 147).

Finally, many artists are attempting to make statements about sculpture and nature by constructing environments or Earthworks that seem to go back to elemental ideas about man and the universe at least as old as Stonehenge. Christo (born 1935) has wrapped buildings in packages and even constructed a kind of delicate, modern Great Wall of China (Plate 148)—gestures that assert the dynamic of art on an architectural plane, breaking down the barriers between man and his surrounding world.

Although painting is more easily produced, collected, and perhaps even criticized, twentieth-century sculpture has held its own as a viable, enjoyable, even necessary art. Traditional painting seemed to have nowhere to go after Abstract Expressionism and the bewildering succession of novelties that followed. But sculptors continue to produce amusing, fascinating, even emotionally moving works, both figural and abstract, traditional and innovative, carved, modeled, assembled, projected, found. The curse of the realistic patriotic monument and the classically inspired monolith, which defeated nineteenth-century sculptors, has been completely exorcized. Sculpture lives and breathes, perhaps the healthiest of the arts as we finish out the twentieth century.

105 Paul Gauguin, *Be Loving You Will Be Happy*. Carved and painted lindenwood; 1889–90 (inscribed: "soyez amoureuses vous serez heureuses"). Boston, Museum of Fine Arts

106 Auguste Rodin, *Monument to Balzac*. Bronze; begun 1897, cast 1939. Paris, corner Boulevard Raspail and Boulevard Montparnasse

107 (opposite) Auguste Rodin, *The Kiss*. Marble; 1886. Paris, Musée Rodin

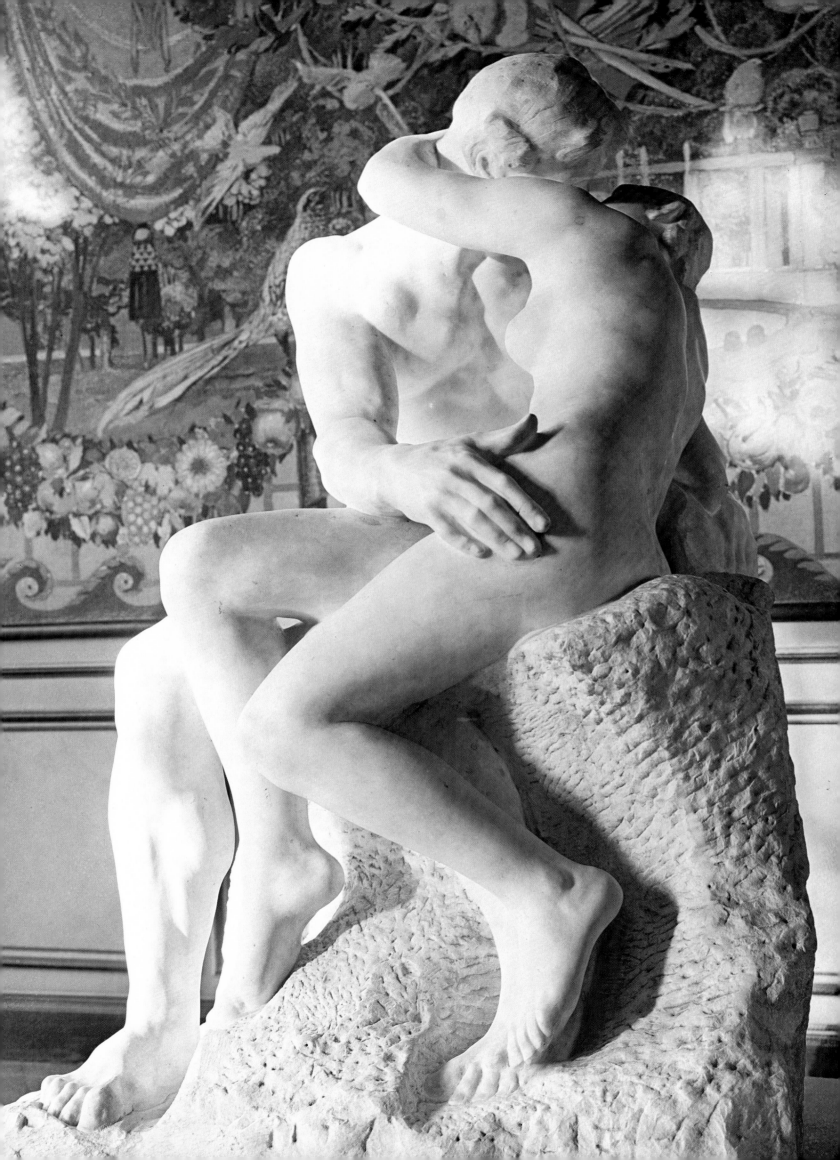

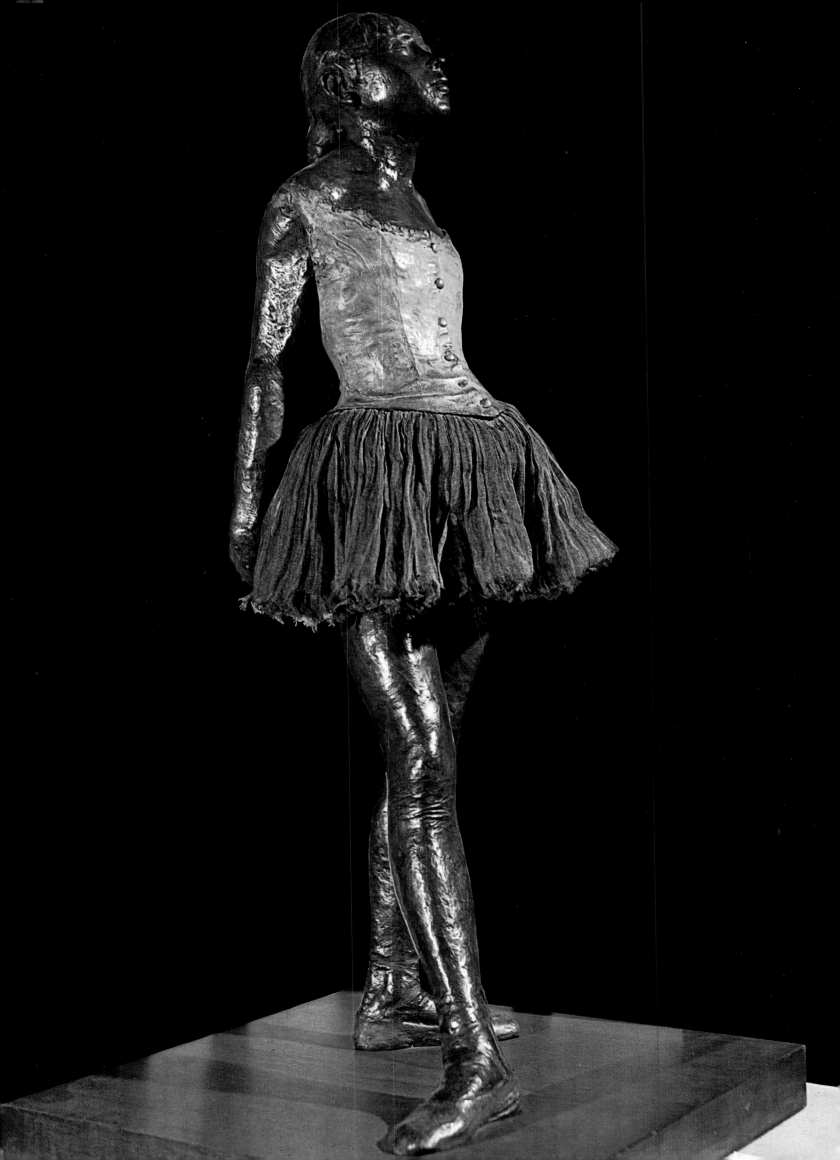

108 (opposite) Edgar Degas,
Little Fourteen-Year-Old Dancer.
Bronze, tulle skirt, satin hair ribbon,
wooden base; 1921 (wax model,
1880–81). New York, Metropolitan
Museum of Art

109 Aristide Maillol, *Flora*.
Bronze; 1912. Winterthur,
Kunstmuseum

110 (opposite) Wilhelm Lehmbruck, *Kneeling Woman*. Cast stone; 1911.
New York, Museum of Modern Art. Abby Aldrich Rockefeller Collection

111 Ernst Barlach, *Singing Man*. Bronze; 1928. Cologne, Wallraf-Richartz Museum

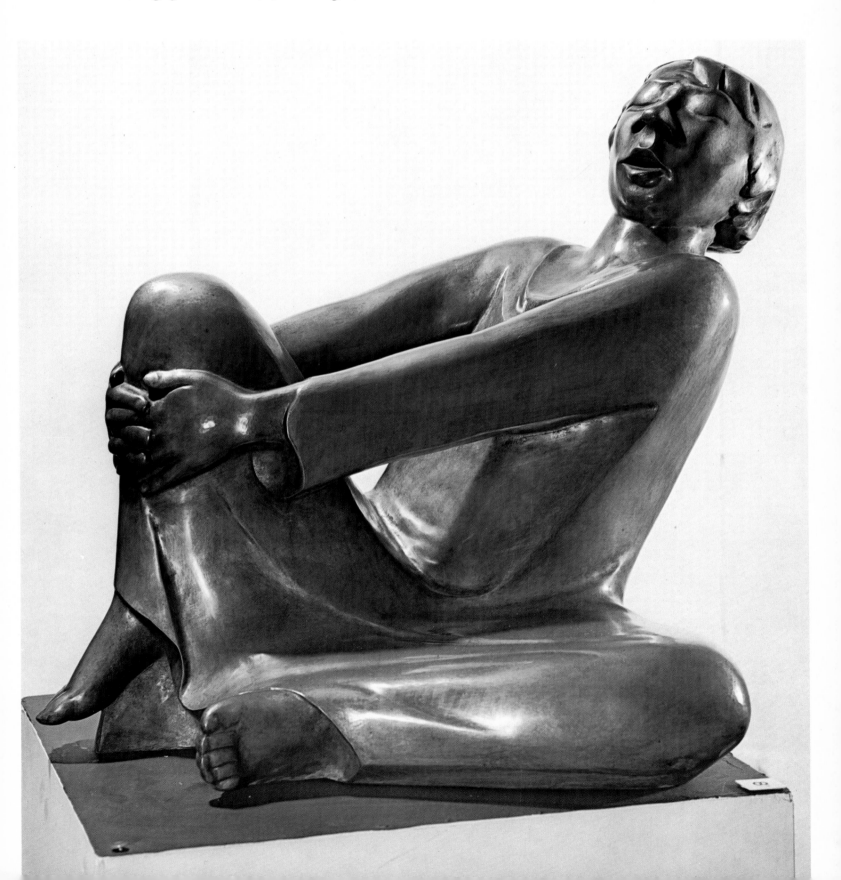

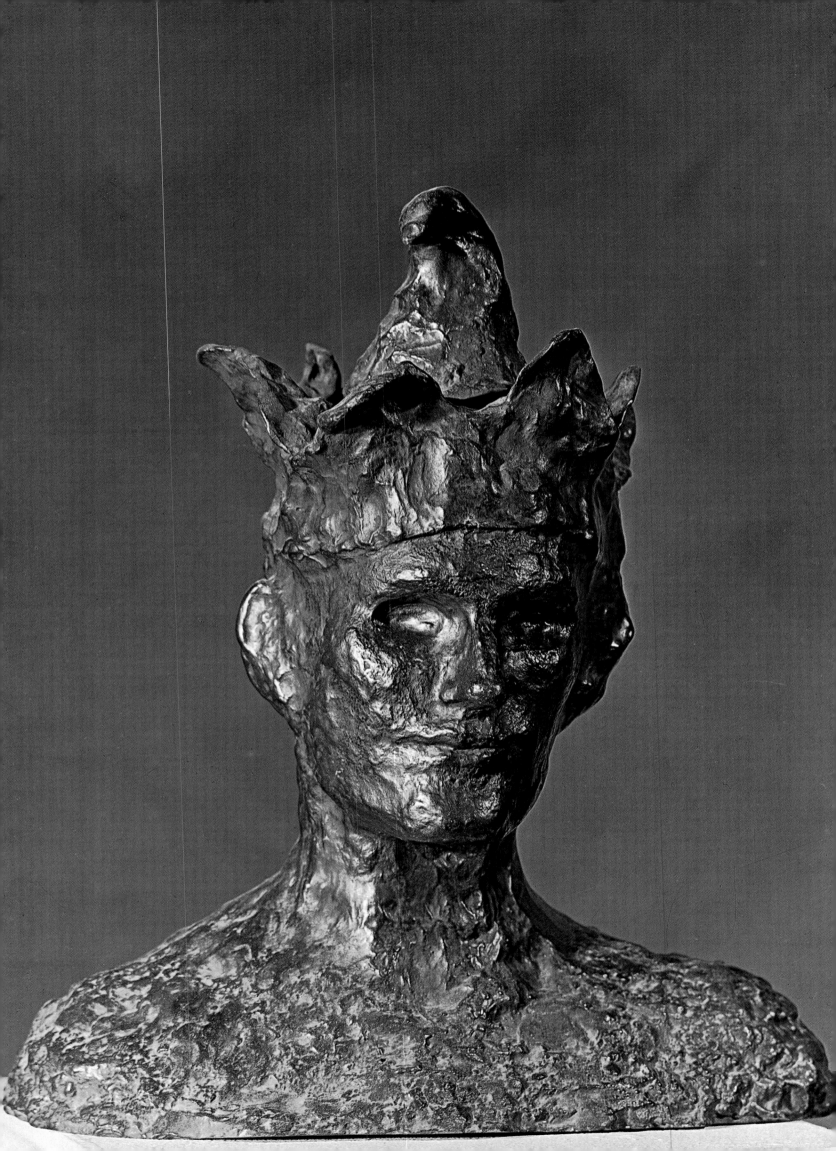

112 (opposite) Pablo Picasso, *Head of a Jester*.
Bronze; 1905 (signed "Piccasso").
New York, Collection Mrs. Bertram Smith

113 Henri Matisse, *Jeannette, I* (Jeanne Vaderin).
Bronze; 1910. New York, Museum of Modern Art.
Acquired through the Lilllie P. Bliss Bequest

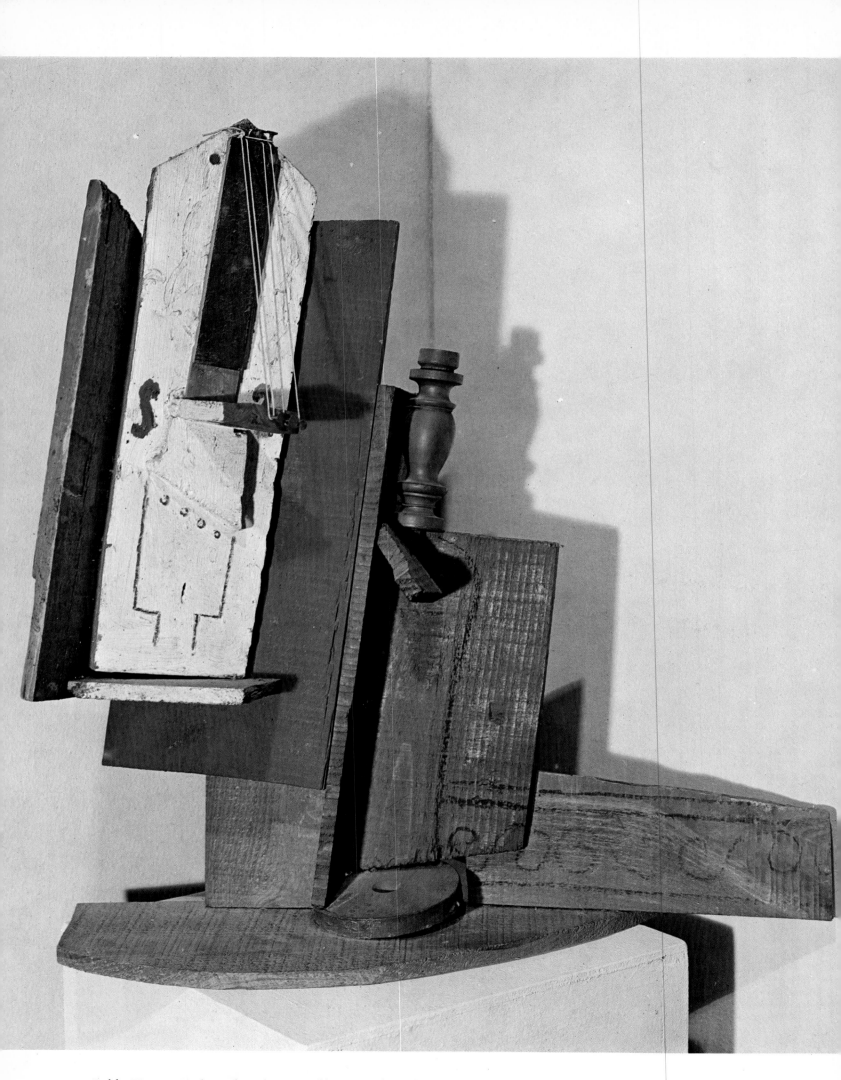

114 Pablo Picasso, *Violin and Bottle on a Table*. Painted wood, tacks, string; 1915–16. Estate of Pablo Picasso

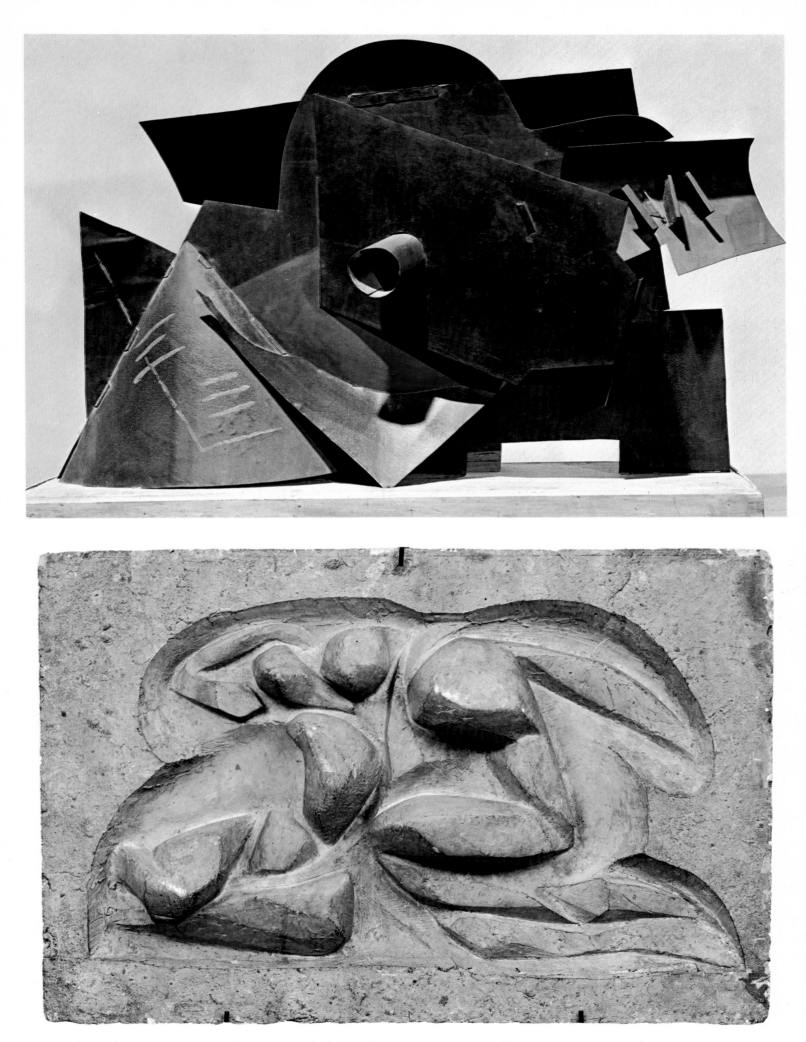

115a (above) Henri Laurens, *The Guitar*. Polychromed iron; 1918. Paris, Collection Maurice Reynal

115b (below) Raymond Duchamp-Villon, *The Lovers*. Plaster; 1913. Paris, Musée National d'Art Moderne

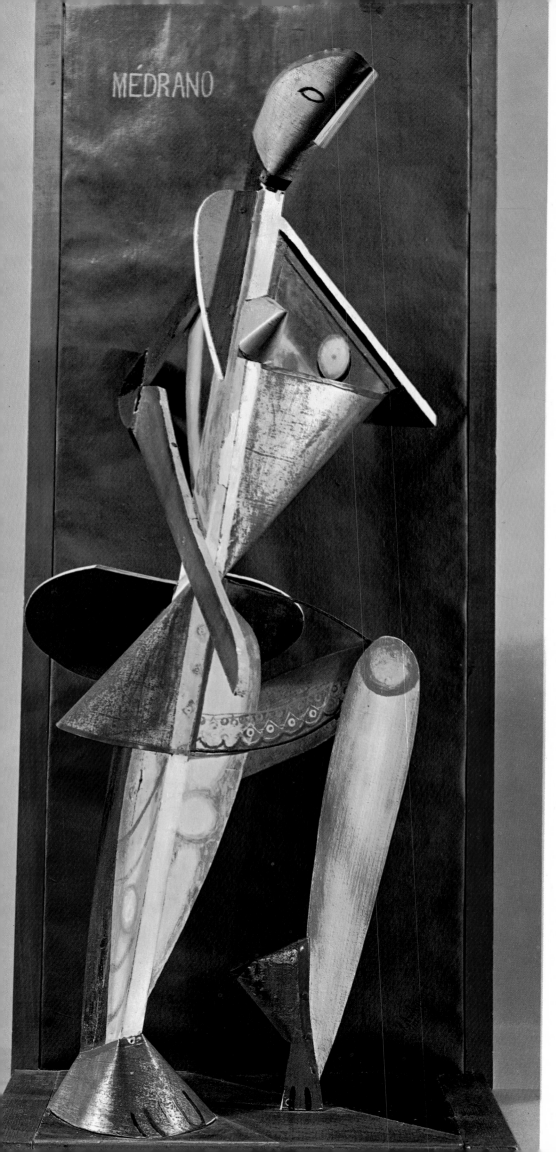

116 Alexander Archipenko, *Médrano*.
Painted tin, glass, wood, oilcloth; 1914.
New York, Solomon R. Guggenheim
Museum

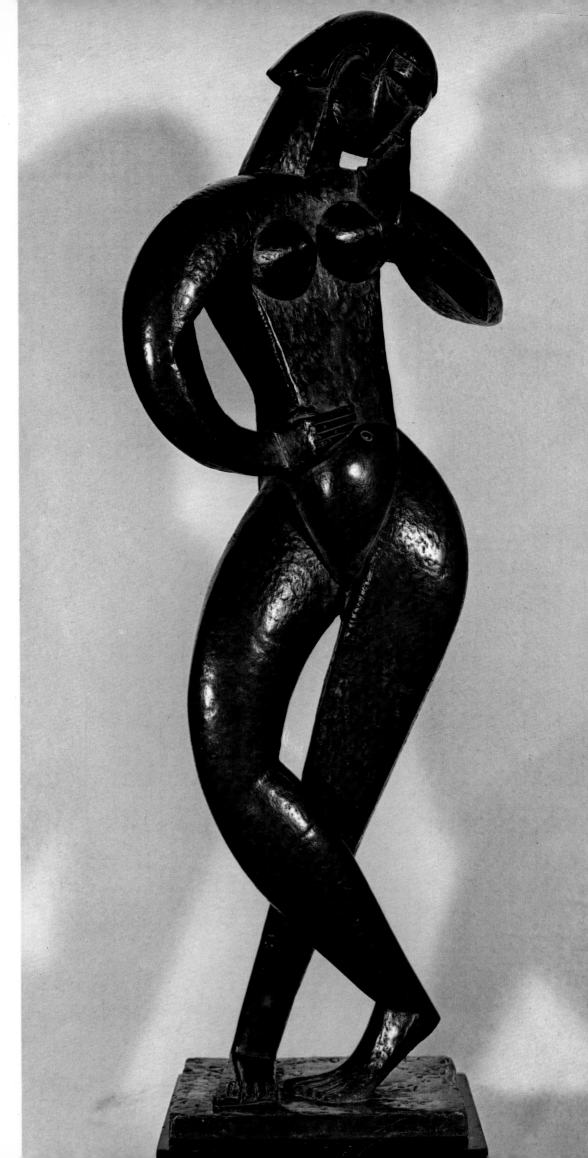

117 Jacques Lipchitz, *Dancer*.
Bronze; 1913. Paris, Musée d'Art
Moderne de la Ville

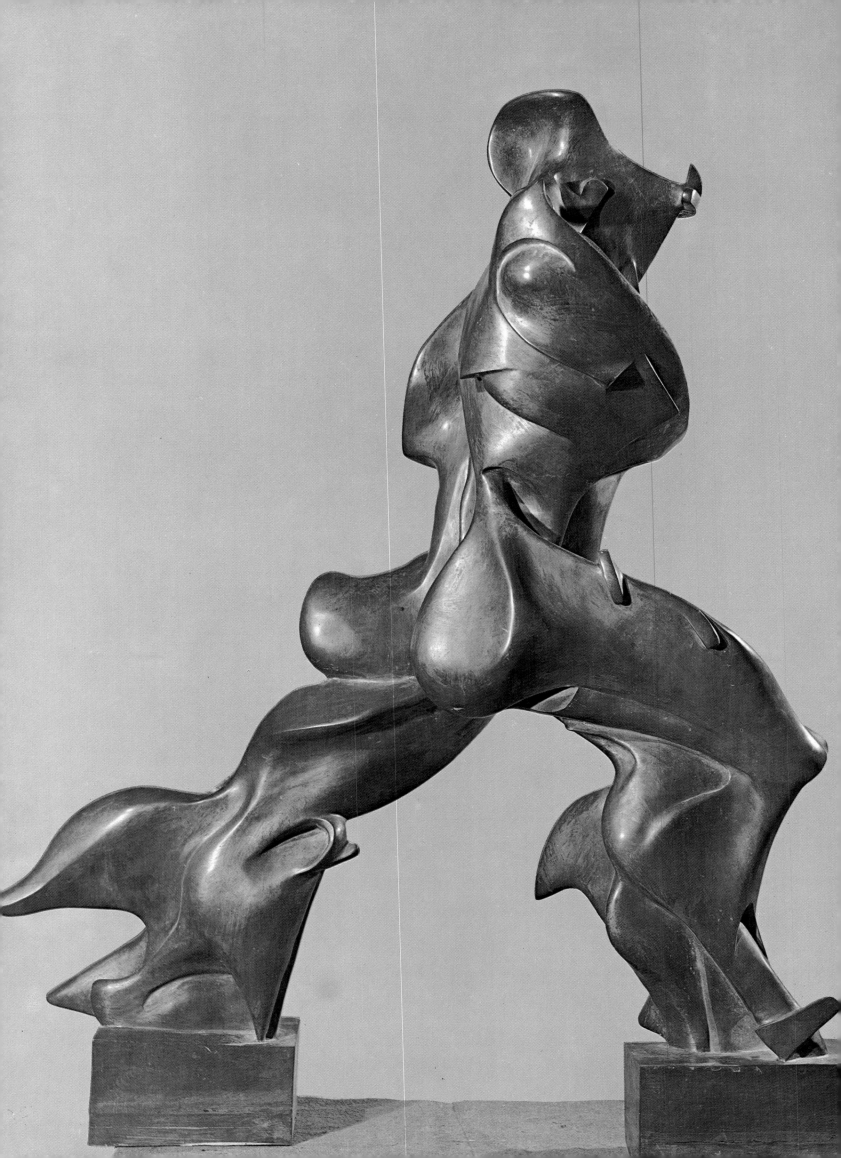

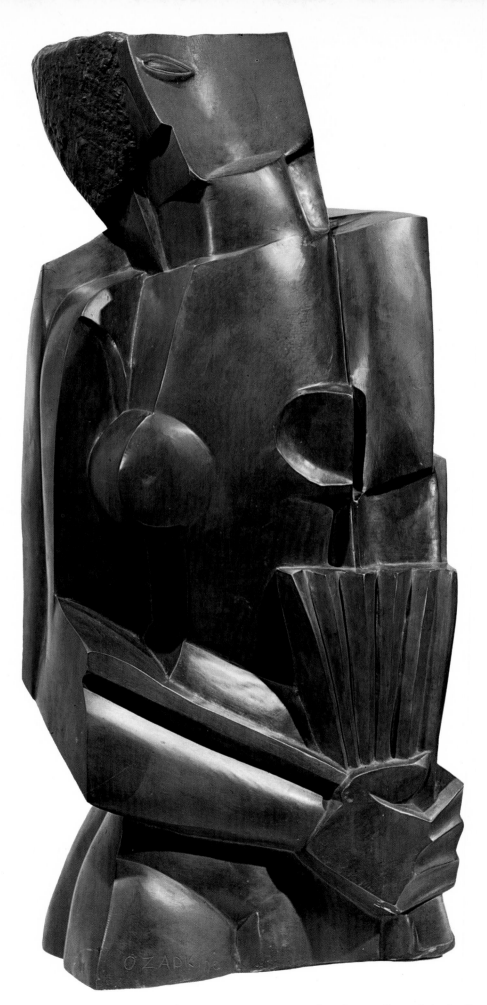

119 Ossip Zadkine, *Lady with a Fan*. Bronze; 1920, after the smaller original of 1914. Paris, Musée d'Art Moderne de la Ville

118 (opposite) Umberto Boccioni, *Unique Forms of Continuity in Space*. Bronze; 1913. New York, Museum of Modern Art. Acquired through the Lillie P. Bliss Bequest

120 Naum Gabo, *Linear Construction in Space, Number 4*. Plastic and stainless steel; 1958. New York, Whitney Museum of American Art

121 (opposite) Antoine Pevsner, *Construction in the Egg*. Bronze; 1948. Paris, Collection Pierre Peissi

122 Gaston Lachaise, *Standing Woman* (*Elevation*). Bronze; 1912-27. New York, Whitney Museum of American Art

123 Elie Nadelman, *Standing Female Nude*. Bronze; ca. 1909. Washington, D.C., Hirshhorn Museum and Sculpture Garden

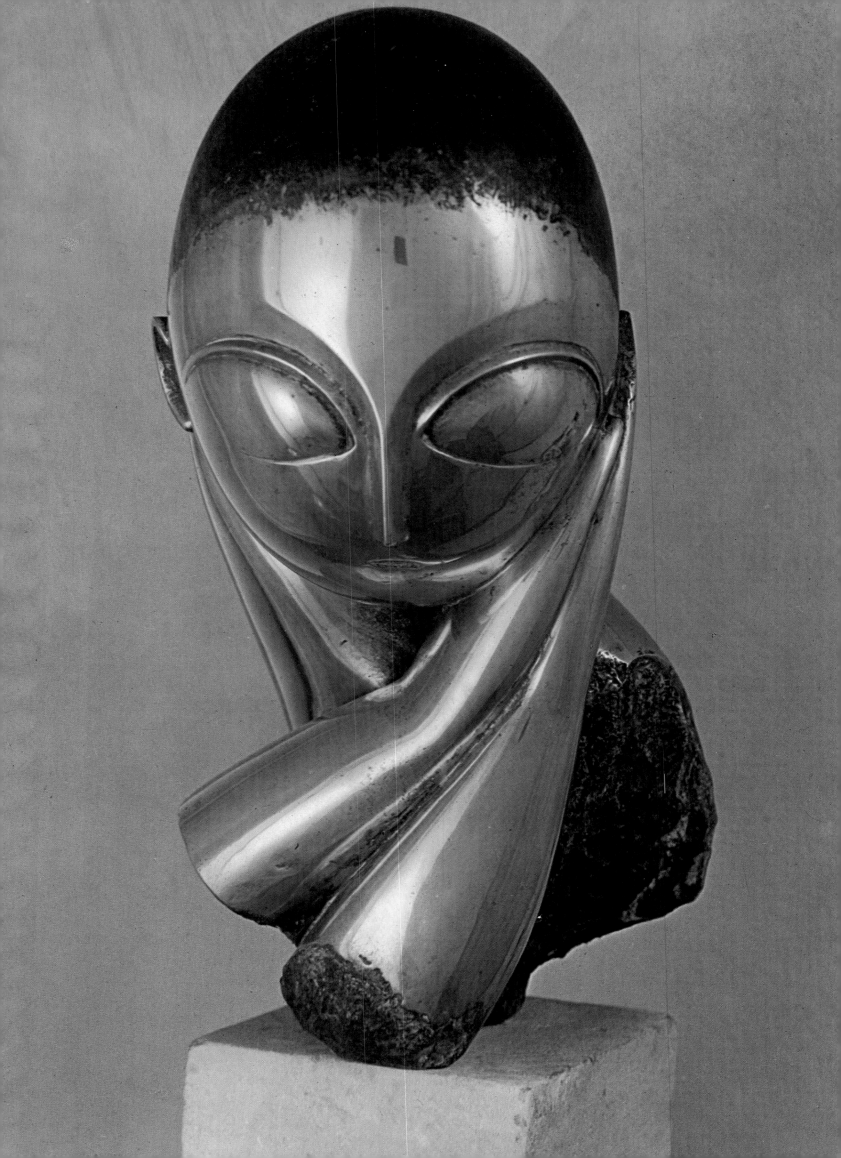

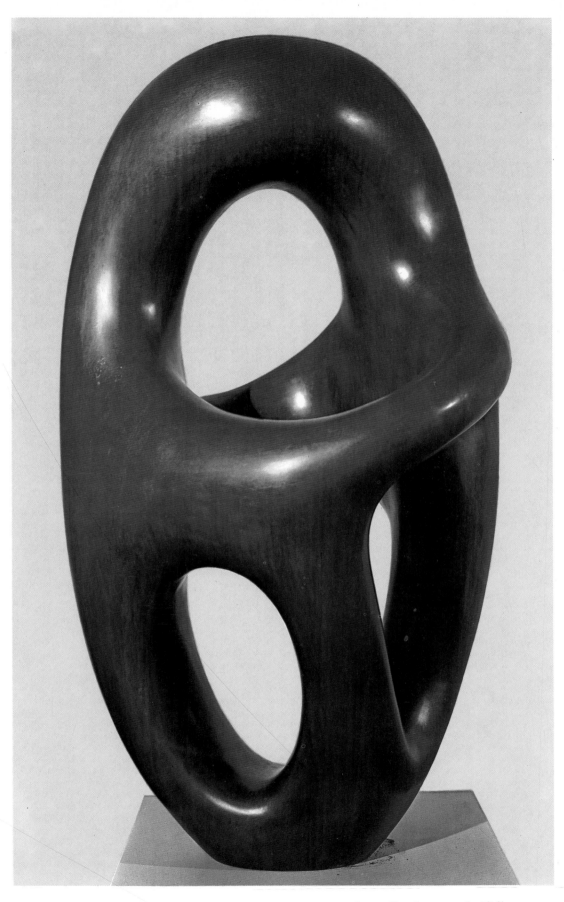

125 Jean (Hans) Arp. *Ptolemy I.* Bronze; 1953. New York, Collection Joseph Slifka

124 (opposite) Constantin Brancusi, *Mlle Pogany* (Margit Pogany).
Polished bronze, black patina; 1913 (four castings).
New York, Museum of Modern Art. Acquired through the Lillie P. Bliss Bequest

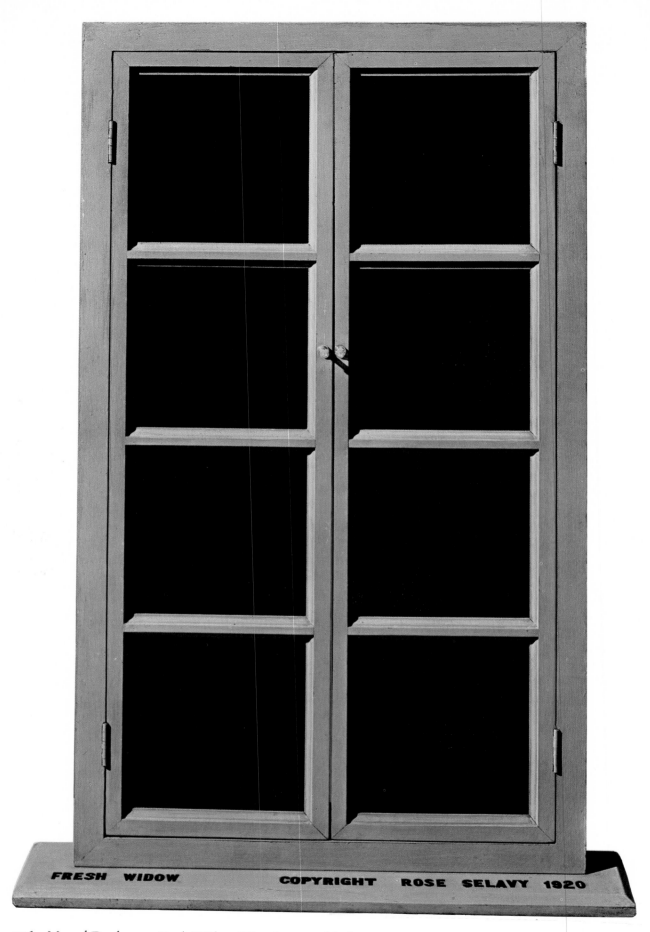

FRESH WIDOW COPYRIGHT ROSE SELAVY 1920

126 Marcel Duchamp, *Fresh Widow*. Wood, painted light-green glass covered with black leather; 1920. New York, Museum of Modern Art. Katherine S. Dreier Bequest

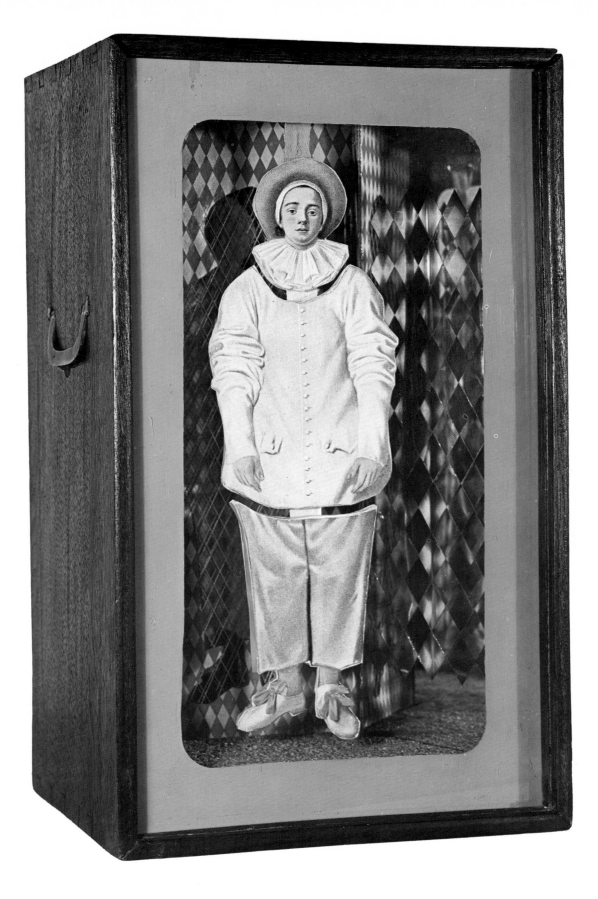

127 Joseph Cornell, *A Dressing Room for Gille* [sic]. Wood, mirror, paper, glass, string, ribbon, cloth tape; 1939. New York, Richard L. Feigen and Company

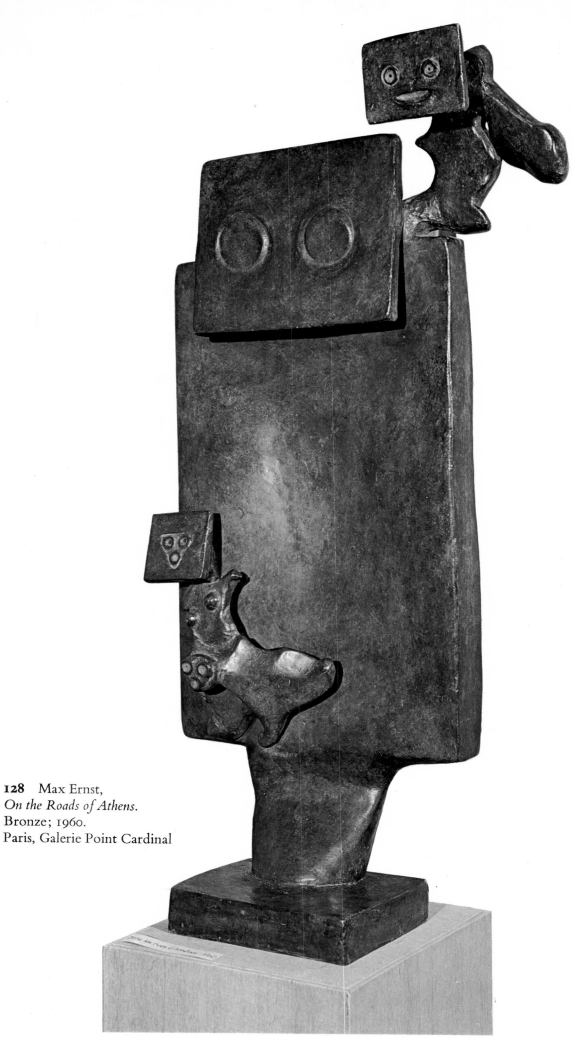

128 Max Ernst,
On the Roads of Athens.
Bronze; 1960.
Paris, Galerie Point Cardinal

129 (opposite)
Collection W. J. Keswick
Henry Moore, *King and Queen*.
Bronze; 1953–53 (edition of five).
Shawhead (Dumfries, Scotland),

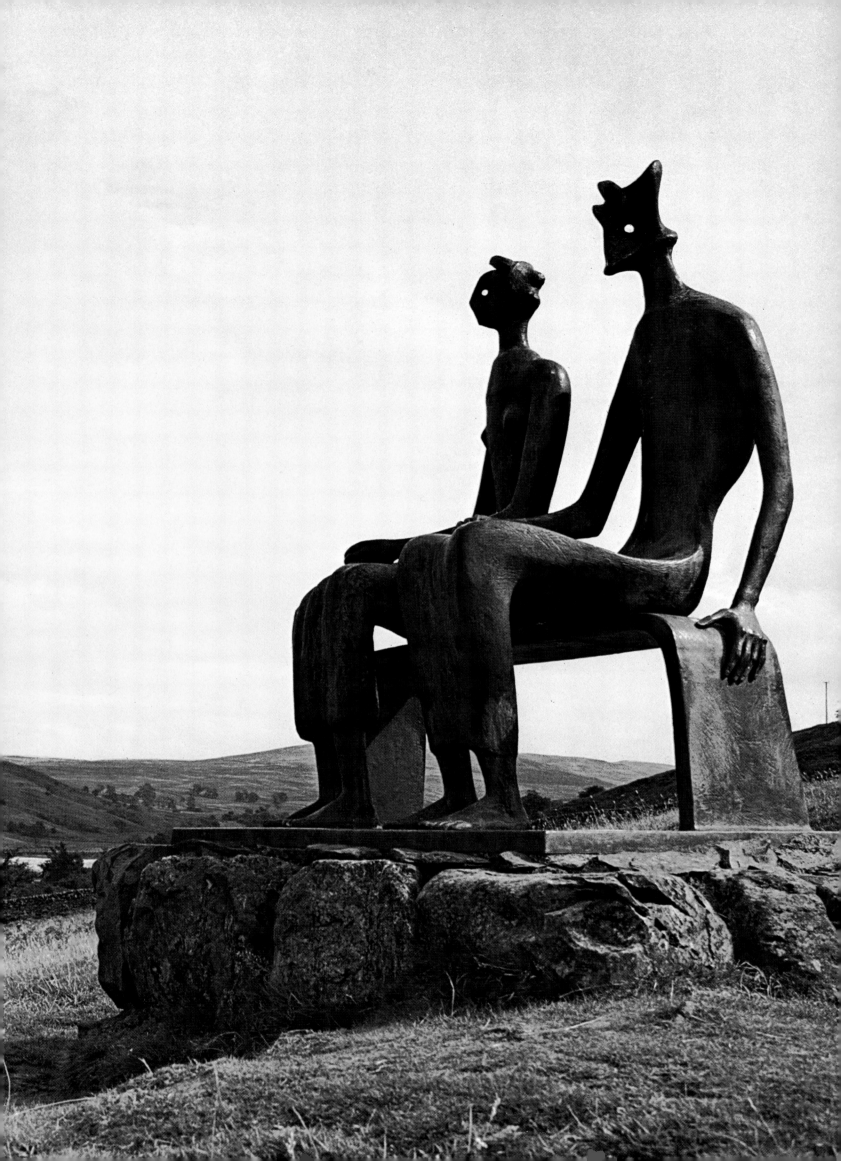

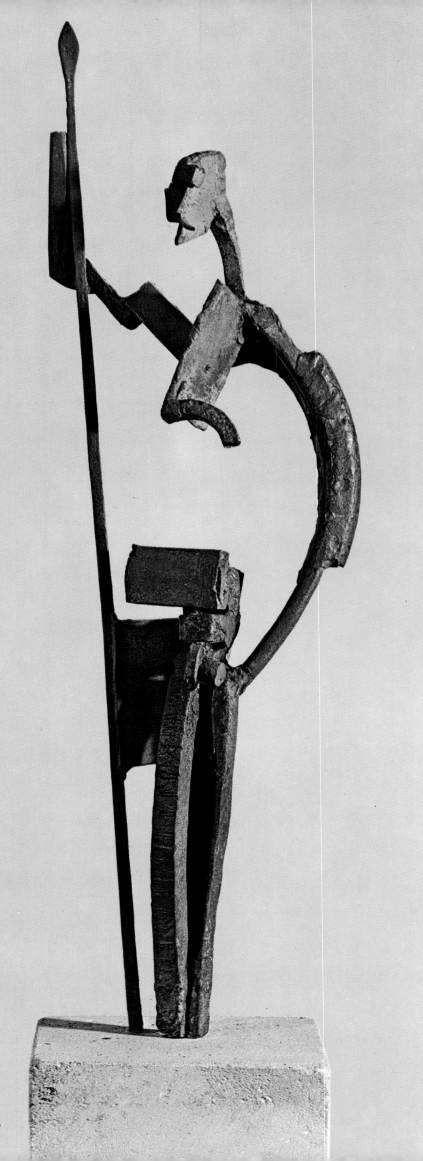

130 Julio Gonzáles, *Don Quixote*.
Welded iron; 1929. Paris, Musée
National d'Art Moderne

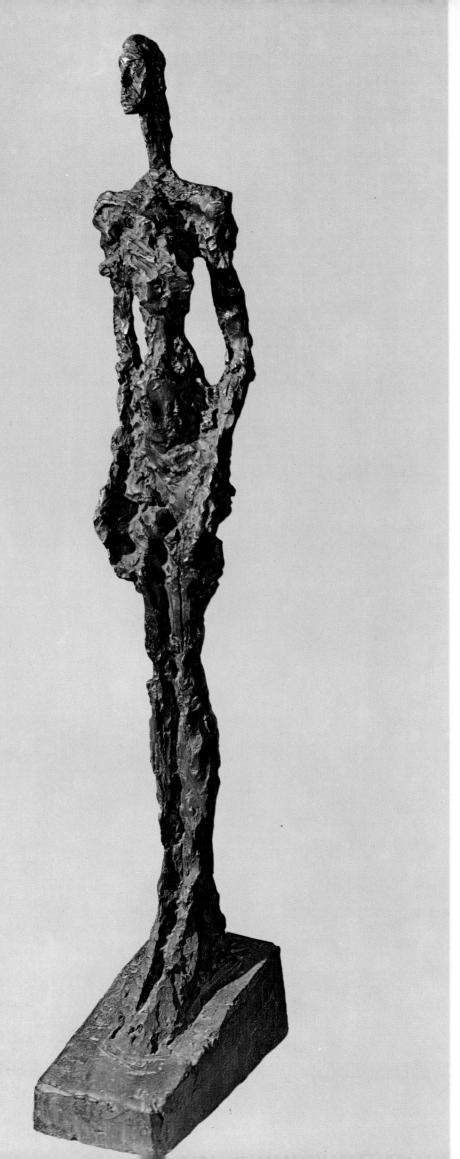

131 Alberto Giacometti, *Lady of Venice, I.*
Bronze; 1956. St.-Paul-de-Vence,
Fondation Maeght

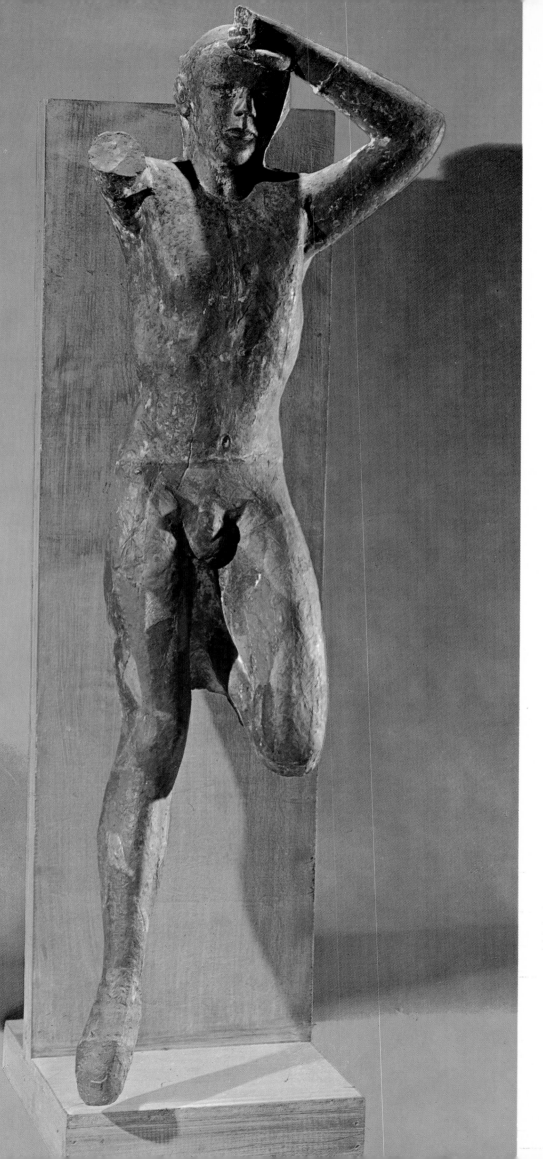

132 Marino Marini, *Juggler*.
Polychromed bronze; 1938.
Hanover, Städtische Galerie im
Landesmuseum

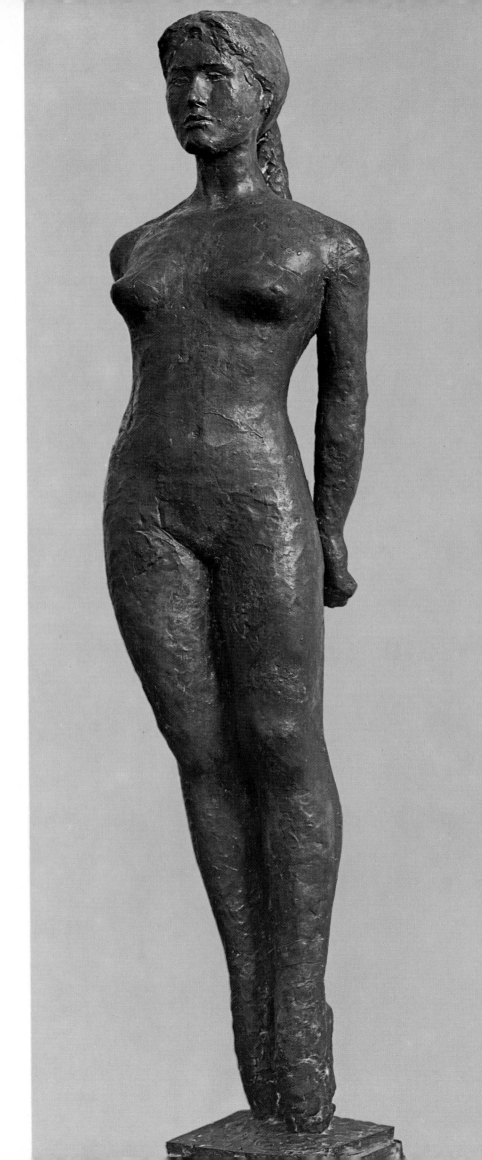

133 Giacomo Manzù, *Dance Step*.
Bronze; 1954. Mannheim,
Städtische Kunsthalle

Overleaf:

134–35 Alexander Calder, *Totems*.
Painted steel. Exhibition, February
1966. Paris, Galerie Maeght

136 David Smith, *Cubi* III. Steel; 1961. Estate of the artist. Courtesy M. Knoedler & Co., New York

137 (opposite) Tony (Anthony) Smith, *Amaryllis.* Steel; 1965. Hartford, Connecticut, Wadsworth Atheneum

138–39 Louise Nelson, *Homage to the World* (wood, painted black; 1966), *Atmosphere and Environment* II (aluminum, black epoxy enamel; 1966), *Offering* (aluminum, black epoxy enamel; 1966), *Young Shadows* (wood, painted black; 1959–60), *Sky Wave* (wood, painted black; 1964), *Atmosphere and Environment* V (aluminum, black epoxy enamel; 1966), *Atmosphere and Environment* VI (magnesium, black epoxy enamel; 1967). Retrospective exhibition, March 1967.
New York, Whitney Museum of American Art

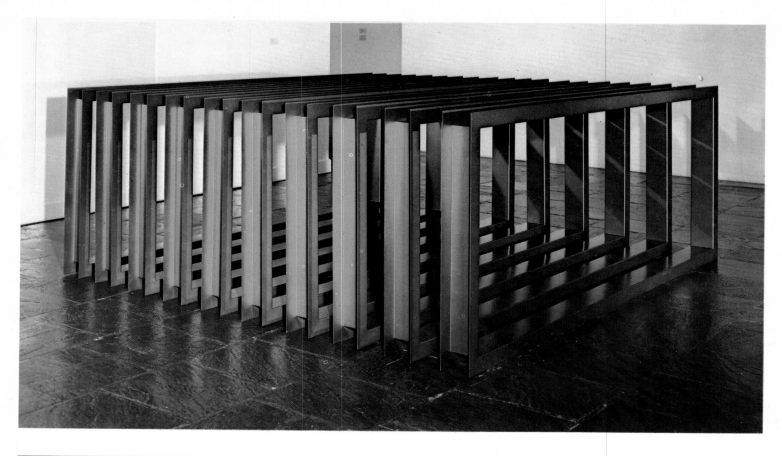

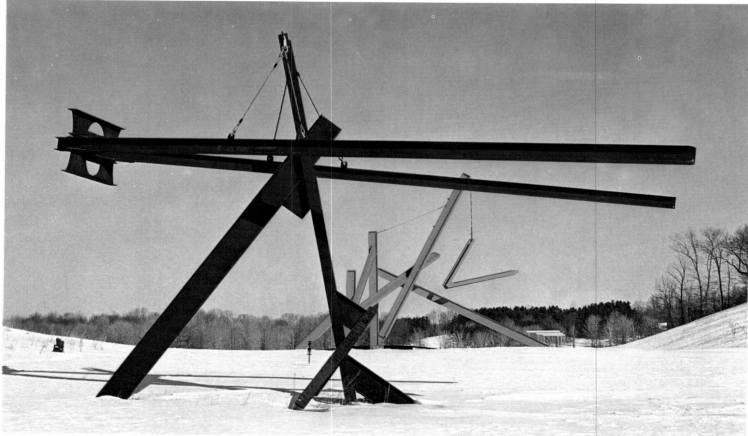

140a Don(ald) Judd, *Untitled*. Painted cold-rolled steel; 1966. New York, Whitney Museum of American Art. Gift of the Howard and Jean Lipman Foundation

140b Mark di Suvero, *Ik Ook Eindhoven* (painted steel; 1971) and in the background *For Marianne Moore* (painted steel; 1967). Collection, the artist.

141 (opposite) Anthony Caro. *Midday*. Painted steel; 1960. New York, Museum of Modern Art. Mrs. Bernard F. Gimbel Fund.

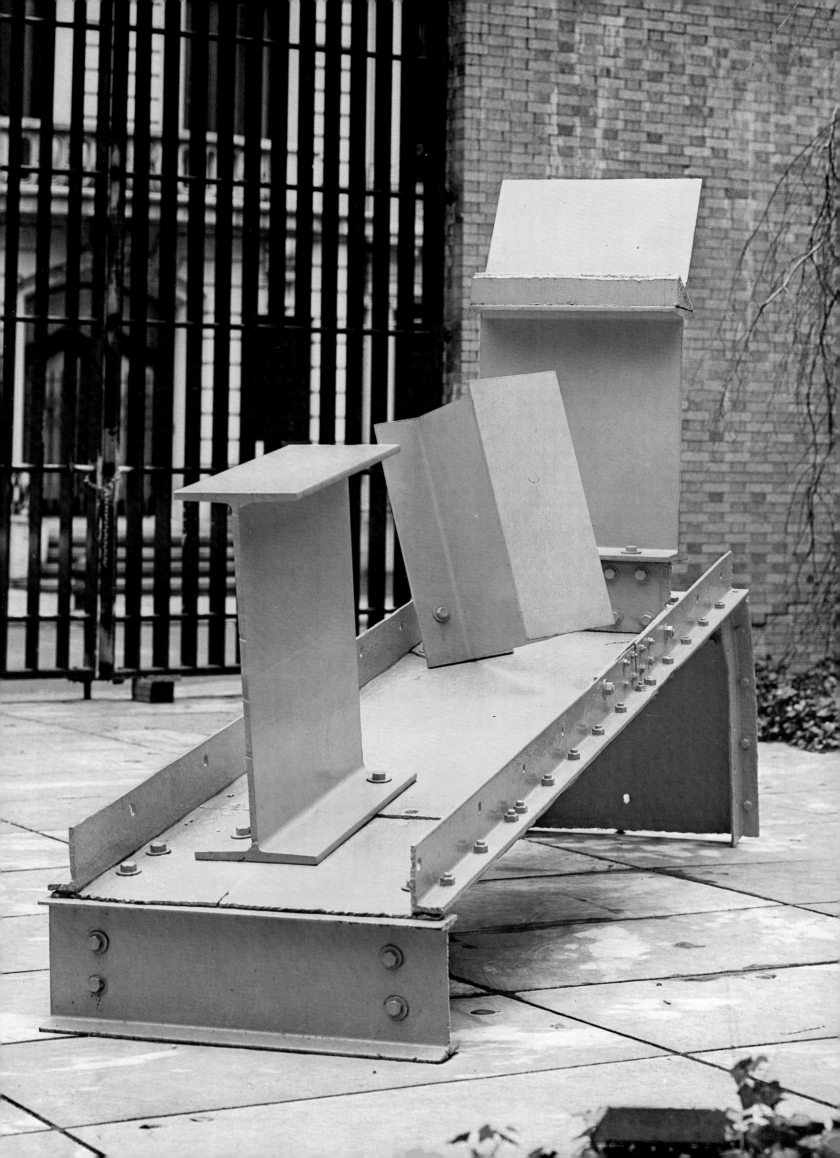

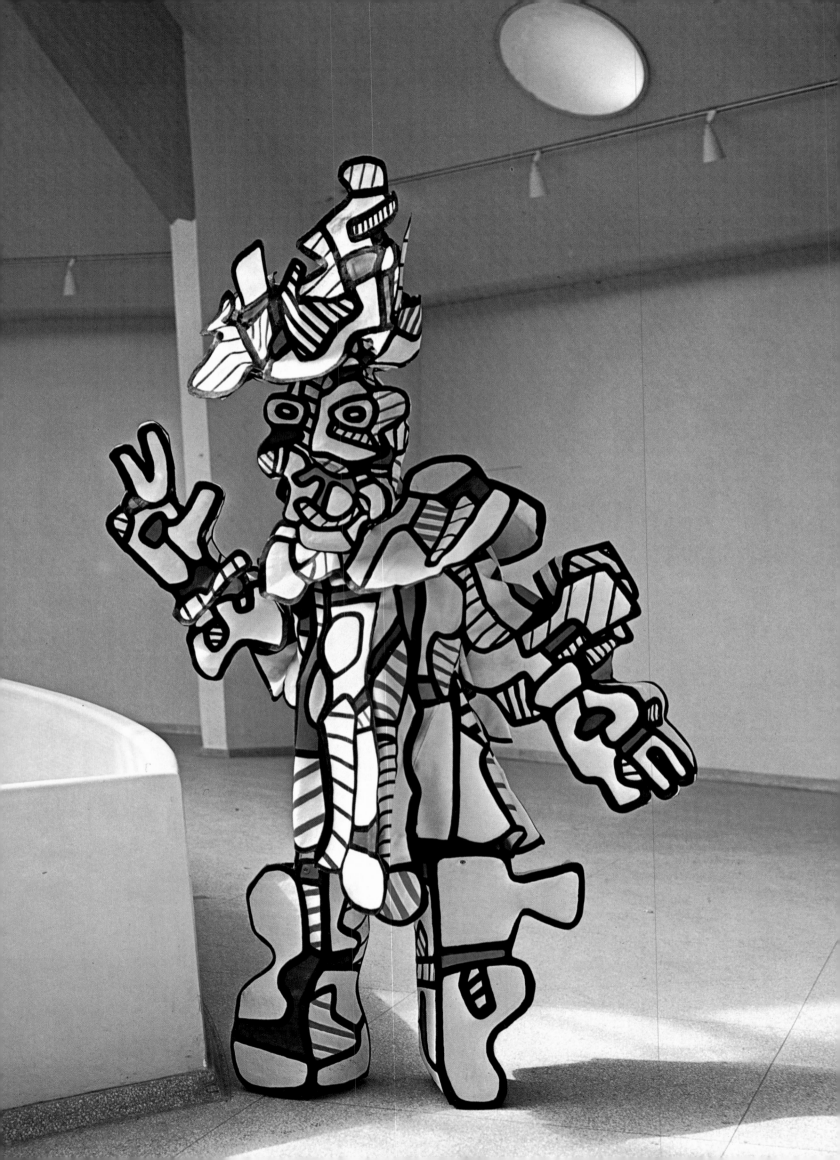

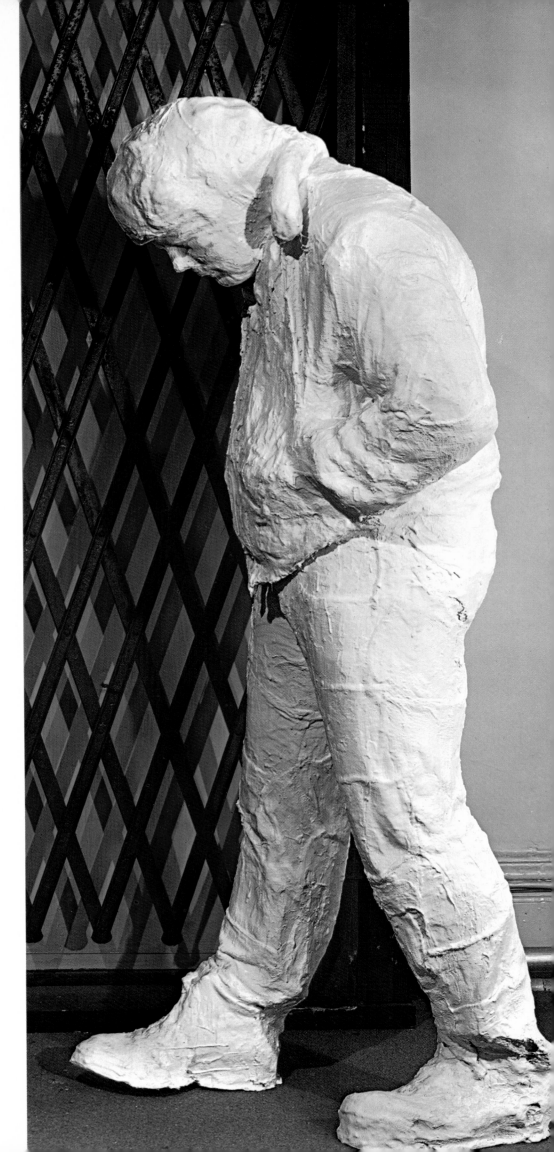

142 (opposite) Jean Dubuffet, *Milord La Chamarre*. Painted fabric and polyester resin costume; 1972. Created for *Coucou Bazar*, 1973, New York

143 George Segal, *Walking Man*. Plaster, painted metal, wood; 1966. St. Louis, Collection Mr. and Mrs. Norman B. Champ, Jr.

144a Edward Kienholz, *The Wait*. Tableau: epoxy, glass, wood, and found objects; 1964–65. New York, Whitney Museum of American Art. Gift of the Howard and Jean Lipman Foundation

144b John de Andrea, *Arden Anderson and Nora Murphy*. Polyester and fiberglass, polychromed in oil; 1972. Germany, Collection Charles Wilp

145 Claes Oldenburg, *Standing Mitt with Ball*. Steel, lead, and wood; 1973. Concord, Massachusetts, private collection

146 Nicolas Schöffer, *Chronos.*
Aluminum; 1968. Paris,
Collection the artist

147 (opposite)
Chryssa (Varda Chryssa),
Clytemnestra. Multicolored neon
tubing and molded plexiglass
with timer; 1968.
Berlin, Nationalgalerie

148 (overleaf) Christo
(Christo Javacheff), *Running Fence*
(detail). Nylon, steel poles and
cable; 1976. Marin and
Sonoma Counties, California

Notes on the Plates

1 *Crucifix of Archbishop Gero.* Polychromed oak; 969–71. Cologne, Cathedral. The earliest piece of large-scale Ottonian sculpture to survive, and the oldest independent crucifix. This powerful image shows the influence of Byzantine models on the workshops of Ottonian artists, but it is at the same time a masterpiece of Western art of great significance and influence. Although this image is obviously the central cult object in Christian thought, large-scale works of this kind were at first rare, probably because of conflicts over the place of images in Christian worship. The crucifix shown here may even have first served as a reliquary. The swaying body and stylized musculature, as well as the ornamental loincloth, are characteristic of Ottonian work. The monumental power of the image and the seemingly effortless mastery of the sculptor are unusual. The agonized face of Christ formerly led scholars to date this work a century later, but it seems more probable that it is the crucifix known to have been commissioned by Gero, who was archbishop of Cologne from 969–71.

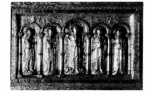

2a *Christ with St. Benedict* (far left) *and the Archangels Gabriel, Raphael, and Michael.* Altar frontal from Basel Cathedral (detail). Beaten gold; ca. 1022–24? (Cathedral consecrated 1019). Paris, Musée de Cluny. Probably executed in Fulda for the Ottonian emperor Henry II, who presented it to the Cathedral. At the feet of Christ are tiny prostrate figures of the Emperor and his wife, Queen Kunigunde. Unlike the lintel in Plate 2b, which is exactly contemporary, this sophisticated antependium shows fresh contact with Byzantine art in the decorative drapery and the relatively rounded and realistic, though stylized, bodies that approach a monumental conception. The figures appear to stand (as opposed to the vaguely floating figure in Plate 2b). Their outlines may point to an influence from contemporary manuscript illumination. The iconography of the Christ figure as *Salvator Mundi* is unusual for the time. Four rounded busts of the Cardinal Virtues (not shown) are again derived from Byzantium; below are figures of Donors.

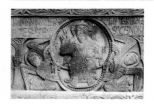

2b *Christ in Glory,* central section of lintel. Marble; 1019–20 (inscription). St.-Genis-des-Fontaines (Pyrénées), west portal. The crude flatness of this relief shows an artist whose models were painted, probably illuminated manuscripts, and who was relatively unsophisticated in stone carving. The inscription, like the patterned folds and anatomical features of the figures, suggests a dim memory of classical models transformed by a medieval mind and hand. The figures themselves reveal some contact with classical images (Christ) through Carolingian or Ottonian sources. Ultimately, the seated figure is based on pagan images of the enthroned emperor, and its representation in a circular frame held by angels is derived from the *imago clipeata* found on Roman sarcophagi. The angels are wholly unantique in their distortion, and the stylized patterning throughout is a typical early medieval reduction of what was once a believable representation of form and drapery in space. Nevertheless, this relief above a church portal foreshadows the Romanesque in its relationship to the architecture; some writers even call it Early Romanesque.

3 **Bonanno Pisano,** *Adam and Eve.* Bronze; 1185 (signed and dated). Monreale, Cathedral, doors (detail). Bonanno, from Pisa, as his name states, had executed the bronze doors for the Cathedral there in 1179–80; he was probably then called to Monreale. These doors are composed of four rows of plaques illustrating scenes from the Old and New Testaments, surmounted by Christ and Mary enthroned between Angels. In taste and design the doors are the product of an Arab-Sicilian art under Byzantine influence, which was then an international Mediterranean style. The clear, simplified nude figures depict our first forefathers in the act of succumbing to Original Sin. The serpent is shown on the left of the two trees that arch decoratively over the figures.
Bonanno was schooled in the work of the sculptor Guglielmo, who was in turn influenced by the art of Provence. But he would also have known Byzantine ivories. This is one of a great series of bronze doors that range from the engraved and inlaid work of Byzantine craftsmen to the vivacious realism of Germanic artists, a style that also filtered down to Verona. This Italian example is representative of the largest single group of surviving works, which includes other examples in Troia (two), Trani, Ravello, Monreale, and Pisa.

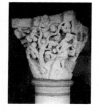

4 *Rivers and Trees of Paradise,* capital. Stone; ca. 1095 (but variously dated between 1090 and 1140). Cluny, Musée du Farinier. One of eight sculptured capitals that survive from the columns of the great arcade of the ambulatory of the former Abbey Church. The side not pictured here shows the fall of Adam and Eve. Something of the antique capital shape is preserved by the unknown artist, who set a decorative tree between the two rivers and made the figure at the corner a transitional form mediating between the round column below and the essentially square abacus above. The tree is charming in its unrealistic proportions and deep carving, whereas the figure is modeled with some subtlety and turns in a complex pose.

The sophisticated technique combined with a learned iconographic scheme probably indicate that this was no ordinary mason-sculptor but, rather, a fine artist trained in ivory or stucco work. The only precedents for sculpture of this quality come from Germanic lands, and it is probably there that we must look for the origins of this beautiful and sophisticated style.

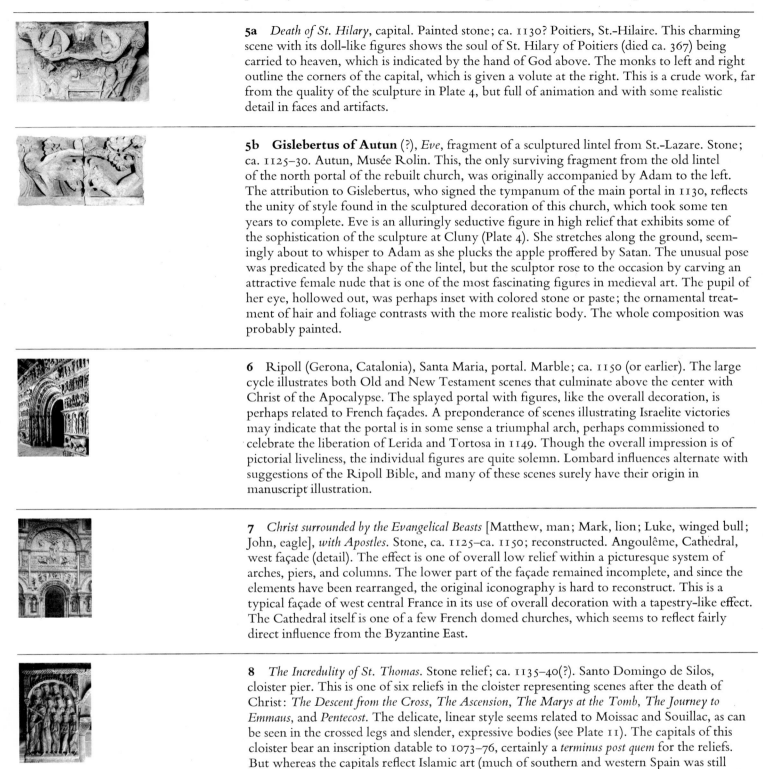

5a *Death of St. Hilary*, capital. Painted stone; ca. 1130? Poitiers, St.-Hilaire. This charming scene with its doll-like figures shows the soul of St. Hilary of Poitiers (died ca. 367) being carried to heaven, which is indicated by the hand of God above. The monks to left and right outline the corners of the capital, which is given a volute at the right. This is a crude work, far from the quality of the sculpture in Plate 4, but full of animation and with some realistic detail in faces and artifacts.

5b Gislebertus of Autun (?), *Eve*, fragment of a sculptured lintel from St.-Lazare. Stone; ca. 1125–30. Autun, Musée Rolin. This, the only surviving fragment from the old lintel of the north portal of the rebuilt church, was originally accompanied by Adam to the left. The attribution to Gislebertus, who signed the tympanum of the main portal in 1130, reflects the unity of style found in the sculptured decoration of this church, which took some ten years to complete. Eve is an alluringly seductive figure in high relief that exhibits some of the sophistication of the sculpture at Cluny (Plate 4). She stretches along the ground, seemingly about to whisper to Adam as she plucks the apple proffered by Satan. The unusual pose was predicated by the shape of the lintel, but the sculptor rose to the occasion by carving an attractive female nude that is one of the most fascinating figures in medieval art. The pupil of her eye, hollowed out, was perhaps inset with colored stone or paste; the ornamental treatment of hair and foliage contrasts with the more realistic body. The whole composition was probably painted.

6 Ripoll (Gerona, Catalonia), Santa Maria, portal. Marble; ca. 1150 (or earlier). The large cycle illustrates both Old and New Testament scenes that culminate above the center with Christ of the Apocalypse. The splayed portal with figures, like the overall decoration, is perhaps related to French façades. A preponderance of scenes illustrating Israelite victories may indicate that the portal is in some sense a triumphal arch, perhaps commissioned to celebrate the liberation of Lerida and Tortosa in 1149. Though the overall impression is of pictorial liveliness, the individual figures are quite solemn. Lombard influences alternate with suggestions of the Ripoll Bible, and many of these scenes surely have their origin in manuscript illustration.

7 *Christ surrounded by the Evangelical Beasts* [Matthew, man; Mark, lion; Luke, winged bull; John, eagle], *with Apostles*. Stone, ca. 1125–ca. 1150; reconstructed. Angoulême, Cathedral, west façade (detail). The effect is one of overall low relief within a picturesque system of arches, piers, and columns. The lower part of the façade remained incomplete, and since the elements have been rearranged, the original iconography is hard to reconstruct. This is a typical façade of west central France in its use of overall decoration with a tapestry-like effect. The Cathedral itself is one of a few French domed churches, which seems to reflect fairly direct influence from the Byzantine East.

8 *The Incredulity of St. Thomas*. Stone relief; ca. 1135–40(?). Santo Domingo de Silos, cloister pier. This is one of six reliefs in the cloister representing scenes after the death of Christ: *The Descent from the Cross, The Ascension, The Marys at the Tomb, The Journey to Emmaus*, and *Pentecost*. The delicate, linear style seems related to Moissac and Souillac, as can be seen in the crossed legs and slender, expressive bodies (see Plate 11). The capitals of this cloister bear an inscription datable to 1073–76, certainly a *terminus post quem* for the reliefs. But whereas the capitals reflect Islamic art (much of southern and western Spain was still under Moslem domination at this time) the panels are related to ivory carving and Mozarabic illumination.

9 *St. Trophime, St. John the Evangelist, St. Peter*. Stone; 1190–1200. Arles, St.-Trophime, west portal (detail). This impressive portal was inspired by that of St.-Gilles du Gard nearby. Although the workshop active here may well have known the west portal at Chartres (Fig. 11), the chief influences are local and reveal the imitation of Roman architecture and sculpture, which abounds in the region. This Roman flavor is evident throughout: in the free-standing columns, in the frieze above the figures, in the massive figures themselves, with their classical togas falling in rich folds, and in their noble gestures and attitudes.

10 *David.* Granite relief; ca. 1120. Puerta de las Platerías (west jamb). Santiago de Compostela, Cathedral. This detail is from what is probably the earliest of the three Romanesque façades of the Cathedral, but the sculptures vary greatly in style and even in date. This figure may be later than much of the rest (a fire of 1117 made necessary a rearrangement and some new additions). David is shown as king and musician; his crossed legs and feet crush a clawed, tusked monster. The figure bears a resemblance to figures at Toulouse but is more richly decorated, as is typical of Santiago in general.

11 *Isaiah.* Stone; ca. 1130–40. Souillac, Abbey Church, portal (fragment). The portal, which was gravely injured by rioting Calvinists in 1562, is focused on Mary and shows Isaiah, who supposedly prophesied the Virgin Birth, and Hosea, as well as marvelous tangled figures of grotesque energy on the *trumeau.* The style is related to that of Moissac (1115–20) and Beaulieu, and since Moissac was a Cluniac church, they all connect somewhat with Cluny to the east. Here we see a style of unparalleled linear grace. The tense, visionary figure seems to dance and swing his robes around and out as he displays his scroll with the prophetic message. His excessively slender, elongated body is revealed schematically beneath the swirling drapery, which was originally painted red.

12 Baptismal Font. Bronze; 1240–50. Hildesheim, Cathedral. This most finished example of medieval German Gothic metalwork is supported on four symbolic figures representing the four Rivers of Paradise (cf. Plate 4). The font itself is decorated with a program relating to Baptism (*The Baptism of Christ, Crossing of the Red Sea, The Crossing of the River Jordan*) and a fourth scene, *The Virgin and Saints.* Cardinal Virtues, Prophets, and Evangelical symbols surmount the kneeling figures to frame the main groupings. There are more scenes on the lid, including *Christ Enthroned* (visible here). In style these vignettes are indebted to miniature paintings and to Byzantine influences that give a harmony and axiality to the composition.

13 **Nicholas of Verdun,** *Reliquary of the Three Magi* (façade). Oak chest with applied embossed panels of metal, enamels, jewels; 1181/91–ca. 1230. Cologne, Cathedral. Above, *Christ Enthroned with Angels;* below, *The Adoration of the Magi with Emperor Otto IV* and *The Baptism of Christ.* This magnificent shrine encloses relics that had recently been acquired from Milan. It is in the form of an aisled basilican church with an unusually high clerestory area. On the sides are Prophets and Patriarchs below, Apostles above. This reliquary is the last work of Nicholas of Verdun, who worked on the façade shown here in 1198–1200. The figures display a new and refined drapery style of folds that reveal the bodies beneath. There is clear evidence of classical influence in the realistic tendencies seen in the Prophets and Apostles. Nicholas was the most original artist of his time and the precursor of Gothic naturalism.

14 *Madonna from Ger.* Polychromed wood; ca. 1150–1200. Barcelona, Museo de Arte Cataluña. This beautiful example of Spanish Romanesque woodcarving is one of a great series of images that were sometimes also reliquaries. Many were sheathed in metal and encrusted with jewels—the earliest and most famous is at Ste.-Foy in Conques and is of the ninth or tenth century. Such a statue was called a *Maestas* and depicts the Virgin Mary as the Throne of Wisdom and the Mother of God (*Theotokos*). They are true cult statues, Christian idols in a sense, and were probably carried in processions and often moved about—hence the damage typically found on their lower extremities.

15 **Arnolfo di Cambio** (died ca. 1302), *Enthroned Madonna.* Marble; ca. 1282. Orvieto, San Domenico, Tomb of Cardinal de Braye. Obviously inspired by ancient marble statuary, Arnolfo shows his architectonic interests here in a majestic *Madonna* that may have influenced Giotto. Arnolfo was a pupil of Nicola Pisano and worked on his great pulpit in Siena (finished 1268); here he shows a new interest in classicism that is evident in most of his later works. The inlaid glass pattern-work is related to that of the Cosmati, marble and mosaic workers of this period in Rome. Arnolfo was also a great architect and planned the Cathedral of Florence.

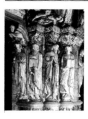

16 **Master Mateo,** *Apostles.* Granite, formerly polychromed; 1188 (signed and dated). Santiago de Compostela, Cathedral, Puerta de la Gloria. Sometimes considered the first Gothic portal in Europe, this is the highest achievement of the Spanish "pilgrimage style" and shows a late Romanesque moving into something like Gothic. Turning and gesticulating as if in lively conversation, the figures at the left even seem to have their lips parted in speech. The animated, benign expressions seem symptomatic of the new style, as do the active draperies of classical inspiration. The elaborately interlaced capitals above are, however, typical of the Romanesque.

17 *Annunciation* and *Visitation*. Stone; ca. 1230–33; Angel, ca. 1245–55. Reims, Cathedral, west façade, central portal (right jamb). The *Visitation* at the right is the most famous example of a classical renascence in Gothic sculpture, notable in the easy poses and drapery style. Despite the antique vocabulary, these are distinctively medieval figures with faces of finely observed realism. The *Annunciation* is evidently a composite, with a charming, smiling angel that must have been moved from another, later group and whose right wing has been removed to fit into the new space. The simple Virgin, markedly different from that of the *Visitation*, has smooth drapery that hangs in regular folds over her rigid figure; the angel's more deeply cut drapery pulls around the figure in jagged folds. But neither figure is related in style to the *Visitation* (see Fig. 12).

18 *Jonah* and *Hosea*. Stone; ca. 1225–30. Bamberg, Cathedral, St. George's Choir Screen. The master of these statues, a major medieval artist, was influenced by South German book illumination. The expressive poses and gestures are echoed by the deeply undercut, decorative draperies that fall and swirl in heavy folds about the bodies. Jonah is partially nude. There seems to be some contact here with the drapery styles of late antiquity, but the deep furrows may well come from France. Nevertheless, such sculptures are obviously far from the spirit of the French Gothic and seem, rather, to be a continuation of the expressionism typical of the Romanesque.

19 *The Elect*. Stone; 1255–60? Bourges, Cathedral, west façade, tympanum of central (Judgment) portal. These happy figures are among the saved souls in a representation of the Last Judgment; led by St. Peter, a Franciscan monk, and a king, they are about to enter the gates of Paradise. The iconography of the entire Last Judgment follows the example of Nôtre-Dame in Paris. The figures here are the product of a workshop different from that of the other figures on the façade. The refinements of style visible at Reims (see Plate 17) and Amiens are continued here on a more popular level.

20 **Giovanni Pisano** (ca. 1245/50–after 1314), Pulpit. Marble; finished 1301 (inscription). Pistoia, Sant'Andrea. This is the best preserved of Giovanni's pulpits; it has never been restored, and there may originally have been some polychromy that is now lost. By this time in his career Giovanni had come under the influence of French Gothic sculpture, but there is still evident a debt to Nicola's pulpits in the humanity and emotional content of the scenes. The relief is often very high, with framing elements almost free-standing. The scenes from the life of Christ are divided by angels and other figures. Over the arches are Prophets and, between them, Sibyls, seers who foresaw the coming of Christ. Four of the columns are supported by symbols of the Evangelists. The statuettes are related to the figures Giovanni carved for the façade of the Cathedral of Siena, which was also his design.

21 **Claus Sluter** (active ca. 1380–1405/6), "Well of Moses." Polychromed and gilded stone; 1395–1403. Dijon, Chartreuse de Champmol. This famous work was originally part of a monumental Calvary composition in the center of the cloister and had above it a large cross with figures of Jesus, Mary, and John, largely destroyed during the French Revolution. Sluter was probably from Haarlem, worked in Brussels, then went to Paris whence he entered the service of Philip the Bold of Burgundy in 1385. He is the greatest Northern sculptor of the period, and his works have a lively realism and an active surface that gives a sense of the volume of the form beneath. Although the overall composition is calm, the figures of the six Prophets are independent of the architectural background, with strongly individual qualities and portraitlike faces (seen here are David, Daniel, and Isaiah).

22–23 **Claus Sluter** (active ca. 1380–1405/6), *Tomb of Philip the Bold, Duke of Burgundy* (died 1404). Black marble slab, white alabaster figures, partly painted; finished 1410, later reconstructed. Dijon, Musée des Beaux-Arts. Left unfinished at Sluter's death, the tomb was completed by his nephew Claus de Werve. Although traditional in form, with the over-life-size image of the deceased lying in state with mourning angels at his head, this tomb was enormously influential because of the parade of realistically mourning monks in the Gothic arcade below. The figure of Philip has been badly restored, but it is surely Sluter's imagination that transformed the mourners, traditionally shown in relief, into this affecting procession of Carthusians led by choirboys, a cross-bearer, a deacon, an abbot, and singers. When the tomb was removed from the Chartreuse de Champmol, the figures were badly damaged and restored, and the original composition of the procession is now partially lost. The majority of the "pleureurs" are probably by Claus de Werve and Hennequin de Prindale.

24 **Giovanni Pisano** (ca. 1245/50–after 1314), *Madonna*. Marble; 1305–6 (inscribed: DEO GRATIAS + OPUS JOHANNIS MAGISTRI NICOLI DE PISIS). Padua, Arena (Scrovegni) Chapel. This relaxed but majestic figure combines a French Gothic sway with an Italianate head. The Christ Child, lively and naturalistic, looks into his Mother's face and she turns her powerful Mediterranean profile to him. The figure, contemporary with the famous frescoes by Giotto in the same chapel, was done at the same time as Giovanni's last pulpit, in the Cathedral of Pisa. The *Madonna* was ordered from Pisa by the patron, Enrico Scrovegni, and there is no reason to assume that the sculptor went to Padua. The tall, elegant proportions and fluted, tubular drapery point to French Gothic influence, which by this time had swept over most of western Europe.

25 **Tilman Riemenschneider** (ca. 1460–1531), *Madonna* from Würzburg Cathedral. Gilded and painted lindenwood; ca. 1485. Vienna, Kunsthistoris_..es Museum. This is probably an early work by the master, a Northerner who appeared in Würzburg as a journeyman in 1479, settled there in 1483, and attained citizenship and master's status in 1485. By and large, Riemenschneider preferred to leave his wood carvings uncolored; this work may, like others, have been painted somewhat later by someone else. The pretty *Madonna* holds out her baby, whose nakedness contrasts with her elaborate and decorative Late Gothic drapery. The crescent moon at her feet is that of the Apocalyptic Woman (Rev. 12:1) and refers to the Immaculate Conception, a popular idea that became dogma only much later.

26 **Michael Pacher** (ca. 1435–1498), *St. Florian*, St. Wolfgang Altarpiece (detail). Gilded and painted wood: 1471–81. St. Wolfgang, pilgrimage church. This is one of two life-size figures on the outside of Pacher's masterpiece, the largest German altarpiece of the Middle Ages, which combines painted sculpture, painting, and architecture. The greatest Tyrolean artist, both painter and sculptor, Pacher is an intermediary figure between the Gothic North and Italy. In his painting, particularly, we see the influence of Mantegna; his sculpture is less Italianate. The graceful figure of St. Florian extinguishes a fire with his right hand and holds a large pike in the other. The saint's elegant suit of mail gives him a fashionable air that is emphasized by his sophisticated *contrapposto* pose (see Fig. 15).

27 *Angel Pilaster* (detail). Polychromed sandstone; ca. 1230. Strasbourg, Cathedral. These unique figures rise on a tall central pier of the south transept. In style they parallel the figures of *Ecclesia* and *Synagoga* by the same master, who came from a group of sculptors previously active at Reims. The figures form part of a Last Judgment on three tiers, four figures on each. Below are four Evangelists, then these four Angels dressed as deacons, and above them Christ the Judge with angels holding instruments of the Passion. The flat, clinging folds of the patterned drapery accentuate the slender, rather unanatomical forms. The heads are individual and expressive, with colored flesh, hair, and eyes.

28–29 **Tilman Riemenschneider** (ca. 1460–1531), *Altar of the Holy Blood*. Lindenwood figures, pine frame; 1501–04/5. Rothenburg ob der Tauber, Jakobskirche. Only the figures are by Riemenschneider; the dark stain dates from the nineteenth century. The *Last Supper* is framed by *Christ's Entry into Jerusalem* and *Christ on the Mount of Olives*. Not visible: *The Annunciation*; *Ecce Homo*; *Angels*. The Altar gets its name from a relic of the Blood of Christ held in a cross above. This great altar is typical of Riemenschneider's mature art in its moving, lyrical representation of the Christian drama. Originally the scenes were in the form of a chapel constructed so as to have the western light flood through the glass seen behind the central group.

30 **Gil de Siloe** (active 1486–1505), *Tomb Monument of the Infante Alfonso* (died 1468). Alabaster; designed 1486, executed 1489–93. Burgos, Cartuja de Miraflores. This wall memorial was commissioned by Alfonso's successor, Isabella, and was probably built in collaboration with the architect. The young Infante kneels in eternal adoration in a setting of overpowering ornamental richness. The massing of designs and textures is typical of Spain, especially of Spanish Gothic. The intense, almost unbearable elaboration is related to lower Rhenish sculpture; the vigorous realism of the figure is typical of the Hispano-Flemish style—Spain governed the Netherlands and was flooded with Netherlandish art and even artists.

31 *Can Grande della Scala* (died 1329). Marble; ca. 1330. Verona, Castelvecchio. The unknown artist has shown a memorable, crudely grinning warrior mounted on his elaborately armored steed, posed on a tomb high above the city he ruled. Both horse and man have headdresses capped with frightening devices—Can Grande's, appropriately, with a big dog. The vigorous naturalism and sense of life are unique, but this monument ultimately derives from Germanic sources. Such equestrian funerary monuments became a Veronese speciality and ultimately influenced Donatello's *Gattamelata* (Plate 47; Fig. 19).

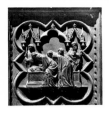

32 **Andrea Pisano** (Andrea da Pontedera; ca. 1290–1348), *Burial of St. John the Baptist*. Gilded bronze; 1330, set up 1336. Florence, Baptistery, doors (detail). Andrea first appears as an artist in these doors, which reflect both the powerfully expressive simplicity of Giotto and the French Gothic (quatrefoil frames). The reliefs were cast separately and then placed within the quatrefoils. The iconography of the cycle is influenced by the mosaics of the Baptistery dome, but the intense scene of the aged Baptist being laid to rest is Giottesque and Florentine. The idea of providing the Florentine Baptistery with a set of bronze doors is first recorded in 1322. Andrea's doors are double and comprise a total of twenty-eight scenes; in each wing the ten upper reliefs show scenes of the life of St. John the Baptist and the four lower reliefs depict Virtues. A document of 1329 refers to the doors (now destroyed) executed by Bonanno for the Cathedral of Pisa, and Bonanno's works may well have influenced Andrea in his earliest ideas for these (see Plate 3).

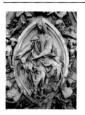

33 **Nanni di Banco** (ca. 1384–1421), *Assumption of the Virgin Mary*. Marble; commissioned 1414, left "incomplete" at Nanni's death in 1421, installed 1423. Florence, Cathedral of Santa Maria del Fiore, Porta della Mandorla (detail). This portal, the chief one on the north side of the Cathedral, was begun in 1391; Nanni's relief is the uppermost and last portion of the decoration. It shows Mary being taken up to heaven while dropping her girdle to the Apostle Thomas, who kneels below at the left (not shown). The primarily Gothic design of the pinnacle containing the pointed mandorla is reflected in the elongated figure, which is far less classical than Nanni's earlier figures of Saints for Or San Michele. The Virgin's dynamically twisting pose and dramatic gesture make this a transitional work between Gothic and Renaissance. The windblown drapery of the angels parallels work by Jacopo della Quercia.

34 **Jacopo della Quercia** (ca. 1374–1438), *The Creation of Eve*. Istrian stone; 1430–34. Bologna, San Petronio, portal (detail). This panel from Quercia's celebrated decoration shows his low-relief style with figures carefully accommodated to the rear plane and completely dominating the background. Quercia's investigation of anatomy is only superficial, and his Sienese background is revealed in the essentially ornamental drapery and surface patterns. Nevertheless, the grave dignity of God's action in summoning Eve out of the sleeping Adam's side is unforgettable and may well have influenced Michelangelo's depiction of the scene on the Sistine Chapel ceiling (ca. 1510). Quercia's interpretation is personal and even lyrical: As Adam divides into two, the solitary tree behind also seems to split; Eve, in her first consciousness, examines her limp hand with quizzical wonder.

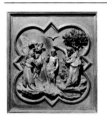

35 **Lorenzo Ghiberti** (1378–1455), *The Baptism of Christ*. Gilded bronze; 1407–24. Florence, Baptistery, north (originally east) doors (detail). This panel is from the first set of bronze doors executed by Ghiberti, who won the competition of 1401 (see Figs. 16, 17). The general scheme of the doors follows that of Andrea Pisano (see Plate 32) but reads from the bottom up. This scene is one of the earliest, perhaps done soon after 1409, and shows a crowded composition close in style to Ghiberti's competition panel. The swaying, schematized figure of John (right) with his ornamental drapery is still clearly attached to the International Gothic style, which was then in full command of most of western Europe. Both figures and landscape stand out against a blank background in a clear composition that only partially reflects the ornamental quatrefoil frame. Compared with Andrea Pisano's composition, Ghiberti seems to move the figures out in front of the decorative border, a step that ultimately led to the complete rejection of medieval frames on his second set of doors.

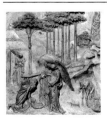

36 **Lorenzo Ghiberti** (1378–1455), *The Story of Abraham* (detail). Gilded bronze; commissioned 1425, cast by 1436, finished 1452. Florence, Baptistery, east doors. These doors (Fig. 18) abandon the busy Gothic scheme of the earlier sets (Plates 32, 35; see Fig. 17) for a simpler rectangular format with five large scenes to each door. This, the second panel from the top of the right door, probably dates from 1432–34. Since the panels are reduced in number, several scenes are usually shown in each, all set within a broad perspective with landscape or architectural background. The foreground scene is set into a landscape background executed in progressively lower relief with brilliant spatial and pictorial effect. This is a kind of sculptured painting, full of Ghiberti's lyrical charm and poetic imagination, exemplified by the speaking angel at the front. The entire panel is heavily gilded.

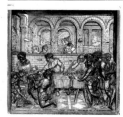

37 **Donatello** (1386–1466), *Herod Presented with the Head of St. John the Baptist*. Gilded bronze; 1423–27. Siena, Baptistery, baptismal font (detail). Far more than in Ghiberti's reliefs, we see here the exploitation of the newly discovered laws of perspective applied to a complex architectural background. In the rear, left, the bearer approaches with John's head, perhaps to present it to Herodias. Although the orthogonals of the foreground floor do not vanish to a single point, this is the first relief that seems to illustrate the laws of perspective first expounded in Alberti's *Della pittura* of the 1430s. Since the relief, which is one of a series by

distinguished artists, decorates a rather low font, the viewpoint is appropriately close and high. Unlike either Quercia or Ghiberti, Donatello is the master of a dramatic style based on antique proportions and drapery style. The insistent patterning is typical of his intense, emotional approach to narrative. The horrifying act of presenting John's severed head to Herod is reflected in the faces of the guests, who exhibit all the familiar variations of human reaction, while the musician behind fiddles on in ignorance and Salome, in the right foreground, begins her voluptuous dance.

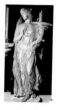

38 Donatello (1386–1466), *David*. Bronze; ca. 1430/40(?). Florence, Museo Nazionale del Bargello. Both the material and the nudity of this enigmatic figure clearly show that Donatello was quite consciously producing a work in emulation of antique statues. The origins of the commission are unknown; by 1469 the figure stood on a column in the courtyard of the Medici Palace, whence it made its way into the public collections. The combination of nudity with the ornamental hat and leather boots on his legs gives the statue a provocative quality that has aroused comment. Donatello's technique was barely sufficient to produce this statue, which is patched in some places and betrays less than masterly modeling in others. Nevertheless, the youthful figure is an art-historical classic, an uneasy amalgam of fresh observation and antique prototypes that typifies the best features of the early Florentine Renaissance: novel, daring, awkwardly beautiful.

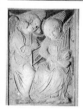

39 Francesco di Giorgio (1439–1501/2), *Angel Bearing a Candlestick*. Bronze; finished 1497. Siena, Cathedral, high altar. One of a pair, this aristocratic figure of fluid grace seems more an example of the art of drawing or relief than a free-standing, cast figure. Although there is a sense of the moving body gliding underneath the sheath of metal drapery, this charming statue is particularly notable for its decorative surface, veined with linear detail. The entire surface is chased and finely polished. Reflected light here becomes an instrument of design, sending out faceted messages that tend to interfere with our perception of the figure as an anatomical whole. This *Angel* with its pendant originally flanked Duccio's famous *Maestà* on the high altar.

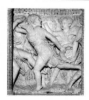

40 Agostino di Duccio (1418–1481) or **Matteo de'Pasti** (ca. 1420–1467/68), *Music-Making Angels*. Marble; 1450–57. Rimini, San Francesco, Chapel of St. Michael (di Isotta). This church, drastically remodeled according to a new design by Leon Battista Alberti about 1450, is the most richly sculptured Renaissance building in Italy, but the attributions of the reliefs in the various chapels are not altogether reliable. Matteo de'Pasti, also a great medallist, was in charge of the architecture, Agostino di Duccio the sculpture; but various authorities divide the reliefs between them and certainly there are stylistic and qualitative differences. Pope-Hennessy assigned this and other reliefs in the Isotta Chapel to Matteo de'Pasti, who would thus be the originator of the fluid, decorative low-relief style with its elegant linear rhythms that is seen here and elsewhere in the church. If Matteo did invent this style, it can be traced easily to the Veronese International Gothic, whose best-known practitioner was Pisanello. But the patterned elegance of the drapery may also have some relationship to the abstract decorative formulas of Byzantine ivory carving.

41 Donatello (ca. 1386–1466), *Cantoria* (detail). Marble; 1433–39. Florence, Museo dell'Opera del Duomo. Unlike Luca della Robbia's *Cantoria* of 1432–37, Donatello's shows a continuous frieze of life-size dancing figures in the narrow space between the colonnettes and the patterned ground. Moving fluently from very high to low relief, Donatello created a believable spatial scene in a cramped and unlikely setting, with the foreground figures moving one way and the back ones the other, as if to set up a circular compostion. The inspiration came from Roman sarcophagi of playing children, but the turbulent action seems quite different from the serene order of the classical world.

42 Antonio Rossellino (1427–ca. 1479) and **Bernardo Rossellino** (1409–1464), *Chapel and Tomb of the Cardinal of Portugal*. Marble and other materials, partly painted; 1461–66. Florence, San Miniato al Monte. Part of a larger design by the architect Antonio Manetti (1423–1497), a follower of Brunelleschi, this tomb is the focal point of a Renaissance chapel exhibiting all three major arts in equilibrium. The open curtains reveal a niche in which the Cardinal is shown lying in state above his bier, attended by angels and watched over by the Madonna, a novel *tableau vivant*. The chapel contains a ceiling in glazed polychrome terracotta by Luca della Robbia and frescoes by Antonio del Pollaiuolo and Alesso Baldovinetti; originally there was also an altarpiece (now in the Uffizi) by the Pollaiuolo brothers. Both the figure and the sarcophagus have ancient Roman models; the tomb rests on a base decorated with Mithraic and other pseudo-antique scenes. The surface of much of the marble seems originally to have been colored: the columns, capitals, and robes of the Cardinal were once gilded, the curtain and wall were originally red.

43 **Andrea del Verrocchio** (1435–1488), *Tomb of Piero and Giovanni de'Medici*. Porphyry and bronze sarcophagus on a marble base set on bronze tortoises; *pietra serena* architecture with marble frieze; bronze grill; 1469–72. Florence, San Lorenzo, between the left transept and the Old Sacristy. This richly ornamented decoration has a majestic austerity because of its lack of figural decoration. The splayed face of the arch reveals an elaborate foliate frieze growing out of two ornamental vases. This design, a fusion of Early Renaissance architecture and sculptural decoration, is the grandest example of a common type of Florentine tomb without an effigy. Much of its character derives from the need to fit it into Brunelleschi's pre-existing architecture; and the bronze complements Donatello's bronze doors within the Sacristy. The richness of effect derives from the contrast of the dark green epitaphs framed in bronze within the red porphyry, which is in turn framed by exuberant bronze foliage.

44–45 **Antonio del Pollaiuolo** (ca. 1432–1498) and **Piero del Pollaiuolo** (ca. 1441–1496), *Tomb of Pope Sixtus IV*. Gilded bronze; begun 1484, finished 1493 (inscription). Rome, St. Peter's, Grotte Vaticane. Pope Sixtus died in 1484; the commission for his tomb was given to Antonio del Pollaiuolo by the Pope's nephew, the future Pope Julius II. The lower part of the tomb is a chamfered bronze pedestal with the Seven Liberal Arts in deep relief, separated by acanthus foliage. Above this is a flat slab composed of reliefs of the Seven Virtues. The bronze effigy of the Pope lies above, the head fully modeled, the body in high relief. Since the low reliefs of the Virtues are not easily legible from the side, it seems possible that at first only the top slab and effigy were planned and that the base was an afterthought. Classical motifs abound in the Liberal Arts section, but the program is essentially medieval.

46 **Andrea del Verrocchio** (1435–1488), *Bust of Woman with Flowers* (Ginevra de'Benci?). Marble; ca. 1475–80. Florence, Museo Nazionale del Bargello. This outstanding portrait bust breaks new ground in its inclusion of partially free-standing arms and hands and its lengthening of the body down to a believable half person. Despite this new sculptural freedom, the ornamental detail of the dress is done in the most delicate low relief. Verrocchio was the teacher of Leonardo da Vinci, whose portrait of Ginevra de'Benci (ca. 1478; Washington, National Gallery) shows a similar pose and person, and may have included comparable hands. This correspondence reveals Leonardo's dependence on his teacher, also evident in other respects, but it should not tempt us (as it has others) to attribute the sculpture to Leonardo himself. The sense of *contrapposto*, with elements of the composition disposed off center, indicates a departure from the frozen rigidity of other busts (see Plate 49) toward a more sculptured sense of the potentially living figure in space, a development that culminated in Leonardo's *Mona Lisa*.

47 **Donatello** (ca. 1386–1466), *Gattamelata* (Erasmo da Narni), detail. Bronze equestrian statue, marble base, limestone pedestal; 1445–50. Padua, Piazza del Santo. Famous as the first monumental bronze equestrian statue since antiquity (Fig. 19), the *Gattamelata* was nevertheless planned as a cemetery memorial and so has connections with medieval monuments such as that in Plate 31. The obvious model was the ancient bronze equestrian statue of Marcus Aurelius in Rome, but the horse may have been modeled on the closer examples of ancient bronze horses on San Marco in Venice. The portrait of Gattamelata himself seems to be wholly imaginary and is based on busts of Julius Caesar. Thus the imagery is carried through, equating a Renaissance *condottiere* with the imperial might of Rome. Erasmo da Narni was the Captain-General of the Republic of Venice. When he died of a stroke in Padua early in 1443, Donatello was then working on the high altar of Sant'Antonio in Padua and was the natural choice for this epoch-making commission. It was essentially finished in 1450, the equestrian statue itself having been cast in the shop of a bell founder in 1447.

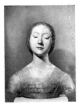

48 **Francesco Laurana** (ca. 1430–1502), *Bust of a Woman* ("Isabella of Aragon"). Tinted marble; ca. 1487–88? Vienna, Kunsthistorisches Museum. Laurana, a peripatetic artist of the court, was born in Zara and died at Avignon. He was active in Naples, where this bust was probably carved. Laurana's art tends toward the abstract, and the idiosyncrasies of the sitter are in every case suppressed in favor of a cool, schematized beauty. This kind of frozen likeness very often makes critics think of posthumous portraiture, but in fact Laurana's subjects were almost invariably alive. It is, rather, his reduction of individual heads to geometric stereotypes that invokes the sense of a masklike beauty. This lovely bust, despite its abstraction, is given lifelike color, as if to compensate for the almost deathly rigidity of Laurana's frozen style.

49 **Andrea del Verrocchio** (workshop?), *Bust of a Woman* ("Isotta degli Atti"). Wood, gilded and polychromed; ca. 1461–64. Paris, Louvre. Although this charming bust has often been attributed to Desiderio da Settignano, a sculptor of rare delicacy, it is probably not by him, or even necessarily Florentine; it was once attributed to Francesco di Giorgio (1439–1501/2). This kind of polychromed wooden portrait is much closer to folk traditions than the bust in Plate 48 and emphasizes individual details of costume and coiffure. By comparison with Verrocchio's bust in Plate 46, this attractive portrait is a relatively rigid, conventional work without either insight into the personality of the sitter or a powerfully individual sculptural style. Verrocchio's shop, nevertheless, seems closer to the mark than Desiderio's as the potential source of this bust.

50 **Niccolò dell'Arca** (died 1494). *Angel with a Candlestick*. Marble; ca. 1469–78. Bologna, San Domenico, Shrine of St. Dominic. This charmingly serious angel is part of a large sculptural tomb begun by Nicola Pisano in the thirteenth century and finished only in the sixteenth. Niccolò, who was from Bari, in Apulia, arrived in Bologna in the 1460s and began to work on the upper level of the Arca di San Domenico in 1469, thus getting his familiar name. His design was to display a large amount of free-standing sculpture, with God the Father at the summit, evangelists at the corners of the upper level, and eight saints below. This angel is one of two who adore the image of Christ on the front of the monument. After Niccolò's death the young Michelangelo carved the second angel and two saints. Niccolò's figure, although hardly more than a statuette, has a simple fall of drapery and a soft, smooth surface that belies its size. Usually compared unfavorably with Michelangelo's more monumental and virile angel, this is a work of high quality and great appeal.

51 **Il Riccio** (Andrea Briosco; 1470/75–1532), *Putto with Tragic Mask*, Easter Candlestick (detail). Bronze, marble base; 1507–15. Padua, Sant'Antonio. Riccio was especially noted for his small bronzes, often done in rivalry with the antique. This very secular putto resting on a Paschal candlestick is typical of the Paduan Humanism that produced Mantegna, which moved easily between pagan inspiration and Christian devotion. Riccio was trained as a goldsmith and worked in the shop of the bronze sculptor Bartolommeo Bellano, Donatello's last great follower. Riccio was close to Pomponio Gaurico, who wrote a treatise on sculpture (1504) that emphasizes the joys of the connoisseur in just such statuettes and plaquettes as Riccio produced.
The Paschal Candlestick is an elaborate confection of many levels devised by the scholar Giambattista de Leone with alternating religious and profane figures and scenes—satyrs, centaurs, putti, and sphinxes are combined with reliefs of Religion, Theology, the Virtues, and the Life of Christ. Every part of this large bronze is produced with a finish and elegance and individuality that make it a masterpiece of its kind. Riccio also later designed separate statuettes and even fire-dogs from this almost inexhaustible treasure trove of sculptural motifs.

52–53 **Guido Mazzoni** (died 1518), *Lamentation over the Body of the Dead Christ* (*Pietà*). Painted terracotta; 1477–80. Modena, San Giovanni della Buona Morte. Mazzoni specialized in this kind of terracotta tableau, which depends on a highly emotional and individual group in Bologna by Niccolò dell'Arca of 1462–63 that was evidently influential on both the sculpture and painting of this region. Niccolò, who was considered a madman, was less successful than the more stolid Mazzoni, who turned out sculptures such as this by the yard, not only in north Italy but in Naples and France. The somewhat conventional poses and gestures are often relieved by charming genre details and bits of realistic observation. His realism is based on the acceptance of life casts (or death masks) as the starting point for art. Such artifacts were common ex-votos in holy places, and Verrocchio's studio was reported to have had life casts of faces, hands, feet, and even bodies. A group such as this must have been painted many times, but strikingly lifelike realism was probably always desired.

54–55 **Michelangelo Buonarroti** (1475–1564), *Battle Relief*. Marble; 1491–92. Florence, Casa Buonarroti. This very early relief was carved while the teenage Michelangelo was living as a privileged guest in the house of Lorenzo de'Medici, "Il Magnifico"; it was reportedly just finished when Lorenzo died in the spring of 1492. Actually it is not finished: details are left uncarved, and the strip at the top, which may have been first projected as a landscape, was left in the rough. Michelangelo already shows his active, muscular ideal in these battling figures; he also seems to show his bias toward the human nude, for although the subject was supposedly the Battle of the Centaurs, we find their horselike hindquarters only with difficulty among the mass of male nudes. The story, which is found on the Parthenon metopes, is the battle following an attempted rape of a Lapith princess. She too is disguised, however, for Michelangelo's preferred subject was the male.
The manner of this high relief reflects ancient sarcophagi. Michelangelo created no real space, but, rather, piled up the bodies—a crowded style that is also found in the work of the

Pisani (see Plate 20). Nevertheless, both the manner and the matter of this early relief are consciously antique. It is also, typically, a work of carving; Michelangelo disliked modeling and preferred all his life to work in marble. The muscular nude figures that we find here remained his ideal for over seventy years.

56 Michelangelo Buonarroti (1475–1564), *Pietà*. Marble; 1497–ca. 1500. Rome, St. Peter's. This early masterpiece shows a scene derived from Byzantine art (the *Threnos*) that was adopted in some Italian paintings. A later Northern development produced sculptures of the dead Christ on Mary's lap; and since the patron of Michelangelo's group was a Frenchman, he may well have dictated the subject. Michelangelo's greatest task was to accommodate the lifeless body to the form of the seated Mary, which he did by altering the normal scale and creating a monumental cascade of marble falling over the Virgin's lap. The highly polished work, still full of quattrocento detail, is a triumph of marble carving, the handsome, anatomically correct body contrasting with the gorgeous flow of drapery behind and beneath. In the Counter-Reformation period the group was criticized as irreligious; but it illustrates a familiar idea popularized by St. Bernardine of Siena, that of the Virgin holding her dead son, thinking back to the days when she held him as a baby and dreaming that he has merely fallen asleep. (Many more conventional Madonnas allude to this symbolism in reverse, showing the Christ Child asleep in a deathlike pose.)

57 Michelangelo Buonarroti (1475–1564), *The Deposition of Christ*. Marble; ca. 1547–55. Florence, Cathedral. Michelangelo originally conceived this sculpture, which is obviously related to the early *Pietà* in Plate 56, as his own grave monument. In 1555 he abandoned it after having tried to destroy it in frustration and anger. Christ's left leg is missing and the entire group is unfinished except for the Magdalen, which was poorly completed by a follower. The Nicodemus at the top was recognized by Vasari as a self-portrait. Even in this late group we see Michelangelo's overriding concern with the physical beauty and pathos of the male nude. The struggle between his essentially pagan instincts and his deep religiosity proved insoluble, and this work, which was uniquely personal and private, seems to be a battleground between those forces and other, perhaps unconscious ones. The poignance of the joined heads of Mary and Christ is almost unbearable even to a modern outsider. Sculptures like this, in varying states of completion, ultimately became an inspiration to sculptors like Rodin (see Plates 106, 107), who planned "unfinished" sculptures for expressive purposes—but this is very far from the spirit of Michelangelo, who seems always to have desired highly polished, finished works.

58 Michelangelo Buonarroti (1475–1564), "Dying Slave." Marble; 1513–16. Paris, Louvre. This figure, another "Slave," and the *Moses* (Plate 59) are all that remain from the early phases of the grandiose Tomb of Pope Julius II, commissioned in 1505, abrogated in 1506, recommissioned at the Pope's death in 1513, and finally finished in the 1540s according to a completely different plan (Fig. 21). This sensual relic of the tomb that his biographer Condivi called the tragedy of Michelangelo's life shows an apparently sleepy figure that would be more at home recumbent than standing. As in all of Michelangelo's works, the iconographic reason for the figure (one of the Liberal Arts chained at the death of the Pope?) was transformed by the artist's personal vision of heroic, sublimated male sexuality, which he had developed in a great series of nudes on the Sistine Ceiling between 1508 and 1512. This figure represents Michelangelo's most voluptuous homage to the form that was central to his conception of art, and it is not surprising that in the period of the Counter Reformation even he seems to have found it unsuitable for the tomb. The figure, derived from the younger son in the Hellenistic-Roman group of the *Laocoön*, transforms a death struggle into a sensual dream. The unfinished figure behind was to represent an ape, perhaps signifying that "art apes nature."

59 Michelangelo Buonarroti (1475–1564), *Moses*. Marble; 1513–16, 1542–45. Rome, San Pietro in Vincoli. The famous *Moses* was originally meant to be seen from below, on one corner of the middle story of a huge, roughly pyramidal tomb. As finally placed on the lower level of a wall tomb, it became the chief sculpture of the much reduced monument, which was installed in 1545–47. The power and vigor of Moses and the concentrated gaze of his eyes have led amateurs to conjure up elaborate stories; but as originally planned this was one of many symbolic statues and should not be considered part of a psychological narrative (*pace* Freud). Rather, Michelangelo's imagination has galvanized an everyday pose into an unforgettably virile image of a visionary leader. The horns, placed deliberately on the terrifying head, were conventional—originally they had been a mistranslation of the Hebrew "rays of light." As was observed at the time, *Moses* radiates the *terribilità*—frightening power or sublimity—associated with Pope Julius and with Michelangelo himself, and so was ultimately an appropriate memorial for the tomb.

60 Jacopo Sansovino (Tatti; 1486–1570), *Apollo*. Bronze: 1540–45. Venice, Loggetta. Sansovino was the architect of the new Loggetta at the base of the great Campanile in front of St. Mark's as well as a principal sculptor of its decoration (Fig. 23). *Apollo* is one of four symbolic bronze figures, the others being *Pallas*, *Mercury*, and *Peace*. According to the artist, Pallas represented the wisdom of the Senate, Mercury the eloquence of the Venetians. The sun (Apollo) symbolized the unique (*sole*) Republic with its constitution, liberty, and wise and just government harmoniously administered. Peace was the virtue greatly loved by the Republic. Apollo seems caught as he emerges into the light, pausing with his quiver, arrows, and lyre. Although the famous antique *Apollo Belvedere* should be cited, this statue is a fluent, Raphaelesque conception of poised beauty and harmony deriving from the painted Apollo in a niche of Raphael's *School of Athens*. Unlike Michelangelo, Sansovino cared most for a lyrical silhouette and for a statue that seemed to move easily within the niche. This statue and its companions were the chief inspiration for the bronze statuettes that were produced in Venice in quantity later in the century.

61 Alessandro Vittoria (1525–1608), *St. Sebastian*. Marble; 1563. Venice, San Francesco della Vigna. This figure is part of an altar triptych that includes a larger figure of St. Anthony in the center and a St. Roch—like Sebastian, a plague saint—on the left. Vittoria evidently was particularly fond of this *Sebastian* since he produced two different bronze reductions of it. In pose it depends on Michelangelo's "Dying Slave" (Plate 58), although Vittoria could have known it only from a cast. In 1563 his knowledge of Michelangelo's style was still shallow, and the pose of this figure is discontinuous in movement. Later, Vittoria seems to have made a more profound study of Michelangelo's works—always apparently from casts—and used his knowledge as the basis for his successful later figures, including another *St. Sebastian* in the church of San Salvatore. Thus Vittoria moved in a direction opposite to that of his Raphaelesque teacher Sansovino toward an increasing Michelangelism. Vittoria was also a master of the small bronze, the Venetian counterpart to Giovanni Bologna (see Plate 71).

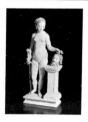

62 Conrad Meit (active 1496–1550/51), *Judith*. Tinted alabaster; ca. 1525–28(?) Munich, Bayerisches Nationalmuseum. A cosmopolitan artist from Worms, Meit worked in Wittenberg with Cranach and then settled in the Netherlands, perhaps in the service of Philip of Burgundy. He executed a great series of tombs for the church at Brou (Bourg-en-Bresse) between 1526 and 1532 for Margaret of Austria, the imperial regent of the Netherlands; he also carved her portrait. The *Judith* is related to work at Brou, showing a developed Northern Renaissance esthetic related to that of Albrecht Dürer (1471–1528), whose works of graphic art taught a whole generation of Northern artists. Such a corporeal statuette, with its serene command of space, would seem impossible without some contact with Italian art; it is wholly unprecedented in the North.

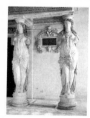

63 Jean Goujon (active 1540–62), *Caryatids*. Stone; 1550–51. Paris, Louvre, Salle Lescaut (detail). These are two of four caryatids supporting a gallery, a new conception in French architecture. Goujon's figures (restored in the nineteenth century) represent his classical style at its most developed, an elegant manner deriving ultimately from Greek works he did not know, and displaying a mastery of the draped figure. Goujon's chief Italian inspiration was from Benvenuto Cellini, who was in France between 1540 and 1545. Goujon perfected a Mannerist style that parallels the painted and stucco decorations of Fontainebleau (see Fig. 27). It is exquisitely delicate in the Fontaine des Innocents (1548–49), more classicizing and sober in these decorative caryatids.

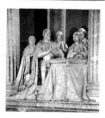

64 Pompeo Leoni (ca. 1533–1608), *Mausoleum of Charles V*. Gilded bronze; 1591–98. El Escorial, San Lorenzo, High Altar Chapel. Represented are: Charles V, his wife Isabella, his sisters Eleanor of France and Maria of Hungary, and his daughter Maria. This group is balanced by another, opposite, of King Philip II with his wives and son, all kneeling in adoration of the host displayed above the high altar of the church of the royal monastery outside Madrid. Pompeo Leoni is a product of the Milanese school of portraiture, whose chief representative was his father Leone; but the superficially rendered, impassive features of the imperial family were clearly not the main objects of interest. It was, rather, the rich panoply of gilded stuffs, brocades, and armor that engaged the sculptor's attention. The imperial mantles of both Charles and Philip were removable.

Leoni employed a number of specialists, some of them Spanish, as well as his son Miguel in the gilding and incrustation. The general form of these tombs reflects earlier Spanish models showing kneeling figures in adoration (see Plate 30), a pious motif that found great favor in Counter-Reformatory times and that was carried on in works by Bernini.

65 Francesco Primaticcio (1504/5–1570) and **Germain Pilon** (ca. 1530–1590), *Tomb of Henry II and Catherine de' Medici*. Marble and bronze; 1563–70. Paris, St.-Denis. The architectural design was Primaticcio's, the sculpture executed under the direction of Pilon. The four bronze Virtues at the corners, which were ready to be cast in 1565, show Pilon's earlier style, which derives from Fontainebleau. They are classically proportioned figures with Roman drapery that falls in sculptured abundance over their freely moving limbs. The tomb follows an old tradition of showing the subjects both dead and alive: Inside the chapel we see the marble effigies of the dead figures, called *gisants*; above, bronze effigies kneel in eternal prayer. The bronze statues are realistic, displaying emotional gestures (Henry) and beautiful detail in dress and jewelry (Catherine). Perhaps these qualities stem from Cellini's influence (see Fig. 25). The naturalistic *gisants* avoid the ghoulish details found on some earlier tombs. Henry is modeled with a sensitive fluidity, his head thrown back as if in emulation of Michelangelo's early *Pietà* (Plate 56). Catherine is more rounded and generalized, relaxed in death.

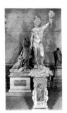

66 Benvenuto Cellini (1500–1571), *Perseus*. Bronze, marble base with bronze statuettes; 1545–54. Florence, Loggia dei Lanzi. Cellini's most famous work of monumental sculpture is the subject of an arresting series of anecdotes in his *Autobiography*. The commission, from Duke Cosimo de'Medici, gave Cellini an opportunity to produce a public sculpture to rival those already on exhibit by Donatello, Michelangelo, and Bandinelli. He produced a wax model and then a bronze before making the full-scale version in gesso, but then gave up and made a terracotta model for the Medusa, covered with wax. This figure was then cast, and was followed by the model of Perseus, which was successfully cast in one piece after much ado. The base contained four frontal figures, Danae with the infant Perseus, Jupiter (visible here), Athena, and Mercury. Below is a relief of Perseus Freeing Andromeda. Cellini believed that free-standing sculpture should have eight main views, the four chief sides and the four points in between. The figure rises above a rectangular base that enunciates these positions. The *Perseus* shows some influence from Donatello's *David* (Plate 38) and was consciously planned as a pendant to his *Judith*. The vital pose and expressive detail (note the hanging hand of the decapitated Medusa) make this a Late Renaissance masterpiece (see Fig. 29).

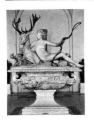

67 Jean Goujon (active 1540–1562) or **Germain Pilon** (ca. 1530–1590), *Diana of Anet*. Marble; before 1554. Paris, Louvre (originally Chateau d'Anet). This elegant, enigmatic work originally came from the fountains of Anet, a now-destroyed royal chateau designed by Philibert de L'Orme around 1550. The *Diana* refers to Diane de Poitiers, the influential mistress of Henry II for whom Anet was built, and whose initial is incised in the elaborate pedestal of the *Diana*. Diane de Poitiers was the artistic dictator of France in this period; the coy reference of this group to her chaste mythological counterpart must have been a source of quiet amusement. The group has been attributed to several artists, notably Goujon and Pilon, but its authorship remains uncertain. It is a work of great charm and individuality, conceived fully in the round. The style is clearly related to that of Primaticcio and may also show the influence of Cellini's elegant *Saltcellar* (Fig. 25). The fine, mannered head is presumably a portrait. The *Diana* has been connected with Pilon's reliefs on the base of the Tomb of Henry II (Plate 65), and it may thus be associated with the stylistic milieu that produced Pilon, who emerged as an artist slightly after this group was carved.

68 Niccolò Tribolo (1500–1550) and **Giovanni Bologna** (Jean de Boulogne; "Giambologna"; 1529–1608), *Fountain of the Labyrinth*. Marble fountain by Tribolo with bronze figure of *Florence* by Giambologna, 1555–60. Florence, Villa della Petraia (formerly at Villa di Castello). This, the smaller of two towering fountains, was executed for Duke Cosimo de'Medici by Tribolo, who studied with both Michelangelo and Sansovino. The fountain is of the candelabrum type, in the decorative tradition of the quattrocento. It was originally part of a formal garden complex with pools and fountains on an axis with the palace. The *Fountain of the Labyrinth* is a study in contrasts: the outer basin and pedestal are octagonal; the basin and other elements above are circular; the marble candelabrum is surmounted by a bronze statue. The personification of Florence was executed after Tribolo's death by the young Fleming, Giambologna. *Florence* is like a voluptuous, twisting Venus emerging from the bath who wrings out her hair—and when the fountain is turned on, as is shown here, water pours from her long tresses.

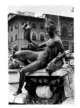

69 Bartolommeo Ammannati (1511–1592), *Nymph* (Doris). Marble and bronze; 1563–75. Florence, Piazza della Signoria, Neptune Fountain. This famous fountain is surmounted by a rather bland marble figure of Neptune in the center, but its real gems are the bronze figures around the basin, including this elegant nymph. Large piazza fountains had been built elsewhere, notably in Messina by the Florentine sculptor Montorsoli—a precedent that stimulated Duke Cosimo de'Medici to create a rival by his favorite, Baccio Bandinelli (1493–1560). A huge marble block was excavated for the figure of Neptune, and Cellini, Bandinelli, and

others fought for the commission, which was awarded to Ammannati only after Bandinelli had defaced the block, in a typical fit of pique, and died. Trained in the Venetian studio of Sansovino and armed with the support of Michelangelo, Ammannati was certain of victory over his rivals. Although the fountain itself had probably been designed by Bandinelli, the sculptural decoration was executed under Ammannati's direction. The nymph is not, however, surely his but may have been executed by Andrea Calamech (1514–1578), possibly on Ammannati's model. The elongated, schematic figure reclines on a dolphin and raises her shell as if it were a glass. We think of such an exaggerated form as Mannerist, but this does not mean that it was unclassical: an influential commentator on Vitruvius wrote in 1556 that "the ancients made bodies rather large, the heads small, the thigh long . . . I speak now of perfect bodies"

70 L'Antico (Pier Jacopo Ilario Bonacolsi; ca. 1460?–1528), *Venus Felix*. Bronze, gilded hair and drapery, silver inlaid eyes, base inset with nine silver coins of late antiquity; date unknown. Vienna, Kunsthistorisches Museum. Perhaps the best example of a High Renaissance bronze statuette, this is a transformation of a genuine antique, marble and life-size, in the Vatican. Antico was a connoisseur of ancient statuary; his ideal was the smooth surface of Hellenistic carving, which he studied in Rome in 1497. His is a courtly art of refined elegance whose patrons were the Gonzaga and Isabella d'Este, for whom he made bronze statuettes, restored antiquities, and served as silversmith. His subtle work thus reflects the cultivated Humanist taste of the Mantuan court at the turn of the century.

71 Giovanni Bologna (Jean de Boulogne, "Giambologna"; 1529–1608), *Astronomy*. Gilded bronze; ca. 1565–70. Vienna, Kunsthistorisches Museum. This elegant example of Giambologna's early statuette style already displays the abstract forms and complex rhythms that we associate with him. The absolute master of the small bronze, Giambologna typically fashioned figures that were meant to be turned, stroked, and admired from all points of view. They are thus wholly different from the frontal niche statuettes of Cellini's *Perseus* (Fig. 26) and do not have the dependence on antiquity found in the work of Antico. Giambologna's interest in the subject matter was perfunctory (this statuette could be, and was, changed into a Venus by a mere substitution of attributes). Rather, his interest lay in the refined spiraling composition, in the delicate turning, folding and unfolding of arms and legs as the statuette is moved, and in the ever-changing, elegant, even extravagant silhouettes provided by the sophisticated outlines of the beautifully abstract body. Naturalistic references and textures are minimized in favor of an ideal of pure beauty.

72 Giovanni Bologna (Jean de Boulogne; "Giambologna"; 1529–1608), *Apennine*. Stone, bricks, mortar; 1580–82. Florence, Villa di Pratolino. Over ten meters high, this fantastic grotto sculpture may have been inspired by reports of a sculptured mountain by the ancient Greek architect Dinocrates, a subject that had also excited Michelangelo. Pratolino, the most famous of the Medici villas, hardly exists today. It was begun by Grand Duke Francesco I in 1570. On an axis with the palace was a long avenue of fountains leading to an oval pool, a prototype of Versailles that included, in addition to the usual formal gardens and fountains, moving, echoing figures and hydraulic organs. The hulking *Apennine* is a combination of figure and grotto presiding over a pool; it is the largest sculpture of the Renaissance. Originally meant to symbolize the Nile, the figure presses on a fish that spouts water and is thus itself a fountain. Three stories of rooms rise inside the colossal figure at the rear, "in which are painted all the mines and men who dig from them metals and stones." The main room was decorated with an octagonal fountain of Thetis. The colossus was originally framed by an artificial cavern in a great mountain—a mountain within a mountain. This huge, amusing fantasy shows the other side of Giambologna's genius, which is better known from the style of Plate 71.

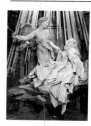

73 Gian Lorenzo Bernini (1598–1680), *The Ecstasy of St. Teresa*. Marble, gilded wood rays; ca. 1648–52. Rome, Santa Maria della Vittoria, Cornaro Chapel. The famous centerpiece of a larger decoration that covers the entire left transept of this small church (Fig. 32), St. Teresa of Avila (died 1577) is shown in an ecstatic vision she described in her *Autobiography* and which was cited in the bull of her canonization in 1622. The depiction of a Counter-Reformation figure is itself a sign of the new, more confident Church of the seventeenth century. Bernini's group is lighted by actual sunlight from a hidden window above, reinforced by the rays behind. Neither relief nor free-standing, the group appears as a theatrical vision to inspire and convert. Bernini's conception is pictorial; in the Cornaro Chapel he fused architecture, sculpture, and painting to "conquer art," as his son wrote. The beautifully ethereal angel contrasts with the sinking, fainting saint, whose body disappears beneath turbulent drapery. Her feet are shown bare (she was a Barefoot Carmelite), her mouth open in sensual and spiritual exhaustion.

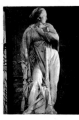

74 Francesco Mochi (1580–1654), *Virgin of the Annunciation*. Marble; 1605–08. Orvieto, Museo dell'Opera del Duomo (reserve). Originally this figure stood at the left of the Cathedral choir, the electrifying Angel at the right, charging the air of the sanctuary of this venerable medieval church with the energy of God's startling message. The Angel is shown descending on a spiraling cloud, draperies swirling, arm upraised. Mary rises from her chair, which protrudes between her legs, closing the Bible she has been reading and recoiling physically as she looks back in surprised alarm. Her profile should be seen as one in a long line of classicizing Italian figures (see Plate 24).
Mochi's masterly command of expressive form turns a pliant Mannerist technique into a dynamic new style to produce what is perhaps the first truly Baroque sculptural group. Mary's pose may derive from Michelangelo's *Rachel* on the Tomb of Julius II (Fig. 21), but her emotional communication is new, breaking sharply with the immediate Florentine past.

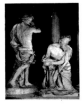

75 Alessandro Algardi (1598–1654), *Beheading of St. Paul*. Marble; 1641–47. Bologna, San Paolo, high altar. Algardi was Bernini's chief competitor, an excellent portraitist, whose preferred mode was relief or, as here, relieflike tableau. The isolated group is set before a semicircle of columns that isolate it and emphasize the contours of the figures, which retain the sense of their original blocks. Unlike Bernini, Algardi did not want to set his figures into a background, and in this sense (as in others) he is relatively classicizing. Algardi's mastery of a Berninesque technique is nevertheless evident: the executioner turns powerfully, showing us an impressively rendered musculature; his drapery flies out and his hair is wild. All of this contrasts with the compact resignation of the saint, who turns to receive the blow. Algardi's ultimate inspiration was pictorial, a painting by Andrea Sacchi, another classicizing artist who formed together with Algardi and others a faction that opposed the more extreme Baroque of Bernini.

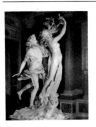

76 Gian Lorenzo Bernini (1598–1680), *Apollo and Daphne*. Marble; 1622–25. Rome, Galleria Borghese. The masterpiece of Bernini's early, virtuoso phase, this group was carved for Cardinal Scipione Borghese, the powerful nephew of Pope Paul V (reigned 1605–21). It is still in the same room for which it was carved but has been moved away from the wall. The original impression must have been of a white vision skimming over a small base (now enlarged). The idea of catching moving figures on the wing had been pioneered by Mochi; here it reaches its climax in the transformation of Daphne into a laurel beneath the uncomprehending hand of the still-running Apollo, who is a modification of the *Apollo Belvedere*. Bernini himself claimed that he never surpassed the effect of Daphne's swinging tresses, and indeed this statue is a technical tour de force that extends the limits of marble carving far beyond anything known in antiquity. The Ovidian theme, common in painting, had also been treated by the poet Giambattista Marino, whose brilliant word-play seems to be translated here into the hard marble. The sensual subject was then given a moralizing epigram by Bernini's friend, Pope Urban VIII (reigned 1623–44).

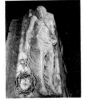

77 Giuseppe Sammartino (1720?–1793), *Christ Under a Shroud*. Marble; 1753. Naples, Cappella Sansevero de'Sangri. This work of shocking virtuosity seems to carry the Baroque love of spectacular technical display well past the boundaries of acceptable taste. A model for the figure by Antonio Corradini (1668–1752) introduces another personality associated with this style and this chapel, one who depicted Chastity by carving an extremely voluptuous nude only seemingly covered by transparent drapery. Thus Corradini would appear to be the perpetrator of the tasteless exercise shown here, and Sammartino only the able executant. Corradini was a Venetian, but the Cappella Sansevero is a truly Neapolitan creation, "a veritable Valhalla of the del Sangro family," containing a chaotic mixture of allegorical statuary and medallion portraits of the dead. The entire little church is filled with tours de force such as this one, mere displays of technical bravura that make Bernini's most pagan works seem as solid and respectable as Giotto.

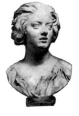

78 Gian Lorenzo Bernini (1598–1680), *Bust of Costanza Bonarelli*. Marble; ca. 1635. Florence, Museo Nazionale del Bargello. This unique portrait bust shows Bernini's mistress in an unguarded private pose, mouth open, hair carelessly combed back, chemise parted—"more a piece of life lived than a work of art." Whereas Bernini perfected a great series of imperious state portraits culminating in the bust of Louis XIV (Fig. 31), this private record of a famous passion shows the firm flesh and sparkling eyes of a voluptuous girl. We may speak here of a naturalistic portrait of a type that otherwise did not exist for another century. The *Costanza Bonarelli* is a kind of false dawn of the unvarnished realism that we associate with the Age of Reason (see Plates 94, 95, 100; Fig. 41).
Bernini, who often discussed the problems of marble portraiture, thought that the face was

most expressive when a person was either just beginning to speak or just finishing. The lively glance was another of Bernini's trademarks; in other portraits he experimented with less naturalistic, more coloristic ways of showing the darkness of the pupil and the flash of reflected lights.

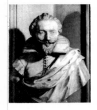

79 Francesco Duquesnoy (1597–1643), *Bust of John Barclay*. Marble; 1627–28. Rome, Sant'Onofrio, Museo Tassiano. Duquesnoy, a Fleming, was the most gifted Roman sculptor after Bernini. This bust was originally installed, together with another, on a pair of tombs designed by Pietro da Cortona flanking the entrance to San Lorenzo fuori le Mura. They commemorated the tutors of Cardinal Francesco Barberini, nephew of Pope Urban VIII, who commissioned the tombs. Barclay, who died in 1621, was an English poet. Duquesnoy uses a Venetian formula for the trapezoidal base of the bust and shows Barclay in his English clothes, presumably on the basis of a painted portrait. The textural verisimilitude is remarkable and depends on Bernini's innovations, as do the eyes. The sense of a body and arm beneath the drapery, and the turn of the head, are also indebted to the brilliant Roman, but the tender, almost romantic rendering of the dead man is uniquely Duquesnoy's.

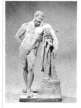

80 Stefano Maderno (1576–1636), *Hercules*. Terracotta; 1617 (signed and dated). Oxford, Ashmolean Museum. This terracotta corresponds to a bronze in Vienna. A typical reduction of a famous antiquity, the *Hercules Farnese*, this statue is a seventeenth-century survival of an old Renaissance practice illustrated by the *Venus* of Antico (Plate 70). Maderno combines a careful study of the classical model (supposedly by Lysippos) with solid realistic observation, which shows the continuing influence of the cult of the antique that we associate with the fifteenth and sixteenth centuries. In fact, both Bernini and Algardi were active in the restoration of antique statuary, and despite the prestige of Michelangelo, antique sculpture was still prized above all other for its physical embodiment of the ideals and forms of the lost civilizations of ancient Greece and Rome.

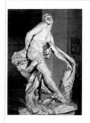

81 Pierre Puget (1620–1694), *Milo of Crotona*. Marble; 1671–83. Paris, Louvre. Puget was trained in Italy under Pietro da Cortona and later worked in Genoa. His checkered career was full of failures at the French court, and necessity often forced him to work in Provence on the decoration of ships. The *Milo of Crotona* was carved from a block of marble abandoned in Toulon; and although it is dependent on the Roman Baroque, it displays Puget's characteristic personal quality of pathetic anguish combined with a concentration and regular geometry that we associate with France. This is the greatest example of French Baroque sculpture, a style not usually appreciated at Versailles. Puget's naturalistic tree recalls the *Apollo and Daphne* (Plate 76), which he must have known; but unlike Bernini's works, the *Milo* is based on straight lines and planes; it composes into a simple silhouette that is meant to be seen from only one vantage point. Even the emotion is regulated by a pervasive classicism: Milo's head is obviously based on the *Laocoön* and exhibits an antique restraint even in dying. The group was taken to Versailles in 1683, where it was installed prominently in the gardens and led immediately to much-needed commissions for the aging master.

82 Juan Martínez Montañés (1568–1649), *St. John the Evangelist*. Polychromed wood; begun 1637. Seville, Convent of Santa Paula. Spain's greatest sculptor produced this vision of the ecstatic Evangelist toward the end of his career, "neither standing nor sitting," according to the contract. Montañés practiced a realistic style based on the distinguished Late Gothic traditions of the city, which survived into the sixteenth century. Called the Dios de la Madera ("God of Woodcarving"), he produced a great series of works during a half century of activity and trained Alonso Cano, his most important successor in the craft. The simple, stereometric realism of his early works is reflected in the Sevillian paintings of Velázquez, as is their realistic coloration. Montañés progressed from a Mannerist fussiness of surface in his early works, through sober realism, to the ecstatic drama of this Saint, which is now shown in an illusionistically painted niche but was originally part of a complex retable. Montañés portrays him as an otherworldly mystic in the grip of a vision in the tradition of the great Spanish seers of the preceding century.

83 Francisco Salzillo (1707–1783), *St. Jerome in Penance*. Varied materials; 1755 (signed and dated). Murcia, Cathedral Museum. Salzillo here depicts Jerome in a similar moment to that shown by artists some three centuries earlier. The contrast emphasizes the realistic, folk-art tradition to which the pronvincial Salzillo properly belongs—a very late representative of a popular style that can be traced back to the Gothic. Although Jerome's active, open pose is clearly Baroque, the scattered attributes in various colors, which exemplify Salzillo's strong naturalism, diminish the emotional intensity of this work.

84–85 **Pierre Le Gros** (1666–1719), *Blessed* (now *Saint*) *Stanislas Kotska*. Marble; begun 1703. Rome, Sant'Andrea al Quirinale, dormitory. Le Gros, a Parisian who made a successful career in Rome, produced this realistic statue of a Jesuit novice to be placed in the room where the boy, an eighteen-year-old Polish youth, had died in 1568. Compared with Bernini, who never used naturalistic colors (see Plate 73), this statue is a pedestrian exercise in pious realism. It has, however, a morbid fascination and even a quiet charm for the viewer inured to Baroque excess—indeed, compared with Sammartini's uncolored *Christ* (Plate 77), Stanislas seems almost restrained, despite its insistently realistic coloration. But Le Gros did not find it possible to inject Berninesque drama into his work, and the result is a curiosity rather than the deeply moving image he desired.

86 **Egid Quirin Asam** (1692–1750), *St. George*. Polychromed and gilded stucco; 1721. Weltenburg, Benedictine Church. The church itself was built, beginning in 1618, under the direction of Egid Quirin's brother Cosmas Damian, who also painted the main ceiling fresco. Here we see St. George on horseback appearing like a *deus ex machina* on stage, illuminated by concealed light and seemingly materialized out of the ceiling fresco of heavenly figures. The aim of both brothers was to create a theatrical scene with all the splendor of decoration at their command. In order to achieve these effects, Cosmas Damian had put in a productive Roman apprenticeship while Egid Quirin studied in Munich. This culmination of what may be called the Berninesque Baroque is not wholly in the spirit of the older master, since Bernini always made a clear separation between art and life, carving his statuary in white marble (see Plates 73, 76); no matter how impressive the illusion, the spectator always knows where he is. Here the dramatic effect loses esthetic distance; art and life merge to the detriment of art. Still, it is a grand production.

87 **Ignaz Günther** (1725–1775), *Annunciation*. Polychromed wood; 1764. Weyarn (Miesbach, Bavaria), Stiftskirche. Günther is one of the truly outstanding sculptors of the German Rococo and this is perhaps his greatest single achievement. Mary kneels decoratively as the balletic angel, scantily but brilliantly clad, arrives on a cloud. The vivid folk naturalism, heightened by polychromy, made this one of the sculptor's most popular works (which is portable in order to be carried in religious processions). Lively realism is a trademark of Günther's style; his is a truly Bavarian art, steeped in local traditions, full of sensuous human warmth and sometimes also humor. Nevertheless, Günther was a sophisticated courtly artist who had studied at the Vienna Academy and copied antique monuments. Although he admired and emulated the Asams, his sympathies were with Mannerist elegance rather than dramatic power.

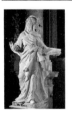

88 **Joseph Anton Feuchtmayer** (1696–1770), *St. Anne*. Stucco; 1746–50. Birnau, Pilgrimage Church, high altar. Feuchtmayer was the son of a stucco worker and sculptor (the craft tradition in these South German areas was amazingly strong) who trained with the stuccoist D. F. Carlone at Weingarten (1718–25). His life was spent around Lake Constance, whose religious climate is reflected in his art. *St. Anne* is a figure of high drama, almost a caricature, with a mannered, elongated body in an outrageously theatrical pose. Feuchtmayer had to set this and the other figures on a narrow base; therefore he elongated the forms, making them twist at the hips to create an envelope of swirling drapery. Feuchtmayer was a master of the grotesque who injected humor even into serious subjects and sought originality at all costs. At Birnau he benefited from collaboration with more sober spirits to create his most memorable and vivacious images, which range from the famous putto licking honey from a hive to a moving and dramatic series of Stations of the Cross. Feuchtmayer's superb technique produced stucco sculptures of marble-like smoothness and polish that brilliantly display his exaggerated virtuoso handling of form.

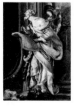

89 **Johann Joseph Christian** (1706–1777), *Isaiah*. Stucco; 1752–56. Zwiefalten, Abbey Church, high altar. The inspired prophet is shown as the Hebrew visionary who predicted the Virgin Birth: "The virgin will conceive and bear a son, and he shall be called Emmanuel" (Isa. 7:14 and Matt. 1:23). These are the words he has been reading as he looks up in amazement to see them materialized before his very eyes. Christian's serious and powerful image is clothed in swirling robes from which the head emerges. He comes closer to a Rococo classicism in his reliefs in the choir stalls; here he is in the Swabian Baroque tradition but without the caricatured exaggerations of J. A. Feuchtmayer and displaying a religious intensity rarely found in nearby Bavarian work. The collaboration in this church among Christian, his stuccoist J. M. Feuchtmayer, and the architect J. M. Fischer, continued in a more sober key in the Abbey Church at Ottobeuren (1757–66), where Christian's increasingly serious and even classicizing style matures into one of spiritual grandeur and restraint.

90 Giacomo Serpotta (1656–1732), *Fortitude*. Stucco, gilded column and shell; 1714–17. Palermo, San Domenico, Oratorio del Rosario. Posing stylishly in her niche, extravagantly dressed and coiffed, this determined young lady represents one of the mysterious anomalies of Baroque sculpture. Serpotta, a Sicilian, now seems to have sprung from nowhere, although there had been a tradition of local Sicilian sculpture at the time. He probably made an undocumented trip to Rome since his equestrian statue of Philip IV (now destroyed) betrayed reflections of Bernini's *Constantine*. Serpotta's chief production was in statues like this, as well as reliefs for a series of church interiors. His style is elegantly mannered, often relieflike with a refinement and grace that make him a kind of Rococo artist without contact with the actual style. The exotic costume is made more acceptable by the classicizing whiteness of the figure. The fancy pose allows the statue to fill the niche without overstepping its boundaries. The broken column on which Fortitude leans is an old symbol of the virtue she represents.

91 Johann Baptist Straub (1704–1784), *St. Barbara*. Stucco painted white and gold; 1752–56. Ettal, Klosterkirche, Altar of St. Catherine. The figures of St. Barbara and St. Margaret flank the painted altarpiece of the *Martyrdom of Catherine*, the "heilige drei Mädln," on one side of this unusual circular monastery church. As became customary after the middle of the century, the statues are painted white and gold, giving an elegant, cool classicism to figures that are already restrained and noble by comparison with the more exuberant Baroque style of the Asams or of J. A. Feuchtmayer (see Plates 86, 88). Like many of the younger generation of sculptors, Straub went as a journeyman to imperial Vienna rather than to Italy and may have been influenced by G. R. Donner (1693–1741). Straub is less Baroque than the Asams, less sensitive and individual than his pupil Ignaz Günther (see Plate 87). His aristocratic realism fits perfectly into the rather cool, classicizing Baroque of Ettal.

92 Michel-Ange (René-Michel) Slodtz (1705–1764), *St. Bruno*. Marble; finished 1744. Rome, St. Peter's, nave. Bruno, the founder of the Carthusian Order (1084), is shown rejecting the Bishop's mitre offered him by a surprised angel-putto. The symbolic book, skull, and chains refer to the ascetic austerity of this strictly contemplative order. Slodtz, a Frenchman who worked successfully in Rome from 1728 to 1745, chose a moment of Berninesque drama to illuminate his subject. His treatment, however, is refined and elegant, the gestures are self-conscious, the serpentine pose rhythmically graceful. All of this can be called a French Rococo modification of the Roman Baroque, an inevitable process that also affected many Italians of the period. The statue is large and situated fairly high in the nave. Slodtz had to accommodate his work to a distant view and so the action is large and clear; perhaps for the same reason, he left the surfaces unpolished to avoid blinding reflections. Within the limited space of the niche Slodtz created a momentary drama on two planes, full of psychological insight and executed with refined grace.

93 Jean-Antoine Houdon (1741–1828), *St. Bruno*. Stucco; 1766. Rome, Santa Maria degli Angeli. Houdon's statue of a stoic St. Bruno stands in contemplation, arms folded, as if in silent reproof of the energetic drama of Slodtz's version in St. Peter's. Houdon, who had been trained by Slodtz in France, perhaps had no choice but to reject a drama he could not better. The masterpiece of Houdon's Roman period (1764–69), *St. Bruno* was praised for its lifelike realism: "He would speak, but the Rules of the Order forbade it." Simple and monumental, this is arguably the last great niche statue produced for a Roman church—and, characteristically for the period, by a Frenchman in a severely classicizing style that marks the birth of the Neoclassic age. Nevertheless, there are features that link this statue with the Baroque past: The sober figure is not quite centered in its niche, his loose garment is rendered with quiet but telling drama, the hands and fingers are spread with an intensity that belies the closed eyes and bowed head. Realism, here as in Houdon's other works, was a safe middle road between the Baroque, now passé, and Neoclassicism, which was never wholly in vogue—and it is as a realist that Houdon lived and died.

94 Jean-Baptiste Pigalle (1714–1785), *Paul*. Terracotta; ca. 1760–61. Orleans, Musée des Beaux-Arts. This fresh and bold terracotta depicts the black valet of Tomas-Aignan Desfriches, whose bust Pigalle also sculptured in terracotta. The contrast between the powerfully modeled, smoothly finished face and the rough, "unfinished" turban and clothing gives an improvisatory air to a work of great sophistication, the last breath of the French Baroque. Like Falconet, Pigalle was the pupil of J.-B. II Lemoyne (see Plate 95), but unlike Falconet, he studied in Rome (1736–39) and was later patronized by Louis XV (see Plate 98). Pigalle prepared his marble figures by making finished, full-size terracotta models. Thus modeling in terracotta actually came to be the true act of creation, the transfer to marble only a technical afterthought. It was therefore natural to prize terracottas as original sculptures, and many were produced, like this one, without any thought of carrying out a marble version.

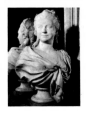

95 Jean-Baptiste II Lemoyne (1704–1778), *Bust of Mlle Dargeville as Thalia.* Marble; 1771. Paris, Comédie Française. Lemoyne, the son of a sculptor, is now as famous for his pupils as for his own works: Pigalle, Falconet, Pajou, and Houdon all studied with him (see Plates 93, 94, 97). He was a splendid, spirited portraitist whose flattering realism makes him the true predecessor of Houdon. Here he shows an actress with vine leaves in her hair and a loose drapery held across one breast by a ribbon. Alert intelligence, poise, and even wit seem to be implied in this handsome face, which turns and looks sharply to our left as if suddenly engaged. She represents the Greek Muse of Comedy, an appropriately flattering allusion to clothe one of the leading actresses of the time.
Lemoyne, Louis XV's favorite, was essentially an uneducated craftsman, a gifted Rococo practitioner whose empathetic portraits give us a rose-colored picture of the French society of his time. But Lemoyne was more a modeler than a carver, and his most expressive effects were achieved in terracotta.

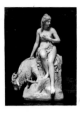

96 Pierre Julien (1731–1804), *Girl with a Goat* (Amalthea). Marble; 1786–87. Paris, Louvre (formerly Rambouillet, Castle Dairy). Carved for Marie Antoinette's dairy in the gardens of Rambouillet, this statue was set into the back room of a small pavilion in a bower made to look like a grotto. Amalthea was the foster mother of Zeus who fed him goat's milk on Mount Ida. The group was exhibited at the Salon of 1791. The storybook subject, set in the toy temple of a play dairy for the doll queen, perhaps typifies the "decadent" art of the *ancien régime.* This is a charmingly simple figure of modest realism, a perfect example of the Louis XVI style in sculpture—which is to say, not very exciting.

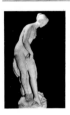

97 Etienne-Maurice Falconet (1716–1791), *Bather.* Marble; ca. 1757. Paris, Louvre. This charming girl, a modern Venus, was produced the year that Falconet became Director of Sculpture at the Sèvres Porcelain Manufactory, thanks to the patronage of Mme de Pompadour. There he supervised the production of many porcelain figurines based on his own models. The *Bather* was exhibited in the Salon of 1757 and gave Falconet his first real success, not wholly deserved since the pretty figure is graceful but a bit dull—and even testing the water with her dainty foot was not a novelty.
Falconet, a friend of Diderot's, wrote extensively on sculpture and espoused the opinion that the warm softness of human flesh was better imitated in his own day than in antiquity. Like other figures of the French eighteenth century, this *Bather* has many views, as her downcast glance and the oval base help to indicate. "If the sculptor has well rendered one view of his work," Falconet wrote, "he has only fulfilled one part of his operation. For his work has as many viewpoints as there are points in the space surrounding it." The *Bather* is in this respect representative of the Rococo style, but it has a classical restraint typical of Falconet, who identified himself with the Enlightenment.

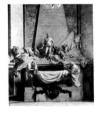

98 Jean-Baptiste Pigalle (1714–1785), *Tomb of Marshal Maurice de Saxe.* White and colored marble; 1753–76. Strasbourg, St.-Thomas. Pigalle's most impressive work, a royal commission, is composed on a large scale. The Maréchal de Saxe (1695–1750) was a brilliant general in the service of Louis XV. Since he was Protestant, he was buried in this Protestant church, which was remodeled extensively to become his well-lighted shrine. Pigalle shows Saxe as an invincible heroic figure, isolated against the pyramid behind, accepting Death with stoic dignity. The cowering animals at his right represent the terrified powers he had defeated— England, Flanders, and Austria. The crying infant, a genius of War, extinguishes his torch. The tomb is held open by the shrouded figure of Death where, despite the intrusion of mourning France, clothed in the fleur-de-lis, the general proceeds courageously, gripping his baton of command. At the left, Hercules in despair represents the mourning armies of France. This elaborate but rather cumbersome symbolism is a relic of the Baroque age; the centralized composition set before the timeless symbol of immortality, and the relative clarity of the parts, point to the new age of Enlightenment. Pigalle was arguably the greatest sculptor of the French eighteenth century and is represented here at the height of his powers; but the heroic tone of the tomb and even the steady gaze of the Marshal in the face of Death were dictated by the king.

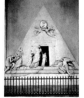

99 Antonio Canova (1757–1822), *Mausoleum of the Archduchess Maria Christina of Austria.* Marble; 1798–1805. Vienna, Augustinerkirche. In 1790 Canova began a model for a monument to Titian, which was never executed. In 1799 he was commissioned to produce this work, which was carved in Rome and erected in Vienna under his supervision. Canova was probably influenced by the classicizing theories of Francesco Milizia, who abhorred the complex allegories of the Baroque tomb, writing that a monument should "demonstrate in its simplicity the character of the person commemorated and bear no symbols that are not immediately intelligible." Canova did use one device dear to the Baroque, the illusion of a room behind a door that actually leads nowhere, into which the mourners, led by Piety holding an urn, seem to pass silently. Maria Christina's profile portrait is carried aloft by Happiness, the

medallion framed by an ancient symbol of immortality. At the right a genius of Mourning kneels against the Lion of Fortitude. Above the door is a laconic inscription. Hugh Honour has compared this great monument to an elegy, with the deceased mourned by the Three Ages of Man.

100 Jean-Antoine Houdon (1741–1828), *George Washington*. Marble; 1785–91 (signed and dated 1788). Richmond, Virginia, Capitol. In 1785 Houdon went from Paris to Washington, D.C., with Benjamin Franklin in order to model the first president at his home in Mount Vernon, where he remained for two weeks. Houdon customarily took life (or death) masks of his sitters; here he not only measured Washington's head but took his other dimensions as well, then returned to Paris to execute the marble, which was finished in 1891. This excellent likeness, which shows Washington dressed as a general in boots and spurs, is also a symbolic image: it includes a walking stick (an emblem of authority in the seventeenth and eighteenth centuries), the *fasces* of the Roman Republic covered by a cloak, and a sheathed sword. Houdon lacked imagination and excelled only in portraiture, where his aim was to make his art as natural as nature.

101 Antonio Canova (1757–1822), *Napoleon*. Colossal bronze; 1809–11. Milan, Palazzo di Brera, courtyard. The idea of showing a living person in the nude was first tried by Pigalle in a reviled figure of Voltaire. Houdon made the genre acceptable by heroizing the nudity, and here, too, Canova weds a realistic portrait head to a figure derived from antiquity. The combination is uneasy, but Canova had become a reluctant hero-worshipper who thought that Napoleon's features were ideal for sculpture, and most suited to the heroic style he had in mind. Canova had been called to Paris in 1802 to portray Napoleon and had made a plaster bust at that time. The full model, over fourteen feet high, was finished in 1808, but the marble version displeased the great man. The bronze seen here is reduced in size. The striding figure with a long pike recalls the "Hellenistic Ruler" of antiquity, and the globe in his right hand carries a figure of Victory inspired by antique representations.

102 François Rude (1784–1855), *La Marseillaise*. Stone; 1833–36. Paris, Arc de Triomphe. This symbolic relief depicts the departure of the volunteers of 1792 for battle, illustrating the popular song that later became the French national anthem. The theatrical chauvinism of this blatant sculpture is typified by the histrionic armed figure at the top with out-thrust sword and open mouth, shouting encouragement. No doubt much imperial Roman art was similarly coarse and obvious, and thus a decoration such as this on a modern triumphal arch may be considered appropriate. Rude was the principal French sculptor of the early nineteenth century, combining classicism and romanticism in his works.

103 Jean-Baptiste Carpeaux (1827–1875), *The Dance*. Marble; 1868–69. Paris, Louvre (formerly Opéra). This exuberantly spirited work is Carpeaux's masterpiece but it was criticized as pagan—which of course it is. The group was so much disliked that its imminent removal was halted only by the outbreak of the Franco-Prussian War in 1870. The spatial illusion of a circle of dancing figures around the central winged spirit with the tambourine is a remarkable achievement. The open mouths showing teeth, the buxom figures, the abandoned poses—all are typical of the eroticism of much late-nineteenth-century sculpture throughout the Western world. The marble was executed from a plaster model, now also in the Louvre. Carpeaux was the chief French sculptor of his day; he was the pupil of François Rude, but was influenced by the Romantics both in painting and in sculpture. He was in Italy from 1854 to 1862, where he made his reputation, but his career was short, clouded by persecution mania and cancer.

104 Honoré Daumier (1808–1879), *Caricature of the Financeer Lefébure*. Bronze; ca. 1832. Milan, Borletti Collection. Daumier typifies the unofficial artist of the nineteenth century who broke through the boundaries set by the commissions and judges, Salons and critics. This satirical portrait obviously caricatures the man by emphasizing the long jutting nose and receding forehead of the huge, egglike cranium. The modeling is free and expressive, far less naturalistic than the work of official artists, and so anticipates the new sketchy freedom of Rodin. Daumier's power as a caricaturist lay in seizing the expressive aspects of the face and neglecting the rest, thus achieving both force and humor.

105 Paul Gauguin (1848–1903), *Be Loving You Will Be Happy*. Carved and painted lindenwood; 1889–90 (inscribed: "soyez amoureuses vous serez heureuses"). Boston, Museum of Fine Arts. This large relief, almost a meter high, was a major project that Gauguin called his "best and strangest work" so far. Exhibited in Brussels in 1891, it was of course reviled; the inscription seems misleading even now since the scenes show no happiness, only female psychological conflict that presumably can be cured by sexual love. A combination of primitive sources, derived from his visit to Martinique in 1887, together with the tribal arts he had seen in the Paris Exposition of 1889, seem to have inspired this radically novel work, which breaks

completely with the heroic, academic traditions of sculptural composition, figural types, and relative scales. Gauguin worked color and gold into this smoothly finished relief, which is closely related to his Post-Impressionist paintings in its use of line and flat areas of color.

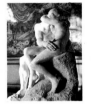

106 Auguste Rodin (1840–1917), *Monument to Balzac*. Bronze; begun 1897, cast 1939. Paris, Corner Boulevard Raspail and Boulevard Montparnasse. When *Balzac* was commissioned in 1891 by the Société des Gens de Lettres, Rodin asserted, "I should like to do something out of the ordinary." A version of the final plaster was unsuccessfully exhibited in 1898, along with *The Kiss*; but it had to be withdrawn. Oscar Wilde saw it and wrote that the figure was "superb—just what a *romancier* is, or should be. . . . The head is gorgeous, the dressing gown an entirely unshaped cone of white plaster. People howl with rage over it." The commission was then abrogated, and Rodin never cast the statue. The process of creation had been unusually difficult even for him, and he had tried many versions—nude, seated, and so on—as if at a loss (see Fig. 46). Finally, he hit upon the idea of a standing *Balzac* clothed in the gown he habitually wore when working. Rodin rejected detailed realism in favor of an expressive silhouette and exchanged literal truth for empathetic identification. In so doing he buried the traditional nineteenth-century monument at a stroke.

107 Auguste Rodin (1840–1917), *The Kiss*. Marble; 1886. Paris, Musée Rodin. This and Plate 106 display a lesson that Rodin himself hoped the public would learn at the exhibition of the Société Nationale des Beaux-Arts in 1898. As he wrote, "Undoubtedly the intertwining of *The Kiss* is pretty, but in this group I made no discovery. It is a theme treated according to the academic tradition, a sculpture complete in itself and artificially set apart from the surrounding world." *The Kiss*, like *The Thinker*, derives from *The Gates of Hell* (Fig. 44), from which it was excised. The original small bronze is probably the best version since the handling is Rodin's own; in the over-life-size marble versions executed in his lifetime (Paris and Tate Gallery, London) the stonecutting is sometimes insensitive. Nevertheless, Rodin inscribed on its base a quatrain from Baudelaire's *La Beauté*:

Je suis belle, ô mortels, comme un rêve de pierre,
Et mon sein, où chacun s'est meurtri tour à tour,
Est fait pour inspirer au poète un amour
Eternel et muet ainsi que la matière.

Rodin did have a somewhat different esthetic for his marbles; as Albert Elsen has explained, "A more feminine or cosmetically attractive mode and idealization of the figure frequently prevailed in stone, which did not tolerate the rugged or ragged passages and the tonal range of shadows found in bronze."

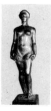

108 Edgar Degas (1834–1917), *Little Fourteen-Year-Old Dancer*. Bronze, tulle skirt, satin hair ribbon, wooden base; 1921 (wax model, 1880–81). New York, Metropolitan Museum of Art. Degas was self-taught as a sculptor and usually improvised armatures onto which he built up his sculptures in clay or, more commonly, wax. His favorite theme, in sculpture as in painting, was the unglorified female, observed, as he said, "as if you looked through a keyhole." He used models for his statues, which occupied him increasingly after 1880. Ours is the largest, one of the earliest, and the only one exhibited in his lifetime (1881). It caused a sensation and was widely denounced as repulsive or depraved. The little dancer, holding the fourth ballet position, wears real clothes; the wax model was painted realistically and had real hair as well. Degas's extreme realism extended beyond the shock of the fabrics to the look of attentiveness on the girl's face, the wrinkles in her stockings, and the wooden dance floor. Degas's later statuettes are smaller and often cruder—partly because of his increasing blindness —and display an increasing simplicity that is a hallmark of modern art and that leads in a sense to Maillol (see Plate 109) as well as to later abstraction.

109 Aristide Maillol (1861–1944), *Flora*. Bronze; 1912. Winterthur, Kunstmuseum. This figure, classical in style, recalls Poussin's famous remark about the beautiful girls of Nimes, whom he likened to the columns of the Roman temple there—which were, according to ancient theory, themselves modeled after human proportions. There is much that is academic in Maillol, and this figure may even recall Goujon's *Caryatids* in the Louvre (Plate 63). In fact, Maillol often talked about his figures as if they were architecture. *Flora*, a simplified vision of youth, stands in almost invisible transparent drapery that is gathered to hold her attribute, flowers. There may be a decorative echo of the Art Nouveau in this handsome creature, but like all of Maillol's sculptures, she reflects an ideal of timeless female perfection based on a memory of Greek art. The period that particularly fascinated Maillol was that transitional moment in the first half of the fifth century B.C. when the Archaic was melting into a more human and mobile classicism. Maillol's massive forms make a clear appeal to the sense of touch; and his happy mixture of modern simplicity with the antique was a productive example for many younger sculptors.

110 Wilhelm Lehmbruck (1881–1919), *Kneeling Woman*. Cast stone; 1911. New York, Museum of Modern Art. Abby Aldrich Rockefeller Collection. Lehmbruck, the son of a miner, entered the School of Arts and Crafts in Düsseldorf in 1895, where he learned a classicizing style of sentimental realism that he never wholly outgrew in his brief career. His individual style emerged only in 1910, after he had settled in Paris and experienced the power of Rodin's sculptures. Even after repudiating Rodin, Lehmbruck continued to make not only whole figures but also partial ones; this statue also exists as a bust. The *Kneeling Woman* was produced after he had absorbed ideas from the sculpture of Maillol, but the elongated forms and architectonic structure are his own, a medievalizing tendency that does not exclude lyrical elegance. Like other works by Lehmbruck, this one was produced as a plaster model; versions exist in plaster, bronze, and stone. The artist, who was often depressed, had so little faith in the *Kneeling Woman* that he left it to his wife to have it cast and exhibited. Its melancholy style became characteristic of much of his succeeding sculpture until his suicide in 1919.

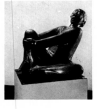

111 Ernst Barlach (1870–1938), *Singing Man*. Bronze; 1928. Cologne, Wallraf-Richartz Museum. Unlike most of the sculptors in this section, Barlach was a provincial recluse; he lived most of his life in a tiny town in Mecklenburg. His few travels left him hungry for home, and although he was aware of the avant-garde currents in Germany and France, he did not seem to understand Picasso and rejected abstraction. His visual sources were largely Late Gothic wood sculpture; his attitude toward life was that of a mystic. What he wanted to do, he said, was to present not what the eye sees, but the real and the true. He created images of common people, often in voluminous clothing, who experience the universal emotions of life. Barlach came into his own during a trip to the Ukraine in 1906: "I found in Russia an amazing unity of inward and outward being, a symbolic quality. . . . [We are] all beggars and problem characters. . . . It shines out of the Slav, while others hide it." His unification of feeling and physical expression made Barlach an Expressionist without his having been part of the movement in any official sense.

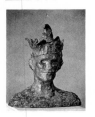

112 Pablo Picasso (1881–1973), *Head of a Jester*. Bronze; 1905 (signed "Piccasso"); (Zervos I, no. 322). New York, Collection Mrs. Bertram Smith. Picasso told of how he happened to model this head late at night after returning from the circus with his friend Max Jacob. In the early stages the clay looked like Jacob; but as Picasso continued, the upper parts followed their own course as he became involved with the way the rough surface reflected the light. Then he added the jester's cap with its floppy, irregular shape. Picasso's earliest known sculpture is a small bronze, the *Seated Woman* of 1901, which reflects the subject matter of his Blue Period. *The Jester* clearly falls in with his circus pictures of the Rose Period; it was accompanied and followed by more experimental works (see Fig. 49) that showed the influence of African sculpture. Here we are still in the world of Rodin.

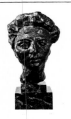

113 Henri Matisse (1869–1954), *Jeannette, I* (Jeanne Vaderin). Bronze; 1910. New York, Museum of Modern Art. Acquired through the Lillie P. Bliss Bequest. Matisse, famous as a Fauve painter and sophisticated colorist, was also an inveterate sculptor. He began to exhibit his sculptures early in his career, was often photographed with them, and even taught a sculpture class. There were two periods during which he was most productive: between 1900 and 1913 and again from 1922 until 1932. *Jeannette I* was nevertheless only the second life-size bust that Matisse had made. Probably done in 1910 at Issy-le-Moulineaux, it is the first of several versions and the most realistic, showing the subject's large nose and asymmetrical eyes. The later versions, produced between 1910 and 1913, become much more abstract as Matisse liberated himself from the model and played with basic forms and shapes. He once told his students, "Close your eyes and hold the vision, and then do the work with your own sensibility." Matisse was himself a modeler, like Rodin, and by the end of his long life he had produced over seventy sculptures.

114 Pablo Picasso (1881–1973), *Violin and Bottle on a Table*. Painted wood, tacks, string; 1915–16 (Zervos II², no. 926). Estate of Pablo Picasso. Cubism was originally a painter's investigation of the three-dimensional forms that were the normal preserve of sculpture, in which forms were reduced analytically to their basic geometric components. Cubist paintings look into form, or tear it apart, and present simultaneous views of the same object from different angles. Thus in a basic sense Cubism is a painter's answer to the sequential aspects of looking at three-dimensional forms; and making actual three-dimensional Cubist works was therefore a secondary matter. Picasso reportedly said that his early Cubist paintings, if cut up and assembled, would have produced "sculpture"—"the colors . . . being no more than indications of differences in perspective, of planes inclined one way or the other. . . ." Sculpture in the round did not interest Picasso much in this period, but the Cubist technique of collage naturally suggested a three-dimensional extension, assemblages of objects that in a sense are

relief paintings. Freed from the boundary of the frame, made up of any kind of fragmentary waste material, and often painted in bright colors, these works seemed outrageous at the time but contained many seeds of sculpture to come.

115a Henri Laurens (1885–1954), *The Guitar*. Polychromed iron; 1918. Paris, Collection Maurice Reynal. Laurens became a Cubist after making the acquaintance of Braque. The invention of the collage—pasted scraps of paper on a ground—led the way to Cubist sculpture made up of meaningless or found objects and forms. These were put together to create the sense of various planes, volumes, and spaces as if experienced by observing objects from many points of view. Laurens remained an Analytical Cubist until 1922; in works such as *The Guitar* we see the jagged angles and diverging planes of Cubism translated into a spatial context.

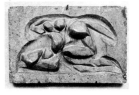

115b Raymond Duchamp-Villon (1876–1918), *The Lovers*. Plaster; 1913. Paris, Musée National d'Art Moderne. The brother of Marcel Duchamp and Jacques Villon, Raymond Duchamp-Villon abandoned medical studies in 1900 to pursue the career of a sculptor. His early work showed the strong influence of Rodin, but in 1910 he developed a new, personal style that depended upon dynamic sculptural thrusts and synthetic, simplified forms. These qualities can be seen in *The Lovers*, a relief of 1913, here reproduced in plaster but also executed in lead. On the left, six bulging shapes comprise the two legs, pelvis, torso, head, and right arm of woman seated on the ground and facing the viewer, her head thrown back under a raised arm. On the right is the larger and more abstract figure of a man kneeling in profile view, with one arm thrown back from the massive shape denoting chest and shoulders. The figure's head, separated from his body, adheres implacably to the woman's neck, while his unseen right arm seems to pull her body upward and outward toward the viewer. Duchamp-Villon treats anatomical elements as large, semi-abstract forms, which are energized by dynamic, angular rhythms. Although the theme of this work is traditional—we need only recall Rodin's *Kiss*—the stark, often hard-edged forms relate directly to the fondness for machine imagery shared by many progressive artists in the period immediately before World War I. When war was declared in 1914, Duchamp-Villon enlisted as a medical aide; two years later he contracted typhoid fever, from which he died in 1918.

116 Alexander Archipenko (1887–1964), *Médrano*. Painted tin, glass, wood, oilcloth; 1914. New York, Solomon R. Guggenheim Museum. This circus figure falls in with a number of others by the Cubists, who had a passion for the marvelous French circus of the time. This is one of a series of Médrano constructions that go back to 1912. The diverse colors and materials give a decorative, almost haphazard quality to a serious Cubist experiment. By using glass for part of the skirt, Archipenko achieved the kind of stereometry that is so characteristic of Cubist paintings. The other forms, too, have the arbitrarily generic quality of Cubist abstractions. Color is an important aspect of Archipenko's works, sometimes reinforcing the character of the surface it is on, at other times denying or complicating it.

117 Jacques Lipchitz (1891–1973), *Dancer*. Bronze; 1913. Paris, Musée d'Art Moderne de la Ville. Lipchitz, a Lithuanian, arrived in Paris in 1909. The *Dancer* records his transition from more traditional forms to Cubism and perhaps shows the influence of the precocious Archipenko (see Fig. 50)—although Lipchitz later considered Archipenko's Cubism "decorative and not too interesting." Here the dancer's body is gently stylized into geometric units, curving tubular forms that move around the wedge-shaped torso with its conical breasts. In speaking of the *Dancer*, Lipchitz mentioned that although it pivots around an axis as did his earlier *Woman with Serpent*, "the forms are generally more simple, massive, and geometric . . . a step . . . in the direction of pure Cubism." Lipchitz nevertheless emphasized in his *Autobiography* that he saw very little Cubist sculpture, had to develop it for himself, and in so doing began to realize the importance of light—"that volume in sculpture is created by light and shadow. Volume is light."

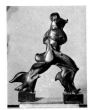

118 Umberto Boccioni (1882–1916), *Unique Forms of Continuity in Space*. Bronze; 1913. New York, Museum of Modern Art. Acquired through the Lillie P. Bliss Bequest. Exhibited in 1913 in Rome and Paris; the original plaster is now in São Paolo. This work is probably the ultimate realization of Boccioni's sculptural theories, although some critics and artists have preferred his still life, *Development of a Bottle in Space*. Here he shows the typical Futurist interest in simultaneity of movement. This sculpture, not unlike Duchamp's slick *Woman Descending a Staircase* of 1912, also relates to Boccioni's own painting *Dynamism of a Human Body* of the same year. Although the Futurists were mechanists, they interested themselves in all kinds of dynamic form, which is here shown as action rather than as a simple object. The work is imbued with a sense of both relative and absolute movement and a combination of just past and just about to happen, visible and invisible, mass and space.
Boccioni was born in Reggio Calabria, moved to Rome where he first met Gino Severini

and Giacomo Balla, and then studied in Venice and Milan. In 1910 he collaborated on the *Manifesto* of the Futurist Painters, which celebrated dynamic movement and the interpenetration of form and space. His meeting with Picasso in 1912 consolidated his own Futuristic style by fusing it with Cubist ideas.

119 Ossip Zadkine (1890–1967), *Lady with a Fan*. Bronze; 1920, after the smaller original of 1914. Paris, Musée d'Art Moderne de la Ville. Born in Smolensk, Zadkine went to London in 1907, Paris in 1909. This work belongs to his relatively brief Cubist period and shows characteristic squared, geometrical abstractions, multiple perspective, and inversions. (Zadkine may have been dependent on early works by Archipenko in his substitution of concave for convex; see Fig. 50.) The compact mass of the block is the governing factor of this and Zadkine's other sculptures of this period, as if he had relied on a wooden or stone block and subscribed to a Michelangelesque (or better, Archaic) esthetic. Indeed, like other Eastern sculptors, Zadkine reveled in his discovery of the art of the past—Egyptian, Sumerian, Greek, Romanesque. The basis of his later sculpture was in his novel woodcarving and in his feeling for the materials, whether wood or stone. In 1920, however, he was still a conventional Cubist, working in a rigid, architectonic style that hardly hints at the lyricism sometimes found in his work, let alone the Baroque expressionism of his last productions.

120 Naum Gabo (born 1890), *Linear Construction in Space, Number 4*. Plastic and stainless steel; 1958. New York, Whitney Museum of American Art. After the First World War, Russian Constructivist sculptors such as Tatlin, Gabo, and Pevsner used their works to glorify technology as the Futurists had done several years earlier (see Plate 118). The brothers Gabo and Pevsner at first made pseudo-Cubist works, using translucent celluloid in order to suggest and define space with an immaterial rather than solid substance. In doing this, they desired to make space itself the sculptural medium, a tendency of great import that was pursued by the brothers for a generation—in such varied materials as glass, metal, plastic, wire, and string.

Linear Construction is a later work (it dates from 1958) that uses a complex web of thin threads, meticulously wound around an armature. In this way, subtle variations in density are achieved, as open spaces contrast with the curving planes defined by the threads and with the sinuous curves of the framework. Trained in engineering, mathematics, and physics, Gabo has created numerous works that display a rigorous precision and a refined craftsmanship.

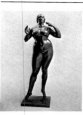

121 Antoine Pevsner (1886–1962), *Construction in the Egg*. Bronze; 1948. Paris, Collection Pierre Peissi. Here Pevsner continues the spatial abstraction that began in the teens in a characteristic work that combines curves and planes among a series of linear projections, like an illustration of a complex geometrical problem. Such works have had offshoots in wire constructions by Richard Lippold and others, which are airier and lighter but which have the same basic desire to create a beautiful abstract form based on geometric or mathematical principles. Pevsner once commented that around 1930 he began a search for a new kind of surface. He investigated skew and radial lines, developing sculpture that incorporated a section of a hyperbolic paraboloid. Many of these works have surfaces formed of rows of bronze wire brazed at different temperatures in an arduous and painstaking technical process. Despite their similarity to mathematical models, the sculptures are actually Pevsner's own creations, independent of rigid systems or formulas.

122 Gaston Lachaise (1882–1935), *Standing Woman* (*Elevation*). Bronze; 1912–27. New York, Whitney Museum of American Art. This characteristically sensual figure was begun in 1912 but was cast only in 1927. The model was the artist's adored American wife, Isabel. The sculpture is characteristic in its emphatic curvilinear and volumetric treatment of the nude female form. Lachaise was obsessed with the mature female anatomy and continued to produce similar works all his life. This one is notable for its buoyant denial of gravity. Like his other female figures, it reflects his passion for Isabel, whom he was not able to marry until 1917. The powerful sexual presence of the work typifies Lachaise's approach to his favorite theme, which may have been influenced by Hindu temple art. Related to Maillol, with a tendency to ovoid forms derived perhaps from Brancusi, the art of Lachaise is personal but limited.

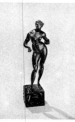

123 Elie Nadelman (1882–1946), *Standing Female Nude*. Bronze; ca. 1909. Washington, D.C., Hirshhorn Museum and Sculpture Garden. Nadelman, the son of a Polish jeweler, left Warsaw at nineteen and entered the Russian army. By 1904 he was in Munich and then Paris, where he participated very early in Cubist experiments with the analysis of form. This small (twenty-six inches high) bronze statue is quite typical of Nadelman's early stylizations of the human figure, which are based on a witty eclecticism that embodies Neoclassical values in a modern manner. Sources as diffuse as the sculptures of Rodin and the paintings of Georges Seurat lie behind his rubbery figures with their attenuated extremities. Nadelman's art depends above all on the expressive silhouette—an approach that exaggerates the curvilinear

contours inherent in human forms. As early as 1910, he remarked upon this preference of his for the animated profile: "I employ no other line than the curve, which possesses freshness and force." In *Standing Female Nude* a delicate balance obtains between large and small forms and between volume and linearity.

Nadelman worked in plaster and often had his numerous woodcarvings produced by assistants; his works in wood, bronze, or marble show no sense of the material and can be translated from one medium to another with no loss or gain of formal properties. Perhaps his best-known works are the two pairs of female figures—each about nineteen feet in height—produced from smaller models in 1964 for the lobby of the New York State Theater at Lincoln Center in New York City.

124 Constantin Brancusi (1876–1957), *Mlle Pogany* (Margit Pogany). Polished bronze, black patina; 1913 (four castings). New York, Museum of Modern Art. Acquired through the Lillie P. Bliss Bequest. This sculpture is based on a marble of 1912 (Philadelphia Museum of Art). A plaster exhibited in the Armory Show of 1913 created a critical scandal. The subject was a Hungarian painter whom Brancusi had portrayed first from memory, whereupon she urged him to do her portrait. During December and January 1910–11 Brancusi made a number of realistic clay busts, and, according to the model, "each time I begged him to keep it and use it for the definitive bust—but he only laughed and threw it back into the boxful of clay that stood in the corner of the studio. . . ." Mlle Pogany herself described the first version as "all eyes," and in the final sculptures Brancusi obviously emphasized this aspect of the model. The combination of head and arms, not altogether worked out, had been a preoccupation of Brancusi's in previous works. Here he uses a spiraling composition of great sophistication, balancing the arms and hands by the curve of the neck.

125 Jean (Hans) Arp (1887–1966), *Ptolemy I*. Bronze; 1953. New York, Collection Joseph Slifka. This sculpture exists in limestone and in three bronze versions. The title may refer to Euclid's patron, but like most of Arp's titles it was surely "found" after the piece was completed. Arp produced *Ptolemy I* after a long interval of inactivity in the forties following the death of his talented wife, Sophie Täuber, in 1943. Unlike much of his earlier work, which recalls organic forms—leaves, breasts, shells—this is a more purely geometrical sculpture although, like everything Arp did, it seems to be a natural form; Herbert Read likened it to the ventricles of the heart. Certainly it has a kind of energy in the connected arms that encircle smaller irregular spaces and, collectively, a larger one. Space or air seems to move in and out of this enigmatic work, which nonetheless conveys a sense of repose and silence. Arp was always a poet, and in a sculpture such as this one, which seems to bring together all of his inventive tendencies, there is a music of mysterious asymmetrical perfection, like a particularly elaborate, surprisingly beautiful mathematical proof.

126 Marcel Duchamp (1887–1968), *Fresh Widow*. Wood, painted light-green glass covered with black leather; 1920 (inscribed: "Fresh Widow Copyright Rose Selavy 1920"). New York, Museum of Modern Art. Katherine S. Dreier Bequest. Duchamp was a leading spokesman for Dada and Surrealist groups although his output was small and almost wholly anarchic or iconoclastic. This work, a miniature French window that does not open and through which one cannot see, is given a punning title. Like some of the other Surrealists, Duchamp tried to exhaust the meaning of words: in colloquial French "window" equals guillotine and "fresh" describes a penis that has performed incest and must therefore be castrated—a sexual connotation that is not visible but derives only from the words. This kind of sexual nonsense is familiar to us from Duchamp's defaced print of the Mona Lisa of 1919, inscribed "L.H.O.O.Q." (which, pronounced in French, sounds like "she has a hot seat"). "Rose Selavy," used here by the artist for the first time, is not a play on "la vie en rose" but on "eros, c'est la vie"—sex is life. Such elaborate verbal joking was carried on in another work inscribed "Rose Selavy" and entitled *Why Not Sneeze*—a birdcage full of marble sugar cubes into which have been inserted a thermometer and a cuttlebone.

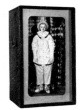

127 Joseph Cornell (1903–1972), *A Dressing Room for Gille* [sic]. Wood, mirror, paper, glass, string, ribbon, cloth tape; 1939. New York, Richard L. Feigen and Company. This typically small (fifteen inches high) box of mystery derives from the Dada-Surrealist traditions. Like most of Cornell's boxes, it summons up a miniature dreamworld of personal fantasy. In many respects, this work resembles a tiny stage set, an intimate glimpse into a private theater of poetic associations.

Cornell's works are constructed largely of objects that he collected in forays into second-hand shops and elsewhere—stuffed birds, illustrations, old trinkets. He was initially quite active in the New York scene; by the 1950s he had become more reclusive, though he had several successful one-man shows in the last years of his life. In the Metropolitan Museum's exhibition *New York Painting and Sculpture: 1940–1970*, his works stood out for their interest and integrity.

128 Max Ernst (1891–1976), *On the Roads of Athens*. Bronze; 1960. Paris, Galerie Point Cardinal. A German expatriate and one of the great radical pioneers of modern anti-establishment art (see Fig. 53), Ernst went to Paris in 1913 and then formed a Dada group in Cologne in 1919; he moved back to Paris in 1922, where he was one of the founders of the Surrealist movement and worked on literary projects. His visit with Giacometti in the Swiss Canton Ticino during the summer of 1934 turned his attention to sculpture in the round for the first time since his youth. He began to produce fairly small, enigmatic works in which abstract forms are often blended with schematic references to a human or animal face, thus conveying a sense of presence that is sometimes menacing, sometimes whimsical.

In his later works, such as this one, Ernst continues to employ these schematic figural references, often subjecting them to a more rigorously geometric structure. Critical opinion is divided on the subject of Ernst's sculptures, and some writers discount them as minor offshoots of his pictorial forms. Nevertheless, these imaginative works often possess a haunting power that transcends their formal economy and their visual unpretentiousness.

129 Henry Moore (born 1898), *King and Queen*. Bronze; 1952–53 (edition of five). Shawhead (Dumfries, Scotland), Collection W. J. Keswick. Following a series of Family Groups done in the forties, this regal pair is perhaps somewhat out of place on the Scottish heath—where irrelevant thoughts of Macbeth probably do arise. The long, flat, attenuated forms have oddly realistic hands and feet; their heads are stylized, with holes for eyes. Various influences can be adduced here, but they have long since been assimilated into Moore's personal vocabulary: Pre-Columbian pottery figures (torsos), Egyptian sculpture (drapery), found objects such as bones (head of King). Moore said that "the King's head is a combination of a crown, beard and face symbolizing a mixture of primitive kingship and a kind of animal Pan-like quality." This group seems to be a compromise between Moore's old static and hieratic forms and a more active, humane approach to the human figure.

130 Julio González (1876–1942), *Don Quixote*. Welded iron; 1929. Paris, Musée National d'Art Moderne. This is one of González's earliest works in soldered iron, highly expressive in its minimal references to the subject, which is shown, as it were, in outline. The concision and force of the image are remarkable. Much of his later work is more abstract, a style that he alternated with a simplified realistic figural style (see Fig. 55). His influence both as a technician and a stylist has been enormous. Toward the end of the twenties, González took metal as a starting point for his form, using it to indicate highlights and outlines, forcing the viewer to fill in the blanks or voids with his imagination. Sometimes he used scrap; in this and in other ways he was a pioneer, but his references are invariably to human or other recognizable forms. This unusual artist grew into greatness in old age, producing his finest works in his sixties.

131 Alberto Giacometti (1901–1966), *Lady of Venice, I*. Bronze; 1956. St.-Paul-de-Vence, Fondation Maeght. This work is typical of the later style of Giacometti, who experienced all phases of twentieth-century art, from study with Bourdelle to abstraction and Surrealism (see Fig. 54), and whose works range from the miniature to the monumental. His elongated figures with scarred or gnarled surfaces have made him a household word; and although reduced and abstracted, they have references to individual models—he often worked simultaneously from life and from imagination.

Giacometti was Swiss, the son of a Post-Impressionist painter, and much of his reclusive life was spent in Paris. His work shows a highly personal attempt to free sculpture from the rhetoric and realism of academic art, a reductionism that was occasionally expressed in extreme smallness—some works are only two centimeters high, and in a long period during the Second World War his total production fit into a few matchboxes. Here, in a life-size figure, the same spirit is exhibited on a larger scale; this is a skeleton of a statue, like something pulled out of the fire, homely, attenuated, yet insistently alive. All of Giacometti's later works relate to man in space, or isolated in space, and his connections with Existentialism are obvious.

132 Marino Marini (born 1901), *Juggler*. Polychromed bronze; 1938. Hanover, Städtische Galerie im Landesmuseum. Marini's art, although never academic, has its roots set solidly in the classical figural tradition: nudes, horsemen, and circus figures are his chief subjects. He was born in Pistoia and trained in Florence. His Tuscan heritage is clear in many of his works, but they also have a modern quality, a generic, even geometrical form that shows his awareness of the abstracting movements of the first half of the century. Marini usually models in plaster and often exhibits these sometimes painted works as completed, but he has also worked as a woodcarver. Here the bronze is painted with a harlequin-like pattern to signify the performer's tights. The traditional melancholy of such circus subjects seems emphasized by the mournful expression and the mutilation of arm and hand—a juggler who cannot juggle. The figure, in the midst of action, is suspended above its base in perpetual levitation.

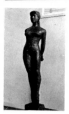

133　Giacomo Manzù (Manzoni; born 1908), *Dance Step*. Bronze; 1954. Mannheim, Städtische Kunsthalle. Manzù, who was born in northern Italy, was apprenticed first to a woodcarver, then to a gilder and stucco-worker. Impressed by ancient sculpture—and by the works of Donatello, Michelangelo, and Maillol—Manzù gradually developed a realistic approach somewhat indebted to the works of Arturo Martini (1889–1947). The *Dance Step* is one of a series of bronze sculptures that depict slender young female nudes in vaguely balletic poses; here, as in other works by Manzù on this same theme, anatomical forms are gently modeled, and a sense of nobility and strength is conveyed through the firm poise of the legs and torso and through the backward thrust of the shoulders. In depicting the female figure, he preferred as models young women who had not yet reached physical maturity, probably because their slightly undeveloped anatomy coincided exactly with his particular blend of idealization and realism. Manzù began his first *Dance Step* in 1941, and he periodically returned to this theme in later years, as he did to other favored subjects such as his *Girl on a Chair* or his *Cardinals* of the Roman Catholic Church.

134–135　Alexander Calder (1898–1976), *Totems*. Painted steel. Exhibition, February, 1966. Paris, Galerie Maeght. Calder's often humorous works are quite different from the more aggressive or brutal art of his younger abstract contemporaries. A third-generation sculptor, Calder graduated from the Stevens Institute of Technology, studied at the Art Students League, and during the late twenties made a study of the circus, which resulted in a miniature animated circus of his own. He made wire portraits as early as 1926; after a visit to Mondrian in 1930 he concentrated on abstract, often colored sculptures. Beginning in 1931 he exhibited abstract sculptures that Arp dubbed Stabiles; in 1932 he first showed the motor-driven or hand-powered sculptures that were given the title Mobiles by Marcel Duchamp. Eventually Calder preferred to let his hanging, delicately balanced creations be moved independently by accidental air currents. Although his sheetlike, cutout metal sculptures since 1950 became repetitive, he was one of the true pioneers of twentieth-century sculpture and his ideas have borne fruit in various directions, including, of course, kinetic art.

136　David Smith (1906–1965), *Cubi* III. Steel; 1961. Estate of the artist. Courtesy M. Knoedler & Co., New York. David Smith's earlier, more calligraphic works (see Fig. 56) developed in the fifties and sixties into greater abstraction—into constructions employing sheets of metal, curved and planar (Zig series), and ultimately into the group he called Cubi, probably his greatest achievements. Totemic qualities pervade these semaphoric sculptures, which stood like abstract heroes in the landscape outside his shop at Bolton Landing, whimsically named the Terminal Iron Works.

Like most of Smith's sculptures, the hieratic Cubi are interesting from various points of view and yet are essentially frontal, or two-dimensional, in effect. The structures themselves are steel boxes, buffed to give an abstract pattern of surface that denies the quality of the metal as such. The size, irregularity, and even potential danger of these large pieces of welded steel create a kind of sculpture that tends to contradict our usual tactile or erotic responses—they are aggressive, rebellious, and unpredictable. Smith's late compositions have an austere beauty that came only after years of struggle with the obdurate material and with the hostile and erotic imagery that possessed him.

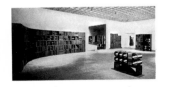

137　Tony (Anthony) Smith (born 1912), *Amaryllis*. Steel; 1965. Hartford, Connecticut, Wadsworth Atheneum. Tony Smith worked as a tool maker from 1933 to 1936 while attending the Art Students League at night; he also studied at the New Bauhaus in Chicago, then worked on buildings designed by Frank Lloyd Wright. Between 1940 and 1960 he designed a number of houses and monuments and was involved with many of the Abstract Expressionists. He turned from architecture to sculpture in 1960, and although associated with Minimal Art (see Plate 140a), he has been independent of any other official connection. His large geometrical abstractions belong in an environmental context and are angular versions of a style found in the more elegant curvilinear forms of Clement Meadmore (born 1929). The abstract polygonal shapes found in Smith's *Amaryllis* radiate a sense of poised energy and controlled power.

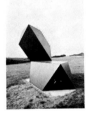

138–39　Louise Nevelson (born 1900), *Homage to the World* (wood, painted black; 1966), *Atmosphere and Environment* II (aluminum, black epoxy enamel; 1966), *Offering* (aluminum, black epoxy enamel; 1966), *Young Shadows* (wood, painted black; 1959–60), *Sky Wave* (wood, painted black; 1964), *Atmosphere and Environment* V (aluminum, black epoxy enamel; 1966), *Atmosphere and Environment* VI (magnesium, black epoxy enamel; 1967). Retrospective exhibition, March 1967. New York, Whitney Museum of American Art. A Russian by birth, Mrs. Nevelson (born Berliansky) was brought to Maine when she was five years old and by the age of nine "knew all along that I wanted to be an artist." In 1931 she studied with Hans Hofmann in Munich, and later returned to New York where she worked with Diego Rivera on his murals. She exhibited small Cubist figures in various materials in the forties, then

began her characteristic boxes, reliefs, and walls, which by the later fifties had become sculptured environments. These works were constructed of wood objects, largely found, and have as their remote ancestor the Dada-Surreal room of junk assembled by Kurt Schwitters in the twenties. Her sculpture is of a more romantic order, displaying, as Hilton Kramer put it, a "maximum of visual incident—accretions of form that state and restate, that amplify and dramatize the basic structure of the work." Her spectacular sculptural rooms arrange wooden forms into still-life landscapes, which for all their architectonic scale and abstract content are fundamentally personal and mysterious, a geometric Surrealist dream.

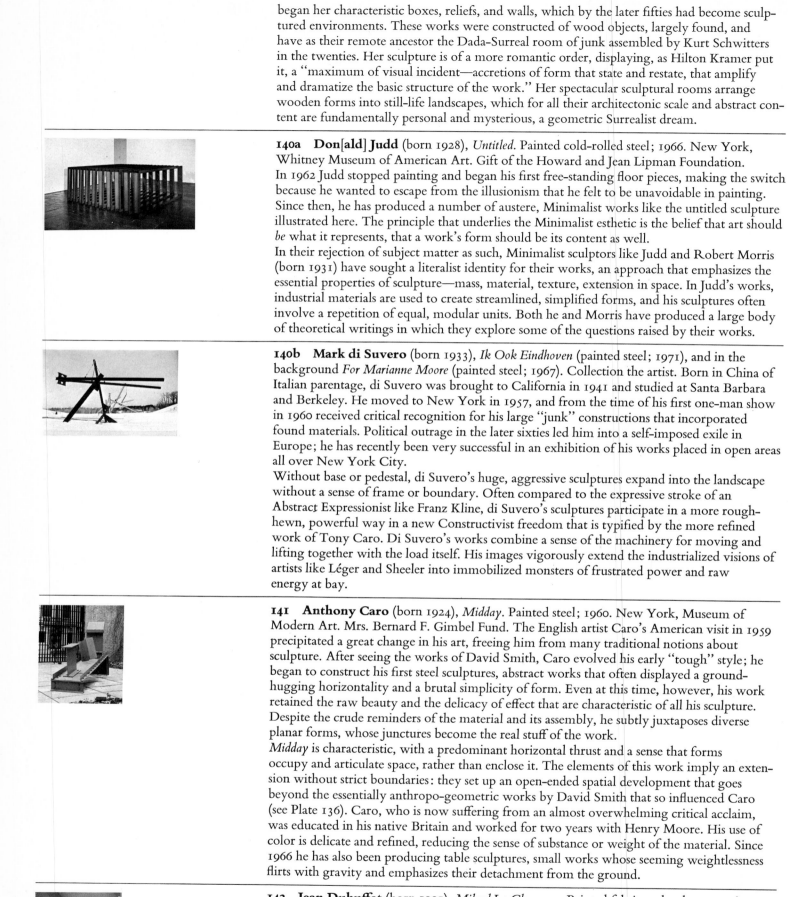

140a Don[ald] Judd (born 1928), *Untitled*. Painted cold-rolled steel; 1966. New York, Whitney Museum of American Art. Gift of the Howard and Jean Lipman Foundation. In 1962 Judd stopped painting and began his first free-standing floor pieces, making the switch because he wanted to escape from the illusionism that he felt to be unavoidable in painting. Since then, he has produced a number of austere, Minimalist works like the untitled sculpture illustrated here. The principle that underlies the Minimalist esthetic is the belief that art should *be* what it represents, that a work's form should be its content as well.
In their rejection of subject matter as such, Minimalist sculptors like Judd and Robert Morris (born 1931) have sought a literalist identity for their works, an approach that emphasizes the essential properties of sculpture—mass, material, texture, extension in space. In Judd's works, industrial materials are used to create streamlined, simplified forms, and his sculptures often involve a repetition of equal, modular units. Both he and Morris have produced a large body of theoretical writings in which they explore some of the questions raised by their works.

140b Mark di Suvero (born 1933), *Ik Ook Eindhoven* (painted steel; 1971), and in the background *For Marianne Moore* (painted steel; 1967). Collection the artist. Born in China of Italian parentage, di Suvero was brought to California in 1941 and studied at Santa Barbara and Berkeley. He moved to New York in 1957, and from the time of his first one-man show in 1960 received critical recognition for his large "junk" constructions that incorporated found materials. Political outrage in the later sixties led him into a self-imposed exile in Europe; he has recently been very successful in an exhibition of his works placed in open areas all over New York City.
Without base or pedestal, di Suvero's huge, aggressive sculptures expand into the landscape without a sense of frame or boundary. Often compared to the expressive stroke of an Abstract Expressionist like Franz Kline, di Suvero's sculptures participate in a more rough-hewn, powerful way in a new Constructivist freedom that is typified by the more refined work of Tony Caro. Di Suvero's works combine a sense of the machinery for moving and lifting together with the load itself. His images vigorously extend the industrialized visions of artists like Léger and Sheeler into immobilized monsters of frustrated power and raw energy at bay.

141 Anthony Caro (born 1924), *Midday*. Painted steel; 1960. New York, Museum of Modern Art. Mrs. Bernard F. Gimbel Fund. The English artist Caro's American visit in 1959 precipitated a great change in his art, freeing him from many traditional notions about sculpture. After seeing the works of David Smith, Caro evolved his early "tough" style; he began to construct his first steel sculptures, abstract works that often displayed a ground-hugging horizontality and a brutal simplicity of form. Even at this time, however, his work retained the raw beauty and the delicacy of effect that are characteristic of all his sculpture. Despite the crude reminders of the material and its assembly, he subtly juxtaposes diverse planar forms, whose junctures become the real stuff of the work.
Midday is characteristic, with a predominant horizontal thrust and a sense that forms occupy and articulate space, rather than enclose it. The elements of this work imply an extension without strict boundaries: they set up an open-ended spatial development that goes beyond the essentially anthropo-geometric works by David Smith that so influenced Caro (see Plate 136). Caro, who is now suffering from an almost overwhelming critical acclaim, was educated in his native Britain and worked for two years with Henry Moore. His use of color is delicate and refined, reducing the sense of substance or weight of the material. Since 1966 he has also been producing table sculptures, small works whose seeming weightlessness flirts with gravity and emphasizes their detachment from the ground.

142 Jean Dubuffet (born 1901), *Milord La Chamarre*. Painted fabric and polyester resin costume; 1972. Created for *Coucou Bazar*, 1973, New York. Dubuffet, a painter, from the time of his first postwar exhibition in 1946 rejected all past culture; he is especially disdainful of accepted ideas of beauty or even of technical control. The study of graffiti, children's art, and the art of the insane led him to create crude, flattened, frontal forms, often grossly sexual, molded out of thick compounds of viscous materials. An exhibition of Dubuffet's collection of monstrosities, produced by nonartists in 1949, was entitled "Art Brut"; all his sources

have been ostensibly from outside the cultural establishment, without reference to traditional concepts of taste or form. "By denying any possibility of distinguishing between beautiful and ugly objects he, as much as anyone else, created the aesthetic conditions for the 'junk culture' and 'Pop Art' of the 1960s" (G. H. Hamilton). This work, a later product of the same iconoclastic mind, was created for Dubuffet's *Coucou Bazar*, an "animated painting" that combined art, music, and theater.

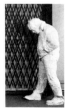

143 George Segal (born 1924), *Walking Man.* Plaster, painted metal, wood; 1966. St. Louis, Collection Mr. and Mrs. Norman B. Champ, Jr. Segal was at first a painter; his chicken farm in New Jersey was the scene for the first outdoor Happening, staged by his friend Allan Kaprow in 1958. Segal's connections first with the Hansa and then the Green Gallery involved him in the experimental art of the sixties: Happenings, collage, assemblage, junk, environments. A sophisticated art historian who studied with Meyer Schapiro, Segal began to experiment with plaster figures in 1958; in 1960 his course was set by the chance gift of some plaster-impregnated bandages normally used to set broken limbs. "Immediately I knew what to do . . . my wife wrapped me in the . . . bandages I had found my medium." Segal's figures are usually taken from his friends in familiar situations—one shows John Chamberlain working on a piece of his junk sculpture. Instead of using his plaster bandages as molds for realistic images, Segal uses the outside of the bandages, which are reassembled after the painful process of casting them on the living model. This creates his numbed but expressive white figures, "vital mummies," which are then set into realistic little environments. As William Seitz pointed out, Segal's works have an unusual life and presence that postulates consciousness.

144a Edward Kienholz (born 1927), *The Wait.* Tableau: epoxy, glass, wood, and found objects; 1964–65. New York, Whitney Museum of American Art. Gift of the Howard and Jean Lipman Foundation. Kienholz has often been labeled a social critic because many of his works attack the least attractive aspects of the human condition. *The Wait* directly and brutally confronts the theme of the loneliness of death: a bony old woman sits passively in an ancient parlor, which is furnished with objects from bygone years. Abandoned or forgotten by those whose photographs surround her, she is accompanied now by her needlework and her pets; she wears around her neck a string of glass jars containing objects that symbolize her memories. Among these souvenirs, she sits and waits.
An autodidactic artist who was trained to be a rancher, Kienholz began in 1954 to make abstract, wooden reliefs; by the late fifties he moved to more three-dimensional, figurative sculptures and several years later constructed his first tableaux. He produced a number of these elaborate environments during the sixties, all depicting similarly bleak subjects—brutal sex in the back seat of a '38 Dodge; the atrocities of war; the inhumanity of state hospitals. With his peculiar combination of real (usually found) objects and surrealistic transformations, he evokes the anxious dislocations that are encountered in contemporary life.

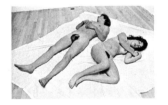

144b John de Andrea (born 1941), *Arden Anderson and Nora Murphy.* Polyester and fiberglass, polychromed in oil; 1972. Germany, Collection Charles Wilp. De Andrea's eerily lifelike nude figures are cast from the model and then spray-painted in oil. Their extreme verisimilitude carries the realism of Segal's plaster casts a step further, since the surface of de Andrea's figures so closely simulates the appearance of human skin. Like the sculptures of Duane Hanson (born 1925; see Fig. 1), de Andrea's works often disconcert the viewer by frustrating his mental expectations: these super-real figures *look* so lifelike that one constantly anticipates a movement that never occurs. When asked how real he wanted his sculptures to be, de Andrea replied bluntly that he wanted them "to breathe."
De Andrea has always been interested in the human figure—a reaction, he has said, to the overwhelming predominance of Abstract Expressionism, an approach to painting that precludes the veristic treatment of the human body. His figures are usually nude, because he finds the unclothed body more expressive, and they are frequently grouped in pairs.

145 Claes Oldenburg (born 1929), *Standing Mitt with Ball.* Steel, lead, and wood; 1973. Concord, Massachusetts, private collection. Oldenburg has long been notorious for his creation of a world of Pop Art objects with a disjunctive relationship to ordinary things. Textural antitheses and distortions of normal scale are essential to his work: hard objects such as typewriters and electric fans are created out of soft, pliable materials; and small objects such as cigarette butts or garden trowels are enlarged far beyond their usual scale. *Standing Mitt with Ball* engaged both types of formal dislocation; the work stands twelve feet high, and the soft folds of the glove have been re-created in dented steel.
In the sixties, Oldenburg began his mock-serious proposals for city monuments, an outgrowth of his more conventional "environmental" studies of the later fifties and of his involvement with Kaprow's Happenings. Besides his projects for a colossal teddy bear in Central

Park, New York, and for giant cigarette butts in Hyde Park, London, he planned a Lipstick Monument for Yale University. This last work, which consists of a bright red lipstick tube mounted on a tractor-like base, was erected in 1969 and with its twenty-four-foot height towered over one of the university's courtyards. Born in Sweden and educated at Yale, Oldenburg has produced a large body of works that can be either whimsical or satirical; in some instances, he is a reformer as well, since he alters the viewer's consciousness of ordinary, everyday things.

146 Nicolas Schöffer (born 1912), *Chronos.* Aluminum, 1968. Paris, Collection the artist. Sculptured light was an early ideal of László Moholy-Nagy's at the Bauhaus in Weimar; his *Light-Space Modulator* of 1922–30 (Harvard University) was a moving machine of different abstract forms illuminated by alternating spotlights that threw light and shadow over the walls and ceiling of a darkened room. Gyorgy Kepes was the chief mediator between Moholy-Nagy and the present day, but only recently has light art made much of an impression. Micro-time is a sequence of sound vibrations that occur so fast that we perceive them as a single tone. In his "Microtemps" series, begun in 1961, Schöffer has tried to create a similar visual effect in table-size boxes with curved aluminum backdrops. Inside, revolving spindles fitted with Plexiglas blocks and metallic surfaces are struck by changing colors. The varying speed of revolution produces alternating and contrasting effects, not always strictly determined by the program. Another light sculptor, Jack Burnham, has compared the plight of avant-garde music to the programming of kinetic sculpture: "Music suffers either from over- or understructuring while visual Kinetics are beset with attempts to impose structures which are meaningless or attempts to produce antistructural situations. . . ."

147 Chryssa (Varda Chryssa, born 1933), *Clytemnestra.* Multicolored neon tubing and molded Plexiglas with timer; 1968. Berlin, Nationalgalerie. Born and educated in Athens, Chryssa studied in Paris in 1953, then immigrated to the United States; in New York she produced reductionist sculpture related to paintings by Rothko. Her development paralleled that of Jasper Johns, and the Pop culture eventually led her to experiment with lights. She seems to have been the first artist to use directly emitted light and neon.
The *Clytemnestra* of 1968 is a monumental construction made up of repeated fragments of neon tubing. Like all of Chryssa's light sculptures, this brash and colorful work grew out of her infatuation with the poetic vulgarity of the illuminated signs in Times Square, which she once described as "Homeric." Her effort has often had to be on a technological level, and at one point in her career she set up her own factory so that she could construct much of her work with her own hands.

148 Christo (Christo Javacheff; born 1935), *Running Fence* (detail). Nylon, steel poles and cable; 1976. Marin and Sonoma Counties, California. Christo was born in Bulgaria and studied painting, sculpture, and stage design in Sofia. After brief periods in Prague and Vienna, he arrived in Paris in 1958; there he began his first series of wrapped objects—groups of bottles and cans that were partially or completely packaged in canvas and secured with string. From these small-scale works, he moved to wrapping larger and larger objects: first, tables, chairs, street signs, and motorcycles; then, entire buildings and other large structures. In 1968 he wrapped the Bern Kunsthalle in synthetic fabric, and a year later he packaged in heavy tarpaulin the Chicago Museum of Contemporary Art.
In 1976 Christo constructed his *Running Fence*, a striking tour de force that twists and turns through twenty-four miles of landscape in Marin and Sonoma Counties in California. The *Fence* consists of more than two thousand nylon panels (each eighteen feet high), which flutter in the breeze and reflect the changing patterns of light. It cost $2 million to construct, a sum that Christo raised largely through the sale of his works. Like Robert Smithson's *Spiral Jetty* 1970, Christo's *Fence* takes art into the environment on a monumental scale; not surprisingly, Christo has expressed great admiration for the Great Wall of China. Despite the enormous amount of labor needed to place the *Fence* in the California landscape, it was intended as a temporary structure, one that would be eventually demolished.

Bibliography

Introduction The literature on esthetics and sculpture is fairly vast. Rhys Carpenter, *The Esthetic Basis of Greek Art* (Bloomington: Indiana University Press, 1959) is stimulating. See also Herbert Read, *The Art of Sculpture* (Princeton University Press, and London: Faber and Faber, 2nd ed., 1961). Jack Burnham, *Beyond Modern Sculpture* (New York: Braziller, 1968) offers a thoughtful text by a kinetic sculptor. Rudolf Wittkower, *Sculpture: Processes and Principles* (Harmondsworth: Penguin, and New York: Harper & Row, 1977), is of the greatest interest for all periods.

Chapter 1: The Middle Ages Roberto Salvini, *Medieval Sculpture* (London: George Rainbird, and Greenwich, Conn.: New York Graphic, 1969) is valuable for its many illustrations. *The Universe History of Art* has small volumes on the various sub-periods written by experts, and with color plates (New York: Universe Books; London: Weidenfeld & Nicolson; Stuttgart: Belser Verlag). More specialized: Peter Lasko, *Ars Sacra 800 to 1200*, Pelican History of Art (Harmondsworth and Baltimore: Penguin, 1972); Marcel Aubert, *La sculpture française au moyen-âge* (Paris, 1949); and Willibald Sauerländer, *Gothic Sculpture in France 1140 to 1270* (New York: Abrams, 1973). John Pope-Hennessy, *An Introduction to Italian Sculpture*, I: *Italian Gothic Sculpture* (London: Phaidon, 2nd ed., 1970), can be supplemented by John White, *Art and Architecture in Italy 1250 to 1400* (Pelican History of Art, 1966). See also the survey in Rossana Bossaglia et al., *1200 Years of Italian Sculpture* (New York: Abrams, 1973).

Chapter 2: Renaissance and Mannerism Herbert Keutner, *Sculpture Renaissance to Rococo* (London: George Rainbird, and Greenwich, Conn.: New York Graphic, 1969), has many illustrations. For more detailed accounts, see John Pope-Hennessy, *An Introduction to Italian Sculpture*, II and III (London: Phaidon, 2nd eds., 1971), and the relevant volumes of the Pelican History of Art: Charles Seymour, Jr., *Sculpture in Italy 1400 to 1500* (1966); Theodor Müller, *Sculpture in the Netherlands, Germany, France, and Spain 1400 to 1500* (1966); Gert von der Osten and Horst Vey, *Painting and Sculpture in Germany and the Netherlands 1500 to 1600* (1969); and Anthony Blunt, *Art and Architecture in France 1500 to 1700* (2nd ed., 1970) (outstanding). For the great artists, see H. W. Janson, *The Sculpture of Donatello* (Princeton University Press, 1963) and Howard Hibbard, *Michelangelo* (London: Allen Lane, and New York: Harper & Row, 1975).

Chapter 3: Baroque to Romantic See bibliography for Chapter 2 above (Keutner, Pope-Hennessy, Blunt). In the Pelican History of Art: Rudolf Wittkower, *Art and Architecture in Italy 1600 to 1750* (3rd ed., 1973) (outstanding); Wend Graf Kalnein and Michael Levey, *Art and Architecture of the Eighteenth Century in France* (1972); George Kubler and Martin Soria, *Art and Architecture in Spain and Portugal . . . 1500 to 1800* (1959); Eberhard Hempel, *Baroque Art and Architecture in Central Europe* (1965) (not wholly trustworthy or up to date). For the nineteenth century: Fred Licht, *Sculpture Nineteenth and Twentieth Centuries* (London: George Rainbird, and Greenwich, Conn.: New York Graphic, 1967); Fritz Novotny, *Painting and Sculpture in Europe 1780 to 1880* (Pelican History of Art, 1960) is disappointing. Outstanding master: Rudolf Wittkower, *Bernini* (London: Phaidon, 2nd ed., 1966).

Chapter 4: From Rodin to the Present George H. Hamilton, *Painting and Sculpture in Europe 1800–1940* (Pelican History of Art, 2nd ed., 1972), is an outstanding survey. See also Licht (cited above), especially for illustrations. Albert Elsen, *Origins of Modern Sculpture: Pioneers and Premises* (New York: Braziller, 1974) is stimulating. For American sculpture, see Tom Armstrong et al., *200 Years of American Sculpture* (New York: Whitney Museum of American Art, 1976), with biographies and bibliographies; Abraham Lerner et al., *The Hirshhorn Museum and Sculpture Garden* (New York: Abrams, 1974). See also William Rubin, *Anthony Caro*, Museum of Modern Art, 1975. For the outstanding master of the period, consult any of several books on Rodin by Albert Elsen.